Also by M J Harper

The History of Britain Revealed
(USA title: The Secret History of the English Language)

The Megalithic Empire (with H L Vered)

Meetings with Remarkable Forgeries

An Unreliable History of the Second World War

YouTubes

A New Model of the Solar System
https://www.youtube.com/watch?v=uPWH9xh_Jy0

The Distribution of Deserts
https://www.youtube.com/watch?app=desktop&v=5uNQIMcKNTM

The Megalithic Empire
https://www.youtube.co/watch?v=IJ_S6zkh_PY

Websites

The Applied Epistemology Library
http://www.applied-epistemology.com/phpbb2/index.php

The Megalithic Empire
http://www.themegalithicempire.com/forum/

Revisionist Historiography

M J Harper

Applied Epistemology Library
publishing@aelibrary.co.uk

CONTENTS

Part Six: Let's Make History

Part Seven: Languages As They Are Wrote

Part One

THE FIRST DARK AGE

1 A Gap in our Knowledge

In 1250 BC or thereabouts King Menelaus of Sparta led his troops against the city of Troy. In 480 BC King Leonidas of Sparta led his troops against the Persians at the Battle of Thermopylae. But what of the kings of Sparta in between the Trojan War and the Three Hundred? Nobody knows. Not only about Spartan kings but about Ancient Greeks in general. It is a blank page in history and since there cannot be blank pages in our past – something must have been going on – historians call such periods 'dark ages'. This one, naturally enough, is the Greek Dark Age.

In 1952 (A.D.) a strange Russian-American called Immanuel Velikovsky said this was all wrong and the Trojan War, insofar as it was a real event, took place around 650 BC and the period between 1250 BC and 650 BC never existed. The centuries had been added to the historical record because of a chronological mis-calculation by historians. This mildly mind-popping theory was met with derision by historians and embraced avidly by the looney-tunes.

After several decades on the fringe, Velikovsky's thesis was taken up by a group of archaeologists and historians and published as *Centuries of Darkness*. The five authors presented the evidence at length and in painstaking detail, though Velikovsky himself received only the briefest of name-checks. The book was warmly received by some quite eminent academics as 'a contribution to the debate' but otherwise had little effect. A single work, no matter how cogently argued, however well-endorsed, could not dent ingrained assumptions. Nor did *Centuries of Darkness* reach a wider history-reading public. It was written in such dense academese as to be all but unreadable to anyone other than the professionally schooled. This is a shame because accounts of academic disciplines getting their basic parameters wrong can be riveting. This book is about faulty academic parameters.

How can hundreds of years get added by mistake to the historical record? Chronology, though vital to the study of history, is not itself a subject much studied by historians. Historiography in general, the study of history, is not much studied by historians. Too nuts-and-bolts. To illustrate how errant time can get spatch-

cocked into academic history, imagine thousands of years hence archaeologists are digging around in the ruins of London...

One of them finds a newspaper clipping, dated 23rd January 2015: 'Saudi Arabia in turmoil as King Abdullah dies at 90'. Another archaeologist points out an Abdullah bin Abdulaziz Al Saud is mentioned in a sherd excavated in Egypt but, it seems, this Abdullah died in 1436 and the event passed off peacefully. They tentatively put forward the idea that Abdullah is a throne name, or perhaps a royal title, used by a dynasty that ruled in the period between c. 1436 and c. 2015.

Hedged around with all the usual caveats, this thesis appears in textbooks about the ancient middle east and much energy is devoted to finding out more about this Dynasty of Abdullahs but little emerges – the six hundred year period must have been something of a dark age. Indeed it is dubbed the 'Arabic Dark Age'.

Many years pass until another historian, a maverick, scarcely a historian at all, announces that these two Abdullahs were one and the same person. The different dates arose solely from one source using a chronology based on the birth of Jesus, the other on Mohammed's journey from Mecca to Medina. 2015 and 1436 are the same year expressed differently and this explained why nothing much had been discovered about 'the Abdullahs' – they did not exist. Nor did the Arabic Dark Age.

This notion might have flown if, in the meantime, and despite the lack of evidence, the Arabic Dark Age had not acquired a corpus of academic literature, an established place in the canon and a fair few academics specialising in the period. The It Never Happened theory was met with derision and did not find its way into any textbook. Not even, it has to be said, to be rejected.

Without a chronology history is all but impossible so, when it comes to our own ancient world, how do historians agree on one, given the limited amount of documentary and archaeological evidence? First in the field were the Egyptologists using 'king lists'. The Egyptians were punctilious when recording their pharaohs and with records being well-preserved in Egyptian conditions, this allowed Egyptologists to provide a more or less complete timeline from circa 3000 BC to circa Cleopatra. The Egyptians corresponded with all the other states of the near and middle east, so once Egyptian chronology was settled, everyone else's chronology could be fixed as well. It did not matter what year each of them gave in their dating system, historians could convert the local date into the corresponding Egyptian date which could then be

expressed as 1352 BC or whatever. Ancient history had acquired its chronology.

Egyptian dates are by no means straightforward at the best of times but, at the turn of the twentieth century when they were being hammered into shape, both Egyptian history and chronological methodology were in their infancy. It would be unfair to blame pioneering Egyptologists if they had spliced phantom time into real time, it would be their successors' fault for not correcting it. And the fault of their colleagues specialising in other areas of the ancient past, taking their word for it. However, in academia

first is best

Scholarship is based on precedent. Whatever is already there is what is taught to students and, in the fullness of time, what some of those students will teach their students. In theory everything should get reviewed and revised from time to time, especially if anomalies start turning up, but this may not happen. It is always easier explaining away anomalies than addressing them. Who wants to rewrite a thousand textbooks? Who wants to admit they have got it wrong all these years? Who wants to admit it was not a properly accredited historian that got it right? Anyway, for whatever reason, the six errant centuries are still there.

Getting it wrong has had serious consequences. History begins with the written record and the 'Birth of Civilisation' in the middle east around 3000 BC, so if six hundred non-existent years have been spliced into middle eastern history, our understanding of civilisation is radically flawed. The added years are also when the Bronze Age was becoming the Iron Age so archaeology, which uses historians' chronologies, went off the rails too. We are the end product of all this so it could scarcely be worse.

Then an odd thing happened. Ancient history and archaeology flourished as never before. The public took to it in a big way. Looked at purely from a professional perspective, the false chronology had not been disastrous at all. Dark Ages, if anything, added to the allure. Soon there was a scholarly industry devoted to the ancient Mediterranean and middle eastern world and, as the researchers multiplied, inevitably the knowledge multiplied. What had once been an informational desert was transformed into a verdant academic landscape. There might be blank centuries but at least the existence of those centuries had been confirmed. So

3

much knowledge was being acquired using the chronology, it was deemed highly unlikely the chronology itself would be wrong.

Which is not to say anybody is comfortable with the blank centuries. Nobody likes specialising in a subject with a heart of darkness. From the start there have been unrelenting efforts either to fill the centuries with new material or, failing that, to minimise the gap as far as was practicable. There are three ways of doing this

creative labelling
nudging from both ends
explaining them away

These are our terms, we being applied epistemologists, radical revisionists, looney-tunes, call us what you will. Academic specialists do not recognise they are doing any such thing, or would do any such thing, but since one of our areas of study is academic specialisms we keep a weather eye out for just such carryings-on. Examples of both will be coming thick and fast in these pages though they are widespread throughout academia.

Or, for that matter, in any competitive environment because

false paradigms are better than no paradigms

A false chronology is better than no chronology. This does have one in-built difficulty. It is easy for people to cohere around a valid paradigm, how do they manage to cohere around a false one? It is essential they do because in competitive environments

agreed paradigms are better than disputed paradigms

Academic subjects are like political parties: few people will sign up to an outfit at odds with itself. To do their job properly, academic subjects and political parties ought to be constantly riven with internal disputes as they check and re-check their fundamental assumptions, but it is death in the real world if they do. That is the way of the world and what puts

the *Applied* into Applied Epistemology

If the six centuries are spurious, standard textbooks dealing with ancient history will show

o no credible explanation why everything stopped
o no observed development for six centuries
o no credible explanation why everything started up again
o the same thing happening twice: once before, once after

A 'dark age' will be recorded, this being the only reasonable explanation for little or no evidence of human activity over a long period of historical time. More exactly 'dark *ages*' varying in length, with differing terminal points, as each set of specialists record their own dark age, given their own local circumstances.

It is quite a list. If we find such things occurring regularly we can assume the chronology is at least prima facie false and spread the word. How to do this? As academic revisionism of the *Centuries of Darkness* type has not worked and as the non-academic revisionism of the Velikovsky type has not worked, can the all-singing, all-dancing revisionism of the Applied Epistemology school do the job? We have no finger in any of the pies and no specialised knowledge of any of them, but we have our little ways.

We use the words of academics to get rid of the pies, then we use the words of academics to bake fresh ones. We are nothing if not parasites. We know we have done a good job if we end up with very few pies and none of them taste very nice. That's one of our little ways.

Provisos

Apart from my own linking commentary which can be judged on its own merits, everything from now on will be either from the authors of *Centuries of Darkness* or their quotes from other academics. It will all have the imprimatur of scholarship.

Really obtuse passages have occasionally been rendered into plain English, though sparingly as the use of academese can be enlightening in itself. Non-controversial material has sometimes been paraphrased into my text.

Whenever the number 750, 850 etc is encountered, the original was 'the middle of the eighth century' etc. Various other dating conventions have been converted into precise numbers. 'The close of the second millennium', 'the start of the tenth century', 'c. 1000 BC' are all the same thing but some are more useful than others when it comes to gentle obfuscation.

The lack of citations and other scholarly apparatuses is dealt with passim. Everything can be checked with *Centuries of Darkness* or by googling. Nobody holds your hand in this business.

*

Readers of my books find the comedic asides out of place in a serious work. I agree. They detract from any authoritativeness I may achieve from time to time. Too bad. I have found, over the

years, readers stop reading books they disagree with unless there is some reason to continue and a laugh every now and then can tip the balance. Because for sure you are going to be disagreeing quite a lot.

2 Greek on Greek

How is the 1250 BC date for the Trojan War arrived at? It used to be conventionally dated to 1450 but the date has been edging downwards for the whole of the twentieth century. Historians readily concede the Trojan War has no specific date – they make no bones it may never have happened. What they are agreed on is that Greeks of that approximate time were *Mycenaeans*, Greeks living on the mainland (as opposed to the earlier Minoans on Crete) in the period 1450 - 1250, though that too has been subject to 'drift-down'.

Whether Minoan, Mycenaean or unspecified, Greeks disappear from the historical and archaeological record, hence the *Greek Dark Age*, until the dolorous centuries end around 650 BC and Greek stirrings are once more faintly visible. These new-born Hellenes have been dubbed 'Achaean' Greeks and imperceptibly become the familiar Classical Greeks – Solon, Socrates, Leonidas, Demosthenes, Plato, Alexander the Great and the rest.

If the period 1250 to 650 BC is removed, Greek historical and archaeological evidence becomes continuous, as Classical Greeks follow on pell mell from Achaean Greeks who follow on from Mycenaean Greeks who follow on from Minoan Greeks. Nobody departs the stage, they just develop into something else, or get called something else. How does that compare with the livelier version on offer in the textbooks and the lecture halls?

We know from our checklist the sort of things to look out for. Developments in Greek chariot technology for example. Those who know their Classics will recall Achilles drove round the ramparts of Troy in his chariot and, whether he actually did or not, this is placed by academics in the Mycenaean period, *c* 1250 BC. Greeks of the Classical period did not use chariots for warlike purposes though the idea of chariots was familiar to all Greeks – they feature in poetry and on pottery and frescoes both from the Mycenaean period before 1250 and the Achaean and Classical periods after 700 BC.

According to the authors of *Centuries of Darkness*, there are no illustrations of chariots between 1250 and 700. This would strike anyone as odd but Hilda Lorimer, an Oxford specialist, added to the oddness by pointing out

> there was a very close similarity between 1450 BC and 750
> BC vehicles

We look to the experts to explain how the Greeks could know what chariots looked like after hundreds of years of not knowing what chariots looked like. Dame Hilda's opposite number, Anthony Snodgrass, Emeritus Professor in Classical Archaeology at Cambridge, posed the question in a slightly different way

> Since there is no sort of evidence from 1250 down to 700
> for the use of chariots in the Aegean, it seems unwise to
> assume any continuity between the Mycenaeans and
> eighth-century chariots until this can be proved

and provided the answer

> 'inspired by the epic poetry of Homer' and 'a few surviv-
> ing Mycenaean pots' showed later artists the way to draw

But what of those necessary adjuncts of sharp-bladed warfare, shields, which unlike chariots were a constant for fighting men in all eras of the ancient world? Greek shields came in three shapes. Two of them were sparsely functional, round or rectangular, used by everyone and hence not much help for archaeological, historical or chronological purposes. The third type was called a *dipylon* and had such an idiosyncratic figure-of-eight shape as to be handily diagnostic of a single culture.

Two single cultures. Both the Mycenaeans before 1150 BC and Greeks after 700 BC illustrated their pots with dipylon shields. Professor Snodgrass applied his beaux-arts theory to the situation

> Snodgrass, having suggested that the chariot depictions in
> Classical art did not represent contemporary objects, was
> forced to argue the same for the Dipylon shield – that it
> was some sort of throw-back with heroic associations. His
> argument was based on the over stylisation of the shield
> on Classical pottery.

Peter Greenhalgh, a specialist in early Greek warfare, felt military considerations were at least as important as aesthetic ones

> ordinary round and rectangular shields were clearly in
> use in the Classical period (a fact also acknowledged by

> Snodgrass) and this implies that the dipylon shield was
> also real

but he would now have to explain the gap himself. Which he did manfully by sweeping it aside

> Greenhalgh could not believe that they were derived from
> pre-1200 BC because of the gap in time and ignored the
> evidence of the Mycenaean pots, putting forward the idea
> that their design was new, dictated in particular by their
> use in conjunction with the spear

Spears in conjunction with shields, whatever will those Greeks think of next? Reynold Higgins, Keeper of Greek Antiquities at the British Museum, decided they were both wrong because dipylon shields were also on *beads* of 1150 BC. Doctor Snoddie was not taking his medicine, he had an entire pharmacopoeia to call upon

> If the dipylon shield was an actuality in 650 BC, then we
> have to assume either that it was modelled, more or less
> slavishly, on the bead miniatures of 1150; or that the
> 'dipylon' shield, having actually developed into this form,
> then remained in use, unchanged for centuries; or else it
> was revived by pure coincidence in identical form, after an
> equally long lapse.

One of the consequences of the six-hundred year gap is that it has allowed the Bronze Age (before the gap) to be differentiated from the Iron Age (after the gap). It should work seamlessly but here it has created metallurgical difficulties. By placing Mycenaean Greeks in the Bronze Age and Classical Greeks in the Iron Age, it had to be explained why they were using identical smelting equipment. The story is taken up by Bernhard Schweitzer of the Deutsches Archäologisches Institut

> the bronze workshops also continued to function after the
> end of the Mycenaean period. With a few exceptions, the
> only surviving products of these workshops are tripods

Notice what Bernhard has done here. His innocent-sounding 'after the end of the Mycenaean period' is our missing centuries and is the equivalent of saying, "The English parliament under Winston Churchill continued to function after the end of the

9

Tudor/Stuart period." He is confident that bronze goods are being produced throughout this time but says only the tripods have survived. Technically the most Schweitzer can claim is the tripods are indirect evidence they were. If he can date the tripods. If he can explain what sort of bronzesmiths churn out goods for six hundred years that all disappear, using tripods that don't.

Professor Snodgrass is back to remark on

> **the close resemblance of the earliest Iron Age tripods to the few known examples from the latest Bronze Age**

Notice what Anthony has done here. It would never be guessed from these words that 'latest Bronze Age' and 'earliest Iron Age' have a six-hundred year gap between them. He redeems himself in fine style

> **I still remain sceptical as to the existence of a continuous industry for the casting of bronze tripods throughout the dark age of Greece**

He is quite right. If bronze artefacts are absent for six hundred years there does not seem a lot of point making bronze-smelting equipment for six hundred years on the off chance.

There is still the question of how tripod *design* can so effortlessly vault the gap. Hector Catling, Director of the British School at Athens, had an ingenious theory

> **he therefore concluded that the late examples were actually highly prized heirlooms**

Notice what Hector has done here. He is using 'late' in the sense of "Hector, you're late. Six hundred years late. Your vichyssoise is on the table." I agree with his general theory though. Metal-smelting equipment has long been handed down in my own family. I was left a Bessemer steel converter by my dear mama. "It's a highly prized family heirloom," she whispered, "look after it well and pass it on to your children and your children's children." "I'm the middle one, mum, I haven't got any children."

The Schweitzer family may not have been long-term collectors because Bernhard took the view the tripods were definitely made in later times, not six-hundred year-old curios from the past. The argument came to a head when some tripods were found in Cyprus that could be securely dated to around 700 BC. This may be

10

thought to have settled matters in Schweitzer's favour but, on the contrary, it sent Catling into raptures

> The tripods were prized long after they were made because of their great technical virtuosity. They were also prized because they could not be repeated – they were marvels ... They became treasured, personal belongings ... passed from hand to hand, generation after generation, acting always as a reminder of the achievements of the past.

I cannot agree. Looking at my own collection, I would judge tripods to be at the lower end of technical virtuosity.

3 Troy, Lost & Found

The Trojan War might be mythical but archaeologists claim to have discovered the site of Troy, and it is truly an archaeological cornucopia. It was occupied from very near the start of the ancient world, around 3000 BC, and lasted until the end of it in Roman times. To make Troy the absolute gold standard of excavation, each level is readily distinguishable from the one above and the one below because the city was subject to regular earthquakes, sackings, fire and similar identifiable misfortunes. Hence archaeologists were able to identify Troy Levels 1–9, mini-cornucopias for every specialist, no matter which period of the ancient world they specialised in.

Being one of the most famous cities of the ancient world was not half bad either. Though not entirely good. None of its denizens, one-through-nine, thought to leave any record that it was called Troy. It acquired its famous cognomen (more famous than its other cognomina Ilios, Wulisa, Truwisa and Hisarlik) courtesy of Heinrich Schliemann, a German 'businessman', as Wiki coyly calls him. After discovering Troy he went on to discover Mycenae so it seems discourteous not to call the world's most successful archaeologist an archaeologist. Heinrich was later associated with various sharp practices so perhaps it was for the best.

Troy is untouchable now the Iliad and Mycenae provide the Years Zero for the Greek Project but that does not exempt Troy from the Greek Dark Age. One would think Trojans had had their fill of Greeks without having to cope with their dark ages as well but it was not Priam, Hector & Co that had to do the coping. The Trojan Dark Age was between Level 7 (the Mycenaean period) and Level 8 (the Classical period). Denys Page, Professor of Greek at Cambridge, was minding the gap

> There is nothing at Troy to fill this huge lacuna. For 2000 years men had left traces of their living there; some chapters were brief and obscure, but there was never yet a chapter left wholly blank. Now at last there is silence, profound and prolonged for 400 years; we are asked, surely not in vain, to believe that Troy lay 'virtually unoccupied' for this long period of time

It is apparently possible for somewhere to be lived in for hundreds of years, be abandoned for hundreds of years, then lived in again for hundreds of years. My own native city had just such an interregnum. After starting life as Trinovantum (New Troy!) it became Londinium, then experienced several hundred years of 'silence, profound and prolonged' before becoming the London we all know and love. Love it or leave it, as we say on our bumper stickers.

Lots of people were loving but leaving Old Troy. Possibly because it did not have our flair for innovation

> Yet despite the apparent lapse of several centuries, there is every indication of continuity between Troy 7 and Troy 8. The excavator, Carl Blegen, could detect no sign of a break in occupation. Furthermore, the local pottery of Troy 8 was the same distinctive, lustrous grey ware used during Troy 7

Dr Blegen mused on this and had a lightbulb moment

> He therefore supposed that the inhabitants of Troy 7 abandoned it for a nearby refuge, where they continued to produce this 'Grey Minyan' pottery for 400 years before returning

Until this refuge is discovered we shall have to rely on Dr Blegen for amplification

> These people in 1100 BC carried with them the tradition of making Grey Minyan pottery and maintained it down to 700 BC ... Did some of the inhabitants perhaps then return to Troy? Though there is nothing to prove this, we do know that in 650 BC the Trojan citadel, which had been virtually deserted for some four hundred years, suddenly blossomed into life once more with occupants who were still able to make Grey Minyan pottery

The fall of Troy was once dated to 1450 but the general scaling down now puts it at 1250. Doc Blegen has got it down to 1100 by having the Level 8 folk turning up four hundred years later in 700 but this is a purely paper exercise. It will have to be confirmed by actual physical evidence

> The problem of the Trojan 'Dark Age' has been slightly alleviated by a subsequent down-dating of the material

> from Troy 7, once dated only to 1250 BC by imported
> Mycenaean goods but now lowered to 1150 by some
> 'imported LHIIIC sherds'

For those with a shameful ignorance of classical classifications

Code	Stands for	Meaning
L	Late	there must be an Early
H	Helladic	imported Greek
III	3	there must be a I and a II
C	C	there must be an A and a B

Troy 7 and the interface with Troy 8 used to be a lacuna, now it is awash with sub-divisions and a 'could-be Greek' get-out clause. Many, many bricks can be made with that amount of straw.

Dr Wardle, Senior Classics Lecturer at Berlin University, was first among hod-carriers

> Kenneth Wardle, a major figure in this debate, has cast
> doubt on the identification of the very small 'LHIIIC'
> sherds ... they were residual sherds from earlier periods,
> left lying around and then incorporated into later deposits
> ... and reduces Troy 7 further, from 1100 BC to 950 BC

Any advance on 950? Dr Blegen declared these LHIIIC sherds

> indistinguishable from 650 BC sherds common in Level 8

The gap would be closed if only the wretched things were not still hanging around from Mycenaean days

> Their occurrence in several areas in Troy 7 presents a
> perplexing and still unexplained problem

which Carl now proceeded to compound by excavating a house that had been inhabited in 1150 BC, then again in 750 BC, but not in between.

Those of us with second homes can see what has happened here. They had all gone off to live in the refuge right enough but used to pop back from time to time to give the old place an airing. Hence the venerable but still serviceable Grey Minyan crockery left on the sideboard.

4 Tickling the Ivories

Nobody keeps pottery very long but it is a different matter when it comes to fancy goods. In the ancient Near East, the situation was both reassuring and perplexing

> **It is remarkable that most examples of continuity occur in luxury goods of the sort one would have expected to disappear during the cultural Dark Age generally envisaged**

Reassuring because something has survived to fill the yawning centuries, perplexing because it is so high-end. Dr Schweitzer, of prized tripod fame, spells out how high is high

> **The Mycenaean artefacts that survived were jewellery, utensils of gold, silver, bronze and ivory.**

Ivory-working was a Mycenaean speciality but, along with all things Mycenaean, this ended abruptly in 1250 BC (or 1150 as it is increasingly being called). Someone must have been preserving the techniques because when the trade started up again

> **The motifs on the ivories are remarkably similar**

With the Mycenaeans gone, who was it? It was a real whodunnit. Were they being preserved on the Asian mainland?

> **It is usually assumed that the techniques of ivory-carving were preserved in the Levant during the Dark Age and then re-exported to Greece for a second time**

No.

> **Ivory working disappeared in the Levant also between 1175 and 850.**

It was turning into a multinational, pan-disciplinary quest to find out who was keeping the style book. When excavations at the Temple of Artemis on Delos produced ivory animals the same as those from Megiddo in Israel, Helene Kantor of the Oriental Institute at the University of Chicago, a specialist in the artwork of Ancient Greece and the Middle East, cannily reset the timeframe to a slightly shorter, slightly vaguer 'three centuries'

15

> When details of the animals from Delos and ... Megiddo ...
> are compared with those of the North Syrian ivories ... the
> patterning is seen to be well nigh identical despite the
> passage of three centuries without any known links

Richard Barnett, the British Museum's resident ivory expert, did his level best by pointing out the Delian animals were an earlier deposit, disturbed during levelling operations on the site, and then re-buried. It's almost as if he was there. Archaeologists, who were there, did not appreciate art historians blaming slipshod archaeological techniques to solve art-historical problems and decided creative labelling was the better answer

> many of the shapes, subjects and devices of the Canaanite-
> Mycenaean tradition

but slipped in a quick *or* to help out on the chronology side

> This is a remarkable feat if there really was a two- or
> three-century break in production

This newly identified Canaanite-Mycenaean tradition was precisely why late Athenian figurines were identical to early Israelite ones

> They were inspired by Syrian ivories of several centuries
> before.

Greek and Israelite artists may have been inspired by Syrian artists, but Syrian ivories had gone too so it must have been somebody else that was keeping the Canaanite-Mycenaean tradition going for several centuries. But who? Where?

It took the doyen of archaeologists, Sir Max Mallowan, to tell them they could stop looking. During the interval, he explained, the Phoenicians had transferred their skills from ivory to perishable materials, textiles and wood. Lady Mallowan, Dame Agatha Christie, did not use this as a plot device, crime novels being held to a higher standard, but the Mallowan Doctrine proved a godsend in the non-fiction world

> The perishable materials theory has had to be employed to
> explain some striking resemblances between the painted
> pottery of the Mycenaean Greeks of 1200 BC, and that of
> the later Greeks of 800 BC and the even later Greeks of
> 650 BC

J. L. Benson, an authority on Corinthian pottery, was no fan of either Phoenicians or superannuated Phoenician excavators but took care not to name names

> Various scholars who in actual fact have worked quite intensively with Greek pottery of 650 BC have recorded the continuing and recurring influence of the Mycenaean, 1200 BC, tradition ... a recent investigator ... has been forced to a recognition of a persistent sub-stratum of Mycenaean influence on Greek art ... another investigator found the origin of nearly all motifs to be Mycenaean and had to postulate their survival on textile and metal ornaments. The theory that the motifs of painted pottery survived through a different medium has to be brought into play because no pictorial pottery is known in the period between the Mycenaean originals and their derivatives several hundred years later

The audience leaned forward, anxious to hear who really had done it. Who *had* been responsible for Greek art styles lasting six hundred years without leaving any trace of the art? DCI Benson of the Corinth CID entered through the French windows at the back of the stage to announce

> This could have taken place in Attica, thought to be a rallying place for refugees after the disturbances at the end of the Bronze Age, bringing with them treasured possessions such as carpets, jewels and possibly vases

Curtain, applause, cries of 'Author! Author!' etc.

5 The Potter's Wheel Goes Round and Round

Even in the darkest of dark ages pots are getting made and pottery lasts forever. Since the Neolithic in fact. It was going to require some very special special pleading to account for its absence anywhere in the civilised eastern Mediterranean for several centuries. Fortunately for the pleaders

o there was a mass of Mycenaean pottery
o there was a mass of Classical pottery
o there is no way of objectively dating pottery

If only pottery didn't come with telltale baggage.

Everyone likes a bit of adornment on their earthenware and no amount of conservatism and Attican style-gurus are going to keep that adornment the same for six hundred years. There simply had to be changes if the Dark Age centuries were to continue intact. Not easy in the absence of the centuries. Fortunately the pottery came in three Goldilocks styles

o plain (doesn't tell us enough)
o fancy (tells us too much)
o lines and squiggles (just enough)

The 'Greek Geometric' style had been born.

Ideally, archaeologists like pottery styles to change gradually, strata by strata, starting from the bottom (earliest) to top (latest) to form a *sequence*. The absence of time, at this time, meant the absence of strata so it was found advantageous to date pottery thus

o a half-hearted design is Protogeometric and shows it is early
o a bold design is full-on Geometric and shows it is late

It did not need a hole in the ground, only a hole in the head

Protogeometric	Early Protogeometric Late Protogeometric
Geometric	Early Geometric I Early Geometric II Late Geometric I Late Geometric II

Anyone who thinks this is complicated has no idea how creative creative labelling can be in the hands of an expert

> It is often with some reluctance that specialists have accepted the necessity of spinning out the limited amount of pottery for the LHIIIC, Submycenaean, Protogeometric and Geometric phases to cover the period between 1200 to 700

We have been given some Submycenaean Polyfilla for that smooth finish everyone is looking for

LHIIIC	before 1200 BC
Submycenaean	'afterwards'
Protogeometric	1025 to 900
Geometric	900 to 700

A sequence? It's a great wall of china. Our Professor Snodgrass provided the instruction manual

> It is clear we are dealing with a very slow rate of advance in the potter's art in Greece. If we make a provisional hypothesis as to the duration of the styles, and assume about 150 years for the residue of Mycenae IIIC, 150 years for the Protogeometric, and fifty years each for Early and Middle Geometric, we shall be taking a wholly arbitrary step, but we shall arrive at approximately the right total, without unduly straining credulity ... no reduction in any one case is possible without a compensatory lengthening elsewhere

The Prof has put a Mycenae IIIC (that's new) alongside LHIIIC (that's old) and slipped a Middle Geometric (that's new) between Early and Late Geometric (they're old). He's a true master.

With the scheme bedding in, the specialists could get down to doing what they do best, making elbow room for their own specialism. Penelope Mountjoy of the British Institute of Archaeology in Athens wanted more space for her Mycenaean pottery and showed how it could be done. By some good old-fashioned give-and-take

> The many phases of building activity at Mycenae during LHIIIC prompted her to suggest a longer span should be

19

> ascribed to this, pushing it to 1050 BC. Allowing two gen-
> erations for the Submycenaean, she had to lower the start
> of the Protogeometric by some fifty years and shorten the
> time available for the Geometric

"We give, she takes," murmured everyone else. Archaeologists excavating around Sparta reported

> the latest Mycenaean material was mixed with Proto-
> geometric pottery and gave it a 1000 BC date in line with
> conventional chronology

The adjudicators were forced to make a judgement of Solomon: a style can have one date at one site, a different date at another site

> The date has since been lowered by Desborough and
> Snodgrass, who start the local Protogeometric to 950 and
> 900 respectively

which killed the whole purpose of the scheme.

That tiresome fellow (of the British Academy), Nicholas Hammond, pointed out this introduced a time gap into a continuous stratum. A *fellow*? Paul Cartledge was the A G Leventis Professor of Greek Culture at Cambridge and brusquely informed his junior colleague

> The stratigraphy was deceptive. Although preserving the
> correct progression, the sequence was formed by material
> being washed down.

"Aye, it rains bloody stair rods in t'Peloponnese," Nick was not heard to say. There would be no need for internecine strife if a new wheeze being given a test drive in Lefkandi proved a winner

> A striking feature at Lefkandi is the overall homogeneity
> in the pottery styles between c.900 and 750 BC, attributed
> by the excavators to the conservatism of the inhabitants,
> 'traditional to an extreme in their unusual burial practices
> and in their adherence to a pottery style which once
> evolved was clung to for over 150 years'

If a style could be stretched over 150 years and no style lasted as long as 150 years, any piece of pottery could be given any age within reason. And if it was not within reason? Who's to say there might not be Greeks more conservative than the Lefkandians?

Greek Dark Age pottery had become a bran tub, available for anyone to dip into. It couldn't be this easy, could it?

> **Lefkandi posed difficulties in defining the difference between the later Protogeometric and the 'Sub-Proto-geometric' – an unfortunately cumbersome term for the local styles equivalent to the Early and Middle Geometric of the Athens area**

'Sub-Protogeometric' cumbersome? If you're afraid of technical terms, chummy, you're in the wrong game. Keep your powder dry for when there is an Early Sub-Protogeometric I and II, a Middle Sub-Protogeometric I and II, and a Late Sub-Protogeometric I and II. It was already a tight squeeze

> **The frequent superimposition of Geometric deposits over later Mycenaean material offers no support for the idea that the Protogeometric was of any great duration.**

Possibly so but, in the judgement of Solomon Snodgrass, the duration was *just* great enough

> **This sequence must be extended over probably about four hundred years or more**

I don't like it. "Must be... extended... probably... about... or more..." Was the Dear Leader signalling his unease? Did he know, deep in that Calvinist Scottish soul, something must be wrong? He chairs the British Committee for the Reunification of the Parthenon Marbles so we know his heart is in the right place. It is high time the Parthenon was taken out of irresponsible Greek hands and relocated to London.

6 Anybody Home?

Ah, the Parthenon. What a relief it is to leave the persnickety world of pottery sherds to embrace the vistas of Greek architecture

> The architectural history of the Greek Dark Age amply demonstrates the post-Mycenaean collapse. On the mainland as well as the islands construction in stone and brick almost entirely ceased ... Monumental architecture ... was not attempted after 1250 BC. The skill of building with saw-cut blocks (ashlar masonry) seems to have been forgotten for several centuries, no new city walls were built anywhere after 1100. It is only in 750 BC that defences were constructed once more.

The skill of unobtrusively scaling down chronology gaps had not been forgotten. City walls surely count as monumental architecture so 1250 has quietly become 1100.

People who build city walls in the good times but not in the bad times when they are needed surely count as people who may well have dark ages visited upon them. Vincent Desborough, the English historian and archaeologist, credited with discovering the Greek Dark Age, was keen to demonstrate how dark this one was. The Greeks, he claimed, had quite forgotten how to use stone. That hasn't happened since the Neolithic.

> The extreme rarity of any stone construction for a period of centuries after 1200 BC strongly supports the view that the skill had been lost ... houses in the intervening time were constructed exclusively, or to a large extent, of perishable materials such as mud-brick, wood or clay.

Desborough could be accused of milking his own theory so it was down to Professor Snodgrass to defend Greek honour

> The paucity of architecture could be explained by a shift to greater dependence on pastoralism, with stock-rearing replacing mixed farming, as a response to the collapse of the centralized Mycenaean palace economy ... this less sedentary way of life would have resulted in semi-permanent settlements with more makeshift buildings of mud-brick and wood

I'm not much of a country person myself but I might have guessed they live in mud huts. It's a wonder they're not still living up trees, the ones I meet. I am surprised though to hear stock-rearing is done on the move. I know all about transhumance of course and shepherds wandering from glen to glen playing their panpipes, but I watch Countryfile religiously so I can assure these so-called experts in their urban ivory towers that rearing animals is done in *fixed* mud huts.

The wanderungen Greeks may not have had the benefits of home, hearth or television but they did have their memories

> **there is a curious continuation of Mycenaean elements in the architecture of the Greeks after 750 ... when construction in stone began to flourish again**

"Stone? Wassat? Oh, I remember now. It's all coming back to me. Where are those damn blueprints I kept at the back of the hut? Where's the damn hut?"

It was not just houses, temples were a distant memory too

> **the strange thing is that no actual temples survive from the Dark Age; indeed it has to be assumed that 'almost all worship took place in the open air'**

Strange? Again, I take issue. Druids and Wesleyan Methodists were great ones for alfresco worship. According to Nicolas Coldstream, Professor of Classical Art at University College, London, these blueprints had been kept safe too

> **The plans of 750 BC temples have undeniable precedents in the pre-1150 type**

It's uncanny. Our own Victorians used pre-1150 precedents when building Gothic revival churches. Verily, we are all one under the blessings of the One True God(s).

7 East, West, Writing's Best

Literacy is such a useful attribute in any social circumstance that for the Greeks to be writing before 1150, writing after 750, but not in between seems, on the face, unlikely. But, as we are beginning to appreciate, anything is possible in a dark age.

> It has been supposed that literacy continued in Greece during the Dark Age, but that the writing medium changed from clay to a perishable material such as wood.

As clay is reasonably plentiful and wood difficult to write on, this view has lost ground

> Current scholarship generally accepts an apparent lapse into illiteracy, and explains it as follows: with the fall of the palaces the need for writing ceased and the script was thus soon forgotten.

Guardian-reading republicans please note.

Another thing we have learned about Dark Age Greeks is that basic knowledge is kept going no matter what. They may not have been writing themselves but, come hell or high water, they were making sure their children were learning their ABC's in case it started up again. The alpha male of ancient alphabets is Joseph Naveh who tells us how the tradition got started

> The earliest Greek writing closely resembles examples from Syro-Palestine conventionally dated to 1050 BC

The WASPish Professor McCarter of Johns Hopkins did not favour Semitic trail-blazing and set about closing the Greek gap by changing 750 to 'before 800', shading 1050 to 1000, slipping in a 'limited' and then summed up by describing two hundred years as 'years later'

> the Greeks, though their script did not diverge as an independent tradition before 800 BC, had experimented with the Semitic alphabet as early as 1000 BC ... The memory of the earlier experimentation survived long enough ... to exert a limited influence upon the final formulation of the Greek alphabet years later

Naveh told McCarter where he could shove his Greek experiment pipe dreams

> 'an impossible formula' and that the Greeks adopted the Proto-Canaanite script in 1050

and was vindicated when a bronze bowl from Crete with 1000 BC Phoenician inscriptions was unearthed.

Things had suddenly got serious. Western civilisation rests on Greece not Syro-Palestine. It was down to the gap-nudgers to save civilisation

> The bowl was found in an unplundered grave with 900 BC Cretan pottery

Professor Coldstream, our General Monk, ensured the Restoration with a nicely chosen 'well before', a literally true 'over a century' and by pointing out we were just looking anyway

> It is tantalizing to know that the Phoenician alphabet was on view in Crete well before 850 BC, over a century before the earliest known use of the Greek alphabet.

Tantalizing. Derived from the Greek King Tantalus, condemned for eternity never to reach the succulent fruits forever out of reach.

8 The Hittite Gallery is Closed for Repairs

Marginal people like Mycenaean Greeks can disappear from history with scarcely a by-your-leave but that would hardly do for the broad sweep of the Fertile Crescent, an area of the world that gave birth to civilisation, was the seat of éus empires and is the bedrock of Ancient History. Could such a vast area of minutely recorded and multifarious human activity encompass a Dark Age? With Egyptian chronology it was going to have to.

The best way to trigger dark ages is the violent entry of outsiders bent on laying waste, so the search was on. At first historians were keen on the 'Sea Peoples' who, like the Vikings of our own Dark Age, were able to rain death and destruction over a wide arc. But they fell short in this instance – maritime brutes could not be raining death and destruction over the wide arc of the landlocked middle east. The call went out for someone, as it were, better.

Applicants would have to pass stringent auditions. They had to be new to history yet have a six-hundred-year history of their own; they had to be hitherto unknown to historians yet well-known to the people they were laying waste. Where was such an ill-tempered Scarlett O'Hara to be found, capable of playing opposite to such an assortment of Rhett Butlers? It turned out to be

The Hittites

Who?

> Until the late 19th century the Hittites were a truly 'lost' civilization. The idea that they had ruled an empire dominating most of Anatolia and northern Syria ... was unheard of ... the Hittites were known solely from a few oblique references in the Old Testament

The Bible crowd could be ignored. Not so the Classical audience

> There seem to be only two references in the whole of classical literature which, with the benefit of hindsight, could conceivably relate to the Hittite Empire

That could be coped with. There are lots of references to Troy in classical literature and Troy is positioned between the Mycenaeans and the Hittites. Troy, one might say, sealed off the Hittites from

the Greeks and when Troy disappeared from classical literature the Greeks had entered their Dark Age so that was all right.

Egypt was proving not to be a problem

> **Egyptian records seemed to allude to such an entity – the armies of a people known as the 'Kheta' repeatedly confronted 18th and 19th Dynasty Pharaohs campaigning in Syria**

The Egyptologists knew from their king lists that the pharaohs of the 18th and 19th Dynasty were dated 1400 to 1200 BC so henceforward the Kheta were the Hittites.

Mesopotamian specialists would need convincing. The baked clay tablets of the Tigris-Euphrates valley last better than Nile papyrus, Mesopotamian states kept better records than the Egyptians, they might even have better chronologies. That is not the way things work in academia. Greece and Egypt are big wheels, Mesopotamia is a flywheel. The Sumerologists were told to get with the programme, inspect those records of theirs, and come up with some Hittites

> **Assyrian texts also commonly referred to Syria as the 'land of Hatti', a name equivalent to the Egyptian term Kheta**

Kheta=Hatti=Hittites. That settled that.

The only cloud on the event horizon was that the Assyrian records about this Land of Hatti were dated to around 800 BC which, read superficially, could be thought six hundred years too late. Not at all, it shows the opposite. If Egyptologists could demonstrate the Kheta went back to 1400 BC and the Assyriologists were equally confident of their 800 BC Hattian date, the Hittites were long-lived desperadoes in anybody's book. The case was closed and Hittite Galleries could start opening. If there was sufficient Hittite material to go in them.

There were some tremendous sets of monumental statuary which could very well be Hittite since nobody knew who had carved them but this was the twentieth century and the age of carting those off had passed. Could the art historians kindly come up with some Hittite exhibits that were more cartable? They were keen to help but handicapped by not having any. The redoubtable Otto Puchstein of Freiburg University was heard complaining

neither in Anatolia nor in northern Syria is there evidence
that 'Hittite' sculpture already existed in 950 BC. This is
incompatible with the view that Imperial Hittite power
and the flourishing of Hittite art could take place five
hundred years before the Anatolian and Syrian monu-
ments came into being

Here's how, Otto. If the Hittites have been conjured into ancient
history, it is a small step conjuring up a Second Coming of the
Hittites into ancient history

From 1400–1200 BC the Hittites extended their sway over
eastern Anatolia and northern Syria. Then, in 1200 BC,
beset by economic troubles, the Empire collapsed under
pressure from barbarian invaders ... plunging Anatolia
into a Dark Age of several centuries' duration. The Empire
was forgotten and its capitals abandoned ... but in the
meantime Hittite civilisation had begun to flourish again
in Mesopotamia in a 'strange afterglow which lasted for
no less than five centuries'

If a Hittite Empire and a Hittite Afterglow have been conjured
into history, it is a small step conjuring up Hieroglyphic Hittites

This 'afterglow' is so pronounced that most scholars
believe that there was a migration of 'Hieroglyphic
Hittites' (speakers of the Luwian branch of the language)
fleeing southern Anatolia after the fall of the Empire

If a Hittite Empire, a Hittite Afterglow and Hieroglyphic Hittites
have been conjured into history, it is a small step conjuring up neo-
Hittites

Founding 'Neo-Hittite' states in areas once ruled by the
Empire, they perpetuated Hittite customs, religion,
names, hieroglyphic writing and styles in art and
architecture until the Assyrian conquest of 750 BC

The art historians would not be told. Now it was Henri Frankfort,
the foremost expert on ancient Near-Eastern art, having a fit of
the vapours

He was prepared to follow to the letter the indications of
Imperial Hittite influence on the one hand, and 700 BC
Mesopotamian influence on the other, effectively dividing

> all Hittite art into two blocks: one ending in 1200 BC, the other beginning in 850 BC. He insisted that there was no continuity between the two, asking how the latter could possibly have preserved 'intact a detailed iconographical tradition throughout the period'

William Albright, the Director of the American School of Oriental Research, told him off and told him how

> the refusal of an earlier authority to recognise the existence of any monumental art or architecture in the neo-Hittite states between 1200 and 850 BC is entirely wrong ... the eleventh and tenth centuries were the golden age of Syro-Hittite art and architecture

We mortals can only watch in awe as this Battle of the Titans plays out. In the red corner a Dark Age, in the blue corner a Golden Age.

It was all very unsettling for the Mesopotamian lobby. They were happy enough having a Hittite Empire looming over them in Anatolia, they did not mind being conquered, they often were, but for the entire Tigris-Euphrates valley to be reduced to a Hittite afterglow for five hundred years was not what they had signed up to Mesopotamian Studies for. Professor David Hawkins of the School of Oriental and African Studies thought he could lead them out of the wilderness

> During these three centuries, such archaeological remains as have been discovered in Syria float in a chronological vacuum

Chronological vacuum? Careless talk costs jobs, Dave. It would be better, his Mesopotamian colleagues agreed, to make a bid for the leadership of these neo-Hittites and parley that into some decent history

> Carchemish on the Euphrates was a vigorous and rich (particularly in metals) independent kingdom, the apparent leader of the Neo-Hittite states ... conquered by the Hittites in the very year that Tutankhamen died, as we know from the extraordinary fact that his widow wrote to the 'Great King' as he laid siege to the city. The capture of Carchemish can thus be dated c. 1325 BC by the conventional Egyptian chronology

Mesopotamian records showed Carchemish was still an important city when the Assyrians captured it in 720 BC so there was no question: Carchemish must have been a major player 1325-720. Major enough to warrant the attention of a major archaeologist, and they don't come more major than Sir Leonard Woolley

> **On a pavement which he dated no earlier than 850 BC, Woolley identified 'several late Mycenaean sherds dated to 1250 BC'.**

The good news was that Carchemish was trading goods over long distances, the less good news was it was trading goods four hundred years out of date. The *new* news was that the Carchemish city fathers had instituted progressive conservation policies

> **These must have come from the Temple Treasury where they had been preserved for many generations**

Critics may think 'many generations' does not entirely convey the essence of 'four hundred years' but criticism would have to cease in the face of Woolley's next find from his Temple Treasury

> **a winged disc... the symbol of imperial power ... evidently a relic from the Hittite Empire**

That's more like it, Sir Knight, what else do you have for us?

> **In a tomb securely dated to 650 BC, Woolley found a series of small gold figures which bore a striking resemblance to the pantheon on a frieze at Yazilikaya, conventionally dated to 1250 BC**

That's not more like it, Sir Woolley-by-name. Four hundred years was bad enough, six is worse. Sir Len compromised on five

> **Woolley considered that the jewellery was manufactured in 750 BC, but in a style which had, somehow, been preserved for five hundred years.**

Hans Güterbock, the German Hittologist, thought it was time to remind everyone who was supposed to be the boss round here. The Hittites.

> **This discovery links the 750 BC Hittite period with the time of the 1250 BC Empire... There is no doubt that both**

> **in style and in subjects these figures... are Hittite in the
> sense of the Hittite Empire.**

He could not argue with such a famous figure as Woolley and dutifully asked the troubling question, "How did carvings of 1250 BC get into a tomb of 650 BC?" But only because he already knew the answer

> **Güterbock preferred to see them as heirlooms, brought
> to Carchemish by the Imperial Hittites and 'kept in the
> treasury in spite of the change in domination'**

Woolley would hardly need reminding the British Museum is full of Roman antiquities brought to Britain by Imperial Rome.

Up to a point. The Romans had not actually put them in the British Museum or whatever their equivalent of a Temple Treasury was. Güterbock had thought of that too

> **alternatively, that they had been carried there by
> migrating Hieroglyphic Hittites who had joined in the
> looting of the 1250 BC centres when they were sacked by
> barbarian invaders**

It's a tricky one all right

- o I like the idea of conservation-minded civil servants
- o I like the idea of barbarian looters bringing their heirlooms along with them.
- o I'm not so sure about barbarian looters turning into conservation-minded civil servants. It doesn't seem natural.

But I'm no expert. I'd have to consult the British Museum whether they know of examples of looters becoming conservationists other than these Hittites of Güterbock's. And themselves, obviously.

9 Don't Cut that Knot

If there was a five-hundred-year afterglow of the Hittite Empire in Mesopotamia, a brighter one might be anticipated in the Hittite heartland. It was not to be.

> **After 1200 BC, the earliest datable finds from central Anatolia belong to the 750 BC Kingdom of the Phrygians, familiar from classical sources, because of King Midas of the Golden Touch and his father Gordius of Gordian Knot fame.**

The Hittites had vanished without trace in Hittite Central when all sorts of mini-Hittites were flourishing elsewhere. With so much history hanging on the Hittites, could they be left in the hands of those relative newcomers, Turkish archaeologists?

Dr Ekrem Akurgaly, excavating the Hittite capital, Hattusa (Boghazköy as they call it) demonstrated they had mastered two of the fundamentals

1. Intractable problems are not intractable when transliterated into the reassuring words of academese

 > **It has to be admitted that thus far Boghazköy has contributed little to the illumination of what we call the Dark Age. Not a single find has turned up which can be attributed safely to the centuries immediately following the fall of the Hittite capital**

2. Explanations for intractable problems must meet both domestic and professional requirements

 > **This could indicate that Central Anatolia at that period was either very thinly populated or occupied by nomad tribes who left no material remains in the dwelling mounds**

Anatolia was later occupied by nomad Turkic tribes. Still is, though they are more settled today. They ruled Egypt for six hundred years so it is only right and proper they are now to be ruled by Egyptian chronology.

Everyone is ruled by western archaeology and, as we know, these two mighty empires between them always leave disconcerting gaps

wherever they rule. Were the Turks fully trained in the three ways of coping with disconcerting gaps?

(A) filling them in
(B) paring them down
(C) explaining them away

The president of the German Archaeological Institute, Kurt Bittel, recommended **(A)** and began by looking at things top down

> The earliest Phrygian constructions were undertaken at a time when Hittite ruins still lay visible above the surface

then bottoms up

> On top of the Hittite layers there is no trace of a sterile stratum as would have been formed by natural sedimentation

As neither of these things is possible if four hundred years separated Hittites and Phrygians, the choices were

rewriting the rules of archaeology
rewriting the laws of physics
rewriting in academese

> This stratigraphical observation as such does not give a measure of time, but it tends to limit the interval

It soon dawned on everyone they had a truly major problem on their hands, one no amount of academese could hide. There have to be Greeks, Egyptians, Babylonians et al before and after the gap but the Hittites have to *disappear*. Anatolia was required to host a host of non-Hittite characters starting with Gordius and Midas. Phrygians were not to be trifled with on account of their hats, as modelled by French Revolutionaries. Marianne is not going to be seen out wearing a Hittite bonnet.

> No archaeological relationship between the Hittites and Phrygians had therefore been envisaged. At Gordion, however, there was no such break. Instead, the two cultures appear to have co-existed for a considerable time

Were the Imperial Hittites, the Afterglow Hittites, the Hieroglyphic Hittites and the Neo-Hittites to be joined by the Co-

Exister Hittites? If so, according to the archaeology found at Gordion, it will have to be for a very long time

> The topmost stratum contained mainly Phrygian pottery but with 'a large admixture of late Hittite'. The next produced 'pottery about half Hittite, half Phrygian'. The third layer 'produced again about half Hittite and half Phrygian pottery'. The fourth level contained 'Hittite pottery with a minimal representation of Phrygian'. The fifth level and 'all the ones below were of pre-1250 Hittite'.

It was acceptable to mix and match Hittites and Phrygians at Gordion because that stretched things out nicely, but it totally contradicted the big fat nothingness found at Boghazköy. One of them had to give, which one was it to be when

o Boghazköy is claimed to be the Hittite capital
o Boghazköy is a Turkish dig
o The Turkish government hands out the permits

It was all hands to close the Gordion Gap.

G K Sams, the Phrygian expert at the Pennsylvania University Museum of Archaeology and Anthropology, thought **(C)** 'explaining it away', might be a good idea

> Another possibility is that the controversial levels at Gordion were somehow 'telescoped', creating the false impression of an overlap

No, a bad idea. Telescoping strata may work apples at Gordion but it destroyed the basis of archaeology. There was nothing for it, it would have to be **(B)** paring the gap from either end.

President Bittel started from the top by easing Phrygia down. Everyone had been proceeding on the assumption that Phrygia was dated to 800 BC but Kurt said it ain't necessarily so

> How much earlier the Phrygian occupation may have been is as yet difficult to determine, but we should emphasize again that the stratigraphic situation does not suggest too long a gap after 1200 BC

Enthusiasm was muted. Nobody wanted to contemplate a Phrygia starting shortly after 1200 BC but remaining unrecorded until 800. It would add a Phrygian Dark Age to the groaning pile.

The British Anatolian expert, James Mellaart, preferred pulling the Hittites up. He started conventionally with a Hittite Empire, then conventionally calling a halt to it

The capital Hattusa was burnt and deserted

Continued conventionally by coining a new type of Hittite

the disintegration of the Hittite New Kingdom

but in doing so had done something *un*conventional, trespassing on somebody else's domain. Egyptologists had already bagged the name New Kingdom and they had no records of New Khetians. Mellaart was not to be denied and proceeded to trespass on an even bigger domain, archaeology's

> **the idea that the Early Iron Age started c 1200 BC must be repudiated as unrealistic. A date of c. 1000 BC plus or minus 50 years seems a fairer estimate for the transition from the Late Bronze Age to Early Iron Age**

Archaeologists were entitled to complain about Mellaart's Early Iron Age. Four hundred years was fine, two hundred was cutting it fine. Plus or minus fifty years was neither here nor there. But Mellaart had pointed the way to a lasting resolution.

History and archaeology had already formed a de facto joint working group for dealing with the Dark Age gap in general

before the gap	**Bronze Age**	Mycenaean Greeks Hittite Empire New Kingdom Egypt
after the gap	**Iron Age**	Classical Greeks Phrygians Late Period Egypt

Metallurgical eras are much less precise than chronologies, better suited in general for hiding joins. But, pari passu, they left the archaeologists in charge, not something historians normally permit when there is a condominium. Here it solved a historical problem so a point was stretched and, besides, Gordion having Bronze Age people all mixed up with Iron Age people went to show how

imprecise metallurgical eras were and how imperative it is to have historians on hand to sort everything out.

Anyone who thinks 'Bronze Age' and 'Iron Age' are exercises in creative labelling made necessary to hide spurious centuries is in need of a thorough training in both history *and* archaeology.

10 Cyprus, an Island Divided

Cyprus is at the centre of the Greece–Levant–Egypt triangle and should make an ideal test bed. It was a prime source for ancient copper (it's in the name) and copper was an essential ingredient of the Bronze Age (nine parts copper, one part tin) so there ought to be plenty of Bronze Age archaeology on Cyprus. It has no iron to speak of so it is only to be expected that Cypriot fortunes would take a turn for the worse when the Bronze Age gave way to the Iron Age. Hector Catling, who includes the Cypriot Bronze Age in his portfolio, said how much worse

> **There was a terrifying diminution in the population and abandonment of large parts of the island.**

Steady on, old chap, one must not get personally involved with one's charges. It may be better to seek out the more measured views of Lawrence Stager, Professor of Archaeology at Harvard

> **In 1150 BC nearly ninety percent of the settlements of Cyprus are abandoned. Practically all of our evidence comes from the coastal sites ... By 1000 BC, even these had ceased to exist**

Clearly we are dealing with something more than a bear market in copper futures but what, precisely?

> **A great earthquake has been proposed. From then on a veil of darkness covers the history of the island.**

This is familiar to students of academic paradigms. Subject areas that use evidence from the past for their basic structures – in the Life and Earth Sciences as well as the Humanities – are keen on earthquakes. Or asteroid strikes, or volcanic eruptions, or tsunamis or pandemics. Anything which has two characteristics

dramatic and extremely long-lasting effects

when they occur in the past and we do not know what happened

dramatic but not very long-lasting effects

when they occur in the present and we do know what happened. A tsunami might kill a million people, the Black Death might wipe

out a third of Europe, but life and the world go on relatively un-
disturbed afterwards. It is a bit heartless to say so which may be
why these extravagant catastrophe theories get such an easy ride.

If an asteroid strike in the Cretaceous did for the dinosaurs,
historians can blame a fifteenth century BC volcanic eruption on
Santorini doing it for the Minoans with a clear conscience. Or the
Justinian Plague in the sixth century AD causing the collapse of the
Mediterranean economy. Or the fourteenth century Little Ice Age
being the harbinger of Protestantism. Whatever it takes. Certainly,
archaeologists can hint at earthquakes denuding Cyprus of its
human population without a blush. Happens all the time.

Cypriots themselves do not favour talk of catastrophes, it might
affect the tourist trade. What they like is anything that smacks of
enosis with Greece. Some Cypriots. The Greek-Cypriot archae-
ologist, Vassos Karageorghis, for instance

**The history of Cyprus after about 1050 BC is clouded by
what is usually called the "Dark Age" in Greece**

Why not an Anatolian Dark Age, Vass? It's a lot closer. No? Fair
enough, it's dealer's choice, though you might find enosis has its
limits. When the Greeks were undergoing their Dark Age they
changed their script from Linear B to the familiar Classical alpha-
bet but Greek Cypriots did not follow their mainland exemplars
on this occasion

pre-1100 BC	they wrote in a script known as Cypro-Minoan
1100 to 800 BC	had their dark age and wrote nothing
post-800 BC	started writing again in Cypro-Minoan and carried on doing so until Roman times

They may not even have been Greek by the sound of it. It was a
close call between two unlikely scenarios

	Greece	**Cyprus**
pre-Dark Age	writing in one alphabet	writing in one alphabet
Dark Age	forgetting how to write	forgetting how to write
post-Dark Age	starting afresh with a new alphabet	carrying on with the old alphabet

In Cyprus's case not just unlikely, miraculous

> **The still largely undeciphered Cypro-Minoan script appears on a variety of objects (tablets, vases, weights, seals etc.) throughout Cyprus, down to 1100 BC ... it then completely vanishes ... it then miraculously flourished again ... from 800 to 100 BC**

Academics are not supposed to believe in miracles. Sterling Dow, Professor of Classical Archaeology at Harvard, went for *astonishing* and in a nod to secularism gave a reason

> **The instance of Cyprus is perhaps the clearest, most neglected, and most astonishing ... during the intervening centuries the Cypriots wrote largely, perhaps exclusively, on perishable materials**

Stanley Casson of the British School at Athens was fed up with the old perishable materials warhorse being summoned for duty yet again. He put some perishable material in his Adler and came up with a daring new thesis

> **The knowledge of the script reverted to the hands of bards**

Daring yes, logical no. How can bards pass down an alphabetic script for three hundred years when they operate strictly by word of mouth? Unless... they were cheating and keeping aide memoires, in which case they would have taken care to destroy the evidence. Yes, not a completely dead letter.

In the end an even older warhorse had to be wheeled out, whittling the gap down, little by little. Einar Gjerstad of Lund University was Professor of Classical Archaeology & Gap Closing

> From 650 BC onwards both Athenian pottery and
> Egyptian scarabs dated everything securely. For earlier
> periods a statistical method could be employed using local
> pottery and not an absolute chronology to date the start of
> the Iron Age which could not be pushed back as early as
> Mycenaean scholars required at that time ie 1150 BC

I should warn you, Einar, the one quality both archaeologists and historians share is a distaste for, and an invincible ignorance of, statistics. Though they will be giving your idea about non-absolute chronologies a warm welcome.

> Arne Furumark, of Uppsala University, the leading auth-
> ority on Mycenaean pottery chronology argued that
> Cypro-Geometric could not have started later than 1150 BC

But Gjerstad showed off the power of non-absolute chronology

> Feeling intuitively that this date was too high, Gjerstad
> arbitrarily reduced it by a century, to 1050 BC and
> launched a lengthy attack on Furumark. Although the
> arguments were unconvincing ... Furumark felt inclined to
> accept most of them, evidently in view of his opponent's
> superior grasp of Cypriot matters.

Thanks to Gjerstad, the Cyprus tail was wagging the Greek dog

> This acceptance had the drastic result that the later part of
> Mycenaean chronology was now dated by Cyprus, against
> all previous expectations.

He looked around to see if any other dogs needed wagging

> A challenge with greater impact came from archaeologists
> working in the Levant

What better site than Armageddon for the battle?

> Palestinian stratigraphy was in such a chaotic state that
> only Megiddo VI was thought important enough to discuss

A quick burst of non-absolute chronology

> Gjerstad decided to pick the very lowest date proposed for
> this level (1050-1000 BC), which suited his own scheme...
> Gjerstad's chronology created pandemonium

Oh my giddy aunt. Aunt Judy Birmingham, the English archaeologist specialising in Iron Age Cyprus, suggested redefining the ceramic categories. There being a dozen or so to choose from surely everyone could be accommodated. Not Scandi-wildcats

> By disregarding the results obtained by numerous, methodical archaeological excavations carried out both by Cypriote and foreign expeditions, she has evidently convinced herself of having made a positive contribution to the study of Cypriote culture.

Meow. Lawrence Stager, our Harvard Professor, came up with a radical proposal. The truth.

> A further possibility to be investigated is that the two to three century 'Dark Age' of Cyprus is largely illusory – created by modern scholars, not ancient disasters

Was understanding dawning at long last? Of course not. You don't get tenure in the Ivy League going round blurting out the truth

> Raising the dates for the Cypro-Geometric to close the 11th to 9th-century Dark Age gap can be carried out only by creating a new 'Dark Age' later in the pottery sequence

There was only one way to bring peace to the warring factions and that was to appoint an umpire acceptable to all sides. Robert Merrilees was Australian ambassador to Israel, Sweden and Greece *and* an expert on the Bronze Age archaeology of Cyprus and the Levant so his qualifications for the job could not have been better. Even so they should have consulted us first. We would have told them Australian diplomacy consists of even-handedly kicking everyone in the teeth

> It is in fact not uncommon to find that the Bronze Age strata of Syria, Palestine, and even Egypt have been dated according to the imported Cypriote pottery, whose chronology in turn depends on theirs! As a result the dates of part of, or even whole, Bronze Ages come to be built up like houses of cards, with all the stability and longevity which characterise that kind of monument.

11 When Religions Fall Out

In the Holy Land there is a pervasive sense of thwarted expect-
ation. The public want confirmation of their favourite stories but
historians and archaeologists have, very creditably, refused to go
beyond the evidence. Take David and Solomon. "Please!" as the
old Catskill joke has it, and the academics have obliged by pointing
out there is no evidence of either man.

One would like the historians and archaeologists to have been
equally resolute against the siren calls of Egyptian chronology but
one miracle at a time. Take Ephraim Stern, a specialist in the
Assyrian, Babylonian and Persian centuries (what he would call the
Late First Temple Period)

> **the old debate, which began in the mid-fifties, in which
> the validity of Gjerstad's chronology was challenged,
> seems now to have found its solution in favour of the
> earlier dating of the Palestinian material**

We have grown used to this kind of push-pull to close chrono-
logical gaps but with David and Solomon conventionally dated to
around 1000 BC, Stern is too good a Jewish archaeologist to fight
shy of the 1000 BC mark

> **Our study of the black-on-red pottery from stratum VII led
> us to assign it to 950 BC ... If this is correct and stratum VI
> began only in 450, the five-hundred year gap creates a
> unique situation.**

His five-hundred-year gap is later than we have grown accustomed
to because Judaeo-Christian made-up history is later than Greco-
Roman made-up history

| Biblical | starts with David & Solomon | c 1000 BC |
| Classical | starts with Minoan & Mycenaean | c 1450 BC |

It is a long-rooted tradition in both faiths

> **This coherent set of chronological evidence is unfortun-
> ately at odds with the accepted date of pottery in Cyprus.**

42

> This dispute has raged since the 1930s ... It seems that the
> basic chronologies of many sites in one culture or the
> other are off by at least a century

No complaints from me. Four, five, six hundred years – they are all at least a century.

Judaeo-Christians cannot fall back on dark ages to resolve anomalies because they have the Bible which, whatever its merits as a historical source, would definitely have mentioned a four-hundred year Dark Age if such a thing had occurred on its watch. They do have a Dark Age of sorts, the Babylonian captivity, but seventy years is not even a century so non-Biblical evidence will have to suffice

> There are also many finds of Assyrian-style pottery in
> contexts conventionally dated two centuries earlier than
> the initial invasion of Israel by the Assyrians in 733 BC. A
> similar anomaly is presented by Black-on-Red Ware, dated
> by Cypriot archaeologists to the period 850 – 700 BC, but
> found repeatedly in 1100 - 900 BC contexts in Palestine ...
> Not only was 950 BC pottery found under the 850 BC
> floors; it was also found above them

As above, so below, as the Gnostic Gospels would put it.

Kathleen Kenyon, one of the most influential archaeologists of the twentieth century, was operating before the vice of Egyptian chronology had completely clamped down

> Kenyon's low chronology, however, never caught on.
> Taken to its logical extreme, it would have created a void
> between 850 BC levels and those firmly placed by Egypt-
> ian evidence to 1200 BC. There seemed to be no way out of
> the dilemma.

There is always one way out of a dilemma, according to our old chum, Henri Frankfort. Abolish it.

> Once it is realised that the whole of North Syrian art after
> 1000 BC represents a fresh start ... the attempts to fill the
> gap between 1200 and 850 BC with transitional work can
> be abandoned

A fresh start in the Middle East? He's got a hope. William F. Albright, he of the American School of Oriental Research in Jerusalem, was old school and denounced Hans for

> What amounts to a systematic campaign to discredit the
> entire Solomonic building tradition by the simple exped-
> ient of denying the existence of art or architecture in
> Greater Syria between ca. 1200 and 850 BC.

Not wishing to discredit Mr Albright, but he has no business bel-
ieving in a Solomonic building tradition unless he cares to tell us
where he picked up such a name in the historical record.

Perhaps they should both turn to the people who even the Bible
acknowledges were responsible for the Solomonic building trad-
ition, the Phoenicians

> The 950 BC finds from Tyre are meagre, while the evid-
> ence recovered from Sarepta, the one Phoenician city that
> has been thoroughly studied, is very limited and the
> possibility of 'a considerable abandonment' from 1100 to
> 800 BC has been discussed

This is unsettling for those of us brought up on Solomon and
Hiram of Tyre. How can Hiram be ruling an abandoned city? I'm
glad my Sunday School teacher wasn't Professor James Muhly,
Director of the American School of Classical Studies

> This is really quite remarkable. The great age of Phoen-
> ician mercantile activity, the time of Hiram I, of Solomon
> and the biblical accounts relating to Ezion-geber, the
> Tarshish fleet and three-year voyages to the Land of
> Ophir, is simply not documented in the archaeological
> record from Tyre and Sarepta.

When I had put aside Sunday school and taken up historical
fiction proper, Rider Haggard was a great favourite. I am glad to
report King Solomon's mines are present and correct, though not
at the time of King Solomon. God may have written the Hebrew
Bible, Sir Mortimer Wheeler wrote the archaeology bible

> Mining activity at the site of Timna was sharply redated to
> c.1200 – 1150 BC, after which time it was supposedly
> abandoned until Roman times ... In spite of traditional
> associations of King Solomon with the mines and the
> landscape, the great king is probably the most eminent
> absentee from the archaeological sequence.

Nelson Glueck, a rabbi and an archaeologist, could serve two masters but could not tell the difference between 1200 BC Midianite pottery from Timna and 600 BC Edomite pottery from the Gulf of Aqaba

> **Nevertheless, there is apparent continuity between the two styles. It has been admitted that the present centuries long gap in the tradition of painted pottery in this area of north-western Arabia makes little sense. Numerous similarities between the Midianite and Edomite wares actually make 'some degree of chronological overlap perfectly plausible'**

Many of us would agree that the same things being made at the same time is plausible. Many of us would love historians and archaeologists to find it plausible. Mandatory, even.

There is only one local big banana who does not have to take any notice of chronological restraints. Creationists believe God deliberately placed the fossil record on earth to test Creationists' faith in the Bible so He may have done the same with the archaeological record to test archaeologists' faith in Egyptian chronology. I wouldn't put it past the old rogue.

12 Thus Sprach Jesus

The language Jesus spoke in everyday life is generally thought to be Aramaic. One hesitates to take on Mel Gibson so let us just say this is 'Not Proven', as his Scottish Bravehearts' verdict has it. The Aramaeans seem to have been bravehearts because, at the time when the Israelite state was getting going, conventionally dated to around 1000 BC, the Aramaean Empire loomed menacingly to the north and east.

Despite this, historians have rather neglected the Aramaeans, presumably because they present more than ordinarily difficult chronological challenges. Baron Max von Oppenheim, a German historian and archaeologist, was first out of the traps with what might be called 'the long chronology of the Aramaeans'. Examining inscriptions from their chief city he placed them in the third millennium BC because of apparent Sumerian influences.

A passage of two to three thousand years did not sit comfortably with the infant Jesus. "Mum, why do we have to talk in this archaic way?" "I don't know, dear, you'll have to ask your father."

> **His extremely high dates are universally regarded as unacceptable: the inscriptions, including one in the Aramaean alphabet, could not possibly have been this early**

Maximum Max was forced to recant and agreed the inscriptions must be later additions.

The problem facing everybody was that despite the Aramaean Empire being so major a force, replete with its own alphabet, it had not corresponded with the other major force of the time, the Egyptian Empire, so it was impossible to tie Aramaean chronology to it. Albrecht Goetze, Yale Professor of Assyrian and Babylonian Studies, sidestepped this by pointing out Aramaean relief motifs were similar to Mitannian examples and Mitannian material could be dated using Egyptian chronology. He had solved one problem only by creating a worse one. According to Egyptian dating the reliefs were made between 1850 and 1350 BC but the inscriptions were in an alphabet and Joseph Naveh had ordained they only started c. 1150. Overall though it was glad tidings because Aramaic

was getting later and later, closer and closer towards the linguistic needs of the Holy Family.

Anton Moortgat, Professor of Archaeology of the Ancient Near East at Berlin's National Museum, proposed Aramaea could be brought closer still

> His scheme allowed two building phases for the palace complex: the first around 900 BC followed by the 'Kapara period' ending in 800 BC

It was open season for Aramaean Studies so those old sparring partners, Frankfort and Albright, resumed their learned fisticuffs

> Frankfort agreed on Moortgat's ninth century dating but felt obliged to explain the conspicuous Late Bronze Age motifs on the reliefs in terms of a revival of Mitannian styles

This revival theory was necessary because Mitannian styles were dated, courtesy of Egyptian chronology, four hundred years too early. His nemesis was quick to seize his opportunity

> Albright saw local continuity as the answer and backdated the reliefs to the tenth century

Nobody followed him. Didn't he know dates always had to go downwards, for chrissake?

Frankfort completed a comfortable victory by coming up with similarities between Aramaea and later, better known empires, notably Assyria. There's no arguing with those big beasts. Albright could legitimately have complained the gap between Aramaea and Mitanni, which had provided the Aramaean chronology in the first place, was now getting so wide it ought to be dispensed with entirely, but nobody was listening. Who's the bigger beast, Albright or Jesus?

Classicists take the Beatles line, Mycenae is bigger than Jesus and keeping the Mycenaeans to 1250 is their rock of ages. So a minor furore ensued when our erstwhile Mycenaean scholar, Helene Kantor, stumbled over some familiar objects

> Unlikely though it may seem to find in local and clumsy Syrian reliefs of 850 BC the continuation of features of 1250 BC Mycenaean sculpture, centuries older and now quite extinct, this is yet the case

47

Clumsy? What would you expect from people living in a four-hundred-year daze?

Then along came something that would test everyone's faith, a life-sized figure with bilingual inscriptions in Aramaic and Assyrian and which could be dated precisely to 866 BC. Uh-oh.

> **In the opinion of the eminent palaeographer, Joseph Naveh, the script belongs to 1050 BC as dated by the standard Egyptian chronology.**

Not in the opinion of the man who had dug it up. Alan Millard wanted to make a career not waves

> **While he agreed that the script had a 'very archaic appearance' he pointed to some features which might suggest a date later than the eleventh century BC including the extraordinary resemblance of the letters to the 750 BC Greek alphabet**

A word to the wise, Alan. Conjoining eleventh century and eighth century like this is no way to earn your stripes in the Wars of the Greek Succession. You would do better to adopt the more quizzical attitude of Stephen Kaufman, Professor Emeritus of Bible and Cognate Literature at HUJ-CIR, Cincinnati, a specialist in Ancient Semitic languages

> **Given the weight of the evidence demanding a mid-ninth century date for the statue, how is one to accommodate such a dating to the apparent eleventh century character of the script of the inscription? What has to 'give'?**

As it was Egyptian chronology that would have to give, the question was assumed to be rhetorical.

13 Oh No, It's the Assyrians

The Aramaeans could be left to their own devices, the same could not be said for the Assyrians who smote the Israelites (and everyone else) on a regular basis. For all their faults the Assyrians rivalled the Egyptians in terms of record-keeping and with many of the smitees keeping records too, Assyrian chronology has become of some importance. It turned out that was another fault of the Assyrians.

They are, for the back half of the ancient Dark Age, what the Hittites were for the front half: fomenters of, but not sufferers from, dark ages. Unsurprisingly the tried and tested 'now you see them, now you don't, now you see them again' Hittite model has been applied to the Assyrians

> While it has been claimed that "Assyria was the one power in western Asia that survived the upheavals at the end of the Bronze Age", it is also agreed that it underwent a serious cultural and political recession at this time. Indeed, the period between 1200 and 900 BC has been aptly described as the 'Dark Age of Mesopotamia'

Not, note, the 'Dark Age of Assyria'.

But if the Assyrians are being held responsible for the Dark Age of Mesopotamia, surely they are going to be telling the world all about it in those very fine records of theirs? In this instance, no

> Thus, for over 250 years, from 1200 BC, Assyrian history is an almost complete blank apart from the interlude around the time of Tiglath-pileser I

How long does one king reign? Twenty years? Thirty at most. It made no sense. Simo Parpola, Professor of Assyriology at the University of Helsinki, set to work. He shortened the Blank Age to two hundred years and trumpeted the basely reactionary nature of his beloved Assyrians

> Virtually no contemporary texts such as letters, administrative records or legal documents are extant from 1200 to 1150 or from 1050 to 900. The absence of datable texts makes it impossible to detect trends – indeed, no changes appear to have occurred.

Whoever heard of two-stage gaps? Whoever heard of Finnish Assyriologists? No, what we'll do is

(1) keep the reactionary bit
(2) make it a straight two hundred
(3) add another puzzle

> Not only is there a dearth of material, but styles on either side of the gulf between 1150 and 950 are curiously similar

(4) solve the puzzle by getting out the old history concertina

> One scholar noted that the forms and decoration of the intricately carved Assyrian seals of 1150 are 'clearly late' as they 'point the way to the ornate figures which line the walls of Assurnasirpal of 850 BC ... working within a tradition which went back to 1250 BC'

Now the Assyrians can rampage around creating Dark Ages for everyone else but not having to suffer one of their own.

No-one was suffering more than the poor old Mesopotamians. John Brinkman, University of Chicago, is considered a reliable authority

> Babylonian history 1000 to 750 BC may be characterised as a period of obscurity or 'dark age', with the land frequently overrun by foreign invaders and with the central government often unable to assert its jurisdiction in many areas. Little source material has survived from these turbulent times, and this little is sometimes quite difficult to date.

At any other time in history archaeologists need JCB's to excavate Babylonian source material but the Assyrians will do that to you every time. Indoors or outdoors

> In fact, no buildings have yet been excavated in Babylonia which can be dated with certainty to the time of any ruler between 1046 and 722 BC

What doom and gloom were the Assyrians meting out further down the Tigris-Euphrates valley?

> After flourishing under the Kassite kings 1500 - 1300 BC the great city of Ur waned a little in importance but there is enough evidence, both written and archaeological, to

> trace its history down to 1050 BC. Then the documentary
> record becomes a complete blank over a period of some-
> thing like 350 years; archaeological remains are equally
> elusive. Ur returns to well-documented history in 700 BC

Ur of the Chaldees, Ur the birthplace of Abraham, Ur the cradle of DIY

> Architectural remains are usually minor repairs on older
> structures, with no inscription left to record the identity
> of the repairer

Ur, the cradle of conservative styling

> The problem confronting the archaeologists was that it
> was almost impossible to identify any pottery styles
> characteristic of the Dark Age. The little material which
> might belong to it was hard to distinguish from the style
> before 1150 BC

This won't do at all, some of us have museums to run. Robert McCormick Adams, Iraq specialist and Secretary of the Smithsonian, complained glumly

> It remains a little-known intercalary period

Don't be such a negative nabob, Bob. Why stick 'Mesopotamian Intercalary Period' on the door when you can take a leaf out of the professionals' book?

> with attitudes towards its limited cultural attainments
> aptly summarized by casual reference to it among field-
> workers as the 'Various Dynasties period'

There you go, Various Dynasties. They'll be queuing up to find out what dynasty is being featured this week. And no need to stop there. At the end of the Tigris-Euphrates valley is Dilmun, often cited as the origin of the Garden of Eden

> In 1000 BC the region vanishes from history, re-appearing
> again only in late Assyrian times ... aptly described by its
> current excavators as 'an occupational enigma'

Again with the negativity, people love enigmas. The way I see it is like this. You have some kind of interactive diorama. There's a serpent and a fruit tree, there's a co-ed wearing something tasteful

51

but diaphanous. 'Are you man enough to bite the apple?' If so, she gets dressed and leaves. We may have to work on that.

14 Iran by Any Other Name

On the other side of the Arabian Gulf (or the Iranian Gulf) is Iran. The fracture line between Semitic and Aryan goes back to before the Iranians were called Persians, before the Persians were called Medes, to when the Medes were called Elamites

> **Elam, as this kingdom was known by 2700 BC ...**
> **remained a distinctive and vigorously independent**
> **civilization, the most important rival to Babylonia and**
> **Assyria**

The history of Elam has been reconstructed from both Elamite records and from what the Babylonians and Assyrians had to say about them. It is continuous right up until the subjugation of Elam in 1100 BC by Nebuchadrezzar, King of Babylon. Not to be confused with the infamous sixth century King of Babylon, Nebuchadnezzar (often confusingly spelled Nebuchadrezzar). But he would seem even worse than the Bible paints his namesake(s) because nothing more is heard of Elam until 821 BC. As the Cambridge Ancient History puts it in sepulchral tones

> **as a political power Elam was finished. This period was**
> **followed by a dark age of three centuries, during which**
> **there are no native texts nor is Elam mentioned in the**
> **Mesopotamian sources. Undoubtedly broken up intern-**
> **ally, Elam was not to be mentioned again until 821 BC**
> **when Elamite, Chaldean and Aramaean troops were**
> **defeated by the Assyrian king Shamshi-Adad V**

But this gave rise to a dilemma. If Elam was finished in 1100 BC, how could it be putting armies in the field in 821 BC? There was only one way it could do this. By creative labelling. It was agreed there was one Elam, in the sense of the area occupied by Elamites, but two Elams in the sense of the Elamite state before and the Elamite state after the Babylonian captivity.

The obvious scheme would be to have *Early Elam* and *Late Elam* but this was not adopted as it carries the implication of a *Middle Elam* and middle-anything carries the implication of a full-flowering, not a total disappearance. The plan eventually adopted:

- ✓ cut all links between the two Elams
- ✓ rename the second Elam 'Neo-Elam'
- ✓ subdivide Neo-Elam into
- ✓ Neo-Elam I and Neo-Elam II

This new Neo-Elam could quietly bide its time as neo-Elam I (the dark age bit between 1100 and 800) until it was ready to become neo-Elam II and turn the tables on its conquerors. Wouldn't they get the neo-surprise of their lives?

Elizabeth Carter, Professor of Near Eastern Archaeology at the University of California, sprang a surprise of her own. There was to be a Middle Elam after all.

> **Since the 'Neo-Elamite' civilization of 750 BC onwards was clearly a continuation from the Middle Elamite before 1100 BC, Carter felt unable to accept that the country underwent a 'sudden and utter collapse'**

Pre-1100 Elam, hitherto 'a distinctive and vigorously independent kingdom since 2700' is now Middle Elam with Early Elam tacked on before it. There was every prospect of a Late Elam but only if the prospectors could get through the three-hundred-year desert of The Neo-Elam I Gap.

> **The Middle Elamite period down to 1100 BC is well represented by material remains, as is the Neo-Elamite civilisation after 800 BC. But the dating of the inter-mediate period, labelled Neo-Elamite I, is fraught with chronological problems**

At first the going was easy

(1) write off 1100
(2) write in 1000
(3) write out in academese

> **The historical realities behind the documentary eclipse between the end of the Middle Elamite monarchy and post 1000 BC population changes have yet to be ascertained.**

(4) write to Pierre de Miroschedji of the Centre Nationale de la Recherche Scientifique, Paris, appointing him sheriff

> **The original scheme proposed by the leading authority Pierre de Miroschedji actually left an ugly gap of 100 years in the sequence between the end of the Middle and the beginning of Neo-Elamite I culture.**

Ugly his methods may be, but he's got the gap down to a hundred years for you. Happy? They're never happy. The establishment pointy-heads objected to Pistol Pete using the same hard-charging methods to get through that last hundred years

> **To avoid this he tried to rationalise the chronology by extending the Middle Elamite period down to 1000 BC – a modification unsupported by textual evidence – in order to meet his own dates for Neo-Elamite I (1000 - 725/700)**

'Tried to rationalise', 'unsupported by textual evidence'? Good grief, this isn't the pampered life you historians and archaeologists have grown fat on in Egypt and Mesopotamia. This is the wild east, where it's Miroschedji's Law. He showed everyone who wore the badge when some goblets turned up. They were, he snarled

> **from the last phase of Middle Elamite, 1100-1000 BC**

and challenged anyone to say different.

Being the leading authority is no sinecure in cowboy country, there's always some punk wanting to make a name for himself. Roman Ghirshman had come over from the old country with his Délégation Archéologique, and right away they dug up goblets just un peu similar to Passé Pierre's except his eleventh century was for the birds

> **They were from a destruction level dated by its excavator, R Ghirshman, to the Assyrian invasion of Elam in 647 BC**

'Kid' Ghirshman was cut down with a withering blast of circular reasoning

> **Miroschedji was forced to reject Ghirshman's dating in order to follow the evidence linking them to a much earlier period**

No sooner was the sheriff back in his favourite seat in the saloon than a new outfit, working a different claim, came hooting and hollering into town, packing some very fancy weaponry

> **Some of the Luristan bronzes, principally daggers, bear the names of Babylonian kings (fourteen in all) who are dated by the conventional Mesopotamian chronology to between 1132 and 944 BC**

This could start an entire range war, Mesopotamia as well as Iran. The French created this mess, the French can clean it up

> **the French chronologist, Claude Schaeffer, ascribed the bulk of the bronzes to 1500 – 1200 BC leaving only a few pieces with Assyrianising designs**

Ghirshman, though wounded, fired off a Parthian shot

> **By concentrating on the parallels offered by late Assyrian art, he dated them to 750 BC**

Federal marshal, Helene Kantor, had to be summoned from Chicago to prevent this French bunfight setting the entire east aflame. They were, she announced, all wrong

> **Kantor placed some of the pieces at 650 BC and others even as late as the Persian period 550 BC**

And there we must leave them, offering their expert opinions about objects from a single find with dates ranging over a thousand years. But let's face it: persuading westerners to go east in the first place means everyone must be guaranteed their own forty acres

> **No consensus has ever been reached regarding the date of the collection, many archaeologists accepting the unhappy compromise that the daggers were manufactured over a period of a thousand years or so.**

These archaeologists should not be accepting compromises, they should be rejecting archaeology. Or at any rate the subjective part of it because, for sure, some of them must have got it wrong and they were all trained the same way. For such discordance to result is a sure sign there is something radically wrong with that training.

But one of the worst aspects of universities is that that they recognise no higher authority so academics are trained to believe there is no higher authority than their own personal opinion. Even when they can plainly see their university training has produced personal opinions crying out for a higher authority.

That said, it is worse when they all agree.

15 The Age of Spain stays Mainly in the Brain

Iran may be the eastern terminus of the Egyptian Chronological Empire but how far west does it extend? To Spain, where it is in rude health. Two British panjandrums – Glyn Daniel, Professor of Archaeology at Cambridge, and John Evans, President of the Society of Antiquaries – report the usual

> **The period 1300 BC to 900 BC is the most obscure in the prehistory of the Peninsula. From the scattered finds which exist it is extremely difficult to piece together an intelligible picture.**

Applied Epistemology has a principle:

<p align="center">one input, one output</p>

so if Spain and Iran are both suffering a dark age at the same time, that is one output. Unless Messrs Daniel and Evans can come up with one input, they will not be eligible for membership in the Society of Applied Epistemologists.

The Mycenaeans did not get as far as Spain but the Classical Greeks took a great interest in it, especially Cadiz which their historians claimed was founded a hundred years after the Trojan War. Messrs Daniel and Evans insist the Trojan War happened c 1250 BC which obliges them to conclude Cadiz was founded around 1150 BC. The evidence, scattered and unintelligible as it is, did Daniel and Evans no favours

> **the only objects at Cadiz that could possibly pre-date 600 BC are three religious statuettes dredged up from the sea**

If the Iliad was not helping, what about the Bible? The Old Testament refers to a mysterious country called Tarshish, *Tarshish* sounds a little like *Tartessos* and Tartessos is the ancient name for southern Spain. That is practically definitive by place-name theory standards. If David, Solomon & Co can be pressed into service, Spain is as old as Biblical Israel and the academics will be home and dry. The theory has been advanced enthusiastically if sporadically ever since sixteenth-century Spanish academics first used it in their efforts to show they were older than the Portuguese.

Spain had a better claim on Biblical antecedents in being a major area of activity for the Carthaginians. Carthaginians are *Phoenicians* by another name, Phoenicians are *Philistines* by another name and Philistines certainly feature in David-and-Solomon stories. Now it was a simple matter of pushing Carthage back as far as the evidence would allow. Alas, not far enough if the Carthaginian evidence is to be believed

> **In North Africa, both Lixus and Utica were supposedly founded before 1100 BC. However, at each site the earliest finds come from 700 BC**

More research is needed. Or perhaps less

> **While it used to be feasible to believe that pre-1000 BC remains would eventually appear, this becomes increasingly less likely with each new excavation**

It is unusual to hear this from archaeologists. British sites like Iona and Lindisfarne are descended on year after year in search of the Dark Age monasteries that are supposed to be there, but cannot be found.

"See you all next year," they say cheerfully to one another at the end of every fruitless digging season.
"Next year in Marienbad," say the Applied Epistemologists.

Archaeologists are the masters when it comes to turning lack of evidence into evidence. The Carthaginians were sea traders, so any fool can see what must have happened

> **Since they were not towns but ports of call, it is logical that nothing should remain on the site and hence nothing of archaeological interest is to be found. The kind of trade the Phoenicians engaged in did not call for permanent structures but perhaps merely a few tents at the various ports they called at to trade with the local population**

Bedouins of the sea. It's a beguiling image.

Albright, last met developing a pottery chronology in his quest to prove the historicity of the Bible, spotted an opportunity to kill two birds with one link. If Carthage could be shifted back to 950 BC that would connect it to Solomonic Israel *and* solve the Spanish problem. Looking at the plentiful post-700 BC Carthaginian pot-

tery he was able to forge a direct connection between 700 and 950 with a superb 'of course'

> We must, of course, assume that this ware was brought to North Africa not later than the late tenth or the early ninth century BC, and that it continued to be manufactured until the eighth century, sometime after it had disappeared in Phoenicia. Such phenomena are exceedingly common

No, old chap, they aren't but feel free to give an example should you think of one.

It was the turn of the Italian archaeologist, Sabatino Moscati, to try his hand at the Great Missing Carthaginian Archaeology Game. He preferred 'quite naturally'

> A few generations would quite naturally have elapsed between the disembarkation of the first settlers and the production of works of art destined to survive for centuries

If I know anything about the children of immigrants, it takes about one generation before they are all social workers and abstract sculptors, but Signor Moscati has forgotten it was not works of art that were missing, it was everything that was missing. Though the elegant way he has described several hundred years as 'a few generations' indicates his own choice of profession was a shrewd one.

It is only fair to leave the last word with Mohammed Fantar, a Tunisian archaeologist and, one might say, a real Carthaginian

> Carthage has never been subjected to systematic, detailed and exhaustive excavations ... the earliest signs of occupation of a given terrain are often hard to identify. Light constructions, perishable materials, the early and hesitant occupation of an area by people homesick for their native land, the destruction and reutilization of dismantled structures – these are all factors of development which tend to cover up the first signs of settlement

We have nothing to teach Tunisian archaeologists.

16 The Italian Jobsworths

The Romans were later than the era we have been dealing with but not according to the Romans. They considered themselves descendants of Trojans decamping after the Fall of Troy via Carthage leaving Queen Dido in floods. An excellent backstory when competing for supremacy with Greeks and Carthaginians but at odds with Egyptian chronology. Rome's historians put it at c 750, our historians say c 1250. Who was right? Who was less wrong?

The wider Italian situation, as modern archaeologists understand it, is that Italy was firmly pre-historic until the eighth century BC, culminating in what they call the 'Sub-Apennine period'. Italy only enters history with the arrival of the ever-mysterious Etruscans (in an area called to this day Tuscany) and the never-mysterious Greeks in southern Italy (called to this day Magna Graecia, though only by academics and tourist guides). The Hegelian rubbing together of the two produced a city in between that eclipsed them both (called to this day the Eternal City – right so far).

The pioneer and chief architect of Italian chronology is Quintino Quagliati who used the discovery of Mycenaean pots to kickstart the process. As Mycenae is dated to the thirteenth century BC and historic Italy is dated to the eighth century this was, like early Lambrettas, not the best of kickstarts. Unlike Sicilian Vespas.

> **The Mycenaean pots are of LHIIIA, B and C styles, much of which (certainly the LHIIIA) predates the Sub-Apennine ... so ought to have been found below it rather than above**

It was bad enough using hopeless LHIIIA, B and C labels to date such an amorphous concept as Sub-Apennine Italy, but accepting newer strata as older strata smacked of very dubious practices. Had Italian archaeology joined the club?

John Coles and Anthony Harding, the ranking Britons, were cross but, being British, damned the Italians with faint praise

> **Of the find circumstances virtually nothing is known. The excavator, Q. Quagliati, made a valiant attempt, under rescue conditions ... to elucidate the stratigraphical sequence, but his information is of the scantiest.**

Ross Holloway, Emeritus Professor at Brown University, being American, preferred to damn the British

> Quagliati's team had for the most part been carrying out a perfectly normal excavation, indeed the resulting report was remarkably detailed with ample plans, sections and so forth.

Sucks to you, Ross, now you'll have to explain how the pots got into the wrong level

> none of the large quantity of Mycenaean pottery recovered by the excavator was in its original position ... it came from elsewhere on the site, becoming mixed into Stratum 1 by erosion, quarrying and modern building work

I am not saying this because I am British but if old Quaggers had left this somewhat salient point out of his report, incompetence is the kindest charge that could be levelled at him.

We can leave Italy to the Anglo-Americans and move across to Sicily, which everyone leaves to the Sicilians. Their chronology, according to the authors of *Centuries of Darkness*, is less subject to 'overlaps' than Italian chronology but has a familiar problem

> a daunting absence of material for the Late Bronze Age, Early Iron Age (1250-650 BC)

Nothing daunts archaeologists armed with creative labelling

> It is, in theory, possible that the coast was abandoned in Pantalica North times, re-occupied in the Cassibile phase, abandoned again in the Pantalica South period, then finally resettled by the Greek colonists

That daunts me but it daunts historians even more because while the archaeologists are busy stretching out these pre-historical Bronze Age natives, Thucydides says plainly the Greeks expelled the natives at Syracuse in 733 BC, and that's Iron Age.

Either the archaeologists have got it wrong or Thucydides has got it wrong and Thucydides cannot get it wrong, he is relied upon for most of Greek history. Perhaps he ought not to be on account of Thucydidian history being made up wholesale in the Italian Renaissance but nobody working in the historically-impoverished centuries of ancient Greece can be picky about gift horses.

"Oy, Trojans, look underneath."

"Oy, Classicists, get a proper job."

Between Sicily and Italy are the Aeolian Islands where the undisturbed ground between Mycenaean evidence and the era of the later Classical Greeks led the British-damning Holloway to declare

> this and related discoveries illustrate, in a way rarely seen in archaeological contexts, the contemporary existence of two diverse groups

We may have been too quick to judge Ross because he is absolutely correct. Thirteenth-century people are rarely seen with seventh-century people in any context. Even when twentieth-century creative labelling is available

> the Ausonian I-II transition is set at c. 1230 BC by the finds of Mycenaean imports. This seems most unlikely, given the conventional end-date of Ausonian II around 850 BC, based on the association of Ausonian II type bronzes with Cassibile pottery in Sicily. Worse still, the new evidence from Sicily clearly indicates that the Cassibile period belongs to an even later date – the combination of these two connections (the Mycenaean and Sicilian) would give Ausonian II an impossibly long span of 500 years

Impossibly long? Nonsense, invented periods can be any length.

A keen exponent of the 'any-length' school was John Evans, not only President of the Society of Antiquaries but author of the standard work on Maltese archaeology. Busy, busy, busy. Too busy to wonder why Malta was suffering exactly the same thing he had found in Spain. Our Antiquarian President began by estimating the lengths any-length would have to go on Malta

> An equally deep recession seems to have taken place in Malta at this time … although Maltese pre-history can be tied to … 1400 - 1200 BC Mycenaean Greece, there are strikingly few remains until the 700 BC Carthaginian settlement

and came up with the Borg in-Nadur Culture which filled the gap between 1200 and 700 with considerable precision. "Just like that," as a well-known British contemporary of Evans would have said.

> It would seem to have survived, if we take literally the evidence of the material … at Mtarfa, until the beginning

> of the Carthaginian period. The total span of the culture
> would therefore be a period of some six hundred years or
> more

Take evidence literally? An innovatory step, but it would mean these Borg in-Nadurites were strikingly like many of Evans' British contemporaries...

> The current chronology suggests a long period of inactivity
> in Malta, but this contrasts strangely with the evidence for
> overseas trade.

...bone idle at home, coining it abroad.

Another Mediterranean island was seeking British assistance. According to puzzled locals, artefacts found at Santa Maria in the north of Sardinia could be dated to anywhere between the thirteenth and the eight century BC. The British Museum sent in a crack team who concluded they were probably collected over a two-hundred-year time span. This was a poor effort. Two hundred years went nowhere near to filling the gap and anyway, who collects things for two hundred years?

Who did they think the ancient Sards were, the French asked, the British Museum de ses jours? And sent in their own man, Michel Gras, Director of the Ecole Française in Rome, to sort it out. He came up with an equally lame explanation: the artefacts were Etrurian, had been preserved as heirlooms, then buried. The Bloomsbury group were just about to blow a raspberry in the direction of this cockamamie theory when they realised it was better than their own cockamamie theory

> They saw Gras' heirloom model as a "desperate measure,
> as its author properly recognises... but one that is rend-
> ered inevitable"

Francesca Ridgway, a leading scholar of Etruscan and Italian archaeology at the Institute of Classical Studies in London, was trying to be helpful

> Gras has shown convincingly how the 700 – 500 BC
> contexts for some of the model boats in tombs ... must be
> regarded as heirlooms because the production of these
> bronzes cannot have gone on too long

No, Fran, pointing out they were all made at the same time might be School of the Bleedin' Obvious but it can't be taught at the College for Stitching Up Faulty Chronologies, can it? And that's not me telling you, it's your old man

> **David Ridgway claimed craftsmen from Cyprus settled in Sardinia in 1150 – 950 BC and continued to make bronzes in the Cypriot tradition.**

Your teas's on the table, pet. Isn't it strange though

> **they seem to have been remarkably inactive for the first two or three centuries**

I suppose it would be too much to ask for a period of inactivity from the academics.

17 Into Darkest Africa

And so, finally, we arrive at the bastion of evil, the cradle of wicked chronology, the place where time went wrong. *Nubia.* You may know it as the Sudan but anciently it was what north-east Africa on the other side of the first cataract of the Nile was called. Not of great account today, not of much account to the ancients who regarded it as little more than a sub-region of Egypt. Apart from the time when Egypt became a sub-region of Nubia. The official history of Nubia is

o it was an Egyptian dependency
o in 1050 BC something dramatic happened
o the Egyptian ruling elite up-sticked and retreated to Egypt
o the Nubians reacted with a surprise move of their own
o they departed bag-and-baggage, southwards
o in 750 BC something else dramatic happened
o the Nubians re-occupied their old stamping grounds
o invaded Egypt, conquered Egypt and ruled Egypt

as what Egyptologists call the 25th Dynasty. What was behind this extraordinary reversal of fortune when zeros became pharaohs?

We can look to no less an authority than UNESCO for the answer. They have been overseeing massive rescue digs necessary when Nile dams threatened to flood Nubian archaeological sites. UNESCO's William Adams was one of the overseers

> **In the eleventh century Nubia vanished entirely from history. Its erstwhile Egyptian conquerors had returned to their native soil, and the indigenous population had retreated somewhere into the wilderness of Upper Nubia, whence they were to emerge with a vengeance three centuries later.**

Adams' account is in the finest traditions of UNESCO. A colonised people escape their oppressors by seeking out their ancient abodes, then march back to defeat their former colonial masters. UNESCO does however draw the line at becoming, in turn, *their* colonial oppressors. "Memo to staff archaeologists: expressions such as 'vengeance' are deprecated in official reports."

Even so, UNESCO will have to clarify one or two points before commending the model to persecuted peoples around the world

? Why did the Egyptians pack their bags and go home
? Why did the newly liberated Nubians head for the hills
? Why didn't the Egyptians take advantage of this vacuum on their doorstep for three hundred years
? Why did it take the Nubians three hundred years to reoccupy the vacuum on their doorstep

The eyes of the world are on you, UNESCO

> **They proposed that an extended dry period, causing low floods of the Nile, resulted in a diminishing agricultural production and an eventual exodus of the population; the Egyptian settlers and administrators, Egyptianized Nubians, local princes and some of their retainers north to Egypt, and the rest of the indigenous population south to hither Nubia**

That would do it all right, no question. Unless you were some kind of professional naysayer, then you might have some questions

Naysayer: Do you in fact have any evidence the Nile underwent a drought at this time?

UNESCO: No, nor would we expect to. We do not have the kind of resources to find out. We are simply putting forward a hypothesis that best fits the known facts.

Naysayer: I appreciate that. As you know, the Nile is historically perhaps the most studied major river in the world. Do you have any evidence it has suffered a three-hundred-year drought or indeed a prolonged drought of any kind at any time in its history?

UNESCO: No, but again it is not something we have ever been called upon to study.

Naysayer: I entirely understand. Do you know of any major river anywhere in the world at any time that has suffered a prolonged drought and then returned to normal?

UNESCO: No, but again...

Naysayer: Quite. Are you aware of any geographical, geological, geomorphological or climatological theory that would lead to such an occurrence?

UNESCO: No, we are historians and archaeologists and wouldn't know the answer to that in any case.

Naysayer: Absolutely. In the light of your answers would you care to amend your statement that this is a hypothesis that best fits the facts?

UNESCO: Look, we thank you for your interest but we are busy people with worldwide responsibilities and not a great many resources with which to meet them so if you don't mind...

Naysayer: Of course. I'll see myself out.

This is doing UNESCO a great disservice. They understand only too well the difficulties facing large organisations when relocating

> To dismantle a 500-year-old bureaucracy is no overnight matter: records of land tenure, endowments, taxation assessments, viceregal correspondence, orders and details of building works all have to be disposed of, or transferred elsewhere. Were the temples closed down? If so, what happened to their administrative records, furniture and fittings, libraries, and, most significant, cult images?

Good questions all, but we must insist on a hypothesis of some sort to account for what happened next. How were the Nubians, newly returned from the hills of Hither Nubia, able to conquer mighty Egypt? UNESCO has elected to pass the buck on this one

> The sudden expansion of Nubian power in 750 BC has baffled Nubian archaeologists

I think they mean archaeologists excavating in Nubia, nothing is imputed against Sudanese scholarship. One has to be careful not to cause offence. We are all, I think it fair to say, baffled.

We shall be on firmer ground when we cross into Egypt proper, a land that has been studied by every kind of scholar, native and foreign, since the very earliest days of scholarship. To be perfectly honest, possibly too much. The preservatory peculiarities of Egypt, the peculiarities of Egypt, have made it more of a magnet than perhaps its intrinsic importance warrants. Be that as it may, Egyptian history is a relatively open book. Apart maybe from the architectural book

> Little else of architectural importance is known for a period of some three hundred and fifty years, until a new stimulus came from the south with the invasion of the Nubians

and a few other books

> the copious sources of information which were available
> in the previous two dynasties vanish. Administrative
> papyri and ostraca prove practically non-existent ... votive
> statuary seem to disappear almost totally

Why such an extraordinary three hundred and fifty year hiatus? *That* we do know. A drying up Nile in the Sudan would inevitably mean a drying up Nile in Egypt. It may be that Egyptologists see UNESCO as rivals because they do not mention this.

It would seem Egypt is suffering from that perennial scourge of the ancient world, a dark age, except Egypt is the one place that is not permitted dark ages. Who is going to rely on countries with dark ages to provide usable chronologies? Apart from ourselves – our chronology was worked out by seventh century monks in the middle of our Dark Age – but that's different.

Being forbidden dark ages, Egyptologists have dubbed their perennial dark ages 'Intermediate Periods', this particular one being the Third Intermediate Period. Better, in many ways, than an Intercalary Period, fully the equal of a Various Dynasties Period, but worrying all the same in there being three of them. Ideally, from a chronological perspective, one would like them kept to a minimum. Only pedants would point out Egyptian history consists entirely of intermediate periods, those that are not called 'Intermediate' being intermediate between those that are.

Fortunately, Egyptian king lists can calibrate Intermediate Periods with ease and this one started in 1070 BC and ended with the arrival of the Nubians in 665 BC. The historians had done their job, were the archaeologists doing theirs?

> Traditions in painted and other arts continued, the
> pottery from the end of the New Kingdom, 1070 BC, being
> indistinguishable from that of the Nubians, 665 BC

They will be telling us next silver bowls never go out of style

> a silver bowl from the tomb of King Psusennes I (1039-991
> BC) continues a type from the Ramses pharaohs of around
> 1300 BC and is a source of inspiration for Phoenician
> bowls of 750 BC

His Majesty, dead or alive, was proving a trendsetter for the ages
.

> The jewellery belongs to a stylistic group regarded as the
> model for Syrian ivory-working in 750 BC ... an alabaster
> vessel bearing the name of the wife of the Assyrian King
> Sennacherib (700 BC) is exactly similar to a jar stand from
> the tomb of Psusennes

Come on, lads, surely you can do better than this? No, says Morris Bierbrier, one of the guardians of Egyptian chronology, but we can do worse

> During the Third Intermediate Period, inscriptions would
> seem to disappear almost totally - a bizarre absence not
> encountered in other periods of Egyptian history.

What, not even during the First and Second Intermediate Periods? Kenneth Kitchen, Emeritus Professor of Egyptology at Liverpool, 'the very architect of Egyptian chronology', sketched out an explanation of sorts

> there is confusion in its record of the other kings of this
> dynasty. Kitchen has supposed that six or seven entries
> were simply omitted from the list by a copyist

He supposes, does he? Well, tell the scouse git the whole of ancient history is based on Egyptian chronology and Egyptian chronology is based on their king lists, so if copyists were making wholesale mistakes in the king lists and he doesn't know if they were or if they weren't, and if they were he doesn't know how many kings might have gone adrift, I'm going to recommend he stays just where he is, in Liverpool. That'll learn him.

> The work of Kitchen and Bierbrier on genealogies has
> been immensely important and influential but has argued
> for lacunae in the records when these appear to conflict
> with the accepted chronology

You mean when the accepted chronology conflicts with the accepted chronology? I am fed up to the back teeth with all this. I am going right to the top with my complaints and in Egyptology that means Sir Alan Gardiner. At one with the pharaohs now but here he is, looking back at a career that had brought him so many accolades

> What is proudly advertised as Egyptian history is merely a
> collection of rags and tatters.

Part Two

A CONSPIRACY THEORY DEBUNKED

18 History in Boxes

> The Treaty of Dover, also known as the Secret
> Treaty of Dover, was a treaty between England and
> France signed at Dover on 1 June 1670. Both kings
> exchanged letters of ratification and kept secret the
> existence of the treaty. A public treaty of Dover was
> also negotiated, but it was a fake designed for
> propaganda and to hide the religious dimension of
> the secret treaty. The actual treaty was published
> by historians a century later. (Wikipedia)

This book being a revisionist guide, nobody need be surprised this
passage needs revising. In the sense of being completely mend-
acious horse manure. For a start

<p align="center">there was no secret treaty</p>

just an ordinary treaty. Nor was the Secret Treaty 'published by
historians a century later', it was

<p align="center">invented by *a* historian a century later</p>

But since it has been taught *as* history ever since, I suppose we had
better begin by finding out just what it is they have been teaching:

> The King of England, Charles II, having spent many years in
> exile and having had a father beheaded for treason, decided it
> would be a good idea if he negotiated a secret treaty with
> England's ancestral enemy, France, which involved declaring
> himself to be a member of England's ancestral enemy, the Roman
> Catholic Church, and then forcing England to become Catholic.
> Were England to take it into its head to resist such a proposition,
> France would send over troops to help out with the conversion.

> To cover their tracks the conspirators put together a pretend
> treaty of the standard sort, in this case an agreement for a joint
> attack on Holland. To lend credence to this they jointly attacked
> Holland. The real treaty, i.e. the secret treaty, was not proceeded
> with.

> To ensure the secret treaty did not leak out ahead of time, leading
> to Charles' immediate arrest and execution for treason, only five

people were involved: Arlington, Arundel, Clifford and Bellings (for England) and Colbert de Croissy (for France).

It could not be helped that, whether it was proceeded with or not, the King of France would be in possession of documents that, if made public, would result in the immediate arrest and execution of the King of England (not to mention Arlington, Arundel, Clifford and Bellings) so henceforward the King of England would be well advised to do whatever the King of France told him to.

Put like that, you would be having doubts. Even historians might be having doubts. If you learned the same sequence of events at school (or if you read it now on Wiki) you will not turn a hair. Thus the prime directive of revisionism:

things are always 'put like that'

When A is teaching B about C, A can either set out the facts for B to make their own mind up about C, or A can use authority to make B's mind up for them. If so, it will be what A believes about C. That sounds a bit North Korean but all societies depend on this method to function at all, such is the sheer volume of *stuff* human beings have to learn. It is the only way. Bringing up children, for instance, depends on it in case you hadn't noticed. The price is a degree of uniformity, generation to generation, but it is a price that has to be paid.

To a degree. Unlike North Korea, pluralistic societies move on. Their histories move on. This is what A (historians) were teaching B (the general public) about C (the Treaty of Dover) before A discovered D (the Secret Treaty of Dover):

England was in constant rivalry with Holland. There had already been two Anglo-Dutch Wars, one under Oliver Cromwell and one under Charles II himself. These had been inconclusive so Charles negotiated an alliance with France, known as the Treaty of Dover, to join together in a third war against the Dutch and which was quite successful.

So what was it that convinced historians to switch from ordinary negotiations conducted by ordinary diplomats resulting in an ordinary war, and start teaching an exciting tale about a traitorous king, aided and abetted by dauntless courtiers, conspiring with a foreign potentate to plot the overthrow of Protestant England? *And,* given England's position in the world at the time, send the world on a completely different path from the one we are presently

on? The short answer is that academia is a branch of showbiz, dependent ultimately on bums-on-seats (no offence, but if the cap fits) so academics prefer glitz and glitter. Don't be fooled by the elbow patches. We at Revisionism Centre, by contrast, have our motto carved over the main entrance

The Truth Is Always Boring

No wonder we can't afford elbow patches. The maxim, by the way, is not original to us, it goes back at least as far as the medieval philosopher, William of Ockham, and is generally referred to as

the principle of parsimony

The boring-but-true version of history was taught for a hundred years from the 1670's until, with a Fourth Dutch War looming, out popped a history book called 'Memoirs of Great Britain and Ireland from the dissolution of the last parliament of Charles II until the sea battle of La Hogue'. Books could certainly be judged by their covers in those days. The author, Sir John Dalrymple, claimed that while doing research in the French archives for David Hume's *History of England*, he had come across the Secret Treaty of Dover (see above). No, he could not produce it and, no, the French cannot find it, but with academic historians compulsively drawn to highly-wrought narratives to brighten their workaday careers, they have swallowed the Dalrymplian Version whole like the follow-my-leader, our own rules of evidence be blowed, if it's in my undergraduate notes it must be true, twerps they are. There goes the reviews.

Historians are unanimous there are two physical documents

o the record of a public treaty between England and France
o a private compact between the Kings of England and France

There is no mystery about the first, it will be knocking around in the archives somewhere, but the second, by the sound of it, is going to take some tracking down. Not anymore.

> **The treaty, kept secure in an oak chest, remained in family hands and has been consigned to Sotheby's by a descendant, the thirteenth Lord Clifford...**

The first Lord Clifford was one of the five people privy to the Secret Treaty so this has the timbre of truth. Not this though

> **...who has decided to keep the oak chest.**

Those Antiques Roadshow people are always impressing on us the importance of keeping the original packaging. Not Sotheby's apparently. "Keep the chest, my lord, we're up to here with packaging as it is. Just leave the treaty and a bit of provenance and we'll take it from here."

> Because of the explosive nature of the negotiation, Charles entrusted them for safekeeping to his favourite aide and one of his most influential ministers, the first Lord Clifford of Chudleigh. Lord Clifford, who helped negotiate the treaty and was Lord High Treasurer of England, hid the papers in a small oak travelling desk at Ugbrooke, the family seat in Devon.

Where they remained until 1987, when Sotheby's took possession of them, and the small oak travelling desk travelled back to Ugbrooke.

> The British state papers of the secret Treaty of Dover – the 1670 agreement between Charles II and Louis XIV that led to war between England and the Netherlands and might have ended British parliamentary rule and the Church of England – will be auctioned at Sotheby's in London.

If this is true the Cliffords are to be commended for coming clean, after three hundred years, about their part in nearly derailing British, possibly world, history. Such public-spiritedness should be rewarded with a big thank you from us, the British public. Is there anything we can do for you?

> "The house at Ugbrooke has vast amounts of dry rot, and the roof needs to be completely replaced," Mr. Davids said by telephone from London

and he should know, he was the negotiator-in-chief

> The documents were described this week by the head of the books and manuscripts department at Sotheby's in London, Roy L. Davids, as 'among the most important state papers we have ever sold.'

Come now, Roy, aren't you being a wee bit modest? Unless Sotheby's has even more sensational offerings up its sleeve.

But while I have your ear, I wonder if you might clear up a legal point that has been niggling me. If the first Lord Clifford was given state papers for safekeeping, who the Dickens gave the thirteenth Lord Clifford the right to hawk them around? Is there some sort of statute of limitation on ownership of state papers? Shouldn't he, at the very least, have consulted officials at the British Library as to the proprieties of the situation? Oh, he did

> **Mr Davids explained that Lord Clifford consigned the papers to Sotheby's after he was unsuccessful 18 months ago in selling the archive to the British Library. The price was apparently too high, Mr. Davids said. Sotheby's estimates the papers will bring between $500,000 and $575,000.**

Reading between the lines, the British Library's response was more likely, "Shove off, palliarchi, we didn't just fall off the Christmas tree." If they can afford nine million pounds for an Anglo-Saxon gospel book that fell off a Christmas tree, they can certainly find half a million dollars for the most important state papers ever to fall under the hammer.

Rebuffed in his attempt to sell state papers to the state, Clifford asked Sotheby's to sell public papers to, as it were, the public. That would inevitably mean emphasising the human interest angle

> **The catalogue notes that Lord Clifford's sense of guilt over the blood shed in the war with the Dutch may have been what prompted him to commit suicide by hanging in 1673**

Not that much blood, to be perfectly honest. The Third Dutch War consisted of a couple of naval engagements. But Clifford was Lord High Treasurer so perhaps he was unused to the more sanguinary aspects of state policy. Even so, it is unusual for English ministers, whatever their portfolio, to commit suicide after the policy they have been collectively pursuing has succeeded. Dying of shock one can understand. Unless this 'suicide' is itself part of some wider but as yet undisclosed conspiracy. One can never be sure what academic historians will come up with when they have an exciting bit between their teeth.

The Third Dutch War being such a maritime affair we might look to that well-connected naval diarist of the time, Samuel Pepys, for the lowdown. The diaries have been available to historians ever since they were found c. 1815. Unfortunately the Pepys Diaries

end in 1669 but he had a friend, John Evelyn, also well-connected, also with the Admiralty, also keeping a diary, also found c. 1815. Bit of luck for historians there. It was Evelyn that provided the lowdown

> **According to Evelyn, however, his conduct was governed by a promise previously given to James.**

It is unusual for English ministers to commit suicide after giving a promise to the next king (James II). But then it is unusual for English ministers to commit suicide after being given a pardon by the current one (Charles II)

> **on the 3rd of July 1673 he received a general pardon from the king**

Then again it is unusual for ministers to be given pardons after carrying out apparently lawful duties. You would think it might draw attention. But nothing, it seems, could cheer Clifford up

> **In August he said a last farewell to Evelyn, and in less than a month he died at Ugbrooke. In Evelyn's opinion the cause of death was suicide, but his suspicions do not appear to have received any contemporary support**

A cover-up if ever I heard one. And a good one too if the only historical evidence that Clifford committed suicide is Evelyn's diary which no-one knew about until it was discovered a hundred and fifty years later.

Ah, the slings and arrows of historiography. We could ask conspiracy theorists (or academic historians as they are called in this instance) why nobody is stressing the reason Clifford is spending more time with his family is because Parliament had just passed the Test Act and, as a Catholic, Clifford had nowhere else to go. Not that his church condones suicide whatever its communicants suffer by way of career disappointments but, one has to say in all good conscience, Clifford does not seem to have been a very good Catholic. Entrusted with something that if made public would bring utter ruin to his co-religionists, he took the coward's way out, leaving box and treaty to his executors

"Here's the next one. Rather nice, if you ask me."
"They're known as 'travelling desks' in the trade."
"Worth a bit, are they?"
"Yes, but it's not what we're here for. Is there a key?"

"Not that I can see."

"Pass me the jemmy then. Let's see now... nothing of much value to speak of. Just old papers. No, hold up, this could be important."

"What? What is it?"

"Title deeds. Put them in the estate management pile."

"There's something underneath."

"So there is. Give it here."

"Estate pile?"

"No, I don't think so. This is of quite a different kidney."

"What? Come on, what is it?"

"Well, just a quick perusal but I'd say it's curtains for the Stuarts if this gets out."

"Not the estate pile then?"

"Mark them down as Miscellaneous Papers, put them back very carefully and park the box somewhere nobody will think of looking for a good few years."

"Why's that then?"

"We've already committed misprision of treason."

"Dear oh lor, doesn't that mean the death sentence?"

"Too right, son. What's in the next box?"

"Doublet and hose, fair condition; two wigs, seen better days..."

Fancy another locked box mystery? Of course you do, everyone does. That is probably why there are more where that came from. As we wave goodbye to the thirteenth Lord Clifford and his oak box departing Waterloo Station en route for Ugbrooke, we say hello to the fifth Lord Clifford, hard at work on *his* oak box

> The Aston family had formerly lived at Tixall, and James, lord Aston, was Clifford's grandfather. The Sadler MSS. had been originally found at Tixall "in an old oaken box covered with variegated gilt leather, and ornamented with brass nails". After publishing the Sadler Papers, Clifford made a search at Tixall for the papers of Walter, Lord Aston, ambassador in Spain under James I and Charles I.

When is all this happening? It wouldn't by any chance be around the time the Pepys and Evelyn diaries were appearing, would it? Funny you should ask that

> The Gentleman's Magazine for March 1811 announced that the State Papers and Letters of Sir W. Aston were then being printed uniform with the Sadler Papers. This work, however, never appeared.

We are deuced lucky to get anything in view of the fourth Lord Clifford's cavalier attitude to oak boxes

> **Clifford's father had at one time made a bonfire of various old trunks and papers that had been accumulating in the house for two centuries**

With the exception of the one with variegated gilt leather and brass nail ornamentation. That one had caught the attention of some passing magpies

> **The gilt leather box was rescued by the ladies of the family**

I should, at this point, explain Georgian female property law as it pertains to locked boxes. Women can spot them, they can rescue them, they can guard them from pyrotechnical fathers, but they must pass them on, intact and unopened, to the son and heir

> **Clifford now found that it contained all the state papers and letters of Sir Walter Aston carefully tied up in small bundles.**

You liked a Cliffordian locked box containing the secrets of a titanic Protestant/Catholic clash featuring kings Charles II and Louis XIV with England's fate on the line, so what about another Cliffordian locked box, another Protestant/Catholic clash, England's fate etc, but with a twist? *Queens*. Yes, it's that ever-popular double act, our own Virgin Bess and the not at all virginal Mary, Queen of Scots

> **On 11 August 1586, after being implicated in the Babington Plot, Mary was arrested while out riding and taken to Tixall**

At first there was no thought of locked boxes

> **Elizabeth asked Paulet, Mary's final custodian, if he would contrive a clandestine way to 'shorten the life' of Mary**

but the wily Paulet knew what happens to people who do that sort of thing

> **which he refused to do on the grounds that he would not make "a shipwreck of my conscience, or leave so great a blot on my poor posterity"**

It will have to be the old locked box routine after all

> In August 1586 Walsingham ordered Paulet to take her
> hunting, while leading members of her household were
> arrested and her papers searched. From these letters it
> was clear that Mary had sanctioned the attempted
> assassination of Elizabeth.

"Dear Babington, I sanction the assassination of Elizabeth. Signed Mary, Queen of Scots."

You don't like the summary dispatch of queens? Does you credit, shows a degree of gallantry noticeably lacking in Tudor times. Could I then interest you in another Cliffordian king-on-king locked box? It is the usual Protestants v Catholics, England's fate on the line, but this time Protestant Charles and Catholic James

> Walter Aston, 2nd Lord Aston of Forfar became a recusant
> Catholic. After his death it was alleged, as part of the
> bogus accusations in the Popish Plot, that he received
> Jesuits at Tixall, and in August and September 1677 held
> meetings at Tixall attended by William Howard, 1st
> Viscount Stafford and Aston's steward Stephen Dugdale
> where the assassination of Charles II was plotted. Amidst
> the Popish Plot allegations, one contemporary witness,
> William Skelton, described finding Dugdale and Stafford
> talking alone together in the Little Parlour and the Great
> Parlour (a dining room next to Aston's chamber) at Tixall
> in September 1678. A letter from Stafford mentioning a
> plot was allegedly found in Aston's study.

"Dear Aston, about that treason we were discussing..."

You're Scottish? You're fed up with English Protestantism and the fate of England always being on the line? Very well, here is Scottish Protestantism on the line and, because I like the cut of your jib, you can have one of each, Catholic Queen Mary and Protestant King James. Not a boring old oak box either but a casket containing the Casket Letters that damned Mary to oblivion. "Dear Scotland, I've been really awful..."

Yes, I know, the letters have officially disappeared (ditto the casket, there's a Portobello in Edinburgh too, you know) but those letters will be around somewhere if we look hard enough. They are among the most important letters in Scottish history so they won't

have *disappeared* disappeared, will they? I doubt a scenario of this sort took place

> **Scottish archivist:** What do you want done with these letters, they are among the most important in Scottish history and underpin the legitimacy of the national religion?

> **Moderator of the Church of Scotland**: Chuck 'em. Water under the bridge now, no point stirring things up. Can you get me two-together for Ibrox?

No, mark my words, better still mark Roy L Davids' words, Sotheby's have got them up their sleeve ready for the big Scottish Independence Day Sale when all the Yank 'I'm a quarter Scotch' billionaires will be in town. Roll on that day, I say. It was nice while it lasted but we'll just have to find someone else to patronise.

There is a specific historiographical reason for this pattern of documentary malpractice. England and Scotland were peculiar for their time when it came to dealing with enemies of the state. Doubtless Britain had the average proportion of people trying for illicit regime change but neither country could do what the average regime of the time did: kill them. Or lock them up with a scribbled signature and throw away the key. By the sixteenth century English and Scottish regimes could not do this, not easily. They might have the same need for the condign removal of traitors but they had the nuisance of trial-by-jury in the way.

The outcome may have been the same but halfway believable evidence had to feature somewhere in the process and treasonable conspiracies tend not to leave much by way of evidence. Especially as, unlike our goodselves, their goodselves did not consider confession by enhanced interrogation enough. Hence the need for incriminating documents. But treasonable conspiracies tend not to leave much by way of incriminating documents either, hence the need to forge them. Hence the need for the documents to follow the traitors into speedy oblivion.

It is not considered a crime in Britain to judicially murder people using dubious documentation if they are known to be traitors. We were doing it as late as 1946 with the Irishman, William Joyce, who committed the crime of using a British passport he was not entitled to when hopping off to Germany to become Lord Haw-Haw at the outbreak of war. Wouldn't you, to avoid internment on the Isle of Man? Or Ireland. Instead of the usual forty shilling fine and

seven days to pay, Joyce got the noose. After a trial-by-jury so that's all right then.

Nor apparently is it a crime to employ historians who believe bogus documentation is part of the historical record, with or without the documentation. It would be a crime not to help them kick the habit and we can make a start with some bogus documents that *have* managed to survive long enough to get into the archives. The Pepys and Evelyn diaries.

19 Diary of a Nobody

What is going on? When is it going on? One common thread would appear to be public/private papers coming to light around the turn of the nineteenth century. Although a profit motive does seem to be present, there are too many state actors involved for it to be an obvious financial scam. The sources appear to occupy a netherworld of 'now you see them, now you don't' and that is inconvenient whether you are relying on Wiki or have unfettered access to Kew. Since we can all read the Pepys and Evelyn Diaries, revisionists and academics can compete on a level playing field when evaluating them as historical sources. Who will win? I'm saying nowt but the shrewd money is on the revisionists.

Though it was academic historians who laid down the gauntlet

Samuel Pepys' diaries are one of the most important primary sources for the English Restoration period

If so, Pepys is entitled to a niche in his nation's remembrance and sure enough his portrait hangs in the National Portrait Gallery. Allowing us to apply our patented Revisionist Portrait Test:

What is the overall probability that a youthful seventeenth-century civil servant would
a) have his portrait painted
b) it will be preserved long enough to take its place in the National Portrait Gallery?

The answer to (a) is one hundred per cent if the Pepys Diaries are to be believed

In his diary, Pepys records on 17 March 1666: 'I sit to have it full of shadows and so almost break my neck looking over my shoulders to make the posture for him to work by'. There were more sittings on 20, 23, 28 and 30 March, when he sat 'till almost quite darke upon working my gowne which I hired to be drawne in; an Indian gowne'. The music he holds is his own setting of a lyric by Sir William Davenant, 'Beauty, retire'.

Most obliging of him. The answer to (b) is not one hundred per cent, whatever the National Portrait Gallery may say. Once upon a time it was a hundred per cent not

it was sold at auction in 1848 as a *Portrait of a Musician*

Pepys was moderately famous by 1848 so a portrait of him turning up in an auction room would be of considerable public interest. Alternatively, nobody in 1848 would have a clue what somebody who died in 1703 looked like, in which case interest would be limited to enthusiasts of mediocre genre paintings. Which is it? The evidence is equivocal

> **However, the man who purchased it, Peter Cunningham, quickly identified it as Samuel Pepys. This was based on its ownership history (it had been sold by descendants of Pepys)**

"Shall we sell our portrait of great great great-uncle Samuel?"
"Good idea. He's famous, we ought to get a decent price."
"I've got a better idea. Let's just say it's a portrait of a musician."

To live up to his name, Cunningham is going to have to pull the other one

> **and the identification of the sheet music as one of Pepys's own setting**

Well spotted that man, you should be in line for a nice little tickle

> **Cunningham offered the portrait to the Gallery for £200 – apparently much more than he had paid for it – but it was declined due to doubts about the identity of the sitter and concerns about the high price.**

That would be the National Gallery (founded 1824) rather than the National Portrait Gallery (founded 1856) but their reasoning, if I may say so, is not very 'national'. If it is a portrait of Pepys, two hundred sovs is cheap at twice the price; if the identity is in doubt they have no business spending any amount of public money.

Knocked back, there was nothing Cunningham could do but shift the picture on to someone else for them to try their luck later. Twenty years later after the National Portrait Gallery had set up shop and was in the market for famous folk of yesteryear

> **The portrait was offered to the Gallery again in 1865 by its new owner Robert Cooke**

Someone has failed to mention the awkward provenance gap. Unless the staff at either institution had eidetic memories there is

no way of knowing it was the *same* painting. It is not as if Cooke wrote them a letter: "Sirs, I have the honour to offer you a portrait of Samuel Pepys despite the fact that it was rejected last time." We know this because we have the actual letter

> **Cooke enclosed in his offer letter the extracts from Pepys's diary in which he related sitting for the portrait: "I... do almost break my neck looking over my shoulders to make the posture for him to work by ..."**

"Why didn't those duffers at the National Gallery think of that twenty years ago?" chortled the National Portrait Gallery, hoisting the prize on their newly turpentined walls.

The authenticity of the painting does not affect Pepys' place in the national pantheon if his diary is 'one of the most important primary sources for the English Restoration period'. Establishing that is going to require further revisionist smell tests:

ONE The years covered by the diary, 1660-9, are momentous, when many of England's modern institutions were taking shape, so why would the personal diary of an Admiralty civil servant be of any great significance as a historical source?

It is a bit odd

TWO Diaries that serve as significant historical sources are common enough but what are the chances two of them will be written by Admiralty civil servants in the years 1660 to 1669?

Long odds against

THREE What are the odds both diaries would disappear, both would be found a hundred years later, both would be published, both would still be in print two hundred years later?

Getting silly

It was Evelyn's diary that first came to public attention

> **Evelyn's direct descendants inherited the Wotton Estate until the early 19th century, when it passed to Evelyn heirs of the Godstone branch. Mary Evelyn, widow of Frederick Evelyn, commissioned her solicitor the Surrey antiquarian William Bray to edit and publish Evelyn's diary in 1818.**

Lucky her, my solicitor is just a solicitor. This kind of incidental detail in a provenance may not be incidental at all. Mary could have taken the diary to any antiquarian, so why would he be that very rare beast, a solicitor who is an antiquarian? And who happened to be *her* solicitor. That's easy.

To discover the diary

How is a Surrey housewife to have a eureka moment when sorting through family papers? Not by finding and then recognising the significance of a diary written by an obscure civil servant. Nor would a high street solicitor sorting through them on her behalf. It takes a solicitor who happens to be an antiquarian to do that.

Or looking at it through the other end of the looking glass, an antiquarian who happens to be a solicitor. If you are William Bray and you decide the crowning opus of your not very glittering career is to be the production of the Evelyn Diaries (whether real, made up or a bit of both) the first thing you have to do is account for how you came by them. Although you have never practised as a solicitor, who is to say you cannot have been hired by a (very distant) member of the Evelyn clan (by marriage) to go through (her husband's) papers which included the Evelyn Diaries?

But while you are about it, why not get an engraving of the diarist's wife done by Henry Meyer in 1818. Not easy with Mrs Evelyn being dead and buried these hundred years. So it will have to be "after Robert Nanteuil", the French portraitist. Why not? Her father was once ambassador to the court of Louis XIV. How did that conversation go, I wonder.

> "Have you got anything on at the moment, Hank? I need a quick stipple engraving of someone who was married to a seventeenth century civil servant that nobody's heard of but soon everyone will have, take my word for it. I've got a portrait of her by a famous French court painter (don't ask how) that you can use but you can chuck it afterwards, nobody's got any record of it so it won't be missed."

Another bit of antiquarian luck was the diary being found in, or very closely associated with, the 'John Evelyn Cabinet'

> **The cabinet was made in Florence. It is veneered in ebony and incorporates 19 pietre dure, or hardstone, plaques supplied by Domenico Benotti. The gilt-bronze mounts and plaques were added in England, in the workshop of**

> Francesco Fanelli, though it is not known for certain when
> this took place. The gilt-bronze strawberry-leaf crest was
> probably made and added in about 1830-1840.

Bray & Co may have offered house clearances as part of the package because

> John Evelyn's diaries were discovered in an 'ebony cabinet'
> at Wotton House, quite possibly this one.

Unless ebony cabinets are running amok in Wotton House. One can see that a valuable diary might pass through a few generations and a couple of branches of the Evelyn family. One can see that a valuable cabinet might pass through a few generations and a couple of branches of the Evelyn family. But a valuable diary remaining undiscovered *in* a valuable cabinet requires some very inattentive generations and branches of the Evelyn family.

Got anything else for us, Mr Bray, before we move on?

> "I am credited with the earliest mention of baseball but I was
> only eighteen at the time so I discount that as a juvenile work."

I think we will move on, if it's all the same to you. The engraving is in the National Portrait Gallery and the cabinet is in the Victoria and Albert so all enquiries should be directed to them. But don't hold your breath.

Evelyn's Diary was such a critical and commercial success, the hunt was on for something similar

> Motivated by the publication of Evelyn's Diary, Lord
> Grenville deciphered a few pages of Pepys' diaries. John
> Smith (later the Rector of St Mary the Virgin in Baldock)
> was then engaged to transcribe the diaries into plain
> English. Smith's transcription was the basis for the first
> published edition of the diary, edited by Lord Braybrooke,
> released in two volumes in 1825.

So that clears that up. The diaries seeing the light of day more or less simultaneously a century later was nothing to worry about after all. One, it is true, was a fortuitous find but history is often a matter of fortuitous finds. The discovery of the second diary was a simple consequence of discovering the first. *Put like that*. It can be put another way

> "I see those Evelyn Diaries have been a big success, why haven't
> we got anything like it on the stocks?"

88

"I understand it was a purely fortuitous find, sir."

"So? Get out there and fortuitously find something along the same lines."

"With respect, sir, how can I possibly do that?"

"I don't know, you're responsible for new product. Bang on some likely doors, I suppose."

"There are a lot of doors out there, sir."

"I'll give you Perkins. He can do the even numbers."

Except the Pepys Diaries were sitting snugly in the Pepys Library in Cambridge and, consulting the list of Admiralty clerks of the second half of the seventeenth century and finding Pepys' name among them, the first likely door knocked on would be the Pepys Building at Magdalene College, Cambridge

"Did Pepys keep a diary by any chance?"

"Do you know, I have no idea. Despite having a whole building devoted to him and his works for the last hundred years, we have never actually checked. I suppose, now the Evelyn diaries are drawing such attention, we had better have a rummage."

Again everyone can be satisfied. It was a simple case of cause-and-effect. Historians know all about cause-and-effect, it is their stock-in-trade, summed up in that self-deprecating apothegm of theirs, 'History is just one damn thing after another'. The way they understand the Evelyn/Pepys connection is that it is just one damn diary after another.

Except it isn't.

Historians are not statisticians and statisticians would look at the situation entirely differently. They would not be concerned with the second event. Pepys's Diary was in a well-known, well-preserved collection and there were people looking for it, it would be only a matter of time before somebody found it. They would be far more interested in the first event because once Pepys Diary is found, Evelyn's Diary ceases to be a providential discovery and becomes a *causa proxima*

"The probability of a politically significant diary being written by someone associated with someone who was also writing a politically significant diary which will be preserved in a well-known, well-preserved collection is vanishingly small."

Revisionists are neither historians nor statisticians but are irresistibly drawn to statistically unlikely events. As soon as we identify one we skip all the probability theory, of which we are as ignorant as everyone else (except we understand the importance of people

being ignorant about probability theory) and do something we *are* qualified to do:

looking for oddities

Everyone notices oddities, whether they are looking for them or not, we do something more, we

list them

If the list keeps growing we know we are in business. If it does not, we conclude it was an oddity and move on to some other bee in our bonnet. Revisionists are not contrarians, we assume experts get it right most of the time. Though it has to be said any time we find they haven't, experts dismiss us as contrarians.

They have their methods, we have ours. Ours is typing keywords into Google to see what oddities emerge and the obvious starting point for judging the authenticity of the Pepys Diaries is the man who knew which door to knock on

> **Motivated by the publication of Evelyn's Diary, Lord Grenville deciphered a few pages of Pepys' diaries.**

Who is this Lord Grenville, the man with the diary-dowsing golden touch? He was once prime minister which assuredly counts as an oddity so we put him on our list and consult his Wiki page in case further oddities will be on view. We discover he has a brother and a brother-in-law and the oddities start tumbling out

> **William Grenville (1759–1834) Prime Minister 1806-7**
> **Thomas Grenville (1755–1846) MP and bibliophile**
> **Catherine Grenville (1761–1796) married to**
> **Richard Griffin (1750–1825) 2nd Baron Braybrooke**

Our ex-Prime Minister has found a diary and wants to publish it as a book. Does he turn to his brother, the bibliophile? No, he turns to his brother-in-law who has no background in the book trade and at seventy years of age not much of a foreground. Since that is odd, this Richard Griffin goes on our list and we turn to his Wiki page, where we discover he has more names than you could shake a deed-pole at

> **Richard Griffin, 2nd Lord Braybrooke, was born 3 June 1750 at Duke Street, Westminster, the son of Richard Neville and Magdalen Calendrini. He was given the name of Richard Aldworth-Neville at birth. In August 1762 his**

> name was legally changed to Richard Neville. He was
> known as Richard Aldworth-Neville or Richard Aldworth
> Griffin-Neville to 1797. On 27 July 1797 his name was
> legally changed to Richard Griffin by Royal Licence. He
> married Catherine Grenville on 19 June 1780 at Stowe,
> Buckinghamshire. He died on 28 February 1825 at age 74
> at Billingbear, Berkshire

a few months before the book he had edited came out. People will do anything to avoid publishers' launch parties.

He appears to have inherited the name-changing gene from his father

> Richard Neville Aldworth Neville (3 September 1717 – 17
> July 1793), until 1762 Richard Henry Ashcroft, was an
> English politician and diplomat. Aldworth assumed the
> name and arms of Neville in August 1762, when he suc-
> ceeded to the estate of Billingbear

You read that far too quickly. Aldworth did *not* assume the name of Neville in 1762, Ashcroft did. On this reading, he was never called Aldworth. Significant? No idea, but odd enough to put him on the list and read the next paragraph

> Instead of finishing his course at Oxford, Aldworth
> travelled abroad. In 1739 he visited Geneva, and he spent
> every winter there till 1744. By his wife Magdalen,
> daughter of Francis Calandrini, First Syndic of Geneva,
> whom he married in 1748, and who died in 1750, Neville
> had two children: a daughter Frances, and Richard.

We get out our odd-o-meter

? Marrying a woman with the same name as the college that ends up with the Pepys Diaries? *Probably a coincidence.*

? The First Syndic of Geneva being their equivalent of prime minister? *Probably another coincidence.*

? Such an exalted personage giving his daughter's hand in marriage to an itinerant foreign drop-out? *It happens.*

? Daughter marries, goes to England, has two children, dies, all in two years. *It happens. But not very often.*

One does not like to intrude in such a tragically foreshortened life, but hubby's name was Ashcroft when all this was happening so for Mr & Mrs Ashcroft to give their son

was odd indeed. Richard Ashcroft appears to be the only name he was not called as he proceeded through life as Richard Neville, Richard Aldworth-Neville, Richard Aldworth Griffin-Neville, Richard Griffin and Lord Braybrooke. Me, I'd need a diary just to keep track of what my name was this year.

It is all very odd but it is only a list. *Only a list*, the man says. This is the moment for a crucial internal switch. The human brain has great difficulty entertaining hypotheses that go against the grain. It demands proof before venturing out into the wine dark sea, a necessary defence against being overrun by all manner of stray thoughts it comes into contact with on a daily basis. Most human beings, including most academics, spend their entire lives without once venturing into wine dark seas. There is no particular need to, life can be lived quite agreeably on the beach.

Revisionists employ a simple expedient to sidestep the human condition.

They have their list of oddities.

This does not require ventures into the unknown, they have all been culled from standard sources. They may be odd but the human brain is prepared to encompass them because they are from standard sources. Assuming the list will tend to grow if the revisionist hypothesis is valid, there comes a point when it is easier to 'believe' the revised version than the original orthodox version. 'Believe' in quotes because it is still only a matter of entertaining a hypothesis. We have enough oddities attached to the Pepys Diary to do what other people – people who have known the Pepys Diary all their lives, and especially Pepys scholars – cannot do

assume the Pepys Diary is a fake

Provisionally. And here's a bonus: the hypothesis can turn out to be entirely unfounded without making the exercise wasted effort because

the list of oddities is valid

The revisionist is left in the position of wondering why standard accounts seem not to know, or not to care, about the oddities. *That* it turns out is what revisionism is really all about, but of that later. For now, it is back to the Pepys Diary.

The chief difficulty facing the Diary Gang in their quest to come up with, ex hypothesi, an Evelyn Mark II is that forging multi-volume documents written by someone whose genuine hand-writing is already part of the historical record is near impossible. Unless the documents are written in shorthand making it near impossible to identify the writer.

The diary was written in one of the many standard forms of shorthand used in Pepys' time, in this case called tachygraphy and devised by Thomas Shelton

So much for all the talk of deciphering, it was written in a standard shorthand though, after all the name changes, it is a relief to find the decipherer-in-chief had the commonest name in Britain

John Smith (later the Rector of St Mary the Virgin in Baldock) was then engaged to transcribe the diaries into plain English

But who on this God's earth writes a personal diary in any kind of shorthand? The diaries are awash with extramarital shenanigans so it may be Pepys did not want his wife to read them.

Attention shorthand diarists!
Never marry your secretary.

Attention shorthand diary-wives!
He's probably up to something but don't worry, it will be in a standard shorthand so you can spend every weekday afternoon with a primer in one hand and a rolling pin in the other.

The Reverend Smith laboured at this task for three years, from 1819 to 1822, unaware until nearly finished that a key to the shorthand system was stored in Pepys' library a few shelves above the diary volumes.

You should have seen his face. It would have taken him as long if he had been writing them from scratch.

Whatever the status of the diaries, there can be no doubt about the status of the diarist

Pepys was a naval mastermind, but he was also a gossip, a socialite and a lover of music, theatre, fine living – and women! He fought for survival on the operating table and in the cut-throat world of public life and politics, success-fully navigating his way to wealth and status until his luck,

intimately entwined with the King's fortunes, finally ran out.

Some doubt maybe. These are the words of the National Maritime Museum publicising a Pepys Exhibition but they would be well-advised not to emphasise Pepys' high status too much or they will run into the problem the Diary Men had run into. Diaries 'tell all'. How are the Pepys Diaries to 'tell all' if the real Pepys – whose life and career can be followed via his voluminous correspondence with Evelyn – was no more than a sometime senior mandarin, sometime minor politician, sometime middleweight late-Stuart fixer? That was easily dealt with: have the Diaries end in 1669, before they can get too revealing

> **Pepys stopped writing his diary in 1669. His eye-sight began to trouble him and he feared that writing in dim light was damaging his eyes. He did imply in his last entries that he might have others write his diary for him, but doing so would result in a loss of privacy and it seems that he never went through with those plans.**

They say it makes you go blind but our hero managed to stagger on somehow

> **In the end, Pepys' fears were unjustified and he lived another 34 years without going blind, but he never took to writing his diary again**

though he did take up writing his memoirs in very old age so the light must have improved considerably.

Ending the diaries in 1669 did, however, threaten the whole purpose of the enterprise. The mature Pepys can be a naval master-mind and a consort of kings, the 1660's Pepys was a junior functionary on the lower rungs of public life, unlikely to be master-minding or consorting much above street level. What could possibly be going on at street level in the London of the 1660's that is going to provide material for the world's best-selling diaries? Oh, I don't know, we'll think of something

> **It provides a combination of personal revelation and eye-witness accounts of great events, such as the Great Plague of London, the Second Dutch War, and the Great Fire of London ... On 3 January 1661 Samuel Pepys wrote in his diary, 'to the Theatre, where was acted Beggars bush – it**

being very well done; and here the first time that ever I saw Women come upon the stage'. Pepys was a fan of Nell Gwyn, today perhaps the most famous Restoration actress, who was also a mistress of the King.

Fabulous! Can we, you know, have them handling the oranges at the same time? Maybe a duel, that will have them flocking to Greenwich for a Pepys show.

Don't be silly. But we can have Pepys consorting with the next best thing. The next best king. If 'best' is quite the right word. The future James II was the Lord High Admiral of England in the 1660's and hence Pepys's boss. Surely day-to-day contact at the office with such a commanding figure is going to be a singular asset for the diarist who won the Posterity Prize?

Funnily enough, and despite everything you thought you knew about Pepys, it was not his diary that made his name. That was only discovered in 1818 by which time the Pepys Building, named in his honour, had been up and running for a hundred years. He had not earned a building by writing a diary of historical importance but because

Pepys was a lifelong bibliophile and carefully nurtured his large collection of books, manuscripts, and prints

Samuel Pepys, naval mastermind and bureaucrat to the stars, achieved fame because of his hobby

At his death, there were more than 3,000 volumes, including the diary, all carefully catalogued and indexed; they form one of the most important surviving 17th-century private libraries

We are back, I'm afraid, in the minefield of statistics. An unlikely event should not be dismissed because it is unlikely. The world is so full of events a fair proportion of them will be unlikely. It is only when an unlikely event gets conjoined with another unlikely event – other than via cause-and-effect – that both events clamber out of the oddities list and onto the wrong-history list. As that is what revisionists are in business to identify, we have coined a memorably Orwellian saying for the juxtaposition

**One world record, good
Two world records, bad**

o Who is the world's most famous diarist? *Samuel Pepys*
o Who put together (one of) the world's most important surviving seventeenth century private libraries? *Samuel Pepys*
o Is there a causal link? *Not one that springs to mind.*

And do not look for one from Pepys biographers. As far as they are concerned this is just one more reason for writing a biography of Samuel Pepys.

We have a companion rule made even more memorable by the office McGonagall

> One world record good,
> Two world records bad.
> Three world records
> You're being had.

and sure enough

> but there are other remarkable holdings, including over 1,800 printed ballads, one of the finest collections in existence

Goodness, whatever did he do with it all?

> Pepys made detailed provisions in his will for the preservation of his book collection. The bequest included all the original bookcases and his elaborate instructions that placement of the books "be strictly reviewed and, where found requiring it, more nicely adjusted".

Fastidious old gent. You would never guess such a fusspot would have three spells in chokey under his belt. Different times.

What is worrying me are the storage charges. These grand muck-a-mucks are forever laying down instructions about how their precious dibs-and-dobs are to be preserved for posterity but they never give a thought to the much less grand folk who are going to have to do the preserving, and not a penny in the pot to pay for it. The muck-a-mucks should give it some thought because there is always the temptation one of the less grand people might sell off a little something on the QT to defray expenses.

"Something like Sir Francis Drake's personal almanac?"
"Yes, something of that sort. What else? In case storage charges go through the roof, you understand."
"Naval records, two of the Anthony Rolls?"
"Not really, no. A bit specialist. Unless they feature some famous ship or other."

96

"Illustrating the Royal Navy's ships c. 1546, including the Mary Rose?"

"It's still a 'no'. The old boy wouldn't thank us if we gave the impression he was taking stuff home under his coat."

"Sixty medieval manuscripts?"

"He's not getting them from the Admiralty. Important, are they?"

"They include the 'Pepys Manuscript', a late-fifteenth century English choirbook."

"Very nice, I'm sure, but this is a library, Uncle Sam must have left lots of books. Not book books, they can go to the charity shop, but early books, the valuable ones."

"Would The Big Three of early English printing be what you are looking for? Incunabula by William Caxton, Wynkyn de Worde, Richard Pynson, that sort of thing?"

"Possibly. If I knew what an incunabula was."

> An incunable is a book, pamphlet, or broadside printed in Europe before the 16th century. As of 2014, there are about 30,000 distinct known incunable editions extant, but the probable number of surviving copies in Germany alone is estimated at around 125,000. Through statistical analysis, it is estimated that the number of lost editions is at least twenty thousand.

Fascinating. Let me see if I have got it right. An incunable is a printed thingummyjig just like any other printed thingummyjig except it happens to have been printed before 1500. They have been given a special name making them highly collectable and there could be twenty thousand more out there depending on demand. Sorry, I mean supply. Sorry, I mean serendipitous discovery, wherever these things get serendipitously discovered.

In the Pepys Library, to name one, to name three, so perhaps we had better find out who did end up having to pay the posthumous storage charges on behalf of this outstanding but not outstandingly wealthy collector

> College records state that the library came to Magdalene College, Cambridge, in 1724 in accordance with the codicil to Samuel Pepys's will. The wife of John Jackson, his nephew, gave the books to Magdalene upon John Jackson's death in 1723.

Fascinating. Let me see if I have got it right. The present owners of the stupendously valuable Pepys collection have a record show-

ing they are the owners of the stupendously valuable Pepys col-
lection. I am afraid that is far from satisfactory. I appreciate the
Diaries were not found for another hundred years (heads rolled
about that, I expect) but what do they have to say, if anything,
about Pepys' own thoughts on the subject?

> According to the Diary entry, it was signed and witnessed
> 30 January 1664, "...in the evening Mr. Commander came
> and we made perfect and signed and sealed my last will
> and testament"

Just as I suspected. Nothing about Cambridge colleges, though it
is nice to see the young man drawing up his will while he was still
writing his diaries. Very responsible of him, and all the more so
because he could not have known he was destined to be one of the
greatest private collectors of all time.

Well, Magdalene College, Cambridge, what have you got to say
for yourselves?

> A fortnight before he died in 1703, Pepys made two
> codicils to his will. In the first, he directs that his
> unmarried nephew, John Jackson—himself a Magdalene
> man, and the first of Pepys's Librarians—is to have 'the
> full and sole possession of all my Collection of Books and
> papers contained in my Library ... during the tenure of his
> natural life'.

My most abject apologies. I should have checked my facts before
casting aspersions. Pepys' final word on the subject. And what is
more, if anything should be amiss, it will not be the fault of Samuel
Pepys or Magdalene College, it will be down to this John Jackson.

A small point. One could not help noticing that Jackson was a
Magdalene old boy. Might not that be thought a little cosy? By ill-
wishers, I mean, it seems fair enough to me. It is asking a lot, I
know, but could you provide someone else, someone associated
with Pepys but not with Cambridge colleges?

> Jackson and Will Hewer (Pepys's executor) are to 'consider
> of the most effectual means of preserving the said Library
> intire in one body, undivided, unsold and secure against all
> manner of diminution, damages and embesselments ... for
> the benefit of posterity'

Speaking for myself, I am entirely satisfied. Great name, by the way, Will Hewer. Very appropriate for Pepys' long-time factotum. Walking out with Ida Ladle, the cook, I like to think. All that is needed now, this being Magdalene's own internal record-keeping, is some kind of external verification and we are good to go.

> in a paper respecting it, preserved among the Harleian Manuscripts in the British Museum, 'either Trinity or Magdalene College, Cambridge' ... 'preferably in the latter' ... 'for the sake of my own and my nephew's education therein'

The chief national archive! You have surprised me there, you really have. In fact you might have gone a bit OTT

> **either Trinity or Magdalene... preferably the latter**

makes about as much sense as "I leave my entire estate to Sally Jarndyce or Humphrey Jarndyce, preferably the latter." You've got me worried all over again now.

I appreciate this is Pepys' final word on the subject, him being on his deathbed and all, but I have a strong presentiment the old boy is going to want to add something

> But Pepys had further thoughts on the matter, for on the following day a second codicil was drawn up. To ensure that the Library should be preserved intact for posterity, he directed that if one book is missing, the whole Library be transferred to Trinity. That College was to have the right of annual inspection.

Now it makes perfect sense. When operating a fakes emporium it is essential to demonstrate everything is tamper-proof, everything comes from the original source, nothing added, nothing taken away (except the one you have just paid over the odds to take away). Magdalene College and Trinity College were running a joint fakes emporium. Nothing happens at Cambridge without a Trinity finger in the pie.

If Magdalene and Trinity were running a joint fakes emporium. I offer no opinion on the subject. A decent emporium demands a decent shop window and institutional forgers operate on a different scale from your common or garden shed blagger

The exact history of the Pepys Building is unknown, and it remains full of puzzles. The building was most likely not completely finished until after the 1700s.

That is very nicely worded. It could mean seventeen-something and be referring to Pepys-the-collector, but alternatively it could mean eighteen-something and be referring to Pepys-the-diarist. Somebody has decided to use a form of words

"until after the 1700s"

that covers both possibilities but does not draw undue attention to it. Why might that be? It is time to be introduced to something revisionists are very fond of

the ambiguous formulation

Formulations are precise, ambiguities are not, so when they are combined it is not by accident. It is when there is a requirement to hide something, whether the formulator knows it or not. In this case the formulator is acting in good faith, they are not trying to deceive

they are being deceived

The formulator is trying to make sense of something that is not making sense to them so they have selected a form of words that sidesteps the problem. This is odd behaviour from someone who prides themselves sufficiently on being a Pepys expert to contribute Pepys material to Wiki, yet is insufficiently curious to resolve the anomaly. We can hazard a guess why.

It cannot be resolved.

This is what makes ambiguous formulations so useful to revisionists. Whatever it is that is being obscured must be important but we would never have found it. A Pepys expert has found it for us. We only had to recognise that an ambiguous formulation was being employed to know it is time to park our tanks on their lawn and find out. We already know it has got something to do with when all this was happening.

Either date – seventeen-something or eighteen-something – requires Pepys (died 1703) to be something of a clairvoyant

Samuel Pepys made three subscriptions to the building fund, although there is no formal evidence of his intention

100

> to bequeath his Library to the College, and of his hope to
> have it placed in 'the new building'

Did you spot that *comma* followed by that *and*? It is another

ambiguous formulation

There is plenty of formal evidence of Pepys' intention to bequeath his library to the College but *not* to the new building. The formal evidence says he made his mind up two weeks before his death and he could not also have been making a series of contributions to his old alma mater during those two weeks. They must have been made years earlier. Except years earlier he could not possibly have the least idea

his own collection would end up in it

much less that it would be named in his honour. Either Samuel Pepys was clairvoyant or Samuel Pepys had very little to do with it.

The Pepys Building today is a tourist attraction and you might be considering a quick trip to make your own enquiries. It is not recommended. Impromptu fieldwork results in blank stares and, if you start explaining your purpose, downright hostility. That is why revisionists stay at home with their laptops. The Pepys Building's official website will tell us all we need to know about the gimcrack world of the Pepys Building. Think 'garden shed'. Think, "Oh look, another ambiguous formulation"

> **Although it is unlikely to have been planned before 1640, the Pepys building was probably not completely finished until after 1700. The main new idea was to bring the front forward by several feet, and create a large room or series of rooms over a loggia in the central link. This may have been specifically envisaged for library use.**

Think 'library' but not yet 'Pepys Library'

> **It seems that the books bequeathed by the then Master, Prof. James Duport, at his death in 1679 were kept there until 1834.**

Think 'now it's time for a Pepys insertion'

> **Samuel Pepys made three subscriptions to the building fund. If the plan was changed in this way in the late 1670s, this would explain why there is such a dichotomy between**

the back and the front of the Pepys Building. It might also explain some of the other abounding anomalies.

Academic historians treat anomalies differently from the way we do. They regard them as interesting shortcomings of the past, to be oohed-and-aahed over, not as reasons to re-examine the past

> It remains full of puzzles. The least of these is the irregular ground-plan: the south wing was deflected northwards because it abutted the College Brew-house, which had been rebuilt as recently as 1629. It is less easy to explain why the dormers are not uniform, or why the south wing is two feet shorter than the north. Much of the carpentry is shoddy. The staircases might well be pleasingly up to standard for the 1670s, but the whole construction in the garrets is surprisingly sketchy for collegiate use. The west front is slightly asymmetric.

Finishing with an absolute riot of ambiguous formulations

> The frieze inscription 'Bibliotheca Pepysiana 1724' records the date of arrival of the Pepys Library

We have been told the date when the Pepys Library is supposed to have arrived, it would have been nice to know when the inscription arrived.

> above it are painted Pepys's arms and his motto

Why is that then, wasn't the mason up to the job?

> To the left and right appear the arms of two College benefactors

If I were one of them I would want to know why I am considered a benefactorial afterthought and why a Pepysian scholar cannot be bothered to mention my name. And to cap it all

> added much later (1813?).

"The ingrates couldn't even be bothered keeping a record of just when it was they decided I deserved commemorating. Gordon Bennet, I'm not Cecil bleedin' Rhodes."

There is no more precise formulation than naming the actual year and there is no better way of making it ambiguous than slapping brackets round it and adding a question mark. They are

almost begging us to zero in on the significance of 1813. Gordon Bennet, they do make it easy for us

- o the Evelyn Diaries were 'discovered' in 1815
- o the Pepys Diaries were 'discovered' in 1818

It looks for all the world as though someone wanted to establish a *terminus post quem* or a *terminus ad quem* or a *terminus a quo*... or something. In English 'someone's playing silly buggers'.

But you're not. What you want to know is whether the villains are still at it. Is it safe to put Jonathan down for Peterhouse? It is not for me to say. It is for Wikipedia to say

> **Lord Braybrooke was the Visitor of Magdalene College; his uncle George Neville-Grenville was the Master. In 1846 Neville-Grenville was appointed Dean of Windsor and offered to resign the Mastership; Lord Braybrooke, as Visitor, refused the resignation, intending that Latimer Neville (his fourth son, then aged 19) should eventually succeed him as Master. With some diplomacy needed to manage the Fellowship, this transition was achieved in 1853 and Latimer Neville became Master at the age of 26 and remained Master for 50 years from 1853-1904.**

No matter how carefully you think you have got everything nailed down, there are always rival gangs trying to muscle in. People in the same line of work, people who know you are not in a position to kick up a fuss

> **Apart from Magdalene College's holdings, the Bodleian Library in Oxford has twenty-five volumes of 'miscellaneous papers' and other books including dockyard accountbooks from the time of Henry VIII and Elizabeth I**

Oxford could not claim to have Pepys or any of his close relatives on their books but they did have his dustman

> **These were bequeathed to the Bodleian by Dr Richard Rawlinson (1690 - 1755), a nonjuring bishop and 'a great collector' who 'rescued' a mass of Pepys material 'discarded in a waste heap' and subsequently bequeathed the papers to the Bodleian. 'His collections in the Bodleian Library defeat the most persistent attempts at analysis.'**

From rubbish comes forth rubbish.

Part Three

HOW TO RECOGNISE FAUX HISTORY

20 He Wasn't There Again Today

In 1794 a meeting between Giacomo Casanova and the Prince de Ligne took place in the Austrian castle of Dux that led to the publication of Casanova's famous book *The Story of My Life*. There are puzzling aspects to this meeting, not the least being why the Prince de Ligne, a powerful figure in the Habsburg Empire, with a dynastic claim to the British throne rather better than the current incumbent's, should find himself in the company of the castle's librarian, even a librarian as colourful as Casanova. Not that anyone is particularly puzzled. It is a matter of historical record why they were meeting, the prince had just written his memoirs and was recommending Casanova do the same. It is, apparently, the most natural thing in the world for celebrities to do this. I wouldn't know.

So I'd make it my job to find out. By deciding, right off the bat, I've never heard such tosh. Habsburg high-ups chinwagging with Venetian libertines about memoirs? Apart from anything else, people like Casanova don't need encouraging to write their memoirs, you have a hard time stopping them. I would, right off the bat, assume someone is lying and that is always a good starting point for the fake-history hunter. Real history is full of people lying but they do it for a reason and historians are on hand to provide that reason. When there is no obvious reason and historians are treating everything as the most natural thing in the world, it requires revisionists to be on hand.

The false note provides the true start point. There must be a reason for wishing to bring Casanova and the Prince de Ligne together and, if it did not happen in real life, who benefits from saying it did? As the purpose here is instruction not entertainment, the ending can be given away at the beginning

o Castle Dux was a high class homosexual brothel
o the Prince de Ligne was a literary forger
o Casanova never existed
o his 'memoirs' are literary forgeries
o published by political revolutionaries
o who, on the back of the commercial success of the memoirs, are now the biggest book publishers in the world.

So now you know. To start finding out why this is all happening, and to start finding out how you can find these things out for yourself (and whether it is worth finding out), Lesson One

If you have access to Wiki you are halfway home

It should not need pointing out in this day and age but Wikipedia is the finest, best curated, most comprehensive, most trustworthy, most up-to-date encyclopaedia money need not buy. When it comes to the basics, if Wiki has got it wrong, everyone has got it wrong.

Casanova existing is a pretty basic aspect of his life story so establishing whether he did or not, will entail looking no further than his Wiki entry. The opening paragraph alone has four smoking guns

> **Giacomo Girolamo Casanova was born in Venice in 1725 to actress Zanetta Farussi, wife of actor and dancer Gaetano Casanova. Giacomo (2 April 1725 – 4 June 1798) was the first of six children, being followed by Francesco Giuseppe (1727–1803), Giovanni Battista (1730–1795), Faustina Maddalena (1731–6), Maria Maddalena Antonia Stella (1732–1800), and Gaetano Alvise (1734–83).**

As it has been drawn to your attention, your first thought might be to wonder if that is an unusually detailed record of an eighteenth century bourgeois Italian family. Or as the faux-history hunter's maxim puts it

Is that a lot or a little?

Your second thought would be, "How the hell would I know?" Quite right, I haven't got a clue either. Which *is* the clue. How would the person who wrote this know? Or the Wiki fact-checker. Or the world's leading Casanova authority? Or every Casanova expert who ever lived. Maybe it should be their business to find out, maybe they *have* found out, but nobody becomes an expert without leaving inconsequential details to others.

If expert fakers are providing these details because they require supporting acts for their leading man, who's to know? Us. We also rely on others doing the hard work, especially Wiki's hard work summarising all the experts' hard work, but we are on the lookout for consequential details. Which we recognise

because they should not be there

So you can, if you wish, become an expert on eighteenth century Italian family record-keeping, or you can rely on Wiki underlining the smoking guns for you

> Giacomo Girolamo Casanova was born in Venice in 1725 to actress <u>Zanetta Farussi</u>, wife of actor and dancer <u>Gaetano Casanova</u>. Giacomo (2 April 1725 – 4 June 1798) was the first of six children, being followed by <u>Francesco Giuseppe</u> (1727–1803), <u>Giovanni Battista</u> (1730–1795), Faustina Maddalena (1731-6), Maria Maddalena Antonia Stella (1732–1800), and Gaetano Alvise (1734–83).

Underlined words denote people with their own page in Wiki, making Casanova one of five people from his nuclear family who have earned a Wiki page. Is that a lot or a little? As this is probably another 'how the hell would I know?' question, this is a good moment to introduce you to a key technique of revisionism

Is it true of you?

Sounds daft, but this simple test is highly effective because while historians write about special people (people not like you)

real special people are surprisingly like you

Apart from their specialness, they are surprisingly humdrum (just like you). Inventors of history have to invent special people, i.e.

they have to be *made* special

and the difference becomes clear if you are looking for it.

Casanova biographers are not looking for it, they have already found it. Casanova being special is why they decided to write a book about him. They would not apply an 'Is it true of you?' test to Casanova's family, but you can:

Casanova is special	Not true of you
Casanova gets a page in Wiki	You do not
His nuclear family is not special	Nor is yours
His nuclear family gets five Wiki pages	Yours gets none

Casanova, it seems, had the peculiar power of being able to make members of an ordinary Italian bourgeois family special enough to

get their own Wiki page. Is that significant? You can find out by becoming *just like him*

- ✓ write some famous memoirs
- ✓ wait two hundred years
- ✓ return to earth and inspect Wiki

You will be there because you wrote some famous memoirs two hundred years ago, but how many of your nuclear family will be there? Your father, the chartered surveyor? The Yellow Pages possibly, but not Wiki. Your mother? Not unless being big in Neighbourhood Watch is big in two hundred years' time. Your brother played a season of semi-pro rugby but that will not get him into Wiki now, never mind two hundred later. Your sister? She would be embarrassed to find herself there. No, you being famous was not enough to elevate your nuclear family into the Wiki Hall of Fame. Casanova was not like you even when you were just like him.

Mystifying as this may seem at present one would have to say, in all fairness, it is not a bad haul from a single Wiki paragraph. And no legwork! Sufficient surely to justify an inspection of the next paragraph

> **Maria Giovanna Farussi married Gaetano Casanova, an actor at the Teatro San Samuele, Venice. She began an apprenticeship at Gaetano's theatre. While she was there, Giacomo was born and (according to Giacomo's memoirs) Gaetano suspected that <u>Michele Grimani</u> (1697–1775), the theatre's proprietor, was actually the father.**

Wiki has thoughtfully underlined another potential member of Casanova's nuclear family. This, I am sorry to have to inform you, will require legwork. A click on <u>Michele Grimani</u> reveals the Grimanis were one of the patrician families of Venice that provided Doges through the centuries so, if Giacomo was a Grimani, that makes him a kind of Venetian royalty, and royal families always get plenty of Wiki underlinings.

Mystifying in a different way, but enough to justify an advance into paragraph three

> **The following year, Maria Giovanna Farussi and Gaetano Casanova accepted a theatrical engagement in London. It was there they had their second son, Francesco. It was**

rumoured that his father was actually the Prince of Wales (who shortly after became <u>King George II</u>)

Two putative royals in one eighteenth century Italian bourgeois nuclear family. A lot or a little? No need to look that up (just the Buonapartes with seven, if you do) because two brothers, two royal bastards, two royal families, does not feature in any memoir I ever read. Not that I have read Casanova's. Too much legwork.

It does though add another layer of intrigue to that meeting at Castle Dux. The Prince de Ligne would have been the King of England if his family had not been Catholic and passed over in favour of the Hanoverians so, with Casanova a paternal acknowledgement away from being a candidate for the Dogeship of Venice and his brother a secret marriage shy of being Francesco the First of Great Britain & Ireland, that meeting at Dux could be characterised as a conclave of great pretenders.

Only five minutes in and we are already inching ahead of the Casanova experts. Not in anything that Casanova experts would think remotely important. They *know* all this. They certainly know Casanova is a great pretender and doubtless made up all the stuff about royal connections. They know altogether too much, that is the great weakness of experts. What is called

the tyranny of knowledge

The more you know, the more you have invested. How many Casanova experts are likely to give a sympathetic hearing to theories that all those years spent acquiring all that knowledge are wasted years because he never existed? Look at it this way

we have the field to ourselves

The memoirs definitely exist so if the memoirist did not, what are they? It is early days to start jumping to conclusions but possibly 'picaresque novel' would come closest. We can adopt this as a working hypothesis and see whether Wiki's next paragraph supports it

> **Casanova was cared for by his grandmother Marzia Baldissera while his mother toured about Europe in the theatre. His father died when he was eight.**

Supports. Protagonists of picaresque novels must undergo a series of highs and lows to make them interesting so it is better they lack

parental help in smoothing everything out. We prefer our picaresque novels to be about people not like us.

Novels are avowedly made up, their heroes can do just as their authors please, and they will be things their readers like reading about. Memoirs are supposed to be true, their heroes cannot do as they please, they have to do what they did, and we may not be quite so interested in reading about the minutiae. What is referred to in the *Forgery Detector's Handbook* as

the over-egged provenance

It takes a lot of fake eggs to make a palatable omelette. By applying an 'Is it true of you?' test, can you spot half-dozen curate's eggs in Wiki's next Casanovan paragraph?

> As a child, Casanova suffered nosebleeds, and his grandmother sought help from a witch: "Leaving the gondola, we enter a hovel, where we find an old woman sitting on a pallet, with a black cat in her arms and five or six others around her." Though the unguent applied was ineffective, Casanova was fascinated by the incantation. Perhaps to remedy the nosebleeds (a physician blamed the density of Venice's air), Casanova, on his ninth birthday, was sent to a boarding house on the mainland in Padua.

1. Can you recall a childhood visit to a medical practitioner with this degree of compelling detail?
2. Did nosebleeds require consultations with medical practitioners during your childhood?
3. Do you recall being sent to both an orthodox and an alternative practitioner about any of your childhood afflictions?
4. Does any doctor, to your knowledge, believe Padua's air is of a different density to that of Venice?
5. Were any medical remedies, in your childhood experience, applied on birthdays?
6. How often did they involve you being dispatched across the sea and into the care of strangers?

You may decide some of these pass muster, forgers never stray further from the truth than they can help, but the whole world has been reading this for two hundred years without wondering if *any* of it passes muster. Too busy saying, "Fascinating, I must read on."

We must read on too. With Wiki. The next paragraph tells us a nine-year-old boy has been packed off to boarding school and, while this may or may not be true of you, I am confident your early life did not proceed via leitmotifs borrowed from any number of literary genres. Tom Casanova's Schooldays begins with a nod to Dotheboys Hall

Conditions at the boarding house were appalling

until Mr Chips turns up

so he appealed to be placed under the care of Abbé Gozzi, his primary instructor, who tutored him in academic subjects, as well as the violin

Remember that violin, it is destined to play an important role later

He entered the University of Padua at twelve and graduated at seventeen, in 1742, with a degree in law. Back in Venice, Casanova was admitted as an abbé after being conferred minor orders by the Patriarch of Venice.

Remember those minor orders, they are not destined to play an important role later. Giacomo suspected as much and was eager to acquire postgraduate qualifications

He shuttled back and forth to Padua to continue his university studies

How true of so many of us but we all discover, one way or another, work cannot be put off for ever

Casanova started his clerical law career. He quickly ingratiated himself with a patron (something he was to do all his life) 76-year-old Venetian senator Alvise Gasparo Malipiero, the owner of Palazzo Malipiero, close to Casanova's home in Venice.

In non-picaresque language, 'went home, got a job, had a short journey to work'.

Casanova then proceeded to do what we all did, let loose with a degree and our first pay packet. Learn to be pretentious

113

> Malipiero moved in the best circles and taught young
> Casanova a great deal about good food and wine, and how
> to behave in society

while still being the ungrateful little swine we always were

> However, Casanova was caught dallying with Malipiero's
> intended object of seduction, actress Teresa Imer, and the
> senator drove both of them from his house.

I wish that had been true of me. I had my moments, don't you
worry about that, but we might both have to worry about Giacomo
because

> After his grandmother's death

where can a poor boy turn?

> Casanova entered a seminary for a short while

Not my first choice, probably not yours, and by the sound of it not
Giacomo's either. But he *is* an abbé and this *is* the eighteenth cent-
ury so what was his problem: the discipline, the chastity, the ritual,
the getting up for matins? My dear, the clothes. No, it was the vow
of poverty

> but soon his indebtedness landed him in prison for the
> first time.

The mind boggles at how anyone gets into debt in a seminary, and
'in prison for the first time' does not bode well either. Wiser
counsels will have to prevail if Casanova's memoirs are not going
to end up as John McVicar meets Jeffrey Archer.

Burying gran means mama has taken time out from her busy
schedule and she is famous for her – what would one call it? – her
networking skills with eminent people

> An attempt by his mother to secure him a position with
> Bishop Bernardo de Bernardis was rejected by Casanova
> after a very brief trial of conditions in the bishop's
> Calabrian see.

Moving right along

> Instead, he found employment as a scribe with the
> powerful Cardinal Acquaviva in Rome

"You've come about the scribe's job, have you, Mr Casanova? Looking through your CV, I wonder if we could clarify one or two points. Why did you leave the employ of Senator Malipiero? Oh, right, the same girl. Clerical life in Rome should suit you. And I see there's that teensy spell in prison. Debt, was it? We count that as an occupational hazard. It didn't work out with Bishop Bernardis either. I'm not surprised, I wouldn't wish his Grace on anyone. Well, it all seems most satisfactory, can you start first thing Monday morning? Dress smartly, you will be dealing with important people in the course of your duties."

On meeting the Pope, Casanova boldly asked for a dispensation to read the "forbidden books" and from eating fish (which he claimed inflamed his eyes)

But all too soon he had become a supernumerary in one of Rome's Shakespearean dramas

When Casanova became the scapegoat for a scandal involving a local pair of star-crossed lovers, Cardinal Acquaviva dismissed Casanova, thanking him for his sacrifice, but effectively ending his church career

Nineteen years old and the only career you're trained for is over. Reminds me of the day I got called to the office at Tottenham Hotspur's training ground to be told I was never going to make it as a professional groundsman. Casanova didn't get a P45, he got a commission. Not this one

In search of a new profession, Casanova bought a commission to become a military officer for the Republic of Venice. He joined a Venetian regiment at Corfu

this one

his stay being broken by a brief trip to Constantinople, ostensibly to deliver a letter from his former master, Cardinal Acquaviva.

There is nothing brief about a trip between Corfu and Constantinople, a thousand miles as the galley sails. Nor does one like to see the word 'ostensibly' in a work of reference because it is not always clear who is doing the ostensibilising

"Comandante, have I your permission to take a few months off to go to Constantinople?"
"For what purpose, Sub-Lieutenant Casanova?"

115

"To deliver a letter from a cardinal in Rome to the Sublime
 Porte."
"And how does this bear on the interests of Venice?"
"Ostensibly, Comandante."
"Oh all right, but straight back."

Casanova's trip to Constantinople may lack a clear purpose but
it does provide us with our next rule of thumb

<p style="text-align:center">forgeries rarely come singly</p>

If it works once, it will work again. In fact, one forgery can lend
credence to another. Eighteenth century memoirs invaluable to
our understanding of the eighteenth century can be counted with
two fingers. This is one of them

> Casanova's autobiography, *Histoire de ma vie*, is regarded
> as one of the most authentic sources of the customs and
> norms of European social life during the 18th century

This is another [machine-translated but you will get the gist]

> The Count de Bonnevale's memoirs host material of gen-
> uine interest for the analyst of cultural identity/ies and of
> the imagological threads that go into their making. This
> paper deals with the long symbolic exile experienced by an
> exciting character subject to public metamorphoses. It also
> looks into the everyday observed by his interested eye spy-
> ing customs, values, protocols and practices of the Western
> and Eastern cultures in which he lived.

With so few historically useful eighteenth-century memoirs
around, it is a major statistical surprise that two of the memoirists
should happen to bump into one another. Little wonder they both
felt it necessary to record it in their respective memoirs. It's as if
they knew. One can almost hear the toast in the Stamboul hookah
bar, "Here's looking at you, kid."

But there is a risk when using such a technique. If one memoirist
is later exposed as a fake, surely the whole tissue of lies will come
apart at the seams? Not when forgers are up against academics.
The scholarly community is now firmly of the view that the
Bonnevale Memoirs are spurious. Probably why not many people
have heard of them. Probably why the scholarly community have
never felt the need to explain how fake memoirs published in the
eighteenth century can feature a Constantinople rendezvous with

a teenage army officer nobody knew about until *his* memoirs were published in the nineteenth. One for the cable channels, I think.

Having done his bit for historically significant eighteenth century memoirs, Casanova returned to garrison duty on Corfu. He cannot be allowed to stay there long – nobody is going to buy books about people with not much to do on Corfu until the Durrells.

> He found his advancement too slow and his duty boring, and he managed to lose most of his pay playing faro. Casanova soon abandoned his military career and returned to Venice.

What does one do if one has lost all one's money gambling?

> At the age of 21, he set out to become a professional gambler but losing all the money remaining from the sale of his commission, he turned to his old benefactor Alvise Grimani for a job

I think they mean *Michele* (Alvise was a seventeenth century bishop) but either way, according to Casanova's memoirs, Signor Grimani had impregnated Maria Farussi with the young Giacomo while she was employed at his San Samuele theatre. Whichever Grimani it was (or was not) the returning prodigal was embraced by the family

> Casanova's growing curiosity about women led to his first complete sexual experience, with two sisters, Nanetta and Marton Savorgnan, then 14 and 16, who were distant relatives of the Grimanis

No doubt a family council was called. How might this double dishonouring with attached consanguinity complications best be dealt with? What could be more appropriate than giving the youth a job at the very place where the family patriarch had dishonoured the boy's own mother?

> Casanova thus began his third career, as a violinist in the San Samuele theatre

Time for another 'Is it true of you' test

> Venice was arguably the capital of world music at this time and the San Samuele was arguably the capital of Venetian music, so it can be taken for granted it had a world-class orchestra. You are

117

that orchestra's manager and you have before you a young man who took violin lessons with his Classics teacher at school.
Do you

 A. Put him straight into the first violins

 B. Put him in the second violins until he is completely comfortable with the repertoire

 C. Give him a mop and tell him to clean out the latrines

Casanova, for one, regarded playing in the orchestra as on a par with toilet duties

> "A menial journeyman of a sublime art in which, if he who excels is admired, the mediocrity is rightly despised ... My profession was not a noble one, but I did not care. Calling everything prejudice, I soon acquired all the habits of my degraded fellow musicians."

We are agog. Just what was the eighteenth-century Venetian equivalent of throwing televisions into swimming pools?

> "We often spent our nights roaming through different quarters of the city, thinking up the most scandalous practical jokes and putting them into execution ... we amused ourselves by untying the gondolas moored before private homes, which then drifted with the current."

Hardly Keith Moon, but being handy with a gondola was to transform Casanova's life not once, but twice. This was the first time

> Good fortune came to the rescue when Casanova, unhappy with his lot as a musician, saved the life of a Venetian patrician of the Bragadin family, who had a stroke while riding with Casanova in a gondola after a wedding ball.

Our twenty-first century sensibilities would encompass elderly aristocrats giving young musicians lifts home and quite understand how the gentle progress of a gondola along the languorous canals of Venice might be conducive to strokes for elderly aristocrats. We would certainly be glad Casanova was present in one capacity or another, his officer training meant he was able to take command and order the gondola back to base without further ado.

The senator's household clearly admired such initiative and asked the young man to continue in attendance as the emergency medical services bled the patient, applied mercury and caused a massive fever. Casanova was still there when the patient started to

118

choke on his swollen windpipe. Possibly it was felt that, being in holy orders, he could administer the last rites but luckily for all concerned the young ensign-musician had gained more useful skills in his varied careers to date

> Casanova ordered the removal of the ointment and the washing of the senator's chest with cool water. The senator recovered from his illness with rest and a sensible diet. Because of his youth and his facile recitation of medical knowledge, the senator and his two bachelor friends thought Casanova wise beyond his years, and concluded that he must be in possession of occult knowledge.

The three bachelors soon became four

> The senator invited Casanova into his household and became a lifelong patron

Casanova described the nature of his duties

> "No one in Venice could understand how an intimacy could exist between myself and three men of their character, they all heaven and I all earth; they most severe in their morals, and I addicted to every kind of dissolute living."

Again with those sensibilities. He was a filing clerk

> For the next three years under the senator's patronage, working nominally as a legal assistant

Nobody will be taking 'I was a Venetian Senator's Legal Assistant' to the beach, he's going to have to go on his travels once more

> Not much later, Casanova was forced to leave Venice, due to further scandals

More untied gondolas, was it?

> Casanova had dug up a freshly buried corpse to play a practical joke on an enemy and exact revenge but the victim went into a paralysis, never to recover.

Keith Moon wished he'd thought of that one. The HR department were less impressed. Final warning, Giacomo

> and in another scandal, a young girl who had duped him accused him of rape and went to the officials

Clear your desk.

> **Casanova was later acquitted of this crime for lack of evidence, but by this time, he had already fled from Venice**

There were openings for ham in Parma

> **Escaping to Parma, Casanova entered into a three month affair with a Frenchwoman he named 'Henriette'. Before leaving, she slipped into his pocket five hundred louis, as a mark of her evaluation of him. Crestfallen and despondent, Casanova returned to Venice, and after a good gambling streak, he recovered and set off on a grand tour, reaching Paris in 1750.**

And not before time. *Casanova, The Early Years* has been a romp but scarcely

> **one of the most authentic sources of the customs and norms of European social life during the eighteenth century**

Still, we have learned something of the customs and norms of European academic life during the twenty-first century. Those saps believe all this is really happening. On to Paris.

21 International Man of Mystery

It is not easy perverting the course of history. It used to be. For Elizabeth I and Archbishop Parker it had been a practical proposition to call in the historical record and replace it with one showing the English Church owed little to Rome. Rome was in no position to complain, they had been doing their own weeding-and-replacing for centuries. In the age of print and mass literacy things had got much more complicated.

The state archives were the least of it. There can be no calling-in when who-knows-what is out there, except there is a lot of it. And not just in one's own country either. Putting a spin on history will henceforth require a whole new profession to come into existence, *historians*. They will be responsible for scouring these multifarious sources to put their country's past in the proper light. And not only their own country either.

We can follow some of the ways they do it from our Wiki armchairs because, from here on in, Casanova will be communing with the 'recorded classes' of many nations. How will he be recorded? Will he be recorded? We had left him making his way from Venice to Paris. In a stagecoach, by stages

> "It was in Lyons that a respectable individual, whose acquaintance I made at the house of M. de Rochebaron, obtained for me the favour of being initiated in the sublime trifles of Freemasonry."

Useful. Back on the coach.

> "I arrived in Paris a simple apprentice; a few months after my arrival I became companion and master; the last is certainly the highest degree in Freemasonry."

Took me longer than that getting the trouser leg rolled up properly. New city, is it to be a new profession?

> Casanova stayed in Paris for two years, much of the time at the theatre introducing himself to notables

Was that profession strictly legal in Gay Paree?

**Soon, however, his numerous liaisons were noted by the
Paris police, as they were in nearly every city he visited**

"Move along, sir, if you wouldn't mind."

**In 1752, his brother Francesco and he moved from Paris to
Dresden where his mother and sister Maria Maddalena
were living**

"Giacomo! Darling! It's been far too long. Have you got a kiss for
your dear mama?" "Nay, mither, tha's been no mither to me, but
I've got yon play, happen."

**His new play, La Moluccheide, was performed at the Royal
Theatre, where his mother often played in lead roles**

It is unusual for a national theatre to put on a play by the son of
its leading lady but at least it has left one of those historical records
we were looking for

Google books and McGraw-Page Library
La Moluccheide, G Casanova
**This playbill contains the title of the play, the list of char-
acters and a summary of the plot in Italian and German**

Any chance of a revival at the Donmar?

No copy of the play has been found.

Shame, but one has to get used to this in the World of Casanova.
There is always sufficient material to meet the needs of devotees
but never quite enough to establish finally the Great Man's place
in the artistic ranks. Or at all. It's the damnedest thing.

It turned out to be a false dawn anyway. Giacomo had tired of
being a playwright and wished to return to the more rewarded life
of the international sex-worker

**He then visited Prague and Vienna, where the tighter
moral atmosphere of the latter city was not to his liking.
He finally returned to Venice in 1753.**

Home sweet home. Anyone who thought this would be the same
Casanova that had left three years before on his tour of Europe's
cultural centres would be correct

In Venice, Casanova resumed his escapades, picking up many enemies and gaining the greater attention of the Venetian inquisitors. His police record became a lengthening list of reported blasphemies, seductions, fights, and public controversy.

Venice had not changed and tolerated such high jinks. Only the thought-police thought differently

A state spy, Giovanni Manucci, was employed to draw out Casanova's knowledge of cabalism and Freemasonry and to examine his library for forbidden books

It was the standard procedure

"The Tribunal, having taken cognisance of the grave faults committed by G. Casanova primarily in public outrages against the holy religion, their Excellencies have caused him to be arrested and imprisoned under the Leads."

Pronounced *leds*, it refers to the lead plates on the roof of the prison, though not the roof of your average prison, more like one from The Count of Monte Cristo

"The Leads" was a prison of seven cells on the top floor of the east wing of the Doge's palace, reserved for prisoners of higher status as well as certain types of offenders – such as political prisoners, de-frocked or libertine priests or monks, and usurers – and named for the lead plates covering the palace roof. The following 12 September, without a trial and without being informed of the reasons for his arrest and of the sentence, he was sentenced to five years imprisonment.

No way, five years. We have arrived at that staple, the prison breakout. Whether in fact or fiction it needs careful handling because the central character is rarely a typical prisoner and may lack the requisite skills. Not so Casanova whose life thus far could almost be said to have prepared him for nothing less

He found a piece of black marble and an iron bar which he smuggled back to his cell and hid inside his armchair

First there was the arduous preparation (reduced to a montage in the film, unless it is a British PoW film where it is the film)

He spent two weeks sharpening the bar into a spike on the stone and gouged his way through the floor

When all was set, the last minute upset

But just at the last minute he was moved to another cell

Unlucky, there being only seven cells. Also the number of brain cells possessed by the prison guards

Luckily they'd let him take his armchair with it still containing the bar

Nobody wants a re-run montage so here comes Plan B

which he passed to a renegade priest

Technically another renegade priest as Casanova was technically a renegade priest, but it allowed for one of those popular 'file hidden in a cake' routines, Italian buffo style

under a heaped pile of pasta

Plan B (ceiling) was Plan A (floor) turned on its head

and this time it was the priest who made the hole in his ceiling, climbed across and made a hole in the ceiling of Casanova's cell.

Floors and ceilings like that supporting a lead roof makes one fear for the safety of the Doge and his family but breaking out of his maximum security prison was always going to be a two-man job

Casanova and Balbi pried their way through the lead plates and onto the sloping roof of the Doge's Palace, with a heavy fog swirling. The drop to the nearby canal being too great, Casanova prised open the grate over a dormer window, and broke the window to gain entry. They found a long ladder on the roof, and with the additional use of a bedsheet "rope" that Casanova had prepared, lowered themselves into the room whose floor was twenty-five feet below. They rested until morning, changed clothes, then broke a small lock on an exit door and passed into a palace corridor, through galleries and chambers, and down stairs, where by convincing the guard they had inadvertently been locked into the palace after an official function, they left through a final door. It was 6:00 in the morning and they escaped by gondola.

Escaped by gondola. It's straight out of a Bond movie. Cue: Casanova the spy, a glamour profession he had yet to try his hand at.

There was the question of who he was to spy for. Bond had chosen his own country (which was a mistake, we now know M was working for Smersh all along) but Casanova opted for France. Scouting prospects, he thought it best to start at the top

He reconnected with old friend de Bernis, now the Foreign Minister of France

What would be suitable cover for an ex-bankrupt gaolbird with a Parisian police record?

Casanova promptly became one of the trustees of the first state lottery

Two hundred years before Casino Royale came up with a similar plotline

The enterprise earned him a large fortune quickly. With money in hand, he travelled in high circles

But not, I think, the very highest circles. Ready cash and an easy manner will only get you so far in the exclusive world of French salon society. One has to bring other qualities to the table

Casanova claimed to be a Rosicrucian and an alchemist, aptitudes which made him popular with some of the most prominent figures of the era, among them Madame de Pompadour, Count de Saint-Germain, d'Alembert and Jean-Jacques Rousseau.

Even I've heard of them. Casanova's spymasters were less dewy-eyed and decided he would be better employed at the social-realist end of the trade

De Bernis decided to send Casanova to Dunkirk on his first spying mission

trained and ready for when the stakes really were worth playing for

As the Seven Years' War began, Casanova was again called to help increase the state treasury. He was entrusted with a mission of selling state bonds in Amsterdam, Holland

being the financial centre of Europe at the time. He succeeded in selling the bonds at only an 8% discount.

Memo to the Dutch: if you want to carry on being the financial centre of Europe it is probably better to buy gilt-edged securities either direct from the French government or from your own world-renowned Amsterdam Stock Exchange, not itinerant lottery salesmen, but it's your call.

Casanova was finding it so effortless. There must be a career out there that would stretch a man of his calibre. How many is it now? Hard to keep count when relying on the reportage of Wiki which in turn is a précis of the reportage assembled by the vast corpus of literature detailing Casanova's activities. Though all the sources do share one underlying theme: down with ancien regimes! It will take some due diligence of our own to find out why.

France, for instance, is being recorded here – and in all the history books – as being run largely by fops, so one can easily overlook these fops were responsible for maintaining France as the leading power of Europe for the entirety of the eighteenth century. Well done, the fops. But then a great deal of history seems to be an unrelenting account of government-by-popinjay, interspersed with regimes that are not and which invariably turn out to be worse.

Not much has changed. At the time of writing, both the world's leading power and my own dear country are being run by joke figures, Messrs Trump and Johnson respectively. Is it true or do we just want to believe it? Is it true or do governments just want us to believe it? Deep waters, I grant, but keep your eye on this, it becomes important later. Very important. Sort of the point of the book really. After that brief message from your sponsor we return you to The Casanova Story

and the following year was rich enough to found a silk manufactory with his earnings. The French government even offered him a title and a pension if he would become a French citizen and work on behalf of the finance ministry, but he declined.

Maybe a little hasty, the private sector is not all wine and roses

Casanova had reached his peak of fortune, but could not sustain it. He ran the business poorly, borrowed heavily

trying to save it, and spent much of his wealth on constant liaisons with his female workers who were his "harem".

Too much wine, too many roses. The eighteenth-century French were more enlightened than we are when it comes to dealing with profligate Me-Too offenders. They lock them up.

For his debts, Casanova was imprisoned again, this time at For-l'Évêque

"Is there anyone in court who wishes to enter a plea of mitigation on behalf of the prisoner? *At* court?"

but was liberated four days afterwards, upon the insistence of the Marquise d'Urfé

"No jail can hold him!" Don't hurry past the flyer, there is an *e* on the end of 'marquise'. The richest woman in France had come to Giacomo's rescue

Jeanne Camus de Pontcarré, marquise d'Urfé, was a French aristocrat and eccentric widow, with a passion for the occult and alchemy. Rich and gullible, she is better known under the name Madame d'Urfé from the biographies of several adventurers of the 18th century such as Cagliostro and Casanova.

Such as Cagliostro and Casanova. A suitable moment for a foray into the manifold ways experts deploy evidence when there is no evidence, and how helpful this is to would-be experts such as ourselves. This one is

the bogus list

Any time a list of two is encountered it is the revisionist's bounden duty to find out why. It being so paltry a list, there is the suspicion that the case is so weak even a list of two is useful. In practice three is suspect: the third, on inspection, often turns out to be a considerable stretch. Suppose, by way of example, a list of eighteenth century adventurers with a biography is required

- o there is Cagliostro of course, that goes without saying
- o there is Casanova – no, wait, isn't he the person for whom the list is being compiled?
- o there is the Count de Bonnevale – no, he's been crossed off, hasn't he?
- o and that seems to be it.

We have found out something worth knowing without having to laboriously find it out for ourselves. There may be a distinct

lack of eighteenth-century adventurers with a biography

But we have also found out that specialists of the period are uneasy about it for some reason. If you look back at the quote, the argument would have been stronger without Casanova, i.e. "she is better known as the Madame d'Urfé of Cagliostro's biography". But stronger still without Cagliostro! It did not require him to provide the detail, *all* marquises are titled 'Madame'. Remember our maxim about the inclusion of unnecessary detail? It seems here more a case of needing to establish the gullibility (or indeed the existence) of Mme d'Urfe by citing her in books about Casanova and Cagliostro.

Or is it simple ineptness on the part of the Wiki biographer? It never is. Experts know what they are doing even when they know not what they do. With a list of two, one of whom is the character we are interested in, we are being practically ordered from on high to check out the other one. Happy to oblige. One click tells us

> **Count Alessandro di Cagliostro, the alias of the occultist Giuseppe Balsamo, was an Italian adventurer and self-styled magician. He became a glamorous figure associated with the royal courts of Europe where he pursued various occult arts, including psychic healing, alchemy and scrying.**

A mirror image of Casanova himself. That was worth knowing too and we would never have stumbled on Cagliostro without the expert help of a bogus list. One of them will have to be speedily dispatched before people start murmuring behind their fans

"You never see Cagliostro and Casanova in the same salon."
"Not at the same time, no."
"We'll have to ask Madame d'Urfé, she knows them both."
"I haven't been in the same salon as Madame d'Urfé lately."

> **Unfortunately, though he was released, his patron de Bernis was dismissed by Louis XV at that time and Casanova's enemies closed in on him. He sold the rest of his belongings and secured another mission to Holland to distance himself from his troubles. This time, however, his mission failed and he fled to Cologne, then Stuttgart in the spring of 1760.**

Casanova is bankrupt and has sold the rest of his belongings, can you guess what came next?

he lost the rest of his fortune

Can you guess what came next?

He was yet again arrested for his debts

Can you guess what came next?

but managed to escape to Switzerland

Can you guess what came next?

Weary of his wanton life, Casanova visited the monastery of Einsiedeln and considered the simple, scholarly life of a monk.

Been there, done that

Moving on, he visited Albrecht von Haller and Voltaire, and arrived in Marseille, then Genoa, Florence, Rome, Naples, Modena, and Turin, moving from one sexual romp to another.

I was not aware Haller and Voltaire swung both ways though I might have guessed the Pope was up for it

Pope Clement XIII presented Casanova with the Papal Order of the Éperon d'Or

Speaking as a much-decorated writer myself (mainly foreign, you wouldn't have heard of them) these awards are gratifying but to be honest one would prefer cash

He convinced his old dupe the Marquise d'Urfé that he could turn her into a young man through occult means. The plan did not yield Casanova the big payoff he had hoped for, and the Marquise d'Urfé finally lost patience.

Speaking as an international publisher myself (British Amazon, American Amazon, you name it) it is essential to have all the major markets covered

Casanova travelled to England in 1763, hoping to sell his idea of a state lottery to English officials

Speaking as an Englishman myself, I can assure the insolent puppy he won't be getting very far with us

he worked his way up to an audience with King George III

Speaking as a revisionist historian myself, I can reveal the true cause of the madness of King George was syphilis

These and other liaisons, however, left him weak with venereal disease and he left England broke and ill.

Speaking as a fan of the National Health Service myself, I am glad to report they were already using antibiotics

He went on to Belgium, recovered, and then for the next three years, travelled all over Europe, covering about 4,500 miles by coach over rough roads, and going as far as Moscow and Saint Petersburg (the average daily coach trip being about 30 miles).

Another country, another monarch

a meeting with Frederick the Great bore no fruit

I could have told you that, matey, a cheerless curmudgeon at the best of times, but word on the street is that Catherine the Great has a more open-door policy with eighteenth-century adventurers

Not lacking either connections or confidence, Casanova went to Russia and met with Catherine the Great, but she flatly turned him down too

Potemkin had it covered. Anything on the way back? It would be a grave mistake to suppose that Casanova socialised exclusively with royalty

In 1766, he was expelled from Warsaw following a pistol duel with Colonel Franciszek Kwasery Branicki over an Italian actress

It would be a grave mistake to suppose royalty socialised exclusively with Casanova

He returned to Paris for several months in 1767 only to be expelled from France by order of Louis XV himself

It would be a grave mistake to suppose Casanova would run out of crowned heads of Europe

so he headed for Spain ... wining and dining with nobles of influence, and finally arranging an audience with the local monarch, in this case Charles III

It would be a grave mistake to call Charles III a 'local monarch', he ruled over a greater proportion of the earth's surface than any individual of his day. It would be a grave mistake for Casanova to leave the Escorial

In Barcelona, he escaped assassination

It would be a grave mistake to do that in Catalonia where they take their assassinations very seriously

and landed in jail for 6 weeks

That did it for Casanova. He'd had a good run but it was time to be making tracks

His Spanish adventure a failure, he returned to France briefly, then to Italy

One last bit of bureaucratic bumf

While waiting for supporters to gain him legal entry into Venice

One last modern Tuscan translation of the *Iliad*

Casanova began his modern Tuscan-Italian translation of the Iliad

We all know Casanova as a dramatist and a memoirist (not that these two activities should be conflated) but how many of us knew he was an accomplished Classicist? None of us can doubt his fluency in Ancient Greek (he had been tutored by his violin-teacher) but there is bound to be a query concerning his command of modern Tuscan. Casanova had not, if memoirs serve, spent much time in Tuscany. They do say though that Tuscan, the language of Petrarch and Dante, is modern Italian bar the shouting so he may have been speaking it in its literary form all the time. Nobody has enquired into the matter so I see no reason why we should.

We all know Casanova as a dramatist, a memoirist and a classicist but how many of us knew he was an accomplished historian, the author of 'History of the Troubles in Poland'? The ignorance is pardonable as getting hold of a copy can be difficult. Impossible even, so we will just have to make do with John Fowler's earlier *History of the Troubles of Suethland and Poland*.

This time Casanova was returning to Venice a new man. The city fathers appreciated that playing host to their new-minted lion of letters would mean granting their favourite son the freedom to do what he did best

> "We, Inquisitors of State, for reasons known to us, give Giacomo Casanova a free safe-conduct ... empowering him to come, go, stop, and return, hold communication where-soever he pleases without let or hindrance. So is our will."

That will be in the state archives for sure. Someone have a look next time they are in Venice.

> At first, his return to Venice was a cordial one and he was a celebrity. Even the Inquisitors wanted to hear how he had escaped from their prison.

The Venetians may not be much good at keeping prisoners safe, they may not be much good at keeping Venice safe (the thousand year Republic was extinguished in 1797) but they are very good at keeping the state archives safe. They have the actual repair bill for the broken slates. You can have a look at it next time you are in Venice.

Casanova could not dine out on tales of derring-do indefinitely, he had a living to make

> Of his three bachelor patrons, only Dandolo was still alive and Casanova was invited back to live with him. He received a small stipend from Dandolo

I was referring to the day job

> and hoped to live from his writings

I was referring to the day/night job

> but that was not enough. He reluctantly became a spy again for Venice, paid by piece work, reporting on religion, morals, and commerce, most of it based on gossip and rumour he picked up from social contact

Have a care, old friend, you have already picked up the French and/or English disease from social contact

.

He was disappointed. No financial opportunities of interest came about and few doors opened for him in society as in the past.

I know the feeling. Except for the bit about 'as in the past'. What about taking on another lion of letters mano a mano to get your name back in lights?

He got into a published dispute with Voltaire over religion

A published dispute? Printed contemporaneously in black and white? We look forward to reviewing the exchange in our chapter on Voltaire. Let us hope *he* existed. Let us hope Candide *wasn't* written by Goethe.

Casanova's Iliad was published in three volumes, but to limited subscribers and yielding little money

Tell me about it. Publishing three-volume Iliads is always a nightmare. The print run for Casanova's was so small you can't find a copy nowadays even for, as Algy said to Lady Bracknell, ready money. If our own Bunbury is not going to go short there was no alternative but to play what we publishers call 'the Prince Edward card'

he made his only public statement that Grimani was his true father

A word of advice for anyone thinking of going the same route. For heaven's sake don't start insulting the nobs now you are one

after writing a vicious satire poking fun at Venetian nobility Casanova was expelled again from Venice in 1783

or you might find yourself having to go on one of those ghastly Greatest Hits tours.

Forced to resume his travels again, Casanova arrived in Paris in November 1783

You can try out new material

he met Benjamin Franklin while attending a presentation on aeronautics and the future of balloon transport

but mostly they want the old tunes

> He also became acquainted with Lorenzo Da Ponte,
> Mozart's librettist. Notes by Casanova indicate that he
> may have made suggestions to Da Ponte concerning the
> libretto for Mozart's Don Giovanni.

Takes one to know one. Da Ponte couldn't write an opera libretto
to save his life but, like record producers in the Golden Age of Tin
Pan Alley, he always insisted on a writing credit

> Lorenzo Da Ponte was born Emanuele Conegliano in 1749
> in Ceneda, in the Republic of Venice ... at his 1779 trial
> accused of "public concubinage" and "abduction of a
> respectable woman", it was alleged that he had been living
> in a brothel and organizing the entertainments there. He
> was found guilty and banished for fifteen years from Ven-
> ice. He wrote the libretti for 28 operas by 11 composers.

But we are not rewriting Grove, we are rewriting Casanova,
whose life had reached that stage in every writer's career: when all
else fails, there's always public relations

> For a while, Casanova served as secretary and pamphleteer
> to Sebastian Foscarini, Venetian ambassador in Vienna

When public relations fails, there's always librarianship

> In 1785, after Foscarini died, Casanova began searching
> for another position. A few months later, he became the
> librarian to Count Joseph Karl von Waldstein, a chamber-
> lain of the emperor, in the Castle of Dux, Bohemia

and where we came in. After completing his great work, Giacomo
Girolamo Casanova was buried in a now lost grave. A fitting last
repose for the world's greatest Bohemian. Or none of the above.

22 Follow that Manuscript!

Until the twentieth century, history *is* manuscripts. Books may be printed but they are secondary sources. The archives, all primary sources, are handwritten, and those interested in the way history really works can learn a lot from the history of the manuscript of Casanova's *Ma Vie*. If there was no Casanova, he cannot have written a manuscript, so what are we to make of this?

> **In 2010, thanks to the support of an anonymous donor, the manuscript was purchased by the Bibliothèque nationale de France for over nine million dollars, the institution's most expensive acquisition to date.**

Judged purely as historical sources, manuscripts suffer from two grievous shortcomings. The first is that they are so frangible. Unless somebody takes the trouble to preserve them, manuscripts are unlikely to see out their first hundred years, and it is a fact of historical life that nobody can rightly say at the time which are going to be worth preserving. Secondly, each manuscript is unique. They can be copied century by century but to serve as primary evidence historians require some degree of quality assurance about the copying process. Should require it.

Beware copied manuscripts that are produced without evidence of the previous copy, let alone the original. The truth is, for most of history, there is no history, such is the nature of manuscripts. There are some official records, there are some privately kept papers, there are fragments, inscriptions, coins, archaeology, but of the stuff of history, mostly not. There are though a great many historians and they love being historians more than they love history.

Did you know, for instance, the entire history of Greece and Rome suddenly appeared in a plethora of manuscripts during the Renaissance? The clue is in the name. These manuscripts, bearing news from antiquity, are reported as having arrived from a variety of places and for a variety of reasons, but chiefly via fleeing Greeks arriving in the west after Constantinople fell to the Ottomans in 1453.

"Run for your lives and take Europe's heritage with you."
"I thought maybe some gold coins sewn in the lining..."
"No, manuscripts."

It gets worse. Renaissance writers had a tricky decision to make. They could write under their own name and be ignored, maybe get put to death for heresy, or they could publish under a Classical name, reach a Europe-wide audience and live out their lives as esteemed scholars keeping the flame of civilisation burning. Did you think Homer, Thucydides, Vitruvius, Euclid, Galen, Plutarch, Ptolemy (the names they choose!) and the rest wrote it all, suffered the indignity of silence for a thousand, two thousand, three thousand years and then burst onto the world stage all over again just when the world was ready to take up their mantle? Well, please don't.

Does it matter? It depends what you want from your history. There is no doubting, for instance, that Britain was part of the Roman Empire. That much is clear from the archaeology. But do you want to be part of a sturdy island race who twice resisted that awesome Roman, Julius Caesar, or would you rather be heir to a bunch of woaded deadbeats who got rolled over in short order when Clau-Clau-Claudius sent over a few legions? Your own heirs will be paying many thousands of pounds a year in tuition fees to hear version one from people who maintain that the manuscript of *De Bello Gallico* was written in the first century BC and faithfully copied, century after century, for the next fifteen hundred years. Should you ask the people pocketing the money whether they are applying their own rules of historical evidence, you will not hear, "More than our job's worth, sunshine. Without all those Renaissance copies there'd only be the archaeology and that's not our department."

The *Histoire de ma vie* manuscript in the Bibliothèque nationale consists of three thousand seven hundred foolscap pages, containing a million and a half words, all written in the same hand. There are four possibilities as to what it is

a memoir
a lot of it is exaggerated, even made up, but overall it is the life story of an unusual man being recollected in old age

a picaresque novel
written in the form of faux memoirs

a publishing scam
put out as a memoir but made up

auto-pornography
written for personal gratification

That last category may have a target audience of one but it can still have historical consequences. The *Casement Diaries* were written by Sir Roger Casement who got off on doing unspeakable things with and to small boys in distant parts of the world, latterly the Belgian Congo where he was on a humanitarian mission for the British government. *Or* he contented himself with writing about doing these things in order to read about doing these things without necessarily having done any of these things. Which was it? All one can say for sure is that the Belgians had every reason to be rid of this pestilential observer of their vast catalogue of Congolese crimes, but never once managed to catch him in, as it were, flagrante delicto. Hundreds of times they didn't. Most remiss of the Sûreté de l'Etat, the second-oldest security service in the world (after the Vatican's).

Whether Sir Roger did or did not abuse children on a gargantuan scale, he was definitely unwise not to destroy his jottings when he turned gun-runner for the Irish Easter Rising of 1916. The British, who did get rid of him by hanging him for treason, discreetly circulated the diaries. The Irish claimed they were forged but this is highly unlikely. One can admire the perfidious industry of the British but even they would have blanched at the technical requirements of forging voluminous notebooks in Casement's apparently genuine handwriting for such a limited purpose.

The Irish claim though is understandable. It scarcely matters whether Casement abused small boys, it scarcely matters whether he only wrote about abusing small boys, *thinking* about abusing small boys is crime enough for a Founding Father of the new Irish Catholic rechtsstaat, so he can't have done. The Irish are well-practised in national self-deception. They all worship at the shrine of the Book of Kells which ironically is an English forgery. We need only observe that all nations need founding myths and leave them to their slumbers.

We are engaged in a task with, apparently, no national interests at stake. Who on earth would compose a million and a half words in crabbed handwriting, recounting the sexual and social triumphs of a Venetian libertine if it was not the Venetian libertine himself?

If it was, *this* book stops here. Luckily for my pension fund the true story of the Bibliothèque nationale's manuscript does not involve Venetians of any kind but it does feature secret services, revolutionaries, forgers turned publishers, Napoleon Bonaparte, Johann von Goethe, Joseph Goebbels (twice), Dwight D Eisenhower and Nicolas Sarkozy, so I shall be living out my days on easy street. Yeah, and the rest.

Authenticity does not come from authority, it resides in the object itself. We must start therefore with the Casanova manuscript considered as a physical object

> Casanova allegedly wrote the first chapters of the book in 1789, during a profound illness

Even the experts agree these are the works of a sick librarian

> In 1794, Casanova met Charles Joseph, Prince de Ligne. The two of them established a mutual friendship. The Prince expressed a desire to read Casanova's memoirs, and Casanova decided to polish the manuscript before sending it to the Prince.

Of all the people in all the world who might strike up a literary friendship with a suspected memoir-faker, what are the chances it will be a *known* memoir faker?

> In 1809 the Memoirs of Eugene of Savoy was published in Vienna. The book was written by Charles-Joseph de Ligne, a Flemish prince who lived seventy years after Eugene of Savoy, the general who commanded the army of the Holy Roman Empire in the War of the Spanish Succession. The memoirs were only attributed to Eugene for a short period and then tossed aside as the creative musings of a cultured prince who left quite the written legacy. Charles-Joseph de Ligne desired to be as good a writer as he was a soldier.

There is no dispute about this. The Eugenian memoirs exist, they were *not* written by Eugene of Savoy, they *were* produced under the auspices of the Prince de Ligne. It is in any standard work of reference. So there is no dispute that Casanova's memoirs are associated with someone that produced fake memoirs. The bit that does not find its way into standard works of reference is any reference to a memoir-faker being involved with Casanova's memoirs.

It is time to be introduced to the *very* best of all revisionist tools. Learning to recognise

careful ignoral

Things can be ignored for all sorts of reasons, good and bad, but only a select few get 'carefully ignored'. When something has to be ignored because it is too important not to be. One would think human beings might find it difficult ignoring important things but we know they do quite regularly because of

cognitive dissonance

of which careful ignoral is a sub-category. All Casanova experts

o know the Prince de Ligne faked memoirs
o know he was involved with Casanova's memoirs but
o carefully ignore a memoir-faker was involved with Casanova's memoirs

It is obvious why Casanova experts might have to do this

o making a conscious link between a memoir-faker and Casanova renders Casanova's memoirs suspect
o the memoirs are pretty much all he has got going for him
o if the memoirs are fake there would be no Casanova experts

but not so obvious why this is helpful to revisionists. If pressed, a Casanovan expert would correctly point out

o a memoir-faker can be involved with genuine memoirs
o Casanova experts can weigh up the evidence and
o come to the conclusion that this is what has happened

Except any revisionist worth his merit badge would point out

o weighing up evidence inevitably means residual doubt
o what sort of person devotes himself to the study of anything knowing there is a small but definite possibility it is a fool's errand?
o no sort of person

If you doubt any of this, type 'Casanova memoirs forgery' into any search engine. Nothing will come back. It would seem nobody has so much as contemplated the possibility the world has been on a fool's errand for two hundred years.

Admittedly a small fool's errand, and that is important to revisionists who would rather not waste their time on such minor quarry. If it were only Casanova we would quickly conclude that

because he is unimportant, this is simply a case of the world preferring it that way. We all have a bit of the Casanova in us so we like him to be real. Casanova's contemporary, the Marquis de Sade, is an equally fictitious character, apparently we all have a bit of the sadist in us as well. We get attached to these imaginary creatures from the past without much harm coming to history.

By contrast, the world would happily let the Prince de Ligne go but since he is at least a real person, and a real faker of history, revisionists will not let him go without a passing expression of interest. Chiefly, wondering just why he has drifted into the story in the first place because the truly stupefying aspect to his presence is that the Prince is totally irrelevant to Casanova's memoirs! That's right, it's the old 'unnecessary detail', and that always has our noses twitching. The official account is that

o Casanova was already writing the memoirs when the Prince showed up
o There is no suggestion the Prince was involved in the finished product
o Casanova rejected the Prince's proposal about how to get the memoirs published

The Prince de Ligne departs the story immediately after not starting it. Yet there he is. One wonders why. We shall have to find out for ourselves since no-one else can be bothered.

Revisionists are not greatly concerned about the status of Casanova's memoirs. We care that the possibility they were faked is being carefully ignored. To be grandiloquent for a moment, if everybody has been suffering from cognitive dissonance for two hundred years about a not particularly important detail about a not particularly important book, and the cause of the dissonance need not have been there in the first place, it is reasonable to suspect something is afoot. In the words of that well-known adjuration

it is not the crime, it is the cover-up

Careful ignoral would not be employed unless there are bigger fish that need frying. We may not know who they are as yet but we can rely on our tried-and-tested methods to reveal who they were. We have found our loose thread, it is the Prince de Ligne, and a gentle but persistent tug should unravel the whole garment. It will be a substantial garment, worth the unravelling, because if careful ignoral is being employed, some emperor or other will (not) be

wearing it. Well... talking of emperors, why are historians unanimously of the view

- o that a leading statesman of the Habsburg Empire took time out from his duties at the height of the Napoleonic Wars to forge the fake memoirs of Eugene of Savoy?
- o that he did it so badly the fake memoirs were rapidly exposed?
- o that he did it for no other purpose than his own vainglory?

One would have to admit that will take some explaining and historians are unanimous with their explanation. It is the standard *non*-explanation

because he did

"That's what happened. Sorry if you find it upsetting, but that's history for you. Full of strange people doing strange things. We're only the messengers."

So are we, but we prefer 'boring' to 'strange'. We prefer unravelling tangled tales, not using the standard 'popinjays-in-charge' assumption to ignore them.

Historians are also unanimous that the Prince de Ligne's forgery was not exposed in time to prevent the strutting booby taking his place at the top table of the Congress of Vienna, which dictated the next hundred years of European history. *That* is maybe worth picking apart:

- o As hosts, the Austrians were responsible for the day-to-day chancery services necessary for all international peace conferences – drawing up treaties being the most important.
- o With the top strutting booby, Klemens von Metternich, busy negotiating with other delegations and having affairs with other delegates' wives, these prosaic housekeeping duties tended to get devolved onto such as the good old Prince de Ligne
- o In an ideal world, would you want a known forger having anything to do with drawing up treaties that dictated the next hundred years of European history? Come on, be honest, yes or no?

If you don't, you may want to hear from the revisionists, the people who do not subscribe to notions about mountebanks like princes Metternich and de Ligne being in charge of great powers. You know, the kind of mountebanks who kept the Habsburg

Empire in the front rank of the European powers for several hundred years. If so, you might care to hear the true history:

1689 - 1714
France was so dominant the other European powers oscillated between opposition and accommodation. All the leading nations did both at one time or another and it was obvious they would have to either hang together or continue to hang separately.

The Habsburgs had a soldier called Eugene of Savoy who was not so much a military genius as a diplomatic one. He held the anti-French Grand Alliance together long enough to put Louis XIV back in his box.

1791 - 1815
France was so dominant the other European powers oscillated between opposition and accommodation. All the leading nations did both at one time or another and it was obvious they would have to either hang together or continue to hang separately.

The Habsburgs had a soldier called the Prince de Ligne who was neither a military nor a diplomatic genius but was shrewd enough to understand, in this new war of nations, that the people had to demand their masters stick together long enough to put Napoleon back in his box.

So he arranged for an obscure biography of Eugene of Savoy to be slightly recast, augmented it with authentic Eugenian material from the Vienna state archives, and had it published as the newly discovered memoirs of 'the man who did it last time'.

Just routine black propaganda.

1809 – 2021
Academic historians are so stupid etc etc

That's hardly news so, sorry, it turned out to be a small garment.

Which means we have not found the big one yet so, sorry again, it's noses back to the manuscript grindstone to find it

> **After reading at least the first three tomes of the manuscript the Prince de Ligne suggested to Casanova that the memoir be shown to an editor in Dresden to publish in exchange for an annuity**

The Prince, according to this, has not entirely grasped how publishing works but Casanova, a librarian who might be expected to know a thing or two about books, disagreed

> **Casanova was convinced to publish the manuscript, but chose another route. In 1797, he asked Marcolini Di Fano,**

142

minister at the Cabinet of the Saxon Court in Dresden, to
help him with the publication.

Not geographically another route then. Either a coincidence or
Dresden is the local centre of excellence for publishing memoirs.

> In May 1798, Casanova was alone in Dux. He foresaw his
> death and asked for members of his family currently
> residing in Dresden to come and support him in his last
> moments.

Dresden for a third time! I hope my family is living in the local
centre of excellence when it comes time to publish my post-
humous memoirs. [They're in big red Lett's diaries under the stairs
next to my collection of pith helmets. You're all in there so publish
and be damned.]

 Publishing fraudulent memoirs is not a straightforward business.
It is a criminal conspiracy for a start which tends to make for
difficulties on the creative side. Writers are such blabs. Though it
is in providing the provenance where the creativity needs to begin.
For those who fancy having a go the main things to watch out for:

o enough time has to elapse to ensure all the people that are
 mentioned in the memoirs are safely dead and in no
 position to point out they did not do what the memoirist
 said they did, i.e. have any dealings with the memoirist

o during that time the manuscript will have to pass through
 fictitious but believable owners before

o arriving safely into the legal ownership of the publisher

 It needs a deft hand on the tiller and Casanova's memoirs have
been provided with a provenance that has withstood the scrutiny
of Casanova specialists for two hundred years. Not surprising with
them all inside the boat pulling madly on the tiller but our hands,
you can be sure, will be firmly round the coastguard's binoculars

> Carlo Angiolini, the husband of Casanova's niece, travelled
> without delay from Dresden to Dux. After Casanova's
> death, he returned to Dresden with the manuscript

But, it seems, did nothing with it

> Carlo himself died in 1808 and the manuscript passed to
> his daughter Camilla

The niece has died too. Very Mayerling. Their son has been passed over for some reason but he returns later. Camilla settles down for her role in *Casanova, The Manuscript*.

> **Because of the Napoleonic Wars, the climate was not favourable for publishing the memoirs of a character belonging to a past age**

Speaking as a publisher, I think you'll find all memoirs are by characters belonging to a past age, not that I would myself describe ten years ago as a past age. I hope you get in a good blurb writer, people notice these things.

> **After the Battle of Leipzig (1813), Marcolini remembered the manuscript**

A considerable feat of memory. He was the cabinet minister who had been shown the manuscript sixteen years before to no effect. Still, it is always reassuring to have real historical figures lending their weight to provenances

> **and offered 2500 thalers to Camilla's tutor**

How old is Camilla by now?

> **but her tutor judged the offer too modest and refused**

Everyone's a critic

> **After some years, the recession compromised the wealth of Camilla's family. She asked her brother Carlo to quickly sell the manuscript**

Roger and out

> **In 1821, it was sold to the publisher Friedrich Arnold Brockhaus**

Enter the real villain of the piece, twirling his mustachios.

It is now 1821 and a manuscript with a full provenance has come into the possession of a certain Friedrich Brockhaus who holds an unimpeachable legal title to it. What did he do with it?

> **Brockhaus asked the playwright Wilhelm von Schütz to translate the book into German**

You are probably not a publisher but being one myself I can assert, on behalf of publishers the world over, that when we need a book

translating we rarely call in the local playwright. Not because they might not be excellent linguists – French was the language of literary discourse at the time, so Herr von Schütz may have been fully equipped to do the job – but because playwrights have a tendency to 'improve' the text, which is not really what we are looking for in a translator, and why we employ professional translators. If we need fake memoirs then, yes, the local playwright is generally first out of the rolodex.

Some extracts of the translation and the first volume were published as early as 1822

Casanova specialists are probably not publishers either so they may not appreciate that 1821-2 is a tight window to complete the stages of the manuscript-to-book production process. This being my department I can give them... a crammer's course

1. Brockhaus peruses 3,700 pages of spidery French handwriting
2. He decides on a selection for a first and, for all he knows, only volume of Casanova's memoirs
3. Von Schütz translates this selection into German
4. He sends the result back to Herr Brockhaus for his perusal
5. There is a bit of back-and-forth on the editorial side as an agreed text is arrived at
6. The end result is sent off to be set into type
7. More to-ing and fro-ing as the galleys get nearer and nearer to the final version (that's a nightmare and a half, I can tell you)
8. Publication date is agreed, wholesalers are alerted, review copies go out (a lot of good that ever does)
9. Final print run
10. Wagons roll.

If that were not dazzling enough, the pace quickens. Four more volumes in two years

The collaboration between Brockhaus and Schütz stopped in 1824, after the publication of the fifth volume

With Slowcoach Schütz out of the way, it's full speed ahead

The other seven volumes were then translated by another unknown translator between 1825 and 1828

"Hello-o, what name shall I say? Too late, he's gone. We'll never know his name now. Take these up to Herr Brockhaus, would you? They're urgent." There was good reason for haste.

Casanova's memoirs were proving to be an international publishing sensation and in the nineteenth century that could spell international trouble

> **Due to the success of the German edition, the French editor Victor Tournachon decided to publish the book in France**

Speaking once more through my publisher's hat I do not care for that word 'decided'. The only person who can decide anything about publishing Casanova's memoirs is the person who has spent several thousand thalers buying the rights, and who has all three thousand seven hundred pages of the originals tucked away in his German bottom drawer. Donner und blitzen, vas ist this?

> **Tournachon had no access to the original manuscript, and so the French text of his edition was translated from the German translation**

Cheeky blighters. A pirate edition of a French translation of a German translation of a French original written by an Italian. What next for the Casanova-go-round?

I forgot to mention in the ten-point plan there may have been detours to lawyers specialising in the libel and/or indecency laws of the larger German states because the Brockhaus Casanova had been pruned to accord with domestic proprieties. But in Monsieur Tournachon's hands

> **The text was heavily censored**

There's two turn-ups for the book: the French being less liberal than the Germans and pirates more worried about the law than the good guys. Now comes a third: a publisher determined to confound pirates by bringing out a worse version than theirs

> **In response to the piracy Brockhaus brought out a second edition in French, edited by Jean Laforgue (1782–1852) which was very unreliable as Laforgue altered Casanova's religious and political views as well as censoring sexual references**

I did warn you about using professional translators. Brockhaus (Friedrich was dead by now, his sons were in charge) were creating all manner of difficulties for law-abiding French readers

> "Es-tu reading the Tournachon translation from Schütz's German translation of Casanova's original French, Pierre?"

> "Non, Jean-Claude, I prefer the official version of Laforgue with the spurious religious and political interpolations since I can use the Tournachon to, as it were, dis-interpolate them."

> "Ah oui, je aussi prefer Laforgue because, while the deletion of so much of the salacious material somewhat defeats the purpose of the book, it means I can let ma femme read it."

> "Ça is all very well, Jean-Claude, but you and your wife, mes regards to madame by the way, will have to wait some considerable time because, despite Casanova's memoirs being le talk of Europe, despite our beloved French being le lingua franca of Europe, despite le original already being in French and sans besoin de translation, the publisher is really taking his time bringing out an official French edition."

> "Merde alors! Les allemands, such lazy people. It may be time to invade again."

The French volumes were published from 1826 to 1838

French pirates by contrast do not hang back

> **These editions were also successful, and another French pirate edition was prepared with another translation from the German edition**

So much so they did not always wait for their victim to leave port before boarding her

> **As the German edition was not entirely published at this time, this edition allegedly contains passages invented by the translator**

I suppose it would have to, what with the source material being in German hands, but I am troubled there is something we are not being told. Invented passages cannot be inserted into a text you have not got so these French volumes must presumably have been created from scratch. That is passing strange in itself but not as strange as the historiographical position. Why is the Wiki expert saying 'allegedly'? The original is sitting in the *Bibliothèque nationale,*

there can be no room for doubt. Unless there is some doubt about the manuscript. But as I say, we haven't been told.

What were the British making of these rum carryings-on sur le Continent? No major publisher, which Brockhaus had by now become, is going to ignore the English-speaking market, the biggest in the world

> **From 1838 to 1960, all the English editions of the memoirs were derived from one of these editions**

Yer what? The British (though not the Americans) were notably hawkish in the nineteenth and twentieth centuries when it came to the pirating of books so what is this 'one of these editions' all about? Why would a German publisher permit British publication of anything other than an English translation of the original manuscript sitting in their vaults? It is almost as if they did not have the original manuscript sitting in their vaults.

> **Arthur Machen used one of these inaccurate versions for his English translation published in 1894 which remained the standard English edition for many years**

Arthur Machen, real name Arthur Llewellyn Jones, was the creator of the *Angel of Mons* legend, but nothing sinister need be read into that. As English-speaking Casanova buffs have been applying careful ignoral to the situation, we shall have to reconstruct the exchange of letters as best we can

> Dear Messrs Brockhaus
> If you would be kind enough to grant me access to the Casanova manuscript, I can make a faithful translation. I would of course accept any restrictions you may care to impose. Since this would be considered a work de novo under English law, you will be entitled to royalties on all British & Empire sales, which should be substantial. Though no outlay will be necessary on your part.
> Kind regards
> Arthur Machen

> Dear Mr Machen
> We have looked high and low but the Casanova manuscript must have got misfiled or something. As one of the world's leading suppliers of academic books we here at Brockhaus really should have brought out a scholarly edition by now, or at any rate a definitive one. As it is you will have to use one of the versions already out there. Good luck with that, they are all

thoroughly unreliable, even our own! One thing they do have in common is being out of copyright, so kindly do not send us any money.
Best wishes
Messrs Brockhaus

The one policy Brockhaus Verlag cleaved to over the years is to never let outsiders have sight of the manuscript. The one policy Casanova scholars have cleaved to over the years is never to wonder why.

That makes it our job. There is little to report for the first half of Brockhaus's stewardship as they pumped out what they acknowledged to be chronically deficient editions of Casanova's manuscript and seemingly allowed without much demur anyone else to pump out pirated versions. They give the impression of not wishing to draw attention to their foundational bestseller. Perhaps being best known as publishers of respectable family encyclo-paedias, as Brockhaus now were, made them chary of any close association with such a notorious work of their unruly youth. Like them, we shall have to draw a veil over the first hundred years of Casanovan manuscript history. Then things really pick up.

In 1919, one Joseph Goebbels submitted his PhD thesis on Wilhelm von Schütz, a minor German playwright. Minor but sig-nificant because von Schütz was a fervent German nationalist, as was Herr Goebbels himself. Strictly speaking, and German PhD requirements are famously strict, the thesis would have to include consideration not only of the plays von Schütz wrote but the volumes of Casanova's memoirs he had translated. It is not known whether the young Goebbels was granted access to the Casanova manuscript, presumably not, but the mature Goebbels was in con-trol of all German publishers when he became Reich Minister of Propaganda, so he was in a position to do so later. There is no indication from the Herr Doktor's own obsessively detailed diaries that he gave the matter another thought. His doctoral supervisor was Jewish so this may be a case of careful ignoral on his part. If only the viva had gone differently.

The authorised account has the Casanova manuscript being stored in the company's archives at its headquarters in Leipzig from 1821 until 1943, when the office was closed by diktat from Goebbels in pursuit of his Total War policy. The then current head of Brockhaus secured the manuscript in a Leipzig bank thereby presciently saving it from the 1943 bombing of Leipzig, which

until that stage of the war had been out of range of the heaviest air raids. Sounds plausible unless you happen to be thinking about it.

Here we have the chairman of one of the great publishing houses of the world safeguarding the manuscript of a book his firm had published a hundred and some years before and had neglected thereafter. With Joseph Goebbels and Bomber Harris on their case, few CEO's would lavish attention on such a bauble. Casanova experts have lavished no attention at all so once again it will have to be one of our informal (but informed) reconstructions

> "Is zat ze sound of Lancasters? Quick, Fraulein Heidi, take zese drei tausend sieben hundert foolscap pages to ze bank."
> "Won't the bank be bombed as well, Herr Brockhaus?"
> "Ven I vant advice from you, Heidi, I vill ask for it."

Goebbels, the war and, for a time, Germany ended in May 1945. By contrast, Franco-Italian manuscripts *in* Germany were enjoying a charmed life

> "Is zat ze sound of Russian tanks? Quick, Fraulein Heidi, go to ze bank and get ze drei tausend sieben hundert pages of foolscap and take zem to ze Vest."
> "How am I going to do that, Herr Brockhaus?"
> "I don't know, offer yourself to a GI with ein lorry or something."

In June 1945, according to company records, American troops took the Casanova manuscript to the new Brockhaus head office at Wiesbaden in the American zone. Not much else to do with the war done and dusted. It was business as usual at the relocated House of Brockhaus

> "Heidi, bring me zose drei tausend sieben hundert pages of foolscap, vould you? I've had ein idea."

> **In 1960, a collaboration between Brockhaus and the French editor Plon led to the first original edition of the manuscript**

As the years rolled by, it was still business as usual

> "Heidi, bring me zose drei tausend sieben hundert pages of foolscap, vould you? I've had ein other idea."

> **In 2010, thanks to the support of an anonymous donor, the manuscript was purchased by the Bibliothèque nationale de France for over $9 million, the institution's most expensive acquisition to date.**

"That's one million for you, Heidi, one million for me, one million for you..."

23 We Name the Guilty Parties

Another chapter on Casanova? Are we not up to here with the wretched man? Silence! We have only now reached the point of the exercise. If you just want to know how to spot fakes, get a job with J Paul Getty. We are concerned with who is faking history.

Fake memoirs, as far as we know, are a considerable rarity so for two of them – the known to be faked memoirs of Eugene of Savoy and the presumed to be fake memoirs of Casanova – to show up at much the same time, at much the same place, means they are overwhelmingly likely to be emanations of a single school of imaginist writers. Or, depending how these things are judged, there is a literary forgery ring at large in Mittel Europe in the early years of the nineteenth century. I seem to recall a similar situation obtained in Britain too at the time. How wide is Mittel Europe? But we must not get ahead of ourselves lest we be branded conspiracy theorists. As opposed to theorists of conspiracies.

There are in any case major objections to a single organisational mind even in respect of the two fakes we are dealing with here

- o Eugene's memoirs were the product of the Prince de Ligne
- o Casanova's memoirs came courtesy of Friedrich Brockhaus
- o the Prince was a leading figure of the Habsburg Empire
- o Brockhaus was a luminary of 'Young Germany'
- o Habsburgs and Young Germany were at daggers drawn

The Habsburg name resounds down the halls of history, Young Germany is nowadays dismissed as a failed political enterprise, worth a place in the history books only as the German arm of the Romantic Movement. Though for a brief moment *in* history, everyone was on the same side, in the struggle against Napoleon.

As the Habsburg Empire (eventually) ended up on the winning side we must be careful about history being written by victors. We must be even more careful about identifying who were the victors. The Habsburgs have disappeared from history, the heirs of Young Germany now rule Germany, Germany rules Europe and… but as I say, we must not be drawn into conspiracy-theorism.

At least our attention has been drawn to the Romantic Movement. What have the history books to say about that, and have they got it right? Or were those dreamy poets and leonine com-

posers strictly 'words and music by' while the real action was going on offstage? To discover what ought to be in the history books we begin, as always, with the Revisionists' Bible, Wikipedia

> *Brockhaus* may refer to:
>
> Friedrich Arnold Brockhaus (1772–1823)
> German encyclopaedia publisher and editor
> F.A. Brockhaus AG, his publishing firm
> Brockhaus Enzyklopädie, an encyclopaedia
> published by the firm
> 27765 Brockhaus, an asteroid named for him
> Hermann Brockhaus (1806–1877), German orientalist

Friedrich has far fewer members of his nuclear family in Wiki than Casanova so the spotlight falls initially on the one that does, his son Hermann. Hermann Brockhaus was an associate of Edward Backhouse Eastwick, the patron of Edmund Backhouse, the British orientalist. Edmund was later exposed as a forger of fake memoirs by Britain's greatest modern historian, Hugh Trevor-Roper, though Hugh's own record exposing fakes was not flawless as he authenticated Hitler's Diaries for Rupert Murdoch.

Family media empires will always contain their fair share of crooks, we shall be limiting ourselves to Friedrich Brockhaus and his family media empire

> The father of Friedrich Arnold Brockhaus was Johann
> Friedrich Brockhaus, the descendant of several successive
> generations of Westphalian clergymen, and a clergyman
> himself in his early life; he gave up that calling for the less
> intellectual but perhaps not less useful one of grocer in
> which he established himself in the ancient city of Dort-
> mund, where he married, became a municipal celebrity
> and where his son, the future publisher, was born in 1772.

Highly respectable, but literary forgers will likely come from good stock by the nature of the job. Friedrich's early working life seemed highly respectable apart from (look carefully) four words

> In 1786, when sixteen years of age, F. A. Brockhaus entered
> the drapery trade, in the establishment of Fr. Hoffman, of
> Düsseldorf, who for five or six years employed him as a
> traveller, intending to take him into partnership and give
> him his niece in marriage

Five or six years. As cross-examining counsel in courtroom dramas bark, "Well, which is it?" A minor point you will think with understandable impatience, except we are entering that hall of mirrors, 'the over-egged provenance', and that is always worth entering.

Whoever is providing this information appears to know every last detail so this outbreak of vagueness jars when it is considered how memorable was the event that brought the five (or six) years to an end

> but Brockhaus was unfortunately robbed on one of his journeys, which caused a disagreement, that ended in his returning to his father's business in Dortmund.

Tough break, kidda. Your home, your betrothed, your career, your good name, your faith in justice, your trust in law and order, gone in a twinkling and you only twenty-two(ish). Have faith! All will be for the best in the best of all invented worlds. A grounding in the drapery trade will be essential later in your jam-packed life. Better make it five rather than six, there is one hell of a lot to pack in.

> It is not to be supposed that Dortmund life and the grocery business would content one whose early dream had been to be amongst books...

The young gentleman has to be prepared for his role as founder of the world's largest publishing company. Your fake-biography reading skills must, I am afraid, be put to the test. Six red flags lie embedded in the remainder of the paragraph. (Pass mark: five.)

> ... though it was while with his father that he first made his acquaintance with at least one branch of the book trade, through being sent to buy volumes to be used as wastepaper in his father's shop, when he occasionally gave what his father considered an extravagant price for books for his own reading.

1. No grocer has ever sent a junior employee out to buy old books. A vast and sophisticated network has grown up from day one of the printing industry to handle the trade in old books and Germany has been in the book-printing industry from day one. Where would young Friedrich go to find them? Totting door-to-door? A second-hand bookshop chucking out second-hand books? If he had been

sent out to get volumes of old newspapers that might be different, but he wasn't.

2. Old books are really not suitable for wastepaper. Page after page can be laboriously torn out but all that is left is a pile of small rectangular pieces of paper with inky writing on them.

3. Such wastepaper is definitely not suitable for grocery shops. The food comes packed in bulk and has to be re-packaged for the customer. Any grocer who offered elderly bits of smeary A5 as part of the deal would get some funny looks. Maybe repacking eggs if the straw had run out but I wouldn't go back there.

4. People do not go through volumes of old books being disposed of in search of reading matter. You go in with your barrow, you load up, you shove off. Any youth caught browsing would get a swift clip round the ear.

5. If any youth did, he would not be heard to exclaim, "Good Lord, I've been meaning to read this, I suppose I'd better pay you extra for it."

6. If any youth did, he would be unlikely to have a father complaining about a few extra pfennigs spent on a job lot of old books since pops could not know the precise value of any given job lot.

How trivial. So trivial you did not spot a single one, and you are not impressed now they have been spotted for you. You have a lot to learn. In our business, trivia is not trivial. In *their* business, trivia is not trivial. Anyone with a passing acquaintance with espionage (sadly, all of us in these untrusting times) knows the 'legend' has to be exactly right, or it is all wrong.

Revisionists need to know where to start and a good place to start is by

spotting small discrepancies

History is quite a sophisticated operation and discrepancies should have been cleared up long before they reach the history books, so when one is spotted it is time to start work. Sometimes it is just a discrepancy and the revisionist can clear it up in a few minutes on history's behalf. Sometimes it isn't. Quite often it isn't. A hall of mirrors provides a reflection of reality with, as it were, discrepancies. The point is someone has felt it necessary to construct a hall of mirrors instead of allowing the chips to fall as they may and

people do not do that without a reason. When they do it with such precision that it is difficult to know it is a hall of mirrors it will be for a very good reason.

This time it concerns Friedrich Brockhaus embarking on the literary life. We have been provided with a fair beginning but a future encyclopaedist will have to be shifted on to a more exalted plane than rummaging through soon-to-be-pulped fiction. Watch carefully as we are treated to a proper fairy story, something else Germany was involved in from the beginning. (The Brothers Grimm were leading lights of the Young Germany movement but, alas, play no further part in this story.)

Soon getting tired of Dortmund, young Brockhaus went to Leipzig fair

Where he bought some magic beans. How else to explain that the young grocer-turned-draper-turned-grocer would travel across Germany to the very city where thirty years later he would set up F A Brockhaus AG which became the biggest source of literary magic beans in the world? Dresden kept popping up in the legend that was Casanova, from now on it is to be Leipzig.

He took a liking to the place, the literary atmosphere of which suited him; there he remained during 1793-4, studying and attending the lectures of the Professors

Not a formal student then. Probably why there are no records.

During his stay at Leipzig, and when only twenty-two years of age, he seems to have been ambitious to enter the field of authorship

He was already twenty-two(ish) when Westphalian footpads were waylaying him but it is the weasel word 'seems' that alerts us we are in for more over-egging

for he offered to Messrs. Voss & Co, of that city, the syllabus and some few specimen pages of the MSS of a book he intended to write or had written.

Another quick test. If you were making this up, which of these details would you get spot on and which not?

1. There is a Leipzig publisher called Voss & Co in the 1790's
2. Aspiring writers submit outlines to publishers

3. They are expected to include specimen pages
4. The title, if 1, 2 and 3 is a fairy story

The title of it, however, is not now on record.

Putting down imaginary markers for the dim and distant future is one thing but Young Friedrich had better remind himself why he is in Leipzig in the first place

He also had made the acquaintance of the agent of a Manchester house and was by him engaged to open a branch business in Leghorn

Grocer, draper, grocer, draper, non-student, would-be author, Dortmund, Düsseldorf, Dortmund, Leipzig, Livorno, Manchester. Can anything stop this early-twenties man of many parts? Yes.

but this being about the end of 1794, the project came to nothing, as war broke out between Italy and France

Between Austria and France *in* Italy but how will our man cope with this disastrous turn of the international wheel? Most young thrusters, finding their career path blocked by revolutionary politics, would shun the barricades. This young thruster made straight for them

This same Manchester house offered Brockhaus a situation at Manchester. He declined it and set up for himself in Dortmund and afterwards at Arnhem and Amsterdam, as what would be called in England "a Manchester ware-houseman" making English woollen goods a speciality.

The French may have sundered the British textile link with Italy, but they were physically occupying Holland, so specialising in English woollen goods there would not be top of the careers master's list.

Unless our old friend 'the ambiguous formulation' is pointing to something else, even making allowance for machine-translation. I live in England (though not, thank God, Manchester) but I have never heard the phrase "a Manchester warehouseman" except maybe applied to forklift truck drivers. Definitely not someone 'making English woollen goods a speciality' which itself can be read in several different ways. This may all be nothing, or it may

be what ambiguous formulations so often are: a biographer trying to make sense of something that is not making sense to them.

Was, for instance, Brockhaus in the smuggling business? That would not have been on the careers master's list either but it might have been on Brockhaus's. The fleet-footed Dutch had given up the armed struggle at the first whiff of grapeshot and had turned the Netherlands into one great entrepôt for the illicit trade in anything Revolutionary France was trying (and mostly failing) to control in war-torn Europe. The fleet-of-foot Brockhaus with his international retail connections could be up for that.

Did it lead to, or possibly get combined with, or indeed be a seamless part of, another career not on the careers master's list, that of professional revolutionary? Since neither of these jobs will be on a biographer's list of suitable occupations for founders of great publishing empires, it may not be wise to rely on the official account. Discrepancies can always be relied on.

> **Business does not seem to have prospered with him after a lawsuit, and he finally decided to put the plans of his youth into practice**

Remember those plans? Sigh, so long ago, so far away

> **and start as a bookseller, which he did at Amsterdam, on October 15th, 1805**

Not sure he had been sighing for the life of a bookseller, only an ambience removed from grocery or haberdashery

> **under the name of Rohloff**

Sailing under false colours might be thought questionable were we dealing with anyone other than sweet F A Brockhaus

> **The use of another name than his own was necessary, as the Amsterdam Booksellers' Guild did not permit foreigners to set up as booksellers in that city so he paid J. G. Rohloff, who was a printer in Amsterdam, a consideration for the use of his name.**

One fears for the livelihoods of Amsterdam booksellers if their guild can be so easily hoodwinked. One doesn't know why anyone bothers. Brockhaus didn't.

> **After trading for two years under Rohloff's name, he dropped it, and called his establishment the "Kunst-und-**

> Industrie-Comptoir", or as the French would say, "Bureau
> des Arts et des Belles-Lettres"

The Amsterdam Booksellers Guild might have preferred a Dutch
name but the cuckoo was no longer selling books

> While in this city he published two periodicals. One he
> named De Ster (The Star), which commenced on March
> 11th, 1806 and was a politico-literary paper of which forty
> numbers were issued

Forty issues is not at all bad as these things go (average expectation
for politico-literary papers: one point five) so either Brockhaus was
a gifted journalist, assuming he had learned Dutch along the way,
or he had some well-heeled angels. What happened after forty
uneventful publication days?

> It was suppressed by the Dutch government

This could be serious. Boney's secret police do not mess around
when it comes to subversive behaviour. Was it to be expulsion?
Prison? The firing squad?

> but afterwards appeared under the title of Amsterdamsche
> Avond-Journaal, very little altered in character, and a tale
> commenced in the Ster was continued on its pages

How terribly Dutch. Perhaps it was Brockhaus's second string that
had put the French watchdogs off the scent

> The other, which he started at the beginning of 1807, he
> named Le Conservateur, Journal de Littérature, de Sciences
> et de Beaux-Arts; he continued this periodical for eighteen
> months, when it reached its sixth volume.

One may by now have the measure of the man – a radical trying
to keep on the right side of both the authorities and the bank
manager. Money is always *the* problem for revolutionaries, it is an
awfully expensive business. Partisan publishing does not provide
the cash, it spends it. Which makes Brockhaus's next step quite,
quite inexplicable. He launched an encyclopaedia

> The Conversations-Lexikon, which will always be rem-
> embered in connection with the Brockhaus name, he
> purchased of Dr Löbel of Leipzig, in 1808, and thoroughly

reorganised it, and there's no doubt that his admirable management of this publication contributed greatly to his success as a publisher.

Leipzig again. But *successful publisher*? It certainly takes one to launch an encyclopaedia, a long-term project of enormous complexity that only the mightiest of publishing conglomerates contemplate. And then mostly pass on. Just how successful a publisher Brockhaus was can be judged from the rest of his stable

> Brockhaus's chief authors in 1810, besides his girlfriend Madame Spazier, were Pastor Cramer and Jens Baggesen (a Danish poet who wrote in German), and Charles François Dominique de Villers, a refugee ex-captain of artillery.

Not what those of us in the publishing game would call full spectrum. Time to move *towards* Leipzig

> In the spring of 1811 he went to Altenburg, in Thuringia, where he continued his publishing business

New country, new author list. It was out with the promising, in with the famous

> here he published for Friedrich Rückert and Franz Grillparzer, both of them great German poets

I expect you are fed up with my publishers' war stories but I cannot begin to tell you how hard it is getting one of the 'greats' onto your list, getting two is nothing short of miraculous. Is this why Brockhaus crossed Germany? Well, no, these two poets were completely unknown at the time. I cannot begin to tell you how hard it is getting a complete unknown onto your list who later turns out to be one of the greats. Doing it twice over is twice as hard. Or four times because it has to be squared. Or something, I've only ever had the one on my list so I've never had to calculate the probabilities with any great precision.

> At Altenburg, he issued the Deutsche Blätter, a periodical intended to bring about the regeneration of Germany

All in a day's work for Friedrich Arnold Brockhaus and would prove to be one of the more remarkable start-ups of the period

> The paper lasted from the autumn of 1813 to the spring of
> 1816 and was afterwards continued under the title of
> Encyklopädische Blätter and still later on as the Isis oder
> Encyklopädische Zeitung von Oken up to 1848.

To survive the dark days of Napoleon, the darker days of Metternich and to continue right up to 1848 and the apotheosis of the German Nationalist movement is no small triumph. We still don't know where the money was coming from

> While at Altenburg he proved himself a good patriot as
> well as a good publisher, if we may judge by the number of
> books and pamphlets he issued on the war, all of them
> being in the German interest.

Not forgetting the encyclopaedia. No wonder Brockhaus was finding Altenburg cramped

> He left Altenburg in consequence of difficulties he exper-
> ienced in printing the Conversations-Lexikon

He could have invested in some new plant but, no, it was time for this modest publisher of amorata, poets and patriotic squibs to embark on his career of world conquest. And beyond if we include asteroid 27765

> In the words of his biographer, "There was only one town
> in Germany which promised to answer all his require-
> ments, Leipzig – the fountainhead of the German pub-
> lishing and bookselling trade, the lively commercial city,
> the seat of a University, and an active intellectual centre."
> He first went as a trial; but finding his expectations
> answered, he finally settled there in the Easter of 1817.

On the way, forge a link with the Prince de Ligne before forging Casanova, why don't you?

> From 1817 to 1819, Brockhaus published a periodical
> connected with the late wars, 'War History and War
> Scientific monographs from the modern era since 1792'

The Prince had just died, leaving a mass of unsorted material including, would you adam-and-eve it

> Miscellaneous Military, Literary, and Sentimental Memoirs
> 1795–1811

But it was Brockhaus's encyclopaedia that was to work the oracle. Dr Löbel (whom God preserve) of Leipzig must have been furious he had not only sold his encyclopaedia in Holland at the bottom of the market but it had now returned to his hometown to bite him publicly on the bottom. Or would have done if he had not died in 1799, eight years before selling it to Brockhaus.

> **"No work of reference has been more useful and successful, or more frequently copied, imitated and translated, than that known as the Conversations-Lexikon of Brockhaus," wrote the Encyclopaedia Britannica.**

Encyclopaedias, boring old things. But effective when it comes to spreading a new gospel. Beats flogging the rag round the clubs and pubs on rainy nights. As the Britannica wrote of *another* encyclopaedia

> **No encyclopaedia perhaps has been of such political importance, or has occupied so conspicuous a place in the civil and literary history of its century. It sought not only to give information, but to guide opinion.**

What encyclopaedia is Britannica referring to? Whose opinion was to be guided? Which century? Here is a clue

We are living its dream.

Part Four

REFERENCING WORKS OF REFERENCE

24 The Enlightenment: No, It Wasn't

> The Age of Enlightenment (also known as the Age of
> Reason or simply the Enlightenment) was an intellectual
> and philosophical movement that dominated the world of
> ideas in Europe during the 18th century, the "Century of
> Philosophy". French historians traditionally date the
> Enlightenment from 1715 to 1789, from the beginning of
> the reign of Louis XV until the French Revolution.

Dominated the eighteenth century. Dominated the nineteenth

> The ideas of the Enlightenment undermined the authority
> of the monarchy and the Church and paved the way for
> the political revolutions of the 18th and 19th centuries. A
> variety of 19th-century movements, including liberalism
> and neo-classicism, trace their intellectual heritage to the
> Enlightenment.

and Romanticism and Young Germany. And an encyclopaedia was
at the heart of it

> The *Encyclopédie* played an important role in the
> intellectual foment leading to the French Revolution

Or would have done if the *Encyclopédie* had ever existed.

The notion of a fake seventeen-volume encyclopaedia may seem
preposterous but this can no longer be completely ruled out now
we have learned that Brockhaus's encyclopaedia, the *Conversations-
Lexicon*, appears to have been something of a put-up job. What
does our own encyclopaedia of choice, Wikipedia, have to say
about its early forebears?

> The beginnings of the modern idea of the general-purpose,
> widely distributed printed encyclopedia precede the 18th
> century encyclopedists. However, Chambers' Cyclopaedia,
> or Universal Dictionary of Arts and Sciences (1728), and
> the Encyclopédie of Denis Diderot and Jean le Rond
> d'Alembert (1751 onwards), as well as Encyclopaedia
> Britannica and the Conversations-Lexicon, were the first to
> realize the form we would recognize today.

The British were first into the field. Makes you proud. Wikipedia is American and it does not make them proud. They dispatch their founding father with noticeable terseness

> **Ephraim Chambers (c. 1680 – 15 May 1740) was an English writer and encyclopaedist, who is primarily known for producing the Cyclopaedia, or a Universal Dictionary of Arts and Sciences in 1728.**

Nor, Wiki informs us airily, did the world beat a path to our door

> **An Italian translation appeared between 1747 and 1754**

The French were thinking about it

> **In France a member of the banking family Lambert had started translating Chambers into French, but in 1745 the expatriate Englishman John Mills and German Gottfried Sellius were the first to actually prepare a French edition of Ephraim Chambers' Cyclopaedia for publication, which they entitled Encyclopédie.**

Come again? According to the textbooks, according to history, according to Wikipedia, the *Encyclopédie* is the work of Diderot, d'Alembert and the encyclopédistes who between them not only produced the Encyclopédie, but are central to the Enlightenment itself. Would Wiki care to elucidate?

> **Early in 1745 a prospectus for the Encyclopédie was published to attract subscribers to the project. This four page prospectus was illustrated by Jean-Michel Papillon and accompanied by a plan, stating that the work would be published in five volumes from June 1746 until the end of 1748. The text was translated by Mills and Sellius, and it was corrected by an unnamed person, who appears to have been Denis Diderot.**

We gave it to them. Clear as day. Black and white. Open and shut.

> **In 1743 Mills was in Paris for the purpose of bringing out, in concert with Gottfried Sellius, a French edition of Ephraim Chambers' Cyclopaedia; but Le Breton, the royal printer commissioned by him to manage the undertaking, cheated him out of the subscription money, assaulted him, and ultimately obtained a license in his own name. This**

**was the origin of the famous Encyclopédie. Mills, unable
to obtain redress, returned to England.**

The blaggards. The Anglo-French battle lines are drawn. Up and at 'em! They say they produced the Encyclopédie, I say there was no Encyclopédie. If they are right there will be reams of evidence to back up their version of history:

Item: Any number of surviving copies of the *Encyclopédie* bearing a mid-eighteenth century date on the fly leaf

Item: A tsunami of surviving contemporaneous material in the form of original manuscripts, working notes, correspondence, transactions, historical records of every kind

Item: A comprehensively detailed list of the encyclopédistes

Item numéro un is not looking at all good for les ruffiens

> An original copy of the first edition is now an expensive antiquarian item. There is an auction record of one copy that sold for $94,000 in 1998 and there are 18th century reprints but these are now as inaccessible as the original.

They might be able to wriggle out of that one if they have a modern electronic version

> Access to digital versions of most of the original edition, both text and plates, is now possible. But in all cases there are issues which complicate, unnecessarily, simple scholarly access to one of the most important books in the history of the western world.

Wriggle, wriggle, little worms, what do you have to say about that?

> The natural source for the Encyclopédie is, of course, the Bibliothèque nationale de France. However, they do not seem to have all of it online via their "Gallica" digital library website. (Volumes 6, 7, 8, 10, and 11 are missing, as is the last volume of plates.)

What are they hiding? Never mind the missing volumes, it is the missing pictures that are worth a thousand missing words

> In the first publication, seventeen folio volumes were accompanied by detailed engravings. Later volumes were published without the engravings, in order to better reach a wide audience within Europe.

So the easy electronic bit, the text, is sort of half-and-half available, but the part that would really take some doing, the detailed engravings and the volume of plates, have taken French leave. Their explanation for this is

o they have not got the original engravings
o they have not got the illustrations from the engravings that were used in the early editions of the Encyclopédie because they do not have any early editions of the Encyclopédie
o they do not have the illustrations from later editions because the illustrations had been removed
o they had been removed because these editions were for non-French people who might have difficulty with the text but not the illustrations

We may be non-French, but we're not stupid.

If they are having trouble producing the work itself, can they offer us contemporary evidence as to its existence? A seventeen-volume work of reference would leave behind an enormous paper trail – everything from first drafts of the contributors to reviews in the 1751 newspapers. This is France's pride and joy, they will have it all lovingly arrayed in a permanent exhibition, won't they? Put away that Eurostar ticket, not a saucisson.

Do they at least have a list of the contributors, the very famous, and the very French, *encyclopédistes*? The people who did not just produce an encyclopaedia but were the moving spirits behind the entire French Enlightenment. They do? They do! Wonders will never cease. (Priez d'excuser ma machine translated Franglais)

> **The first lists were established in 1932 alone for the Exhibition The "Encyclopedia" and encyclopedists in the National Library organized by the International Synthesis Center**

Took their time about it. Anything else?

> **and in 1939 by Louis-Philippe May (Notes on Masonic origins of the "Encyclopaedia" followed by the list of encyclopaedists, Revue de Synthèse, pp. 181-190)**

Then came that business with the Germans but not with the Japanese so they outsourced everything to the latter

> and finally in 1951 by three Kyoto researchers (Kubawara
> Takeo, Turumi Syunsuke, Higuti Kiniti: The collaborators
> of the "Encyclopedia", the conditions of their organization
> Supp. of Zinbun no 1, University of Tokyo, p. 1-22).

Not very impressive, mes braves. Still, you have given us a list so you will not mind if we give them the once-over, will you? We shall take them off the top in strict alphabetical order to avoid any accusations of English cherry-picking.

The A-list of mid-eighteenth century French A-listers begins with Guillaume d'Abbes de Cabrebolles who was responsible, we are told, for the 'Physiologie' entry in the 1751 Encyclopédie. A real person for sure, a real savant for sure, not an expert in physiology for sure

> Admitted to the bar in 1741, he practised in this capacity
> from 1749 to 1789 and worked as correcteur à la chambre
> des comptes de Montpellier

That was his day job. Guillaume was burning the midnight oil in a very encyclopaedic way

> In 1758, d'Abbes published a 12 volume tome, entitled
> Voyage dans les imaginaire espaces

I should like to say more about the physiological aspects of this work but as it is described sometimes as 'rare' and sometimes as 'completely unknown', I will not be able to do so at this present moment in time.

Next off the alphabetical cab rank is someone who does not deal in imaginary spaces

> Monsieur Allard, who applies himself to experimental
> physics and mechanics, has provided us with the models of
> several machines which he excels in accomplishing, and
> several arts articles

Science *and* engineering *and* the arts, a true renaissance man. They were lucky to get him. But after this encyclopaedic but somewhat theoretical contributor they turned to a practical man, Antoine Allut, for the entry on *glace* (glass manufacturing, not ice cream). He worked in the family glassworks so he should know all about it. Antoine wrote it all up for the Encyclopédie, pretty good going

for someone born in 1742. "He's always been a quick learner, the boy," said his mum proudly.

We'll be learning a lot about child prodigies. Eighteenth century France has come in for a lot of criticism one way or another but its education system cannot be faulted. Look out, here comes another one

> **Jean-Baptiste Bourguignon d'Anville (1697-1782)**
> **Geographer and cartographer. Nominated royal**
> **geographer in 1718, aged 21**

and with heavyweight supporters lobbying for his appointment

> **According to his memoirs, he was supported by the Duc**
> **d'Orleans. He worked with his brother, the engraver**
> **Hubert-François Gravelot "on a series of maps and wrote**
> **his eulogy in which he recalls his bibliomania".**

Haven't read the memoirs myself so I cannot say why the Duc d'Orleans, the 'king' of France during Louis XV's minority, was appointing a youthful printer to the prestigious position of Royal Geographer. They can be sticklers when it comes to people in trade. Hubert-François seems not to have been too put out at his brother getting the d'Anville title but no doubt he wanted to keep the family name of *Gravelot* which English printers will appreciate is an excellent pun, (en)grave-a-lot.

Unfortunately for punsters, Gravelot was not his name (it is an unknown surname in France), his brother had not been ennobled and they may not have been brothers. Though they were brothers-in-crime, being respectively engraver and illustrator of a forgery ring being operated by an antiquarian, linguist and historian (and child prodigy) known to history as the abbé de Longuerue. The gang specialised in

o maps for fanciful Roman, Greek and Egyptian history
o mendaciously partisan maps for European governments
o fake rococo merchandise for the English gentry

Engravers do not leave England after twelve years, as Hubert-Francois Bourguignon ('Gravelot', as the English knew him) did, with ten thousand eighteenth-century pounds in their pockets. That would make a dent in either country's national debt.

How do we know all this? We don't for sure, this being by way of a brief excursion from the main Encyclopédic path, but useful

all the same because their stories include tropes that feature quite a lot in French history re-writes. One is the 'posthumous recollection' and the later add-ons found necessary as French 'history' progresses

> After the abbé's death in Paris a volume of Longueruana was published based on the recollections of a devoted amanuensis who had transcribed Longuerue's savant conversations. In 1769 a further selection of fugitive pieces from among his papers was published.

Then there is the royal paean to a great collection that has somehow got lost 'twixt bogus aristocrat and unnamed king

> D'Anville's last employment consisted in arranging his collection of maps, plans and geographical materials. It was the most extensive in Europe, and had been purchased by the king

It is no wonder the Ancien Régime went broke. If d'Anville had been the Geographer-Royale for fifty years, didn't it all belong to the king already? It seems not

> who, however, left him the use of it during his life.

How very non-absolutist of him. Nevertheless, probably a mistake

> This task performed, he sank into a total imbecility both of mind and body, which continued for two years, till his death in January 1782.

That's d'Anville of course. Louis XVI, if he was the right royal recipient referred to, would not be around very long to boast to his fellow royals that his map collection was bigger than theirs.

You can take this or leave it (or explore it) but we must leave the d'Anville Bourguignon Gravelots behind as we move to the next alphabetic entry on our list, Antoine d'Argenville, who contributed no less than five hundred and forty articles to the Encyclopédie. Count them! No, I forgot, we can't, but they were in the general area of 'hydraulics and gardening'

> Antoine Joseph Dezallier d'Argenville, 1680 to 1765, naturalist, collector and art historian. His theory and practice of gardening is very popular in France.

In Britain too, it was translated into English in 1712. Antoine may have got distracted by his work for the Encyclopédie (in addition to his work in the Court of Auditors where he was Master of Accounts) because his

more famous work on shells

did not see the light of day until 1780. Those who thought it was a Swede that introduced the encyclopaedic classification of living things should think again. They should think French

In 1742 Dezallier d'Argenville used a binomial nomenclature which prefigures that of Linnaeus

In 1742 it would have, in 1780 it wouldn't have. I don't suppose priority of publication was important in those days but post-dated cheques are always a matter for concern.

Time and tide presses, let's have some Quota Quickies

Arnauld (?) Articles on fishing and hunting for the Encyclopédie. Perhaps Louis-Roch-Antoine-Charles Arnauld, 1703-1779, known as Arnauld de Senlis

Not shootin'?

Arnulph d'Aumont 1720-1800 He wrote the article "Enfance" in the Encyclopédie. In 1762 he published 'Memoir on a new manner to administer mercury for venereal and other diseases'. His method was to use glazed animal milk.

Possibly another application of glace. At least they got his name right, unlike the military man who wrote articles on warfare for the Encyclopédie

Charles-Louis d'Authville Des Amourettes 1716-1762. Usually (mis)spelt d'Autheville

Get it right, you 'orrible lot.

Somebody, it would seem, is having to scour the French eighteenth century intelligentsia for people who might have contributed to an encyclopedia. For our own part we can bring this short but enchanting *litanie française* to a close with a dynasty – a father and son, two sons. First the other son, the one that did not contribute to the Encyclopédie

> Jacques de Barthes, presided at the general assembly of
> the three orders of the seneschal of Montpellier that met
> March 16, 1789. Collaborated on the Imperial Code and
> became a baron of the Napoleonic Empire.

A right Vicar of Bray. Not the intellectual of the family though, that was his brother Paul-Joseph Barthez (1734-1806) author of 'Nouveaux élémens de la science de l'homme' that hit the streets in 1778. But he had been busy with the Encyclopédie long before

> Paul Joseph Barthez was called upon to edit or contribute
> several entries in the Encyclopédie of Denis Diderot and
> d'Alembert

Another child prodigy. He couldn't have been more than sixteen when Diderot and d'Alembert were casting round for editors stroke contributors. They must have got the teenage scribbler's name from his father who had edited stroke contributed a couple of pieces of his own

> Guillaume Barthez de Marmorières (1707 to 1799) was
> called upon to edit or contribute two entries in the
> Encyclopédie of Diderot and d'Alembert. He was a civil
> engineer for the province of Languedoc. He was elected to
> the Académie des sciences et lettres de Montpellier, and
> gained a wide reputation through either his writings or the
> works he supervised.

You know what they say
- o if you can't do it, supervise it
- o if you can't supervise it, write about it
- o if you can't write about it, edit it
- o if you can't edit it, rely on someone saying you did.

Preferably Denis Diderot or Jean le Rond d'Alembert because, when it comes to the *Encyclopédie*, they are the only two names anyone has ever heard of.

Denis Diderot was less an encyclopaedist and more a second-hand book dealer. Less a secondhand book dealer than a forged-book dealer. He began by forging his own life story. Complete with the obligatory jail time

> On 24 July 1749, Diderot was placed in solitary confine-
> ment in the Vincennes. He had been permitted to retain
> one book that he had in his possession at the time of his

arrest, Paradise Lost, which he read during his incarcer-
ation. He wrote notes and annotations on the book, using
a toothpick as a pen, and ink that he made by scraping
slate from the walls and mixing it with wine.

But only for a week or so because, in a spooky prefiguring of one
of Casanova's spells in the nick, word of the book dealer's pred-
icament had spread through the distaff side of the higher French
aristocracy. Casanova had his Marquise d'Urfé, Diderot had the
Marquise du Châtelet

In August 1749, Mme du Châtelet, presumably at Voltaire's
behest, wrote to the governor of Vincennes, who was her
relative, pleading that Diderot be lodged more comfortably
while jailed.

D'accord, Madame, mais seulement avec le quid pro quo

The governor then offered Diderot a comfortable room,
access to the great halls of the Vincennes castle, to walk in
the gardens and the freedom to receive books and visitors
providing he would write a document of submission.

Always a tough one. Revolutionary credentials stipulate no truck
with The Man but, on the flipside, wine without wall scrapings

On 13 August 1749, Diderot wrote to the governor: I admit
to you that the Pensees, the Bijoux, and the Lettre sur les
aveugles are debaucheries of the mind that escaped from
me; but I can promise you on my honour (and I do have
honour) that they will be the last, and that they are the
only ones.

Nice one, Den. If The Man wants to believe that, he can be your
guest. Just don't rat out the comrades.

As for those who have taken part in the publication of
these works, nothing will be hidden from you. I shall
depose verbally, in the depths of your heart, the names
both of the publishers and the printers.

I see where you're coming from. You can't afford to carry the
weaker vessels, the important thing is you are outside looking in,
free to lead the revolution

> On 3 November 1749, Diderot was released from the
> Vincennes. In 1750 he released the prospectus for the
> Encyclopédie.

I got pig iron.

Diderot has a literary output of enviable range and quality even
if, being so avant-garde, it was not always given its due at the time

> Diderot's literary reputation during his lifetime rested
> primarily on his plays and his contributions to the
> Encyclopédie; many of his most important works, includ-
> ing Jacques the Fatalist, Rameau's Nephew, Paradox of the
> Actor, and d'Alembert's Dream, were published only after
> his death.

With him being more of an editor of encyclopaedias, and before
that more of a proof-reader of encyclopaedias, Diderot's 'literary
reputation during his lifetime' will have to rest on the plays

> Yet his own plays have been called unsuccessful and were
> far from popular even in his own day. Dull, declamatory,
> sermonizing, conventional, and their equivalents, are
> adjectives used by most critics. "Diderot's declamatory
> style, his sentimentality and pathos repel most readers and
> put even the most devoted of students to a hard test."

We call that 'mixed notices'. It is fortunate we have the post-
humous works, though there is the minor mystery of why one of
the leading thinkers of his generation, writing classics of various
genres, could not get published in his lifetime (everyone else seems
to be managing). But I've had my own troubles on that score. A
major mystery.

Diderot's best-known posthumous work, *Le Neveu de Rameau ou
La Satire seconde*, was written, we are told, predominantly in 1761-2
and revised in 1773-4. This ten-year cycle of fits and starts cont-
inued with Diderot's death in 1784 and then posthumously

> After the death of Diderot, the manuscript or a copy of it
> probably made its way to Russia

The eighteenth century Russian publishing industry was not a
patch on the French eighteenth century publishing industry so for
another ten long years the manuscript (or a copy of it) circulated
in samizdat before a keen-eyed Russian had the bright idea of
sending it off to the second-most famous literary figure of the day

177

so he could show it to the first-most famous literary figure of the day

An appreciative Russian reader communicated the work to Schiller, who shared it with Goethe who translated it into German in 1805.

It may have had snow on the cover but a question mark hovers over Goethe's decision to translate it into German. The manuscript was in French, French was the language of cultural discourse throughout Europe, yet this celebrated polyglot felt it was best presented in German. An obvious explanation: Goethe was a German nationalist and the French were occupying his heimat at the time. Polyglots avec frontières.

But what was Goethe like as a translator? We recall with trepidation from our Casanova days that turning French manuscripts over to German translators with literary pretensions can be attended with difficulties. We shall have to examine the two texts side by side to make a judgement. What's this we don't see before us?

the French manuscript Goethe used has subsequently disappeared

Damn. We shall have to wait for the Ten Year Rule to turn something up

The German version was translated back into French by de Saur and Saint-Geniès and published in 1821

That's no use, it's another Casanova moment. French into German into French without the French original. Luckily the days of the Ten Year Rule were well and truly over

The first published version based on a French manuscript appeared in 1823 in the Brière edition of Diderot's works.

What do they mean, 'based on *a* French manuscript'? How many did Diderot write? Many, many ten-year periods would have to elapse before that puzzle got solved

Modern editions are based on the complete manuscript in Diderot's own hand found in 1890 by Georges Monval, the librarian at...

We haven't had a quiz for a while so it is to be four rounds, multiple choice. **Question One:** Georges Monval was the librarian at

A. the Bibliothèque nationale
B. the Académie française
C. the Académie des inscriptions et belles-lettres
D. the Diderot Museum

It was E the Comédie-Française. You'd forgotten Diderot was a playwright, hadn't you? Never mind, let's see if you can do better with **Question Two:** Georges Monval, the Chief Librarian at the Comédie-Française, found Diderot's original manuscript

A. languishing unrecognised in the theatre's archives
B. languishing unrecognised in someone else's archives
C. languishing unrecognised in a secondhand bookshop where he was browsing for music scores on his day off

OK, you got that one but I won't always be putting the correct answer at the end. **Question Three:** France has the original manuscript of Diderot's *Le Neveu de Rameau*, a famous work by one of the central figures of the French Enlightenment. Did they

A. create a special niche for it in the Comédie-Française
B. hand it over for safekeeping to the Bibliothèque nationale
C. sell it to the Pierpont Morgan Library in New York

You're on a roll. **Question Four:** the Pierpont Morgan would have done better to have

A. bought a Seine bridge
B. asked the French for their money back
C. the decency to take the wretched thing off their shelves this minute and admit they're a complete bunch of wallies who wouldn't know a genuine eighteenth century manuscript if it came wrapped round Madame de Pompadour's pompadour

For bonus points tick the appropriate boxes

☐ Le Neveu de Rameau was written in German c. 1805. Since Goethe's name is on the cover, presumably by Goethe.

☐ Schiller died in 1805 under mysterious circumstances having previously written the Ode to Joy, latterly adopted as the anthem of the New World Order, but the Illuminati are not involved

☐ Brière, when compiling his 'edition of Diderot's work', wrote this French manuscript himself. This points to him

being responsible for the rest of Diderot's posthumous works as well.

- [] Georges Monval was an out-and-out crook besides being the Chief Librarian and Archivist at one of France's most august cultural institutions

- [] Chief librarians and archivists at august cultural institutions are no longer out-and-out crooks but they are people who should not be trusted to stack shelves at supermarkets in case they end up killing us all with misapplied sell-by dates. They should be given the opportunity anyway.

The other half of the team that according to the reference books brought us the *Encyclopédie* was Jean le Rond d'Alembert. He has a life story going all the way back to conception

Born in Paris, d'Alembert was the illegitimate child of the writer Claudine Guérin de Tencin and the chevalier Louis-Camus Destouches, an artillery officer

Not a bad genetic base for a future encyclopaedist but the nurture side of nature-and-nurture was not going so well

Destouches was abroad at the time of d'Alembert's birth. Days after birth his mother left him on the steps of the Saint-Jean-le-Rond de Paris church.

We all have to make sacrifices for our art.

According to custom, he was named after the patron saint of the church

Jean can thank his lucky stars maman didn't choose Notre Dame. But how was our future encyclopaedist to acquire the necessary education when

D'Alembert was placed in an orphanage for foundling children

He could thank his lucky stars papa had come home from the wars

Destouches found him and secretly paid for the education of Jean le Rond, but did not want his paternity officially recognised.

Great expectations got an Oliver twist

**His father placed him with the wife of a glazier, Madame
Rousseau, with whom he lived for nearly 50 years**

No information about Monsieur Rousseau but there can be no
connection with Jean-Jacques because Mme Rousseau had strong
views about philosophers cluttering up the place

**When he told her of some discovery he had made or
something he had written she generally replied, "You will
never be anything but a philosopher - and what is that but
an ass who plagues himself all his life, that he may be
talked about after he is dead."**

You tell him, dear, he wants to get a proper job, that one.

Thankfully for the History of Ideas, he didn't, but Jean could
not be blamed if he rejected the various surnames he might be
entitled to (de Tencin, Destouches, Rousseau, le Rond) when fil-
ling in application forms

**He was also interested in medicine and mathematics. Jean
was first registered under the name "Daremberg"**

That was not to last either so there is no alternative but to run
another multiple-choice competition. Who did name d'Alembert
d'Alembert? The rules are very simple: you have to come up with

A. the most unlikely person
B. the most unlikely reason
C. in combination they have to be repeated by all works of
 reference for at least two hundred and fifty years.

The current front runner to beat is

**The name d'Alembert was proposed by Frederick the
Great of Prussia for a suspected (but non-existent) moon
of Venus.**

Where was all this coming from? From the horse's mouth, Jean
d'Alembert himself, albeit curated after he had joined the Great
Encyclopaedist in the sky

**Most of the information on d'Alembert is from his auto-
biography. The text was published by Charles Pougens in
1799 at the head of the first volume of the posthumous
works of d'Alembert.**

After everything we have learned about life-after-life we are duty bound to run the rule over this Pougens to see what he brings, if anything, to the literary executor's table. Nothing to worry about there, the position was made for him

> **Charles de Pougens, man of letters, printer and librarian. Working name of French philologist, artist and bookseller Marie-Charles-Joseph de Pougens (1755-1833)**

and he has a pedigree out of the top drawer

> **According to the marquise de Créquy, Charles de Pougens was the son of the Prince de Conti**

several top drawers

> **but then wanted to persuade and make us believe that he was the son of the Duchess of Orleans. The name he bears is that of a moving fief of the Duchy of Mercore in Auvergne**

It looks as though Charles was attracted to d'Alembert's shade by a number of commonalities in their early life experiences

> **He was cared for by a certain Madame Beaugé, daughter of a trooper, who brought him up as if he were her own**

As a man-of-letters, Pougens would recognise the popular appeal of a rags-to-riches story, the memoir as picaresque novel, if you will. As a bookseller, he must have known it never hurts to include celebrity endorsements

> **A letter in the hand of the king of Prussia, written to M. d'Alembert, when he took leave of this prince, in Potsdam, in 1763. Letter of the empress of Russia; written in her hand, to M. d'Alembert.**

The public are not daft. Let me re-phrase that. Why, they will wish to know, are the pre-eminent potentates of their generation lining up to sing d'Alembert's praises if his main claim to fame was as the back half of a French encyclopaedia double act? Main claim to fame? Oh dear me, no. D'Alembert was the pre-eminent thinker of his generation, and Wiki has been kind enough to list the more important of his contributions

D'Alembert criterion
D'Alembert force
D'Alembert's form of the principle of virtual work
D'Alembert's formula
D'Alembert's equation
D'Alembert operator
D'Alembert's paradox
D'Alembert's principle
D'Alembert system
D'Alembert–Euler condition
Tree of Diderot and d'Alembert
Cauchy–Riemann equations
Fluid mechanics
Three-body problem
The Preliminary Discourse to Diderot's Encyclopédie
More than a thousand articles for the Encyclopédie

I am not personally au fait with much of this, and of course nobody is au fait with the thousand articles he wrote for the Encyclopédie, but my eye has been caught by the *d'Alembert–Euler condition* because I am au fait with Euler, the great German mathematician. I will therefore confine my remarks to the d'Alembert-Euler condition as an epitome of the oeuvre as a whole

> The d'Alembert-Euler condition is named for Jean le Rond d'Alembert and Leonhard Euler who independently first described its use in the mid-18th century.

A complication right out of the gate. Not so much the d'Alembert -Euler condition as the d'Alembert condition *and* the Euler condition. One supposes, if precedent were sought, something akin to the Newton Calculus and the Leibniz Calculus, and we all know what confusion that caused. Can Wiki clear up any confusion?

> It is not to be confused with the Cauchy–Riemann conditions

You just did! You put it on the same list with only the *Tree of Diderot and d'Alembert* between them. Pray clarify.

> In the field of complex analysis in mathematics, the Cauchy–Riemann equations, named after Augustin Cauchy and Bernhard Riemann, consist of a system of two partial differential equations which, together with certain continuity and differentiability criteria, form a necessary and

sufficient condition for a complex function to be complex differentiable, that is, holomorphic.

Duh, we knew that, what we asked for was the connection with d'Alembert and Euler

> This system of equations first appeared in the work of Jean le Rond d'Alembert [d'Alembert 1752]

And Euler?

> Later, Leonhard Euler connected this system to the analytic functions [Euler 1797]

I must protest in the strongest possible terms on behalf of our man. This makes it the d'Alembert Condition with Euler bringing up the rear forty-five years later.

Hang on, that can't be right. D'Alembert and Euler were contemporaries, they both died in 1783, so what exactly is going on? I hope to God we are not back in the world of posthumous monkey business. What happened to his/their equation/equations after his/their death/deaths?

> Cauchy (1814) then used these equations to construct his theory of functions

Oh no, you're not catching us with that one. You said they were the Cauchy-Riemann equations. Where's Riemann got to? Don't tell us he's the grad student doing all the work while the boss gets his name on the finished paper. We know all about that one, thank you very much. Just tell us the facts, Wikipedia, and this time no tacking on a few decades just because you feel like it.

> Riemann's dissertation on the theory of functions appeared in 1851

I give up. Maths will have to be left to people with more than a O-level (Grade C).

I got a 'B' in history so I will be on surer footing with the chief contributors to *The Enlightenment* as a whole. There is Montesquieu of course who gave us 'the separation of powers', and where would we be without that? Where would Montesquieu be without John Locke giving him the idea about the importance of separating

powers? How Montesquieu gained his starring role in the history of political philosophy is a tale quickly told

> The newly independent Americans, having adopted the British Constitution bar a few name changes, were anxious to demonstrate to the world, and to one another, they had not just adopted the British Constitution bar a few name changes, so they claimed to have got it all from Montesquieu. The French were overjoyed to hear one of their own had made such an unaccustomed splash in Anglophonia and sent over the Statue of Liberty to remind everyone, then made *Planet of the Apes* to remind everyone what happens if they ever forget.

I may have over précised.

Topping the Enlightenment tail are Voltaire and Rousseau. Voltaire features in the next chapter so for now Rousseau will have to carry the can. It raises the spirits to hear he had been carousing with Denis Diderot long before the Enlightenment was anything more than a gleam in their pie-eyes

> **Diderot lived a bohemian existence for the next decade. He befriended philosopher Jean-Jacques Rousseau in 1742.**

When they decided to change the world, as opposed to talking about it in le pub, Diderot went off to not-produce the *Encyclopédie* and Rousseau went off to even bigger things

> **His political philosophy influenced the progress of the Enlightenment throughout Europe, as well as aspects of the French Revolution and the development of modern political, economic and educational thought.**

How did that turn out?

> **During the period of the French Revolution, Rousseau was the most popular of the philosophers among members of the Jacobin Club. He was interred as a national hero in the Panthéon in Paris, in 1794, sixteen years after his death**

and sixteen minutes before the Jacobins' deaths.

The Revolution itself did not last much longer. The French do have one major national talent, a capacity for persuading the world their disasters are triumphs

The Revolution was a disaster
Vive la Révolution!

Napoleon was a disaster
Vive Napoléon!

Rousseau's philosophy was a disaster
Vive Rousseau!

The Enlightenment never happened
Vive le Siècle des lumières!

Yes, for some reason, possibly modesty, the French do not have a word for the Enlightenment, an English rendering of 'Aufklärung', a term dreamt up by the Germans. Time for some aufkläring of our own.

The simple truth is that the French had a political problem in the *nineteenth* century when military conquests, with special reference to French military conquests, were thoroughly passé. The leading nations could only compete by, as we would call it today, soft power. Notably whose political system was best suited to this new world of seemingly unstoppable breakneck industrial development but, with recent events firmly in mind, delivered with minimal changes to the political status quo. France had not done much for advancement during the eighteenth century – too busy advancing France – and that would have to be revisited now the thoroughly eighteenth-century Bourbons were back in the saddle.

The French were not alone in wanting to cast a retrospective cultural glow. The Russians and the Austrians were in the same position but were content to respectively re-brand Catherine the Great and Leopold II as towering figures of this Enlightenment everyone was talking about. The French, as can be their wont, went a great deal further by claiming they had invented the whole thing.

And what's more they had an encyclopaedia to prove it. You would think the rest of the world might notice this unsuspected cultural behemoth come amongst them but there you would be wildly overestimating historians' ability to distinguish between historical fact and state-sponsored fiction.

25 Voltaire, not the Best o' Men

Since this skulduggery was going on a long time ago, our own academics can be forgiven for being unaware of it. They were not around at the time. Here is one of their colleagues, hard at work, right under their noses

> In the 1950s Besterman began to concentrate on collecting, translating and publishing the writings of Voltaire, including much previously unpublished correspondence. He published 107 volumes of Voltaire's letters and a series of books entitled "Studies on Voltaire and the Eighteenth Century".
>
> In 1969 he published a detailed biography of Voltaire (541 pages + back matter), including many of Besterman's own translations of Voltaire's verse and correspondence. The Forum for Modern Language Studies called Besterman's edition of the correspondence "the greatest single piece of Voltairian scholarship for over a century."
>
> During the final years of his life, Besterman opened discussions with the University of Oxford arranging for the posthumous transfer of his extensive collection of books and manuscripts, which included many collective editions, to an elegant room renamed the Voltaire Room. Following Besterman's death on 10 November 1976, the Voltaire Foundation was vested permanently in the University of Oxford.

Unfortunately for the University of Oxford, Theodore Besterman was one of the great cultural crooks of the twentieth century. Unfortunately for the rest of us, the University of Oxford is home to legions of over-credulous, under-curious know-nothings intent on a life of pampered ease. The academic staff are worse. Besterman remains untwigged to this day. Until *this* day.

Voltaire was only Besterman's middle period. He entered his salad days after moving on from French philosophy, but he had been wreaking havoc for decades before that. One might almost say he was born to a life of crime

> Theodore Besterman was born on 22 November 1904 in Lodz, Poland. In common with others of his generation and

origin, Besterman in his Who's Who entry preferred to leave another trail and gave Bradford (UK) as his place of birth.

Scholarship relies on honesty. It does not pay well so nobody signs up for it except as a vocation. This is a dangerous assumption.

Lying about one's *Who's Who* entry would normally be too much even in the trusting world of the academy but the writer of this anodyne account is referring to anti-Semitism. Personally, I think it is anti-Semitic to imply Jews routinely lie when supplying their Who's Who details but then, personally, I'd rather be from Lodz than from Bradford. Though admittedly I haven't been to Lodz.

If you are a Polish chancer arriving in Britain set on presenting yourself as an English gentleman there are two hurdles to overcome. Where you went to school and your accent. In Britain, much the same thing. Besterman never entirely got the accent right which might have been thought odd by his family, labouring under the impression he was a Yorkshire-born Englishman, but families can be quite trusting too. A grandson by marriage, later an academic and a biographer of Besterman, felt this was unusual but not *that* unusual

Another foible was an inability to roll an English 'r' at the front of the tongue. To get around this small impediment, he pronounced his 'r's the French way, which to my ears only added to the sense of the exotic.

Geoff Boycott was always getting his batting partners out because of his difficulty saying "Run!"

As for school, which even in the early twentieth century would leave records of attendance, Theodore was more home-schooled

He claimed that he was largely self-educated at the British Museum library, to which his mother dispatched him with no more than an apple for lunch.

Possibly wrapped in a bandanna tied to the end of a stick with which, on his way home, he used to bowl his hoop. As preparation for a life of scholarly appointments this would need adding to

A later (1967) Who's Who entry mentioned private education, the Lycée de Londres and 'Oxford (extra-mural)'. He sometimes later let it be thought that he was at

Magdalen College, Oxford, a view for which no evidence has been found.

We have had occasion to complain about careful ignoral among academics but when it comes to judging one of their own this looks to be wilful purblindness.

Such untruths might disqualify a candidate from being given any kind of job, Besterman's jobs involved the custodianship of extremely valuable books. For a good reason: scholarship may rely on books, not many scholars want to catalogue them.

"Do your archives for you, squire?"
"Oh, how marvellous, you're an answer to our prayers. They're in such a state. Here's the key, lock up after you."

Besterman was given the keys to so many institutions his catalogues achieved legendary status

The various editions he produced were probably the major bibliographic tool in the post-World War Two world, making 'Besterman' a household name with librarians worldwide.

Besterman's early years may be a closed book but he was publishing one in his early years

At twenty he had published a bibliography of the Fabian and theosophist Annie Besant (1847-1933)

While the rest of us were out chasing girls, Theodore was not only compiling a bibliography, surely the dullest of literary occupations, but doing it so well it was published, not an honour accorded to your average bibliography. True, Annie Besant was one of the more exotic figures of her day but a published bibliography ten years before her literary career ended seems... premature.

Besterman was out chasing girls as well

In April 1925 Besterman had married Henrietta Birley of Hampstead (born 1893/4), a secretary, the marriage lasting but a few years.

Did you spot it? Have another look, you'll kick yourself. Most people know when their wife was born, all marriage certificates state when the contracting parties were born, so when a biography can only commit to 'born 1893/4' it is worth wondering whether there ever was a certificate but in its absence we must content

ourselves with wondering why a twenty-one year old is marrying a thirty-one/thirty-two year-old British secretary. It could hardly have been for position in society though it could well have been for a position in the Theosophical Society of which Henrietta was the secretary. Only a temp though as Mrs Besterman.

Later, divorce not being respectable at that time, this union (childless) was omitted from his formal record

Lots of things get omitted from the formal record of Theodore Besterman. Lots of things get added.

If it was not uxoriousness that attracted Theodore to Henrietta and theosophy, what was it? Did he answer a small ad in the sits vac columns, "Well-known London literary and political figure needs bibliographer" or was there some more urgent task that needed doing at the Theosophical Society? There certainly was. Annie Besant had invited the founder of Theosophy, Madame Blavatsky, to share her St John's Wood home, which had thereby become the de facto HQ of Theosophy. When Madame left for the astral plane on a permanent basis, her earthly writings remained behind in NW8. By the time Theodore arrived, theosophy had spread worldwide but was riven with disputes as to how best the Blavatskian message be taken forward. Annie Besant was one of the prime disputants, so the advert may have read, "Well-known London literary and political figure needs creative archivist."

Any road, as they say in Bradford, Theodore had found his and was ready to embark upon it. It was foretold

In 1925 Besterman joined the Society for Psychical Research and, aged twenty-three, became its honorary librarian

What music to the ears of any aspiring lit crim are the words 'honorary librarian'. Someone can't afford to pay for one and will be only too thankful if a kindly soul volunteers to rob them blind. It works like this:

o control of a library means control of the stock
o control of the stock means control of the catalogue
o control of the catalogue means control of provenances
o control of provenances means control of authentication
o control of authentication means lucky honorary librarians

Besterman acquired numerous early rarities for the library and compiled and published its catalogue in five parts (1927-33)

Six years, five parts, small library. It is a good job Besterman's services came free. But his catalogues always came out in parts, at intervals. If at first you don't succeed…

Theodore might have been just what the Society for Psychical Research ordered but small specialist libraries have an inherent limitation for the truly ambitious rare book dealer. They can only go to the well so often before the Acquisitions Committee says, "Sorry, Theodore, you have already used up this year's and next year's budget."

In his late twenties Besterman turned his attention again, and more generally, towards bibliography

The life of the professional bibliographer is not a well-rewarded one, nor a high-profile one. Unless your name happens to be Theodore Deodatus Nathaniel Besterman

Starting in a logical manner with the publication of his important *The Beginnings of Systematic Bibliography* (1935) he had become both special lecturer at the London School of Librarianship (1931-38) and joint editor of the influential, if short lived, series *Oxford Books on Bibliography*

I know what you're whispering to one another. "Old Harper hasn't laid a glove on the geezer. This Besterman is practically a national treasure, if you ask me." I wouldn't dream of it, and not so much of the *old* either. If you're not willing to listen to me, listen to Deep Throat

Follow the money!

Being an honorary librarian, a special lecturer and a short-lived joint editor does not pay the bills. It certainly does not pay for

In 1935-40 he published privately the first edition of his World Bibliography of Bibliographies, a work destined to become a classic and to be found on the reference shelves of any serious library

Not if, as usual

He worked constantly at the revision of this book

Was that because the bibliographies needed constant revising or was it because the provenances of Besterman's rare books needed constant revising? His bank account would need constant revising to pay for the globe-trotting jollies

> **Perhaps not entirely legendarily, he is said to have arranged to be locked into the Library of Congress on a Sunday, that being the only day he could spare in Washington.**

If it's Sunday, it must be Washington. Besterman had to keep on the move because of his insistence on working alone. In the collegiate world of books that can attract adverse comment

> **Being the work of one man, it has been said that it would have been better had a number of specialists also been called on**

though not because of any worries he might be up to no good

> **but few could have worked with a man termed 'a master of near fabulous achievement'.**

I must look up the etymology of 'fabulous' when I have a minute to spare from my own fabulous achievements.

Where *was* the money coming from? Where were the rare books coming from? I acknowledge, for the moment, there is no case to answer, especially as along the way Besterman had acquired a rich American wife and a grand house in Hampstead. A grand house with a printing press on the top floor. Theodore had joined that remarkable interwar British cultural phenomenon, the artistic printing press.

Celebrated in countless adoring books, exhibitions and BBC documentaries, all agree these bijou publishing operations are one of the glories of a traditional, better, England. An England of the arts-and-crafts movement and the Bloomsbury Group. An England that disappeared forever under the all-devouring demands of the Second World War and the necessarily coarser tastes of a more egalitarian post-war society. We shall not see their like again.

Amen to that because it was the England of book forging and pornography. It is (have I mentioned it?) a matter of following the money. The business model of the artistic printing presses was

o producing bespoke limited editions of books
o on the most recondite of subjects
o illustrated by the leading artists of the day
o printed on specially crafted paper
o hand-cranked by worthy artisans
o bound in covers of the finest-tooled calfskin
o offered for private sale to discerning bibliophiles

In philistine Britain? In the Hungry Thirties? Give me a break.

Why don't we hear the real story for a change. It won't make any difference to the waves of nostalgic affection lavished on these little outfits, but you and I need to know what's what if we are to follow the spoor of one Theodore Besterman Esquire

Besterman edited two works for the distinguished Golden Cockerel Press

Too, too modest. He was involved in the whole creative process

The Travels and Sufferings of Father Jean de Brébeuf among the Hurons of Canada (1938) which he also translated

We know Besterman was fluent in Polish and English and he nearly attended the Lycée de Londres so we can add French, though it may be that Latin, possibly Huron, was necessary. We shall never know because the original has disappeared. Father Jean had disappeared too but only because he had become Saint Jean in 1930 during one of the Pope's bursts of canonical enthusiasm. What a stroke of luck they found his book. What a shame they lost it again.

There is precious little money in Ultramontane saints, no matter how topical they may be. Could Besterman come up with something better suited to a predominantly WASP market?

The Pilgrim Fathers: A Journal of Their Coming in the Mayflower to New England (1939)

Just the job. The date, by the way, is Besterman's because the date of the original is not altogether a matter of historical record

This account of the Pilgrims' journey to America and their subsequent travails there, "printed from an exceedingly rare volume (from 1622) in the British Museum"

It is never wise relying on the British Museum for anything other than their reasonably-priced quiche but even they might have smelt a rat about a colony founded in 1620 acquiring a history quite so rapidly

> **Written between November 1620 and November 1621, it describes in detail what happened from the landing of the Pilgrims at Cape Cod, through their exploring and eventual settling at Plymouth to their relations with the surrounding Indians, up to the First Thanksgiving and the arrival of the ship Fortune.**

The electric telegraph and rotogravure presses must have been working overtime for gentlemen in England now a-bed to be reading it with their petit-fours in 1622.

It is even less wise relying on Americans for anything other than their reasonably-priced meat patties in sesame-seeded buns

> **The booklet was summarised by other publications without the now-familiar Thanksgiving story, but the original booklet appeared to be lost or forgotten by the eighteenth century.**

Butterfingers! Thank the Lord of Hosts they found it again just in time for the bicentenary celebrations

> **A copy was rediscovered in Philadelphia in 1820**

A copy of what? The original was a printed copy that had been lost or forgotten in the eighteenth century, now found and reprinted in the nineteenth only to be lost or forgotten again until

> **the first full reprinting in 1841**

Fuller than what? There was only a booklet to start with. Maybe they mean added footnotes

> **In a footnote, editor Alexander Young was the first person to identify the 1621 feast as "the first Thanksgiving"**

Where was Young getting this? All the publications summarising the booklet left it out, the booklet does not seem to be the original and Puritans have thanksgivings like the rest of us have lash-ups down the boozer.

I'm beginning to wish I hadn't got involved with this one, excuses for overeating is a jealously-guarded right in America and they can be quite vengeful when they've a mind to be. The Golden Cockerel was thinking it might have cocked up too

> In Pertelote's bibliography of the Golden Cockerel Press from October 1936 - April 1943, the partners of the press express their surprise that this account of the Pilgrims' journey to America and their subsequent travails there, "printed from an exceedingly rare volume [from 1622] in the British Museum, did not attract more attention among our American patrons"

It was a good thing the porn side of the business was offering relief

> The illustrations in some Golden Cockerel titles, although tame by modern standards, were considered risqué for the time and necessitated the press taking precautionary measures against possible prosecutions for obscenity or provocation, such as disguising the names of translators and illustrators. Gallant Ladies was mild in comparison with the Song of Songs (1925) and Procreant Hymn (1926) both illustrated fairly explicitly by Eric Gill. The main defence of the press was that it was a private press, not a bookseller.

"Oh no, m'lud, Mr Gill is a bona fide artiste with a home life above reproach. I believe his daughters are here in court today along with some of the family pets if your honour wishes to examine them."

But the lights of small printing presses were going out all over Europe

> During the war Besterman indicates that he served in Civil Defence, the Royal Artillery and, doubtless more congenially and appropriately, the Army Bureau of Current Affairs.

Perfectly honourable but calls for a translation. People of Besterman's age and background (too old for the army, too sniffy for the Home Guard) often served as fire watchers during the Blitz (two nights a week staying late at the office with a stirrup pump). When Jerry turned east many of them were redirected to manning ack-ack guns twice a week. When the doodlebugs started up and professional artillerymen were required to shoot them down, the more educated among the amateur gun crews were drafted into

the Army Bureau of Current Affairs to give lectures to squaddies bored out of their minds waiting for the Red Army to win the war. Being lectured to by bibliographers with speech impediments didn't help.

One of the lesser explored byways of Britain's part in the war was how the Far Left employed their customary entryism now the ordinary Left had entered government by the coalition front door. Entire, if minor, branches of the war effort – the talks section of the BBC, black propaganda in the Ministry of Information, parts of the SOE, but above all the Army Bureau of Current Affairs – were swiftly converted into conveyor belts for the advancement of all the Widmerpools thirsting to make their mark in the post-war Brave New World. (Aldous Huxley's brother got UNESCO.)

Besterman now revealed himself to be a Man of the Left and fought Anthony Eden's old seat as the Labour candidate but, being unsuccessful, had to cast around for a post-war job. Preferably far away from bomb-ravaged London, preferably with an apartment in a fashionable arrondissement

He became head of the Department for the Exchange of Information for UNESCO in Paris

The fox had finally got the keys to the world henhouse. It could not last. A combination of being hectored by their new officer class at home and the Soviet Union's brutishness abroad, meant the revolution was all over by 1951 and the old gang were back in charge. A biographer recorded the changing times from Besterman's vantage point

This period of his life was coming to an end. His vision of bibliographical problems was extreme and his advocacy of his causes was ardent, impatient, rather than diplomatic, and around 1950 he turned to the study of, and thus the publishing of, the correspondence and works of Voltaire, a liberal spirit with whom he identified.

Possibly so but would it provide digs that measured up to a house in Hampstead or an apartment on the Left Bank?

In 1952 they moved to Geneva, where Theodore was appointed founding Director of the Institut et Musée Voltaire at Les Délices, Voltaire's former town house,

owned by Geneva City Council. The city fathers provided the building and a salary.

Mr and Mrs Besterman made themselves thoroughly at home. In Besterman's words

> "For over a decade I lived in his house, worked in his library, slept in his bedroom"

and beavered away in his office, forging softcore pornography for soft-brained academics

> Perhaps somewhat unexpectedly, the first stand-alone Voltaire study (1958) deals with the letters of Voltaire to his niece. Besterman was the first to discover the love letters to Mme. De Denis, which clearly prove that Voltaire's relationship with his niece was of a sexual nature.

What is it they say in Bradford, 'Where there's muck, there's brass'? Not in the clean streets of Geneva

> Funding was a problem and when Besterman sold material he had collected both before and after his arrival in Geneva at Sotheby's, there was dispute with the local authorities over its ownership. At issue was the removal and sale of items from the collection at Les Délices, with ownership hotly disputed by both sides.

What tomfoolery is this? A Besterman biographer recounts it in all its Ruritanian glory

> Theodore's tenure at Les Délices was destined to end in tears, with the tragicomic inevitability of grand opera. Theodore had no truck with pettifogging Swiss officialdom and they would no doubt have found M. le Directeur no less difficult to deal with. The atmosphere became increasingly poisonous as acrimonious accusation and counter accusation flew between the Geneva authorities and Theodore.

Pettifogging requests that Theodore stop half-inching the crown jewels led to him cutting and running for the German frontier just as the French wanted him for one of their cultural jamborees. Phone calls had to made in the highest places

**and could thus only attend the Nancy Enlightenment
conference from Germany and with the tacit agreement of
the French authorities in a car with blacked out windows**

though unlike Lenin

**He eventually lost the case and had to make financial
reparation.**

Thank heavens there was the Hampstead house and his wife to
fall back on. Oh no, there wasn't

**Evelyn and Theodore divorced. Theodore must have found
himself suddenly in quite straitened circumstances, with
the loss of both a salaried job and a grace-and-favour roof
over his head, and with no further recourse to Evelyn's
financial support.**

I share your pain, Theo. You spend a lifetime labouring in the serv-
ice of the common weal and what have you got to show for it?
Take my advice and start looking after number one. If only I had
listened.

**He set himself the target of making his first million in two
years**

I'm more week-to-week myself but how did you make out?

**That he succeeded in the 1960s was no mean feat. From
the early 1960s, Theodore decided to collect art seriously.
He sought advice from an authoritative insider, who
understood the trade. At the time, British watercolours
were out of favour, so Theodore began to buy judiciously,
against little competition. Theodore had, I believe, a good
eye.**

Whoa there! Aren't one or two lilies being gilded? Nobody makes
money out of art by having a good eye. Art appreciation refers to
prices not to connoisseurmanship. And anyone who seeks 'advice
from an authoritative insider' will quickly discover the truth of the
old adage, "If you want to make a million collecting art, start with
two million." As for Theodore Besterman needing expert help,
someone's having a laugh.

**In June 1969, an exhibition was mounted at the Leger
Galleries in London, entitled English Watercolours and
Drawings from the Collection of Theodore Besterman. The**

catalogue provides evidence of a collection that spanned 250 years of English watercolourists.

Whenever words like 'collection', 'catalogue', and 'Besterman' (and 'Leger Galleries') start turning up in close association, there are going to be gilded lilies as far as the eye can see

> It included, inter alia, works by Bratby, Constable, Peter de Wint, Flaxman, Rowlandson, Gillray, Hepworth, Kneller, Lear, Lowry, Millais, Palmer, Reynolds, Rosetti, Sandby, Sickert, Sutherland, Tissot, Turner and Zoffany.

Now look, when it comes to art I'm a kittens on chocolate boxes sort of person. My area of expertise is pressing Google buttons so here is something I came up with after several minutes of research

> Sothebys auction catalogue 2014. Old Master British drawings. Sixteenth century miniature portrait in water colour. The present drawing is likely to date from after Oliver's visit to Italy in 1596 and it can be compared with his figure studies, now at the Courtauld Institute of Art in London. Previous owners of this rare work include the artist and collector Jonathan Richardson, Miss Dora Webb and Mr Theodore Besterman. (est £4-6000)

Clever old me had spotted that worrying gap in the provenance between Jonathan Richardson (1665-1745) and Dora Webb (1886-1973). Clever old anyone if you're looking for it. According to Mr Google, Ms Webb was also 'a water colourist of miniature portraits' which is not, even I know, one of the more populated areas of the fine arts. I may not know much about art but I know an awful lot about jobbing artists and I can tell you, for an absolute fact, we never hang on to valuable 350-year-old originals of our chosen genre for long. They're the first thing that gets hocked. Unless Theodore Besterman calls round and asks us to knock up another one. I mean, asks us to get it out of hock.

I'll tell you another thing. You are never going to get rich hanging round with jobbing artists, you have to hang with the non-jobbing kind

> Theodore was genuinely interested in art and enjoyed the company of artists. Jacob Epstein was a friend – the story goes that he oversaw the delivery of a consignment of sculptures to New York, for which he received a bronze bust in lieu of payment.

As it happens, I can vouch for this. 'Epps' was a great friend of mine back in the day, and I got a bronze in similar circumstances. I expect you have heard me tell the story on Russell Harty but it is always worth a fresh airing:

Jacob Epstein: Yes?
Mick Harper: It's Mick.
JE: Mick who?
MH: Mick Harper.
JE: Sorry, didn't recognise your voice. I'm a bit frazzled at the moment, to be honest.
MH: Lucky I rang then. Do you fancy coming for a jar?
JE: I'd love to, Mick, but I'm in the middle of organising this consignment for New York.
MH: Anything I can do to help?
JE: I very much doubt it. As a sculptor of some renown I'm used to sending my work abroad and since this will be a good year's worth, I've got to get it right.
MH: So what's the prob?
JE: Well, obviously I use the best shipping agents but somehow I've got myself in a right two and eight. I've got to get it round to them pronto and minicabs are murder at this time of night.
MH: I've got a van.
JE: Have you? That's a stroke of luck. And if we finish early we'll have time for a swift half before chucking-out time.
MH: A half? You tight bugger. Is that what you lot mean by 'There'll be a drink in it for you'?
JE: Yes, sorry. Tell you what, you can have a bust if you like. I've got one hanging round the place somewhere.
MH: Sotheby's? Valuation department, please... I've got this Epstein bust... no, not documentation as such, I was a friend of... yes, all right, two o'clock sharp. Not one of his best, I'm afraid, he was using it as a doorstop.

Serial fakers have one constant pre-occupation: how to persuade the mark that when they are told there is a lot more where that came from, they are going to say, "Keep 'em coming." People can get lucky once, they can get lucky twice, but after that questions may be asked. One of the best ruses is the 'charitable bequest'. Nobody gets asked too many questions if they were not looking to make money in the first place. Besterman knew all the best ruses

Instead of cashing in his investment, when interest in watercolours returned, he first offered his collection to the nation

There are a few inaccuracies in that statement

- He *was* cashing in
- He had *not* invested in art – he couldn't, he was on his beam ends
- Interest in watercolours could *not* have returned because it never went away – there are fads in art collecting but they do not extend to entire techniques
- Besterman did *not* offer his collection to the nation

If he had, questions would most definitely have been asked.

Characteristically, he made conditions, which were non-negotiable

Besterman may not have been the pleasantest person to negotiate with but he was never a non-negotiator. Unless he wanted not to be

He was prepared to allow his collection to be displayed in its entirety in a dedicated extension at the Dulwich Picture Gallery

If I were running a suburban art gallery and I was offered, free, gratis and for nothing, works by Bratby, Constable, Peter de Wint, Flaxman, Rowlandson, Gillray, Hepworth, Kneller, Lear, Lowry, Millais, Palmer, Reynolds, Rosetti, Sandby, Sickert, Sutherland, Tissot, Turner and Zoffany (inter alia, we must not leave out the inter alia, inter alia) I would probably agree to an extension. I certainly would if I was running a suburban art gallery linked to as many malfeasances as the Dulwich Picture Gallery has been over the years. But that's for another time.

or in refurbished rooms in Somerset House

There was always vague talk of turning the old place into a fun palace though, at the time, it was where we Londoners got our birth, marriage and whatnots certificates from. A Besterman biographer had the same broad recollection

The latter option was prescient in terms of today's use of the building but neither alternative was acceptable to the Government.

You know what? Sod 'em

Piqued by his treatment by an ungrateful nation, he con-signed the whole collection for sale through Sotheby's auction rooms. The sale, I was told, lasted two days.

Part Five

MUSEUMS, DENS OF ANTIQUITY

26 Fakes Are Us

- o Visit a museum near you
- o select a room in that museum
- o stand in the middle of the room
- o turn through three hundred and sixty degrees

Decide which of these statements applies

- o everything I see is genuine
- o there may be a few fakes
- o maybe half and half, fake and genuine
- o basically all fake, some of it may be genuine
- o everything I see is fake

The last is more often the case than you might anticipate because

- o museums must have things the public wants to see
- o what the public wants to see, there are not many of
- o there are a great many museums
- o there will never be enough to go round
- o there is no alternative but to accept

fakes

Nobody will think they are fakes because

- o they are in a museum
- o unless the fakes are side-by-side with the genuine article
- o the public will not spot the difference
- o scholarly-trained museum curators might
- o why take the chance by providing direct comparisons?

But won't the curators spot they are *all* fakes? No, because of

careful ignoral

- o museum curators know there are fakes in museums
- o they know there may be fakes in their museum
- o they cannot know everything is fake and be curators

Does any of this apply to famous museums, the ones that can afford the genuine stuff? Yes and no

- o famous does not equate to limitless funds
- o they rely on government budgets and patrons' generosity
- o they are competing with the mega-rich with limitless funds
- o not to mention new museums who want to be famous

Does any of this apply to the great *national* museums? Yes and no

- o the museums were not, in the early days, rich
- o they could hoover up artefacts reasonably cheaply
- o but knowledge about them was limited
- o so authenticity of the artefact could not be guaranteed
- o it didn't matter, the museums were being run by crooks

It is far too late to do anything about it now. Or to mind very much since it is better to have lots of museums with lots of fakes than hardly any museums with hardly any fakes. But revisionists need to know the scale of it because it impinges on true and fake history. We can get started with a quick Q & A

Q: Which museum is the benchmark for national museums
A: The British Museum
Q: Which individual is responsible for the British Museum being the benchmark for national museums
A: Augustus Franks

> **Sir Augustus Wollaston Franks KCB FRS FSA (20 March 1826 – 21 May 1897) was an English antiquary and museum administrator. Franks was described by Marjorie Caygill, historian of the British Museum, as "arguably the most important collector in the history of the British Museum, and one of the greatest collectors of his age" ... "In many respects Franks was the second founder of the British Museum." Franks purchased over 20,000 important objects for the British Museum's collections.**

We can put some of these 20,000 important objects to our new 360 degree test

> **The Oxus treasure is a collection of about 180 surviving pieces of metalwork in gold and silver, the majority rather small, plus perhaps about 200 coins, from the Achaemenid Persian period, which were found by the Oxus river about 1877-1880. The British Museum now has nearly all the surviving metalwork, with one of the pair of griffin-headed bracelets on loan from the Victoria and Albert Museum, and displays them in Room 52.**

About 1877-1880. You will have spotted this screaming red flag. Two red flags actually: the dates are too precise to warrant an 'about' and what sort of treasure takes three years to unearth?

A later report by Sir Alexander Cunningham, the British
general and archaeologist who was the first Director of
the Archaeological Survey of India, described the finds,
which he said began in 1877, as being in the river itself,
"scattered about in the sands of the river", in a place
exposed in the dry season.

One cannot ask for a more expert and more upright witness than
a general appointed the first Director of the Archaeological Survey
of India, so this puts an end to the matter. If only he had

though another account he later gave, based on new
information, rather confused the issue.

He had been talking to someone in the mess

Another account by a British general owning some of the
objects said that they had been discovered in 1876, exposed
by "a land slip of the riverbank"

One sees what the British Museum means by 'about 1877-1880'.
They mean 1876. And call me old-fashioned but I do not approve
of witnesses having a personal stake. This is the land of Warren
Hastings. What did the Director of the Archaeological Survey of
the land of Warren Hastings do, armed with this new information?

Cunningham acquired many pieces himself through
dealers in northern India

Putting the best gloss on this, one of the duties of the Director of
the Archaeological Survey of India was to acquire representative
samples of ancient artefacts for British museums. But if dealers
were supplying the military, who was supplying the dealers?

The treasure was evidently discovered by local people
somewhere on the north bank of the Oxus in what is today
Tajikistan but was in the 1870s in the Emirate of Bokhara,
which was in the process of being swallowed up by the
Russian Empire. Then as now, the south bank of the Oxus
was Afghanistan. At the period when the treasure origin-
ated the whole area was part of the Persian Achaemenid
Empire.

A real clash of empires and we have not reached the British
Empire yet. I see troubles ahead.

The first mention in print of the treasure was an article in a
Russian newspaper in 1880, written by a Russian general
who in 1879 was in the area enquiring into the Trans-
Caspian railway that the Russians had just begun to con-
struct. He recounted that local reports said that treasure
had been found in the ruins of an ancient fort called 'Takht-
i Kuwad', which was sold to Indian merchants.

Two important details here: (1) a fort (2) Indian merchants.

The exact place and date of the find remain unclear, and it
is likely that many other pieces from the hoard were
melted down for bullion; early reports suggest there were
originally some 1500 coins, and mention types of metal-
work that are not among the surviving pieces.

Two important details here: (3) the treasure is real (4) it is in danger.
If what is left is to be saved for the heritage of humankind, it will
have to reach the safe custodianship of the British Museum. If
niceties have to be dispensed with to get it there, so be it.

One large group of objects, perhaps the bulk of the treas-
ure, was bought from locals by three merchants from
Bokhara in 1880

Three wise men from the east. We must pray they did not fall
among thieves

who unwisely left their convoy on the road south from
Kabul to Peshawar and were captured by Afghan tribes-
men, who carried them and their goods into the hills

Kabul to Peshawar! There is a journey that makes every right-
thinking Englishman shudder. An entire British army, with a full
complement of memsahibs, perished lock, stock and honour on
the road from Kabul to Peshawar during the First Afghan War.
One man was allowed to escape, triggering the Second Afghan
War. But I digress.

but allowed a servant of the merchants to escape. News of
the episode reached Captain Francis Charles Burton, a
British political officer in Afghanistan, who immediately
set out with two orderlies.

I don't know why he would need two orderlies. One to carry the butterfly net perhaps, but that would only be a guess.

> About midnight he came upon the robbers, who had already begun to fight among themselves, presumably over the division of the loot, with four of them lying wounded on the ground. The treasure was spread out on the floor of the cave they were sheltered in. In a parlay Burton recovered a good part of the treasure.

A parlay? God's teeth, man, a few slices of Sheffield steel is what the situation called for. But these political johnnies have their own way of doing things and we must respect that

> and later a further portion, which he restored to the merchants. In gratitude, they sold him the bracelet which he sold to the Victoria and Albert Museum (now on loan to the British Museum) for £1,000 in 1884.

Many will wonder just how much gratitude is involved in selling it back to him but if I may intrude an explanatory note here: a provenance is not only important for authenticating valuable items, it must also establish the seller has the legal right to be selling it. Technically, Captain Burton being a British political officer, was only doing his job and had no more right to the bracelet than I do. If he was given the bracelet by way of a thank-you he must hand it in to his superiors or face being cashiered for accepting gifts while carrying out his official duties. He bought it? Case dismissed.

> The merchants then continued to Rawalpindi to sell the rest of the Treasure; Cunningham acquired many of these pieces. Franks later bought Cunningham's collection.

Putting the best gloss on this, the Director of Archaeology has supplied artefacts to a representative of a British museum. Sir Augustus Franks was the right man in the right place, an old hand with anything sourced from Indian dealers

> Dalton records that Indian dealers initially made copies of items and tried to pass them off to Franks, who though not deceived, bought some "at a small percentage over the gold value" and then received the genuine objects, which were easily distinguished

Who would know better than Ormonde Maddock Dalton, also pseudonymously W. Compton Leith, an appointee of and eventual successor to Franks as Keeper of British and Mediaeval Antiquities at the British Museum? Famous for his catalogues was Dalton. Or Leith.

People who have not been out east (Franks being one such) may not be familiar with the technique

o someone sidles up to you
o they offer you a gold replica
o you pay over the odds for it
o but it turns out they have the genuine article
o in case you see through their little game

Sounds complicated. Even, dare one say, a little alarming, so it is something of a relief to hear the British Museum chose a more conventional channel in the case of the Oxus Treasure

Franks bequeathed all his objects to the British Museum at his death in 1897

All's well that ends well. But enough of imperial administration, it is the Oxus Treasure itself we are interested in

As a group, the treasure is the most important survival of what was once an enormous production of Achaemenid work in precious metal

The Achaemenids are the Persian kings who most people would know from what the Classical Greeks did to them at famous places like Marathon and Thermopylae. They bear names almost as famous – Cyrus, Xerxes, Cambyses, Darius – and they were finally consigned to history by that most famous name of all, Alexander the Great. According to our western understanding they are pretty much the most significant royal dynasty that ever lived, responsible for the largest and most successful empire the world had ever seen. Meaning the Oxus Treasure, as 'the most important survival of the enormous production of their work', is a stupendously big deal and well worth a room in the British Museum.

It also means, naturally enough, that the Oxus Treasure will be one of the most pored-over collections by scholars the world has ever seen. With results that lay people can find hard to interpret when reading about it on the museum's official website

> **The metalwork is believed to date from the sixth to fourth centuries BC**

As a layperson myself I am nonplussed. The Achaemenids are *known* to be from the sixth to fourth centuries BC so I am not clear how Achaemenid treasure can only be 'believed to date from' this period. But as I say, I'm only a layperson, we must press on.

> **but the coins show a greater range, with some of those believed to belong to the treasure coming from around 200 BC**

With the Achaemenids dispatched by Alexander and Alexander himself dispatched in 323 BC, we can leave the chronological mismatch to the experts to argue over and turn to the 'find site'

> **The most likely origin for the treasure is that it belonged to a temple, where votive offerings were deposited over a long period. How it came to be deposited is unknown.**

Votive offerings are frequently cast into bodies of water but not entire treasures. If one might be permitted a homonym, there might be loads of treasure cast into the Oxus River but not by the treasure-lode. There has to be an aggregating mechanism somewhere along the line for there to be an Oxus Treasure in the Oxus River. A fort has been mentioned but only in travellers' tales in Russian newspapers and not even a nineteenth century museum can rely on that as a provenance. A temple would be a better bet

> **The approximate area of the discovery is fairly clear; it was near, perhaps some three miles south of Takhti-Sanguin, where an important temple was excavated by Soviet archaeologists in the 20th century, producing a large number of finds of metalwork and other objects...**

That would surely do it. Unfortunately not

> **...which seem to have been deposited from about 300 BC to as late as the third century AD.**

Third century BC to third century AD makes all the finds post-Persian. The Achaemenids were gone by the fourth century BC and no Iranian empire got this far east again. There is some danger the Oxus Treasure has no connection with Persians and hence no connection with those fabled Greeks who ensured Europe would

not be speaking Farsi today. We are in need of some academese, the language museum staff speak today

> **While it is tempting to connect the temple and treasure, as some scholars have proposed, the range of objects found, and a founding date for the temple proposed by the excavators of about 300 BC, do not neatly match up.**

This is literally true, two completely different time periods do not match up, academese prides itself on being literally true. Though 'neatly' suggests it was as near as damnit. The brain has registered

> about 300 BC

Alexander died in 323 BC which is 'about 300 BC'. The brain has registered the metalwork is believed to date from

> the sixth to fourth centuries BC

and that includes 300 BC. It is as near as damnit so even though the temple finds have nothing whatsoever to do with the Achaemenids, the brain has registered

> there is a temple somehow involved

But academese prides itself on being literally true. This has been achieved by rejecting the temple.

Why the need for academese at all in the non-academic context of a museum discoursing to the general public on its website? It is because the British Museum finds itself in such a bind over its Oxus Treasure that it is the professionals, not the public, that have to be bamboozled. Professionals may not read museum blurbs but they do write them, so they dare not write them in plain English without the risk of, we might say, unbamboozling themselves. There would be a real crisis if this happened because the curators at the British Museum

- o know there has to be an aggregating mechanism
- o know they have not got one
- o know one will have to be provided
- o know this can only be achieved by lying their heads off
- o without knowing they are lying their heads off

It is easier than you might think. First, state a truism

> **The area was a major ancient crossing point for the Oxus, and the treasure may have come from further afield.**

This is literally true. Treasure is almost never manufactured at river crossings so the treasure probably came from elsewhere. Indeed, it could have come from anywhere.

The search is over.

"There is no point looking. The Achaemenid Empire was the biggest in the world, we've got no chance."

By taking us all round the houses, the British Museum has left us all assuming the Oxus Treasure came from somewhere. That is the beauty of academese. It takes so long to say everything, it is awfully hard to notice when it is saying nothing.

With the octopus making off in a cloud of ink, the real question was left unaddressed:

How come the Oxus Treasure, the most important survival of Achaemenid work in precious metal, is still the most important survival of Achaemenid work in precious metal?

Surely to Ahura Mazda, archaeologists must have turned up something better since 1875? After all

- o The Achaemenid Empire was the biggest in the world
- o It is famous for its 'enormous production of work in precious metal'
- o It has a great many places more likely to produce treasure hoards than far off river-crossings
- o It is full of royal capitals – Ecbatana, Pasargadae, Susa, Persepolis, Babylon – just for starters

But no, the Oxus riverbank reigns supreme to this day.

It is a world record in fact, and we know how much revisionists love their world records. In this case they would probably enquire who came second. It was this one

> **In particular, finds of jewellery including armlets and torcs in a tomb at Susa by a French expedition from 1902 onwards (now in the Louvre) are closely similar to the Oxus finds.**

The British Museum was so heartened by this French endorsement of its Oxus Treasure, it could afford a rueful apology for being first

> **Considerable comfort has been received from the objects' similarity to later Achaemenid finds, many excavated under proper archaeological conditions, which the Oxus Treasure certainly was not.**

Did you spot that 'certainly'? A tiny foot is being stamped. Why?

You are being lied to.

You are not being lied to by whoever is responsible for official British Museum blurbs. He or she is as honest as the day is long. Of course they must be as dim as an environmentally-friendly lightbulb to believe it but you don't have to be terribly bright to spot the lie. You only have to be looking for it.

What the British Museum is saying is the Oxus Treasure cannot be authenticated historically, archaeologically, numismatically or by provenance, but it can be authenticated

by typology

a standard practice and a perfectly proper one. The Oxus Treasure, they are saying, is similar enough to authenticated Achaemenid artefacts for diagnostic purposes. Now juxtapose the two passages

> **Considerable comfort has been received from the objects' similarity to later Achaemenid finds, many excavated under proper archaeological conditions, which the Oxus Treasure certainly was not.**

> **In particular, finds of jewellery including armlets and torcs in a tomb at Susa by a French expedition from 1902 onwards (now in the Louvre) are closely similar to the Oxus finds.**

Two phrases have been quietly introduced that should not be there. The point of typologies is they are *general* and show *similarity* so why has somebody gone out of their way to emphasise the Susa treasure

in particular is closely similar to the Oxus treasure

The switch took place here

many excavated under proper archaeological conditions

Ya got it in one. Susa was *not* one of the many excavated under proper archaeological conditions. In 1902? Are you kidding? But why bother with Susa at all? They've got squillions of the stuff, all excavated under proper archaeological conditions, so why are they basing their typology on finds made by a bunch of turn-of-the-century cowboys?

Ya got it in two. The Oxus and Susa finds resemble one another but *don't* resemble later Achaemenid finds, the ones excavated under proper archaeological conditions. Yes, yes, very clever of you, but the fine folk over at the British Museum do not have your advantages so we shall have to provide them with one of our ten-step, easy-to-follow, not-in-academese, revisionist guides for them to carefully ignore

1. There is a Russian report of treasure being found, but then scattered to the winds, purporting to come from an area (Afghanistan) and a historical period (600 BC to 300 BC) of consuming interest to westerners because Persian kings and Alexander the Great were operating there at the time.

2. Spotting an excellent business opportunity, forgers in India set to work producing suitably 'Achaemenid' artefacts which was not difficult because nobody at that time had done much Achaemenid archaeology so nobody really knew what they looked like.

3. These fakes are bought by corrupt officials in British India and sold on to corrupt officials in the British Museum.

4. The British Museum puts the Oxus Treasure on display to public acclaim. The Achaemenids are all the rage.

5. This excites the envy of the Louvre who would dearly like some Achaemenid material, but how? The British collection is the result of 'a lucky find', they cannot wait around for one of their own.

6. So the French send out an archaeological team to a handy Achaemenid capital to see what they can come up with.

7. While they are away corrupt officials at the Louvre alert trusted workshops in France they are in the market for artefacts resembling the ones currently being exhibited in the British Museum.

8. On their return home, the archaeologists join the museum officials to select a range of 'Achaemenid treasures' from the workshops which go on display at the Louvre to public acclaim. The Achaemenids are all the rage in France too.

9. Real archaeologists start conducting real archaeological digs in real Achaemenid strata and find real Achaemenid artefacts that are quite different from either the British Museum's or the Louvre's Achaemenid artefacts.

10. Nobody gives a tinker's cuss for a hundred years.

> In 2003 the archaeologist Oscar Muscarella, employed by
> the Metropolitan Museum of Art in New York for 40 years,
> was reported in The Times as having labelled the Oxus
> Treasure "mostly fake".

Has he looked at his contract of employment lately?

> However he was attacked by the Director of the Metro-
> politan, Philippe de Montebello, who said Muscarella, a
> long-standing critic of museums' tolerance and even
> encouragement of the trade in illegal antiquities, only
> remained there because of the "exigencies of academic
> tenure".

"You deal with him, Phil, we can handle everything else in-house
here at the BM."

> In a follow-up article, John Curtis argued there is over-
> whelming contemporary evidence that the Treasure was
> discovered on the north bank of the River Oxus between
> 1877 and 1880, and he also maintains that most if not all of
> the objects in the Treasure are genuine.

Most if not all. Which ones did you have doubts about, John? It's all
right, you don't have to say out loud, just nod as we point.

Curtis was the British Museum's Keeper of the Middle East
Department from 1989 to 2011 so he should know his way about

> He is presently Chief Executive Officer of the Iran Heritage
> Foundation.

The British were happy, the French were happy, the Iranians were
happy. The natives were not happy

> The treasure was evidently discovered by local people
> somewhere on the north bank of the Oxus in what is today
> Tajikistan. In 2007, the President of Tajikistan was
> reported as calling for the repatriation of the treasure, and
> in 2013 "high-quality golden replicas" of pieces from the
> Oxus Treasure were presented to the Tajik government by
> the British Museum, intended for the new Tajik National
> Museum.

Now everyone's happy.

I tell a lie. The Achaemenids were such a rage in Europe during
the twentieth century that the incurably westernising Shah of Iran

decided to throw an almighty bash in October 1971 to celebrate the 2,500th anniversary of the founding of the Persian Empire by Cyrus the Great

> **Some later historians argue that this massive celebration contributed to events that culminated in the 1979 Iranian Revolution**

Thanks, British Museum.

27 History in Another Box

> **The Franks Casket (or the Auzon Casket) is of unique importance for the insight it gives into early Anglo-Saxon art and culture**

The Anglo-Saxons are of unique importance because we *are* Anglo-Saxons, everyone says so, and with 'Anglish' being the current world language, artefacts do not come much more important. Franks being a crook does not mean his casket is a fake but it does mean it may be worth finding out. Who knows, we may discover we're not Anglo-Saxons after all.

> **One of his best known donations was the ninth-century ivory Franks Casket from Northumbria with its runic inscriptions.**

Runes make museum curators breathe more easily.

> **The Franks Casket is a small Anglo-Saxon whale's bone (not "whalebone" in the sense of baleen) chest from the early 8th century, now in the British Museum. The casket is densely decorated with knife-cut narrative scenes in flat two-dimensional low-relief and with inscriptions mostly in Anglo-Saxon runes.**

Mostly. Did the inscriber feel he had better include some foreign ones to fox the reader? No doubt we shall discover because

> **identifying the images and interpreting the runic inscript- ions has generated a considerable amount of scholarship**

Not to say a considerable amount of interest from revisionists though we do not refer to our work as scholarship. One hopes one is better than that. As ever, we start where Wiki starts

> **The Franks Casket (or the Auzon Casket)**

What connection can there be between Anglo-Saxon Northumbria and a village in the middle of France? Such an unusual nexus took an unusually long time to establish, as the British Museum is quick to acknowledge

> **The post-medieval history of the casket before the mid-19th century was unknown until relatively recently, when investigations by W H J Weale revealed that the casket had belonged to the church of Saint-Julien, Brioude, Haute Loire, France.**

Tsk! Best practice is to have provenances sorted *before* items go on public display. It is even better practice to have a provenance *after* they have gone on public display. Although the British Museum wordsmiths have conveyed the impression that

- o the pre-medieval period of the Franks Casket is known (it is Anglo-Saxon)
- o the medieval period was already known (it is not mentioned so that can be assumed)
- o the post-medieval period is now known (thanks to W H J Weale)
- o the Franks Casket has a complete provenance from eighth-century Northumbria to twenty-first century Bloomsbury

If you revisit that paragraph what they have actually done is

- o replace a village in the middle of France (Auzon) with a church in the middle of France (St Julien's, Brioude)

What they have not done is to mention there is no compelling evidence where the casket came from, when it was made or who made it. It is a box with carvings on it. It could have been made by

- o an eighth century Anglo-Saxon
- o a nineteenth century French cabinet-maker
- o Sir Augustus Franks

The whole thing would be cleared up in five minutes by sticking it under the hood of a scanner but, this being a National Treasure, such an indignity may not be visited upon it. The world will just have to put up with us.

Getting the Casket from Northumbria to the middle of France is going to need more than academese, it is going to require

academic chat

Academic chat is an essential cog in all subjects where raw data is so scarce that 'what is known' is not enough to fill lectures, books, learned papers, learned vacancies. It involves experts playing 'let's pretend'. That is not as bad as it sounds. High-level, free-ranging discourse can be very useful for generating hypotheses. But it is not at all proper to present the results as raw data. When there is a shortage of raw data but not a shortage of academics, there is

always the danger that what started out as high-level free-ranging discourse ends up as something indistinguishable from raw data. See if you can spot the difference now that several generations of academics have been chatting about the Franks Casket

What used to be seen as an eccentric, almost random, assemblage of pagan Germanic and Christian stories is now understood as a "sophisticated programme perfectly in accord with the Church's concept of universal history".

I can't and I would certainly be teaching that if I had been taught it in such categorical terms. Given such a firm base of 'what is now known', I would probably be joining in with some more high-level, free-ranging discourse to generate further hypotheses

It may have been intended to hold a book, perhaps a psalter, and intended to be presented to a "secular, probably royal, recipient".

Pagans, Christians, royalty, Britons, Germans, French, a universal church, diplomatic hands across the sea. A whole world in a box.

Academic chat may have got the casket from England to France but for the Auzon Casket to become the Franks Casket it will have to begin its return journey. And what a journey it proved to be. Are you sitting comfortably? Then we'll begin.

It is possible that it was looted from St Julien's during the French Revolution

Saint-Julien's is still there, still full of historic religious bric-à-brac, still connected to France Telecom, so why don't we have a chat with them? We are not academics and nor are they so although it will not be high-level free-ranging discourse it might produce some raw data. [My French is rubbish, having only had four years of daily lessons, and the French always refuse to speak English, so I have had to reconstruct our conversation from standard sources.]

"Any record of an early whale bone casket?"
"No, not as such and we've got inventories going way back."
"Reliable, are they?"
"Good lord, no. We're a church not a museum."
"Any record of you being looted during the Revolution?"
"Not as far as I know but it wouldn't surprise me."
"So you could have had a whale bone casket which might have been looted?"

"Absolutely. We look after it all as best we can, don't get me wrong, but it's not why we're here. People love our stuff. Hard to squeeze in a service some days with the crowds we get, but they don't badger us about the minutiae of art history. Having said that, keep us posted about this casket of yours, we get the odd enquiry. We're in English Wiki, I'm told. Salut!"

It was then in the possession of a family in Auzon, a village in Haute Loire

It has taken time and effort but finally we have real people bearing witness to a real casket. So vital a link in the provenance of the Auzon/Franks Casket deserves nothing less than a formal roll call

The family
who have requested anonymity

Professor P. P. Mathieu
who purchased some panels of the casket from the family

The Carrands, père et fils
who purchased a single panel from the family

The Bargello Museum, Florence
who obtained the Carrands' panel

W H J Weale
who went to Auzon to research all this

The British Museum
who sent Weale to find this out and received his report

The townsfolk of Auzon
the casket having put them on the world map

From a strictly provenance perspective the family's anonymity is both a nuisance and a mystery

- o One would dearly like to know how they acquired the casket and from whom. Was one of them a sans-culotte?

- o One would dearly like to know how they persuaded the townsfolk not to reveal their name for two hundred years as their town became synonymous with Anglo-Saxon artefacts of international renown.

- o One would dearly like to know why neither the Bargello nor the British Museum have disclosed the name at some point between the nineteenth and twenty-first centuries.

Somebody did glean other salient points from the family. For instance, why they wanted it in the first place

It served as a sewing box

One has to admire the good sense of families in la France profonde where there is a place for everything and everything is in its place. If one were to enter a small note of criticism, it would be their grasp of physics

> **until the silver hinges and fittings joining the panels were traded for a silver ring. Without the support of these the casket fell apart.**

Time for another tip for find-a-fake fanatics. The genuine article comes whole or, due to the vicissitudes of time, with

random bits missing

A fake one, not having had to suffer the vicissitudes of time, comes whole or with

specific bits missing

They tend to be the tricky bits fakers try to avoid having to do because they might give the game away if not done exactly right.

Consider, by way of example, why Dark Age gospel books so often lack their covers and frontispieces, the tricky bits from a forger's point of view. The official explanation is that the covers of the gospel books went first because, being studded with semi-precious stones, they would often get ripped off by thieves. This demonstrates an admirable but profound ignorance of the criminal mind. I'm from south London:

o a gospel book has a high value
o a coverless gospel book has a less high value
o a gospel book cover has no value
o semi-precious stones on a book cover have some value
o semi-precious stones are easier to gouge out of a cover attached to a gospel book than from a cover not attached to a gospel book

so if you ever come across a coverless early medieval gospel book you can be confident thieves did not get there before you.

Once a gospel book lacks a cover, it will start losing pages from fair wear and tear. Mainly from the front where the frontispiece pages are. Though obviously it will still have most of the gospel pages or it would have been thrown away at the time. Suffice it to say that enough always survives for modern scholars to say, "Yep, they're the Gospels all right, know 'em anywhere."

There is no shortage of Dark Age gospel books (only everything else) so it will come as no surprise there are variations on the theme. If, for example, it is Irish malefactors making off with the *Book of Kells* the scallywags tore the cover off all right but piously buried the book itself before disappearing into the Irish gloaming with their ill-gotten semi-precious gains. God alone knows how the monks of Kells found the book's burial place. "Have you tried over there, Brendan? They can't have got far, it'll be somewhere in County Meath."

The British Library did not have to search for St Cuthbert's gospel book, it came to them. Being the saint's personal possession it lacked any fancy trimmings on the cover but that had not saved it. Pilgrims visiting Durham Cathedral in the twelfth century were, for a small fee, allowed to walk about with it in a bag round their necks until one of them walked off still wearing it. What happened to Cuthbert's book for the next seven hundred years is unrecorded but it must have passed through many hands before the Jesuits could find some mugs to take it off theirs. For nine million pounds Jesuits are prepared to let the Word of God go. Yea, even unto Protestants.

Anglo-Saxon silver joinery counts as a tricky bit so after the hinges and fittings of the Auzon Casket had gone to the silver-smith (local chappie, didn't catch the name) and the box had been reduced to disarticulated panels, the family could only pile them neatly in a corner hoping for an uptick in the disarticulated sewing-box panel market. Which duly occurred

The parts were shown to a Professor Mathieu from nearby Clermont-Ferrand, a member of the Academy of Science, literature and arts of Clermont-Ferrand

A real head-scratcher. Before Les Antiquités Roadshow very few families showed sewing box panels to inquisitive academics, but the Franks Casket has always been a lucky casket and Professor Mathieu turned out to be just the man to show it to

In 1835 he presided over the commission to erect a monument in Gergovie to the glory of Vercingetorix

The one person locally who would fully appreciate the importance of ancient artefacts and the part they play in the history, indeed the glory, of one's country. The only decision our patriot-antiquarian

had to make was whether to show off his newly-purchased panels proudly in Clermont-Ferrand or send them to Paris and a national collection. No question, it had to be Paris

He sold them to an antique shop in Paris

That is the official story, and remained so for forty years until the British Museum found themselves scratching their own heads. Its revered Sir Augustus had provided them with a backstory but not a provenance

> The panels were in a Paris antique shop where they were bought in 1857 by Sir Augustus Wollaston Franks. It had been dismissed as 'some Ancient carvings in ivory', and turned down by the Museum's Trustees in 1858 when offered to them for 100 guineas. He subsequently donated the panels in 1867 to the British Museum, where he was Keeper of the British and Medieval collections

With Franks now in his casket, the BM needed a provenance for theirs and sent out ace investigator, W H J Weale, to find one. It was to prove a long and winding road.

First problem: Franks had omitted to mention the name of the shop, there was nothing in the archives, so Weale was stymied from the off.

That could be finessed. Franks and Weale overlapped at the museum so maybe Franks mentioned the name of the shop to Weale in passing and both of them had omitted to pass it on to the museum archivists. Not ideal but it meant Weale could hit the road

Second problem: After forty years would the shop still be there? The life-cycle of antique shops being what they are.

Third problem: If it was, would they remember selling some old panels to an English gent forty years before?

Fourth problem: If they did, would they remember where they got the panels from?

All things considered, it might be better to adjust the provenance and, sure enough, the British Museum's official provenance for the Franks Casket now reads

> In the possession of a family at Auzon (France) in the early nineteenth century; Professor P.P. Mathieu before ca. 1850; Jean Baptiste Joseph Barrois (d. 1855), 1850s;

> **Augustus Wollaston Franks, 1858; The British Museum, London, 1867, by gift.**

The British Museum have inserted

a cut-out

Someone who can provide an essential link in a chain of custody but who, for some reason, is unavailable for closer examination. Franks may have got his casket from an antique shop but the shop got it from a Monsieur Barrois and everyone will be off the hook if he was the sort of cove who paid attention to provenances. He was!

> **Barrois, Jean-Baptiste Joseph (1785-1855) Honorary member, Academic society of antique dealers of Moinie (1834-50)**

Barrois had died at just the right time for portions of his estate to be sold off to high-end Parisian antique dealers with a clientele that included high-end English collectors.

Fifth problem: Jean-Baptiste Joseph Barrois turned out to be a wrong 'un

> **Joseph Barrois (ca. 1785-1855) was an erudite but eccentric and indeed crooked bibliophile who became fatally involved with the notorious and unpunished book thief Guglielmo Libri**

This does not fatally disbar the Franks Casket but all the same we had better seek further and better particulars

> **Guglielmo Libri, who, in his capacity of inspector of public instruction, travelled throughout France surveying libraries and pillaging them. Barrois is known to have taken in Libri's manuscripts and had them rendered unrecognizable through rearrangement of quires, rebinding, mutilation, etc**

One does not like to patronise but the French should look after their literary heritage with more care. What else was Barrois up to?

> **Barrois also compiled his own valuable manuscript collection, about a tenth stemming from compromised sources (cf. Delisle)**

A tenth? I think the French are trying to spare their blushes, he sounds more of a ten-tenths man to me.

The French have certainly lumbered themselves with a right dog's dinner when it comes to their historic books but at least they can make a start putting it all back together again from Barrois' collection now he's gone. Sacré bleu, his collection has gone too

> **Foreseeing Libri's conviction, he had the collection dis-**
> **creetly shipped to England in 1849, and sold to the Earl of**
> **Ashburnham (cf. Delisle, pp. xl-xlii)**

That rings a bell. Any connection to the Ashburnham Collection? I only ask because, over the years, anybody with half an eye for these things would know this is a portmanteau term used to cover the fakes and forgeries the British state has felt it necessary to concoct over the years.

> **The Ashburnham family lived in the house for less than**
> **eighty years until John, 1st Earl Ashburnham sold the**
> **lease to the Crown in 1730. It became the repository for**
> **the Cotton Library of historic legal and constitutional**
> **manuscripts originally assembled by Sir Robert Cotton, to**
> **which was later added the Old Royal Library. These books**
> **and manuscripts now form the heart of the collections of**
> **the British Library.**

Ash burn'em, they do like their little jokes. After one year as the national repository

> **A fire in Ashburnham House on 23 October 1731 damaged**
> **many items: a contemporary records Dr. Bentley leaping**
> **from a window with the priceless Codex Alexandrinus**
> **under one arm. One manuscript of the Anglo-Saxon**
> **Chronicle was virtually destroyed. The manuscript of**
> **Beowulf was among those that suffered damage, a fact**
> **reported in The Gentleman's Magazine.**

I hope Doc Bentley was all right, it's not easy landing with one arm round a codex. You should try it sometime. The Ashburnham Lib rary later acquired the world's oldest epic, a cuneiform *Gilgamesh*, found amidst the ruins of Nineveh in the Ashurbanipal Library. They do like their little jokes.

Barrois died before the French (or it may have been the Belgians, he operated on the borderline) could send in the képis but poor

old Libri was facing a goodish stretch in a penal colony. Or somewhere a lot worse according to your average Frenchman

> Convicted in 1850, Libri himself remained comfortably in England, where he was wined and dined by the likes of Panizzi, Keeper of Printed Books at the British Museum.

I *am* sorry, I've gone right off-topic, haven't I? We were discussing the Franks Casket and the problems the British Museum was having with it.

> There are scars left by lost metal fittings on the exterior - handle, lock, hasps and hinges - and crude internal repairs reflect a chequered history

There are three chequered histories – that of the Casket, that of Augustus Franks and that of the British Museum. Which is rotten, the apple, the barrel or the ship? The party line has Franks buying the casket (in panels) from an antique shop, offering it (in panels) to the British Museum and ten years later donating it (in panels) to the museum. *Now* it is not in panels. It is fully restored to casket form and is the centrepiece of the BM's Anglo-Saxon collection. The British Museum can be as lofty as it likes about 'crude internal repairs' but a lot of them are its own internal repairs.

No doubt their Restorations Department will wish to defend its honour by pointing out all this happened in the unreconstructed days of Victorian 'botch it and see' but they should hesitate before doing so. Botch-it-and-see is often the faker's-best-friend which might make the British Museum the faker-in-chief, and right now it is looking a bit touch-and-go

Sixth problem: nobody keeps disarticulated whale bone panels for long but the British Museum's new provenance is going to require a great many people doing exactly that

o It is unlikely Family X would ruin a serviceable sewing box by gouging out thousand-year-old silver fittings, *but they did*

o It is unlikely they would keep the disarticulated panels, *but they did*

o It is unlikely Professor Mathieu, an antiquities collector, would leave the casket in panels, *but he did*

o It is unlikely Barrois, an antiquities collector, would leave the casket in panels, *but he did*

- o It is unlikely a French antique shop offering the casket for sale would leave it in panels, *but it did*

- o It is unlikely Franks, an antiquities collector, would offer the casket to the British Museum in panels, *but he did*

- o It is unlikely he would leave the casket in panels for ten years while it was in his own private collection, *but he did*

- o It is unlikely, adding it all together, the casket would still be in panels when acquired by the British Museum, *but it was*.

So who did put the casket back together again? Whoever it was, they were in for a shock. A panel was missing!

The right-hand side is a replica

Seventh problem: a lot of people were aware there were five panels rather than the customary number for caskets (six) and knew where the missing one must be, yet signally failed to enquire of the Auzon family about it.

'Make do and mend' is the British Museum motto. A whale bone panel of the appropriate dimensions was presumably fashioned by the Restorations Department and a discreet notice placed beside the display cabinet

> The right-hand panel of the casket is not original. It has been added to demonstrate how the complete casket looked.

Was there to be closure at last? Of course not, this is the Franks Casket.

Eighth problem: a *replica* of the missing panel can only mean the original has been found and since the intact casket was last seen in the far off days of Auzon Family X, this panel will need a provenance all of its own. Oh, Gawd, make it end.

The fame of the 5+1 panels they were calling *Le Franks cercueil* in that Londres must have got the Auzon family to thinking

"There were definitely six when we had it. Bien sûr, that was fifty years ago, but maybe the other panel is in an outhouse or something. You never know till you look. Found it!"

> The missing right end panel was later found in a drawer by the family in Auzon. It was later acquired by Louise-Claude Carrand and then passed to the collection of the Museo del Bargello in Florence, where it was identified as

part of the casket in 1890. The British Museum display includes a cast of it.

Not a cut-out man this time, a cut-out family

> The Carrand family amassed a collection of objets d'art which they bequeathed to the Bargello Museum. Next to the famous works by Donatello, Verrocchio, Michelangelo and Della Robbia, in fact, there are also everyday objects such as jewellery, caskets, chess sets, weapons, sticks, combs and mirrors of inestimable value.

Bargello Museum
Today's Staff Notices

Keep anything with the name Carrand in its provenance out of the firing line or we'll all be in the firing line.
Spaghetti for lunch

Please, no stereotyping. The Bargello would never do anything of the kind. Well, maybe that one time

> Even though the bulk of the Franks Casket has a place of honour in the British Museum, its most important panel lies, neglected, at the back of a lower shelf in the Bargello Museum in Florence. Most visitors would take no notice of it.

To fully appreciate the piquancy of the situation it is necessary to understand the relationship between the world's leading museums. It is not a dog-eat-dog world, the dogs need each other for their non-stop, money-spinning, critically-acclaimed exhibitions. No exhibition will be much cop if it consists of familiar items from the shelves, judicious selections from the vaults and a full colour catalogue. The stars of the show will have been loaned for the purpose by other museums. It is a dog-scratches-dog world.

With one glaring exception. When the dogs are the British and Bargello museums and the bone is the Franks Casket. I have checked with the very helpful (at first) staff at the British Museum: they have asked and they have asked and they have asked but the Bargello keeps saying no, no, no. Right dogs in the manger they've been

"We haven't got any use for it ourselves but we're damned if you're going to have it. Not even for a loan. You can have a replica if you ask nicely but as for the real thing, get lost, Inglesi scumbags."

I paraphrase but, for whatever reason panel and casket have never been reunited these hundred and thirty years.

The casket may be permanently cast asunder but scholars are birds of passage and can examine all the panels of the Franks/ Carrand/Auzon Casket to report their findings for the benefit of the scholarly community as a whole

> As for the troubled history of the right side panel, see T. Pàroli, 'The Carrand Panel of the Auzon Casket'

The panel may be in hoggish Italian hands but its message is for the world. Though not perhaps this world

> The runic text of this panel presents many problems as well. For some reason, most of the vowel-runes have been replaced with new, and seemingly arbitrary, runes, and many of the spellings are unusual, making the translation somewhat difficult. It may be read as: Her ltos sitafo on ltarmberga; regl(re) drigip; swa ltiri ertre egi sgrref, sarden sorga rend sefa lorna. A possible translation is: 'Here a host sits on the mound of grief; misery endures; so to (her or them) Erta prescribed dread, a sad grave of sorrow and troubled heart.'

Very moving but, one would venture to suggest, perhaps more northern than southern European

> The text does not seem to relate directly to the scene, but there are a number of connections; mourning over a grave being the most obvious theme in common. The most curious item is the name 'Erta', who may possibly be related to Urt'l, the Norn responsible for cutting the threads of fate, which would argue in favour of the three figures on the right being the Norns.

My thoughts entirely but could it, I'm just running this up the flagpole, be English?

> The fifth panel is least well understood, but was definitively explained by A.C. Bouman in 1965. Bouman compellingly interprets the right panel as celebrating the

> brothers Hengist and Horsa who, according to both Bede
> and the Anglo-Saxon Chronicle, founded England in the
> mid-fifth century A.D. In particular, it depicts Hengist
> mourning Horsa after he died at the battle of Aegelesthrep
> in 455 A.D.

If so, the message from the Carrand Panel can be melded with the cryptic scenes on the Franks Casket to convey, in pictorial form, the Anglo-Saxons' prediction that their language would one day rule the world

> **Although Bouman did not appreciate it, once the fifth
> panel is correctly understood as relating to Hengist and
> Horsa, the rest of the Casket falls into place as using the
> other great world events as metaphors for the history and
> destiny of England.**

Dear Lord, the sun will never set on the Museum Empire until somebody does something about it. I suppose it will have to be us.

We can make a start on the Augean stables by considering how clean are the hands of the British Museum in the case of the Franks Casket. The first scholar on the scene was, if it can be remembered that far back, Professor Mathieu. Nobody in France can remember that far back because, although Mathieu is celebrated today for his championing of the Vercingetorix statue, the French have no recollection of that other feather in his chapeau, his discovery of the world-important Auzon Casket.

History does not lie. The French do not lie. It means either Mathieu did not wish his name to be associated with it or Mathieu did not discover the Auzon Casket, leaving two possibilities as to how his name did get in the frame, one to the discredit of the British Museum, the other more so

1) If Mathieu is removed, the only connection between the Casket and Auzon is the Carrands' claim that their panel was obtained from a family living in Auzon. The Bargello put forward this link, as well as the link between their panel and the Franks Casket, in 1890. Sir Augustus Franks, being the director of the British Museum at the time, could have cleared the matter up there and then, but he must have been away collecting or something because he clean forgot.

2) Weale was tasked with threading together the provenance after Franks' death in 1897, and with only Franks' "I got it from a Parisian antique shop" to go on, Weale was left

with either admitting the Franks Casket had no provenance or going with the Carrands who at least had something.

The Carrands it had to be. Except the Carrands were not officially involved back in the 1850's so Weale was forced to come up with an explanation for how the panels got from Auzon to Paris, primed and ready for Franks to discover them in the antique shop.

What comes next will be pure speculation on my part but as Weale's employers at the British Museum went to all the trouble of dispatching Weale on his lengthy errand but have not gone to all the trouble of keeping 'the Weale Report' in their meticulously-kept records, there is no alternative. You are free to put together something better yourself but do not seek professional assistance when doing so. Archivists and historians are not permitted to say anything not supported by contemporary documents, so they have nothing further to say on the subject. "We've looked and we've looked and we've looked."

Weale needed a suitable candidate to ferry the British Museum's panels from Auzon to Paris and alighted on the well-known figure of Professor Mathieu of Clermont-Ferrand as someone who might have acquired the Casket panels in Auzon and who might have taken them to Paris. Mathieu was long dead and in no fit state to deny it. But how could Weale possibly know this fifty years later when officially he did not know the identity of the antique shop? That connection had to be made by spatchcocking the figure of Barrois into the story. He was long dead too. The kindest presumption is that the whole thing was put together by the British Museum to cover up their dereliction of duty in not keeping Franks up to the mark. To understand all is to forgive all, because the only other explanation is

3) it was a ramp from start to finish.

When Franks acquired the casket in the eighteen-fifties, Weale was not only based in Barrois country, he was in the same line of work as Professor 'Vercingetorix' Mathieu

W H J Weale was a member of the Belgian Royal Commission for Monuments from 1861 on

He was in the same line of work as everyone else in this sorry saga

the Donne Triptych, 'attributed to' Hans Memling, was acquired by the National Gallery in 1957 from the Duke of Devonshire's collection. Memling's work became very pop-

234

ular in the 19th century and a fully illustrated biography was written by William Henry James Weale in 1901.

Not that we are venturing down that road. We shall not be investigating the deplorable record of British art galleries. How, for instance, the Soane Museum invented the "this collection shall be preserved and kept intact by Act of Parliament" clause for the benefit of fakes emporia. We will not be detailing the life story of Richard Wallace who, passing himself off as the illegitimate son of the Marquis of Hertford, drove an ambulance in the siege of Paris and drove off with the Wallace Collection. We are not going to be exposing the crimes and follies of the National Portrait Gallery... oh, apparently we are in a later chapter... but right now we are concerned with the crimes and follies of the British Museum.

Their knowing Weale's story to be a crock is not a big deal. It really isn't. If the British Museum sincerely believes the Franks Casket to be a genuine Anglo-Saxon artefact, all they have done is 'fill in' its provenance and by the standards of c 1900 that would be considered borderline acceptable. Even by c 2020 standards it is no more than a bad case of careful ignoral. What might get them taken away in handcuffs is what they did *between* 1900 and 2020.

We have the BM's own testimony they have tried unavailingly to persuade the Bargello to release their useless and neglected panel and the only conclusion to be drawn from this unprecedented absence of fraternity between two titans of the cosy confraternity of national museums is that the Bargello cannot afford to have

the Carrands outed as crooks

they are responsible for providing many of their best exhibits. The British Museum cannot afford to have

Franks outed as a crook

he is responsible for providing twenty thousand of theirs. Both museums know the panel will not fit the casket so they have agreed

- o to have a 'cast' made that does
- o never donate, sell or loan panels to the other
- o always employ staff and trustees who know nothing about it.

Honest, Guv, we just work here.

28 The French Collection

If Franks can cast his shadow over an important slice of English history with a single fake, it might be as well to find out where he was getting the 'over 20,000 important objects for the British Museum' from. The first clue is: that is quite a lot. Ask the current Big Daddy, if he's not in Parkhurst, how many he is responsible for. It probably is a *he* because while modern museums are exemplary equal-opportunity institutions, men are more criminally minded than women. What a bunch of wusses they turned out to be.

The nineteenth (and eighteenth) century differs from the twenty-first (and most of the twentieth) in that now there is a sophisticated art market, then there was not. *Now*, an Anglo-Saxon whale bone casket would fetch several million pounds; then, they had to be practically given away. Now, forgers can be bespoke craftsmen dealing directly with unsuspecting customers; then, forgers had to operate in rings, manufacturing in bulk, shifting product on an industrial scale to unsuspecting customers. Better, suspecting ones. Possibly, *only* suspecting ones, given the sheer scale of the trade.

There is nothing new in any of this. In the high Middle Ages demand for religious relics was so great, and the pilgrim trade so profitable, there must have been workshops turning them out in volume. Even a simple piece of the True Cross is not something your average vicar can knock up behind the vestry. Where was he to get one? Where was a pilgrimage centre to get its full complement of sacred accessories? And to add to the difficulties, how were they to be acquired without the staff knowing? They are True Believers too.

This is the key to much of the world of fake history. There has to be an apparat sufficiently clandestine to operate away from the public eye but not so hermetically-sealed it cannot be readily available to a wide-ranging clientele. Nor can the practice be so frowned upon that legions of ordinary people will not cheerfully collaborate in making and distributing the product. We know tens of thousands of fakes were being produced in medieval times yet (as far as I know) there is not a single historical record confirming it was going on. This potentially presents a severe historiographical

problem. Historians are so concerned to counter accusations of subjectivity they work exclusively from contemporary documents, meaning a strong tendency to

o demand historical evidence that something was happening
o deny it was happening if there is no historical evidence

After generations of applying this (quite sensible) policy, they have quite lost sight of the fact that

o the historical record is not the same as history
o common sense is not the same as subjectivity
o extrapolation is not the same as making it up

In this case, they concede that fakery was rife in medieval times – the fakes are so blatant, they cannot do otherwise – but how will they cope when the fakes are not so blatant? When history has reached the seventeenth century and the Protestant half of Europe is switching over from religious relics to secular ones. When palaces and cathedrals filled with priceless treasures are giving way to museums and art galleries filled with priceless treasures. Demand for rare things to admire is part of the human condition, irrespective of religion or none.

This new world of lay collecting was highly competitive and, like so many competitive leisure pursuits of the modern age, the rules were codified at English public schools and the twin sets of our dreaming spires. By the eighteenth century, our gilded youth were having their heads filled with the Classics at these places, were going on Grand Tours to classical destinations and returning home filled with a desire to stock their orangeries with classical statuary.

Except there were no classical statues.

Not for love or money. The few that had survived were horrid things – two thousand years will do that to marble – and came missing so many body parts they were wholly unsuited to polite society. Much better to be supplied with 'the real thing' by Italian workshops. In fact, since one's friends were being similarly supplied, putting a genuine one on display would get you no thanks. They were all fakes then and if you think the National Trust, who owns many of them now, will be in a hurry to have millions knocked off its balance sheet by instituting a searching enquiry, you don't know the meaning of *national* and *trust*.

By the nineteenth century classical statuary in stately homes was much too Whiggish for the nation's needs. The Victorian Age

demanded great exhibitions for the newly enfranchised. But it was also the age of Northcote-Trevelyan and Gladstonian candle-ends. Government had become relatively honest, could the museums and art galleries afford to follow suit? The number of antiquities and Old Masters could not be added to, the number of museums and art galleries was being constantly added to. It was time for new men and new methods.

> With limited funds and little institutional support, the networks Franks developed with art dealers, private collectors and museum colleagues both in Britain and on the continent were therefore critical to his success as a curator.

How times don't change. It is a bleak prospect depending on government handouts, forbidden from selling surplus stock and unable to charge the hoi polloi coming through the doors clamouring to see the latest antique objets d'art. There were ways and means.

> Privileged access to sale schedules, price estimates and quality assessments enabled Franks to capitalise on opportunities to swell the Museum's holdings by pinpointing the most valuable acquisitions early and allowing time to secure the necessary funds.

Really? And what were all the other museum directors doing? Not reading the sale schedules, not keeping an eye out for acquisitions, refusing to allow themselves time to get the necessary funds?

> The sale of the Soltykoff Collection in 1861 provides an illuminating example.

Very well, if you insist. Can you give us an idea of what we are looking at, you know, ballpark?

> Prince Peter Soltykoff assembled a vast collection of medieval treasures, the most celebrated private collection of its kind and comprised armour, glass, enamels, watches, ivories, manuscripts and other pieces.

Just the sort of things the public might want to see but how are such expensive rarities to be shifted into the public sector so the public could see them? There are ways and means.

The trustees will have to be squared but these exalted amateur enthusiasts need not be burdened with facts of life at the coal face

> Franks managed to get hold of the catalogue three weeks ahead of the auction, writing: "I was fortunate enough to obtain a copy of it Tuesday evening, which I think it but right (in Mr. Birch's absence) to forward to you that it may be submitted to the Trustees. I have seen Mr Webb this morning who returned last night from Paris and who has informed me that he believes that the sale will be conducted bona fide."

One is sure it will be, that is why public auctions are so popular. And so lucrative. It was good of Augustus to spell it out though in case we were wondering, for no particular reason, it might not be. What he did not spell out was that the Soltykoff Collection was the work of a forgery ring of which Franks and Webb were the British end. Not only for the British Museum, not only for British museums

> Many of these objects are now owned by the Victoria and Albert Museum in London, most notably the celebrated Gloucester Candlestick and the Eltenberg Reliquary. Other items from the collection now belong to three of the world's most important museums – the Metropolitan Museum of Art in New York, the British Museum in London, and the Louvre in Paris

and are still on display, packing them in. What they really are is worth finding out if you think museums should be more than a branch of showbiz.

The first step is to clear up one or two popular misconceptions about Russian princes. There were a great many of them. Here are just the ones beginning Sa:

Saakadze, Saginovy, **Saltykov**, San Donato, Sangushko, Sapieha, Satyginy-Kondiyskie, Sayn-Wittgentien-Berleburg

and they get spelt (not just in English) in so many different ways neither I nor anyone else can be overly confident tracking them down. Especially as details about them can change even as one is tracking them down

> Very little is known about Prince Pierre Soltykoff (1804-1889). He was born in Russia in 1804 and died in Paris in

1889. More than a century after Soltykoff's death, errors and misconceptions about him are perpetuated in published accounts of his life and collection. The primary error is that he died in 1861, the year his collection was sold at auction. This mistake reflects the reluctance of scholars to comprehend that the owner of such an outstanding collection decided to part with it during his lifetime

Including yours truly. The first typescript of this book had Prince Peter Soltykoff dying in 1861 and I was about to post it off to the printers when my fact-checker roared up in her Lamborghini (you've got to get the staff somehow) and shouted, "He didn't die, he went bankrupt" and roared off to Groucho's. They don't let writers in anymore so it was a weary wend home for yours truly to start on the redraft.

In addition, Prince Pierre Soltykoff and his brother, Alexis, have frequently been thought to be the same person. Both brothers earned considerable fame and are still often confused with one another.

Check. Electronic sources are a great boon for revisionists but they can change without the revisionist being told they have been changed. In sharp contrast to learned journals, the staple source of information for academics, which are punctilious about recording new information. Not that I will be given any leeway because of that. And quite right too.

Another misconception is that Russian princes are rich. Russian aristocrats at any level are seldom rich. They may possess land as far as the eye can see, they may own enough serfs to invade small neighbouring countries, but that does not equate to being rich. In Russia, as everywhere else, that requires being 'in trade' and that is never a very aristocratic thing to be. You have to be very rich to be a major collector of medieval antiquities.

All this is important because we are dealing here with our old favourite, a world record. If a list of people capable of putting together 'the most celebrated private collection of medieval treasures of its kind' was compiled, most people would put Russian princes near the top even though they are maybe nearer the bottom. But is there any need to put Russian princes on the list at all? According to Sir Augustus Franks, the Soltykoff Collection was not the Soltykoff Collection

240

> "I need hardly mention to you how important is this collection, the history of which is well known. It is now the property of Baron de Seillières who gave I believe 80,000 £ for it."

It was the Seillières Collection. You think that a technicality? You are supposed to think that. Academics think that. Museum curators think that. People flocking to the auction thought that. I don't think that. I think Baron de Seillières was one of the finest cut-outs of the age.

Suppose you have a thousand fakes and you want to sell them at public auction. They are good fakes but you can anticipate a few will be 'returned'. That's fine, you give disgruntled purchasers their money back, it is a working expense as far as you are concerned. But it *is* a concern. Collectors talk. If enough disgruntled collectors start comparing notes you may end up going to gaol. Ouch!

Unless you use a cut-out. Compare and contrast:

> "I need hardly mention to you how important is this collection, the history of which is well known. It is now the property of Baron de Seillières who gave I believe 80,000 £ for it."

> The celebrated collection of medieval and Renaissance art treasures belonging to Prince Peter Soltykoff was sold at the Hotel Drouot, Paris between 8 April and 1 May 1861, achieving a total of £72,000.

The poor old baron has lost eight thousand pounds for his pains. Maybe. His account was that the arms-and-armour part of the collection had gone off to Emperor Napoleon III and it was only the remainder that went to public auction. But in any case 8K would be small change compared to the *real* benefit Baron de Seillières got for his pains

"Excuse me, Baron, but this is a fake."
"A thousand apologies. I bought the whole collection from Prince Peter Soltykoff to save him from bankruptcy. One does not like to see such people dragged through the courts. Also there were some important arms and armour that needed saving for the nation, not sold off piecemeal in a fire sale. I'm afraid you are by no means alone – the Prince was taken advantage of from time to time by unscrupulous dealers. But that's not your problem, it's very much my responsibility. How much, did you

say? Let me add ten per cent to cover any inconvenience you may have been put to."

"Thank you very much, Baron, it is refreshing doing business with a man of the old school."

The baron could afford it, he has just made £72,000, less the costs of production, less a percentage to a Russian prince for the use of his name. What he cleared would, at the time, have bought a pre-ironclad battleship. And if the boys in bleu should call round?

"You will have to take it up with Prince Peter, a man of great rectitude but also, I fear, of too great enthusiasm. Not to put too fine a point on it, he was taken advantage of by unscrupulous dealers. It's proving a nightmare sorting it all out. Why don't your people liaise with my people to discuss the details? Now, if you will excuse me, I have an appointment with the Emperor to discuss the disposition of some arms and armour I know he is particularly interested in."

And if the Paris arts-and-antiques squad swoop on Prince Peter?

"I am distressed to hear it. Circumstances obliged me to sell everything to a Baron Seillières for a lump sum to satisfy my creditors. This was done on the best legal advice but if I have broken any French laws I will have to hold my hand up to it."

I am not the first person to point out there were forgeries in the Soltykoff collection, but academic forgery-spotters cannot afford to spot too many, it would give academic art history a bad name

> Neil Stratford has convincingly shown that the Soltykoff collection included some fakes and pastiche enamel metal-work produced in Paris in the mid-nineteenth century. These were sold to the Prince by his trusted dealer.

So says a trusted Keeper of Medieval and Later Antiquities at the British Museum. A word in your shell-like, Neil. Mid-nineteenth century dealers in enamel metalwork know at least as much as you do about what is and what is not mid-nineteenth century enamel metalwork, so if you can spot the hooky ones, so can they. If the Prince is relying on someone who is knowingly supplying him with fake enamel metalwork, I doubt very much if the supplier had a fit of conscience when supplying the Prince with other than enamel metalwork, wouldn't you agree? But stick around and we'll show you how to play Soltykoff three-card monte.

Here is the first card (no pun intended)

> **Prince Peter Soltykoff came to Paris in 1840 where he assembled a vast collection of medieval treasures**

Not to be confused with the second card, Prince Alexis Soltykoff

> **In 1840 Alexis retired and moved to Paris**

and finally the third card, Prince Dimitri Soltykoff

> **A personal friend of the Prince of Wales, he was the owner of the Kremlin stud in Newmarket and one of the most successful racehorse owners of the 19th Century**

To begin playing you will need to know when the Soltykoffs became players

> **Nikolai Ivanovich Soltykoff (1736 - 1816), became chairman of the war committee under Empress Catherine II and Emperor Paul I, and later president of Council of the Empire and of the Board of Ministers. In 1814, General Soltykoff was exalted to the dignity of Russian Prince and his descendants also acquired this hereditary title.**

The first Prince Soltykoff by inheritance was the general's son, Dmitri Nikolaevich, who was blind. With such a disability it does not sound as if he would be much involved in the world of antique collectibles, or even to have substantially increased the family's fortunes, but whatever he passed on had to go five ways

> **Prince Dmitri married Anna Leontieva, and they had five children: Princes Ivan, Vladimir, Peter and Alexis and Princess Mariya**

Looking at things from Peter's point of view
o he is the third son of a so-so aristo
o he has to acquire 'the best private collection of its kind'
o he has not got a lot of time to do it
o there is always time if you have a cut-out

> **Ivan had married into the richest noble family in Russia - the Stroganoffs - and upon death, left considerable wealth and a part of his collection of art, arms and armour to brother Petr**

I wish I had a brother like that. Especially one who died in time for me to enjoy the spoils. Don't let that stop you, bro.

> **Ivan died in 1832**

243

Aged 35. Too much cream with the beef, I expect. Even ignoring the needs of Ivan's family, the next Soltykoff brother in line will have to go before Peter can get his mitts on the gravy

His other older brother, Vladimir, died in about 1835

Aged about 36. It's a Soltykoff Brothers Borodino. The claims of Vlad's family will have to be set aside too but, one way or another, everything has ended up in Peter's lap. Perhaps fearing the Curse of the Brothers Soltykoff, he shifted the locus of his operations

> **Peter Soltykoff came to Paris in 1840 where he assembled a vast collection of medieval treasures, which he housed in two hôtels built specifically for the purpose.**

Two whole hôtels! The word has a slightly different meaning in French (something like 'grand town house with public access con-notations') but just the job for tout le monde to come in for a quick shufti at his collection. Which they did in droves

> **Soltykoff opened his home and collection to visitors. This allowed people to study the objects he owned and many later published first hand accounts of their visits. The best known residence for the display of Soltykoff's collection was at the hotel de Bretonvilliers on the Ile St-Louis, where visitors were welcome to tour the collection on Thursdays. The fame of the collection was such that one writer expressed, "Every true Parisian, I mean anyone who really savoured Parisian life ... had visited it at least once."**

Why do phrases like *shop window, Magdalene College* and *they're at it* come unbidden to mind?

Hotels or hôtels, there was plenty of room to accommodate the last surviving brother, Alexis, who had arrived in Paris hot on Peter's heels. What had the runt of the litter been up to?

> **Alexis's early days are somewhat of a mystery. He grew up in St Petersburg and at the age of eighteen joined the dip-lomatic services with the Russian State Board (Collegium) for Foreign Affairs in Moscow. By the age of 23 he was with the Russian Foreign Service, first in Constantinople, then in Athens, later in London, Florence, Rome, and Teheran.**

244

All the prime spots for antiquities. I mean all the prime spots for Russian diplomacy.

In 1840 Alexis retired and moved to Paris.

That is not my reading. After a meet and greet with Pete, Alex was back on the road

> **In late 1840, armed with letters of introduction to the top British administrators in India, Alexis Soltykoff began his trip. He said he was after some "colour" in his life, but the collection of art and oriental arms his brother Petr had started to accumulate after Ivan's bequest, indicates that Alexis's motives may have been considerably more than that.**

If you say so. And you could be right because once out east Alex caught the arms-for-royalty bug

> **the arms and armour collection, purchased from Petr Soltykoff and exhibited at the Musée de Tsarskoé-Sélo, states: "The most remarkable pieces in this last series had been collected in the Indies by Prince Alexsei Soltykoff. It was acquired en bloc by a representative of the Russian Tsar (March 25, 1861), and for this reason, the auction catalogue does not contain any of this material."**

I should say not, what with so many tranches of the Soltykoff collection going out the back door to heads of state wanting to round out their collection of antique arms and armour. It is not known why Baron de Seillières omitted mention of the Tsar of all the Russias, alongside Emperor Napoleon III, but with so many European crowned heads in those days, it is easy to miss the odd one.

Alex had also caught the 'die early, enrich Peter' bug because he ascends to Orthodox Heaven in 1859, aged fifty-three, two years before the Great Soltykoff Cash-Out. Peter thereupon disappears from the public record (now, officially dies 1889) but the *money* does not disappear. It has many more tasks to perform. Peter may have gone bankrupt but he has somehow managed to equip his son, Dimitri, with the wherewithal to go racing with the Prince of Wales. Take it from a close student of the Racing Post, that takes serious De Niro. Where has it come from? We can find that out by playing a few more rounds of Soltykoff chase-the-lady

1. After paying off his creditors Dad has got, say, several thousand pounds from the 1861 sale
2. To maintain himself in the style of a Russian prince until 1889 Dad needs, say, several thousand pounds
3. To maintain himself as King of the English Turf and hob-nobber by appointment to the Prince of Wales, Dimitri needs, say, several thousand pounds. *A year.*
4. Son has no visible means of support except Dad's money
5. Son dies in 1903

There are your cards, which one is the Queen of Hearts?

In his will he left all his horses and the Kremlin stud to actress Ethel Clinton plus a yearly dowry of £15,000.

Nice work if you can get it.

And so finally to the Grand Reveal. Who was operating this massive con from behind the arras? Here are your clues

✓ They will be person or persons you have already met
✓ They will have links to everyone you have already met
✓ They will be past masters in putting together celebrated collections of valuable antiquities
✓ They will not have figured prominently in the story because they were operating from behind the arras

Spoiled for choice? Allow me to mark your card:

? Is it Russians calling themselves Soltykoff princes
 No. Bogus or real, they are recipients not principals
? Is it Baron Seillières
 No. He is right out front in full view
? Is it Sir Augustus Franks
 No. A public figure of the highest repute
? Is it the Carrand family
 Yes

> **Prince Soltykoff also acquired works of art individually and in groups with the aid of dealers and advisers, primarily Jean-Baptiste Carrand (1792-1871), a collector-dealer from Lyon. Carrand's influence on Soltykoff's collecting activities was considerable. This collector-dealer was interested in works with significant historical associations, and Soltykoff's medieval collection contained many such medieval works.**

How remarkable that Sir Augustus Franks, the best-informed museum collector of his generation, did not know the Soltykoff/ Seillières Collection was the Carrand Collection. Or if he did, he forgot to mention it. But then again, thirty years later he forgot to mention he knew the Carrands when they found the missing panel of his famous casket and supplied a provenance for it. What a forgetful chap he was.

A crying shame because if Sir Gus had cried foul at any time, his own and a whole slew of other museums might have been spared from acquiring a whole slew of fakes

> Carrand was responsible for cataloguing Soltykoff's collection before its sale in 1861 and many contemporaries criticised Carrand for providing poor descriptions of the artworks. Moreover, he was accused of heavily restoring works of art and allowing fakes into the collection, examples of which can be found in Soltykoff's medieval collection and his collection of arms and armour.

Yes, that nice Neil Stratford was telling us about it, though I don't think he said whether any of them have been removed from the museums. Early days, I suppose, they will have to learn to crawl before they can walk.

Which reminds me. Although my own tortuous climb up the social ladder has left me drinking in rather than with the Prince of Wales, his mom and pop can bring this tremendous Anglo-French production of the *Government Inspector* to a suitably royal finale

> In 1861, 1109 lots were auctioned at Hotel Drouot over 4 weeks, 26 lots of which were purchased by John Webb and offered to the South Kensington Museum, including the cruciform Chasse (7650-1861), known as the Eltenberg Reliquary and considered to be the star of the entire collection.

Some names have been changed to protect the famous

o The South Kensington Museum is now better known as the Victoria and Albert Museum
o The Eltenberg Reliquary is now better known as the Victoria and Albert Crucifixion
o Sir Augustus Franks' right-hand man, John Webb, was once less well-known as 'Monsieur Fieux'

'Victoria and Albert Crucifixion' dated second quarter of the ninth century to the tenth century. Provenance: sold to M. Fieux in 1861, acquired by V&A in 1862.

29 Portraits Were Us

The 360 degree test has a further application. Visit a city of your choice, climb a local landmark with a telescope and report back to us here at HQ how many portrait galleries you can see. Your answer should be "Nothing to report, over" unless you are in either London or Edinburgh (Amsterdam are trying to put something together). It may seem odd given how many portraits and how many art galleries there are in the world, but there it is.

On the national and historical side, this absence must be down to supply more than demand. Before photography, it was impossible to record anyone's likeness other than by making a portrait painting, drawing, engraving, bust, statue or death mask. Expensive to begin with and all too likely to end up in the dustbin of history rather than a national gallery of historical portraits.

On the other hand there were centuries of pre-photographic figurative art so your next challenge is to estimate how many likenesses of historical people are extant in your country (to see if it is worth opening a national portrait gallery). Roughly, a lot or a little. I appreciate this is an unusual request, but whatever approximation you come up with, keep it firmly in mind for the rest of the chapter. I won't be needing to, my country has already done it

> **The Reference Collection is held in the Archive and Library and contains more than 80,000 portraits of important and lesser known figures in British history. The majority of these portraits are prints, but the collection also includes drawings, silhouettes, caricatures, paintings, miniatures, medallions and related items.**

We are all familiar with drawings, silhouettes, caricatures, paintings, miniatures, medallions. We can all speculate as to what 'and related items' refers to. What I cannot get my head round is

the majority of these portraits are prints

I can see people might run off likenesses for sale of, say, the Duke of Wellington (I've got one of Jimi Hendrix) but London's National Portrait Gallery cannot be referring to that kind of print. They are claiming to hold the printed likenesses of

I had no idea there were that many to start with. But *in print*? I have read a lot of books in my time, I cannot recall many that had printed likenesses in them. One is lucky to have a photo of the author on the jacket, though I leave mine off to attract female fans.

Clearly the situation was quite other in those days and was, it seems, down to something called 'grangerisation'

> **A work has been grangerised if illustrations have been added from other sources, usually other books. In a transferred sense, the verb can refer to the mutilation of books by removing their illustrations for this purpose.**

This may explain why our two national portrait galleries stand alone. There cannot be many countries in the world, at any time in history, who would encourage the citizenry to roam around on the lookout for books with people's likenesses in them, then tearing the likenesses out, then printing them out all over again. We British are cut from a different cloth

- o we think nothing of tracking down such books
- o we say 'Fie' to anyone objecting to their books being mutilated
- o we vault effortlessly over the technical hurdles of printing them out again in the days when printing lacked photographic aids
- o then presenting them to the nation.

But here is something even harder to credit

- o the National Portrait Gallery makes not the slightest fanfare about its portrait collection of historically significant Britons. It is vast, it is unique, it is their pride and joy, it is locked away in their vaults.

It is careful ignoral

There may be a perfectly straightforward explanation but, in its absence, we can only eavesdrop on the NPG as they set about convincing us, or as may be themselves, that a world-boggling printed portrait collection is what any self-respecting national portrait gallery would have. Being the *only* national portrait gallery will have to wait.

> **'Grangerisation' is an eponym. It commemorates James Granger, who would have lived and died as an obscure**

parish priest (he was vicar of Shiplake in Oxfordshire from
1747 until his death in 1776) had he not been an early and
avid collector of portrait prints, amassing in his lifetime
some 14,000 of them. In 1769 he published A Biographical
History of England from Egbert the Great to the Revol-
ution, which combined a chronological catalogue of prints
with biographical information. This was a huge success,
even among people who didn't collect portrait prints, and
went through several editions.

Fourteen thousand. That is impressive. We must know more about
this indefatigable man

> The son of William Granger, by Elizabeth Tutt, daughter
> of Tracy Tutt, he was born of poor parents at Shaston,
> Dorset. On 26 April 1743 he matriculated at Christ Church,
> Oxford, but left the university without taking a degree.

Surprises keep on coming

- How many eighteenth-century Dorset villages keep records
 of maternal grandmothers with such zeal?
- How many of them send their poor off to university?
- How many recipients of such unexpected largesse repay
 their benefactors by waltzing off without a degree?
- How many of these degreeless ne'er-do-wells waltz into
 plum jobs normally requiring a degree?

> Having entered into holy orders, he was presented to the
> vicarage of Shiplake, Oxfordshire, living a quiet life there

'Presented' implies, as was normal in Georgian England, the local
gentry family was instrumental in the appointment and 'a quiet life'
suggests he had a curate to do the Monday-to-Saturday grunt work.
 The luckiest parson of his day will surely bring the greatest
chronicler of his day down to inspect this phenomenon

> His political views gave rise to Samuel Johnson's remark:
> 'The dog is a whig. I do not like much to see a whig in any
> dress, but I hate to see a whig in a parson's gown.'

Good to hear the Great Cham is getting down Shiplake way des-
pite that other remark of his, 'When you're tired of Shiplake, you're
best getting back to London.' In fact, this quiet corner of the
Thames Valley was positively seething with literary luminaries

251

> Henry Constantine Jennings, the antiquarian, was born at
> Shiplake and on 15 August 1731 baptised in the parish
> church

Henry Jennings was a scion of local gentry and might well have
benefited from some spiritual guidance from his parish priest judg-
ing by this

> At the age of seventeen he became an ensign in the 1st
> Foot Guards. Resigning his commission soon after, he
> went abroad, spending eight years in Italy.

The Reverend Granger had arrived the year before but we do not
know the precise motivation for Jennings' sojourn in Italy. Perhaps
he did have his parish priest's blessing because he struck lucky

> In a back street in the city he discovered in workshop
> rubbish the marble "Jennings Dog", between 1753 and
> 1756

Just because it takes three years to sort through Roman rubbish
heaps does not mean it is time misspent

> and bought it from the sculptor, restorer and dealer in
> antiquities Bartolomeo Cavaceppi for 400 scudi

I know what you're asking yourself. "Why is he paying good
money for a marble dog that was done so badly it's been chucked
on the reject pile?" You're forgetting that the locals, surrounded as
they are by Classical clutter, are absurdly complacent about
antiquities

> The stone sculpture was discovered at Monte Cagnuolo,
> near the ancient Lanuvium, the site of an imperial villa of
> Antoninus Pius, 32 km south-east of Rome

'Four hundred scudi?' mused young Jennings, translating it into
real money. 'I'll have some of that,' and gleefully hightailed it home
with his prize

> The sculpture became famous on its arrival in Britain,
> praised by Horace Walpole among a scant handful of
> masterly Roman sculptures of animals, with replicas that
> were thought to make "a most noble appearance in a
> gentleman's hall", in Dr Johnson's words.

It remained so famous in Britain that two hundred years later the Americans were sniffing around

> The Sarah Campbell Blaffer Foundation at the Museum of Fine Arts, Houston had attempted to purchase it (the sculpture had been shown in the US in the 1980s), at the price of $950,000

Houston, you've got a problem. The British have rules about what is part of their heritage and it includes Italian works of art

> but the granting of an export licence was deferred by the UK government allowing the British Museum enough time to raise the remaining £662,297 through a public appeal. It is now on permanent display in gallery 22 of the Museum.

Did I say Italian? I meant of course Greek

> The Jennings Dog is a 2nd-century AD Roman copy of a Hellenistic bronze original

A copy? A copy! We shelled out hundreds of thousands of our British pounds on a copy?

> Though it is one of only a few animal sculptures surviving from antiquity, a pair of similar marble mastiffs of the same model can be seen in the Belvedere Court of the Vatican Museums.

So few animal sculptures have survived from antiquity that to get three of the same dog can only mean one thing. Best in Show, Athens Cruft's.

With the Reverend Granger ensconced in Shiplake, Jennings could have joined him, swapping anecdotes of Rome and Shaston over the claret. I cannot say they did but the vicar's passing in 1776 seems to have led directly to a severe decline in moral compass on the part of Shiplake's other Most Likely

> Taking to horse-racing, Jennings lost money heavily, and in 1778 sold his collections and the famous dog. In 1777–8 he was a prisoner in the King's Bench Prison.

We've all been there. It's what you do afterwards, having learnt your lesson, that counts

Soon after he settled in Essex and collected objects of vertu

Vertu can be its own reward, but not on this occasion

He was later a prisoner for debt in Chelmsford gaol

After two stern lessons, had the message finally sunk in?

> **About 1792 Jennings came to London, where he resided in the first house on the east side of Lindsey Row, Chelsea. Here he amused himself with writing and with forming a new collection.**

Please, Henry, remember what happened last time. And the time before that. Don't you have any other strings to your bow?

> **He is said to have had an income from West Indian property. In his later years he took the name of Noel (or Nowell) on receiving a legacy. At the time of his death he had before the House of Lords a claim for a barony in abeyance.**

I must emphasise there is no recorded connection between Jennings and the Reverend Granger and it would be wholly improper to suggest they were anything other than fortuitously linked as Shiplake contemporaries. The only connection, apart from a pastoral one, would be a professional one because Rev Granger had also been dabbling in the value-added art market

> **Before the publication of the first edition of Granger's work in 1769 five shillings was considered a good price by collectors for any English portrait. After the appearance of the Biographical History, books ornamented with engraved portraits rose in price to five times their original value and few could be found unmutilated.**

Granger was responsible for fourteen thousand of them and it may have been that Britain was running so short of unmutilated portrait-studded books he had to look abroad to continue his well-intentioned vandalism. To the land where the woodcut-illustrated book had been a speciality ever since the mysteriously ubiquitous Christophe Plantin set up shop there in the sixteenth century

> **In 1773 or 1774 Granger accompanied Lord Mountstuart on a tour to Holland, where his companion made an extensive collection of portraits**

We've all been there. We've all had difficulty recalling the precise year we went, we are often hazy about which of our party was in the portrait-collecting business and who among us can truly remember whether it was British or Dutch people's portraits we were collecting? It's all got terribly muddled in our minds but one thing we can be certain of: having introduced likeness-collecting to a country buzzing with this new pastime, the Reverend James Granger would not be short of either money or admirers.

But he was a country mouse, caring little for such things. He asked for no more than a bit of comfort in his old age

> **Some time before his death he tried unsuccessfully to obtain a living within a moderate distance of Shiplake**

God took a dim view of this blatant act of simony and made His wrath manifest

> **On Sunday, 14 April 1776, Granger performed divine service apparently in his usual health, but, while in the act of administering the sacrament, was seized with an apoplectic fit, and died next morning**

First and last time that has ever happened according to my non-existent enquiries at Church House.

Bad for Granger, bad for everybody, it left the new national yearning for portraiture in disarray. With its founding father and leading practitioner so untimely struck down, no adequate provision had been made for the proper preservation of this important new historical resource

> **His collection of upwards of 14,000 engraved portraits was dispersed in 1778**

It must have been the devil's own job for the National Portrait Gallery's archivists to put it all back together. Their labours were not made easier when this dropped through the letterbox in 1932

> **The print collection and library of Dr William Fleming of Rowton Grange in Cheshire includes approximately 15,000 engravings and more than 150 volumes**

WTF, they would have said if it had been current at the time.

Fleming began collecting books and portrait prints in 1814 and drew upon his extensive print collection to extra-illustrate many of the published works in his library

Dr Fleming 'draws upon' his 'extensive collection' of printed books for printed portraits, then sticks them into other printed books he has also collected. WTF, indeed. Rather him than me. Now they are to be added to the collection of similarly compiled portraits by the National Portrait Gallery. Rather them than me.

But it wasn't all just mindless cataloguing. The NPG eager beavers had found an engraved portrait of John Evelyn's wife (q.v.) amidst the printed throng

Mary Evelyn (née Browne) by Henry Meyer, after Robert Nanteuil stipple engraving, published 1 February 1818 (1650) 12 1/8 in. x 8 7/8 in. (308 mm x 225 mm) paper size. Given by the daughter of compiler William Fleming MD, Mary Elizabeth Stopford (née Fleming), 1931 Reference Collection NPG D30610

Though it has to be said, it was mostly more of the same

The most substantial of these sets is Fleming's Granger which comprises a collection of approximately 11,000 prints arranged and interfiled to illustrate a disbound copy of Rev. James Granger A Biographical History of England from Egbert the Great to the Revolution (1st edition 1769)

Here's a thought, NPG. Think of them as *swapsies*. From a historical record perspective, you have to admit there is no point in having two of the same person, so gather sets of a few thousand duplicates together and offer them to other countries to start their own national portrait gallery. That way yours won't stick out like a sore thumb so much. Technically, yes, the portraits are of historically significant *Britons* but one gets the impression that is not an insurmountable barrier.

30 The Wife of Bath Takes an Early Bath

Do you have a certificate attesting to a sound command of English? Me too, Lang and Lit. I was reminded of this when, browsing through fakes in the National Library of Wales, I came across

**an early illuminated version of the Canterbury Tales,
known as the Hengwrt Chaucer**

If the *Canterbury Tales* are fake, neither of us had to spend all that time pretending the Wife of Bath amused the hell out of us. I cannot say exactly when the Canterbury Tales were composed or by whom, but I can say it was not in the fourteenth century by someone called Geoffrey Chaucer. And don't worry, as far as I know, we get to keep our certificates either way.

First, the bad news

There is no known original manuscript of The Canterbury Tales. First publication by Caxton was in 1476

then the worse news

The first edition of the Canterbury Tales is not dated

then the 'get them out of jail' news

but it has been convincingly argued, on the basis of an analysis of the type and the paper, that it was from 1476

and finally the revisionist news

- o When the academese phrase 'convincingly argued' is used it means other people have been arguing something else.
- o When the argument is couched in terms of 'an analysis of the type and the paper' it means no scientific test has been carried out.
- o Caxton's Canterbury Tales is purportedly the first work ever printed in English, hence important for the study of Eng Lit, Eng Lang and Eng Hist.
- o When an important artefact has been the subject of argument but has not been scientifically tested, it is prima facie evidence of careful ignoral.
- o When careful ignoral is around we fear the worst. Or as we revisionists no doubt shouldn't call it, the best.

The Hengwrt Chaucer is purportedly the earliest *manuscript* copy of the Canterbury Tales so our first task is a polite enquiry as to why no-one has performed a date test on it. If it comes back '1400 AD plus or minus' the Hengwrt Chaucer is genuine and Chaucer wrote the Canterbury Tales. The reason no such test has been carried out or ever will be carried out goes like this

Concerned citizen: Why haven't you carried out a carbon test on the Hengwrt Chaucer?

National Library of Wales: We are responsible for Welsh literary history, Chaucer is of no direct interest to us. We have a priceless manuscript and you want us to spend money finding out we have not got a priceless manuscript? Pass.

Concerned citizen: Why haven't you put pressure on the National Library of Wales to carry out a carbon test on their Hengwrt Chaucer?

Powers-that-be: If it turns out to be genuine, we will be criticised for spending public money finding out what everyone knew already. If it turns out to be fake, we will have to start testing all the other Chaucer manuscripts. If they turn out to be fake we will be criticised for not having done it all these years. If we do nothing at all, nobody will criticise us. Pass.

We get criticised just for asking and since we cannot go down the science route ourselves short of donning balaclavas, we must rely on the experts to provide the ammunition. With so many different academic interests involved there should be plenty of it.

For instance, why did William Caxton choose *The Canterbury Tales* as his first vernacular offering? The experts are unanimous as to the reason: the best one in the world, money

> The Tales were already established as a well-loved classic, and it seems a shrewd choice for Caxton to make this work the first big project for his English book-production. He could expect it to sell well.

Their evidence for this?

> There are 84 manuscripts of the work, dating from the late medieval and early Renaissance periods, more than for any other vernacular literary text with the exception of The Prick of Conscience. This is taken as evidence of the Tales' popularity during the century after Chaucer's death.

Ah, familiar territory

? Who holds the world record for surviving manuscripts of
 works written in vernacular English
 The Prick of Conscience
? Who came second
 The Canterbury Tales
? Is that easy to believe
 It is difficult to believe
? So what do we arrow in on
 Manuscript copies of the Canterbury Tales

As the *Tales* are claimed to have been written c 1380 and nobody
in his right mind will be producing manuscript copies after c 1480
when Caxton's printed version can be bought from any branch of
the Early Renaissance's equivalent of W H Smith, we have

o eighty-four manuscripts of the same work
o produced during a single century
o that survived for six centuries from the 15th to the 21st

Is that a lot or a little?

When a medieval work is recognisably worth copying and worth
preserving (Magna Carta, Books of Hours, things of that sort) one
would be inclined to say

Eighty-four? That seems an awful lot

I cannot think of any extant work on anything like that scale from
all the centuries of the Middle Ages put together never mind from
a single one (other than *Prick of Conscience* apparently).

When it is a copy of a poem and will be available shortly from
any branch of Smith's one would be inclined to say

Eighty-four? That is more than a lot

it is ridiculous. Who keeps such things for six decades, never mind
six centuries?

"Darling, have you seen my Canterbury Tales?"
"That tatty thing. I'll get you a new one, Caxton's are doing a
special this week."
"Yes, but I like the feel of manuscripts. And you know how
Gothic type hurts my eyes."
"Poor little love. Oh, all right, it must be somewhere."

However, should we skip forward to a time when a manuscript
copy of England's most famous poem will be a valuable *artefact*

259

- o to the eighteenth century when it will be a valuable add-
ition to any gentry library
- o to the nineteenth century when national archives of histor-
ical manuscripts are being put together
- o to the twentieth century when all manner of scholarly inst-
itutions would simply adore having a *Canterbury Tales* as the
centrepiece of their manuscript collection

one would be inclined to say

Eighty-four? Yes, that sounds about right.

You will not need me telling you none of these scholarly instit-
ions has given their manuscript a carbon test even though a single
one coming back as fourteenth/fifteenth century would authent-
icate the Canterbury Tales. It is understandable if nobody wants to
mess with the Hengwrt Chaucer and the Welsh, or if the eighty-
three other institutions were to hesitate about the expense of a
non-destructive test, but if every last one of them refuses to scrape
a full-stop from their tuppenny ha'penny manuscript for a tup-
penny ha'penny destructive test to confirm England's finest is
England's finest then, I'm sorry, they will have to be taken out and
shot.

Or, I suppose, in these days of health and safety gone mad, given
a jolly good talking to. Except the academy is jolly clever. No-one
is ever responsible for these big picture questions, the ones that
might cause changes in the bigger picture. University departments
are like medieval guilds, offering the same bespoke wares, dedic-
ated to the status quo, protected by law from competition, staffed
by people who have spent years as apprentices and are determined
their own apprentices go through the same spirit-sapping process.
It is almost a shame to disturb them. Shooting them? Who would
notice?

Eighty-four surviving manuscripts from any given century of
anything other than the Bible or *The Prick of Conscience* would not
just be a world record, it is so astounding there would be no need
for a stewards' enquiry to declare the whole thing phoney from the
off. Over to the stewards of Chaucerian manuscripts for the start
of the race

**Even the oldest surviving manuscripts of the Tales are not
Chaucer's originals. The very oldest is probably MS
Peniarth 392 D (called "Hengwrt"), written by a scribe**

> shortly after Chaucer's death. It is an important source for
> Chaucer's text, and was possibly written by someone with
> access to original authorial holograph, now lost.

That is close. Closer than might be thought possible

> The Hengwrt manuscript's very early ownership is
> unknown but recent research suggests that Chaucer
> himself may have partly supervised the making of the
> manuscript, before his death in October 1400

We shall require a second opinion before believing that

> The manuscript may have been written at the end of the
> fourteenth century and then, following speculation it was
> copied out by a scribe called 'Adam Pinkhurst': "This
> association between author and scribe, together with
> palaeographical considerations, suggest that the Hengwrt
> Chaucer may have been written before Chaucer's death in
> 1400, or soon afterwards."

If they can speculate, so can we

Geoff: You've mis-spelled 'Aprill shouers'.
Adam: On it.
Geoff: I'm feeling a bit poorly. I think I'll go for a little lie-
down. Will you be all right on your own?
Adam: No sweat. You are looking a bit peaky. Do you want me
to call a doctor? A priest? A critic?

 This detailed knowledge of a medieval manuscript's creation is
not going to be matched with an equally detailed history of what
happened to it afterwards. Nobody in any of the subsequent cent-
uries could know the *Hengwrt Chaucer* was destined to be the most
important surviving Chaucer manuscript of all time. Except, as we
know, fake world records beget fake world records. The Hengwrt
Chaucer is not only

the world's oldest Canterbury Tales

it holds the record (certainly the British all-comers record) for

most detailed provenance of a medieval manuscript

Leastways, I have never come across a more extensive one and I
have been knee-deep in them for longer than is decent:

> Later additions indicate that by the sixteenth century the
> manuscript had reached the Welsh Borders, for it

261

> belonged to Fouke Dutton, identified as a draper of
> Chester, who died in 1558. By the 1570s the manuscript
> was associated with the Banestar or Bannester family,
> also with Chester connections but whose three youngest
> children were born at Llanfair-is-gaer near Caernarfon. A
> further memorandum, dated 1625, refers to Andrew
> Brereton (d. 1649) of Llanfair-is-gaer. The manuscript
> then found its way into the remarkable library of Robert
> Vaughan (c. 1592-1667) of Hengwrt, Meirionnydd.
> Vaughan's collection remained at Hengwrt until it was
> bequeathed in 1859 to W.W.E. Wynne of Peniarth.
> Wynne's son sold the manuscripts in 1904 to Sir John
> Williams, and he in turn presented the Peniarth manu-
> scripts, including the Hengwrt group, to the newly-
> established National Library of Wales in 1909.

That is not overegging, that is purest eggnog.

But does the National Library of Wales know their manuscripts are not necessarily theirs to keep?

> The Hengwrt Chaucer is part of a collection called the
> Peniarth Manuscripts which is included by UNESCO in its
> Memory of the World Register

Do they know their history is not necessarily theirs to keep? The corollary of national histories is that while every nation is entitled to construct a founding story that suits itself, and they are entitled to expect everyone else to be relaxed about it, there has to be someone back at the ranch ensuring that all the national histories add up to a world history that makes sense. Unbeknownst to UNESCO and university history departments the world over, there is presently some danger they are not doing so.

It is thoroughly beknownst to revisionists and by happy chance the real story unfolds in little old Wales at its big new National Library. Good egg.

Part Six

LET'S MAKE HISTORY

31 Half-Millennial Chunks

In these egalitarian times we like to pretend the world is not Euro-centric but it is. Sorry, China, you may have been the world-leader for a couple of thousand years and no doubt you will be for the next couple of thousand years, but right now you look like us, we don't look like Manchu China. This Eurocentric dominance is currently explained by

o the expansion of western European models after 1500 AD
o the models developed in a Christian milieu 1000 to 1500 AD
o the Christian milieu developed between 0 and 1000 AD

so, right now, that means western Europe's history is the important one for world history. It can be rounded up and summarised:

0 - 500 AD	The Roman Empire
500 - 1000 AD	The Dark Age
1000 - 1500 AD	The Middle Age
1500 - 2000 AD	The Modern Age

Its historiography can be rounded up and summarised as:

before 1000 AD	dependent on copies of manuscripts
1000 – 1500	dependent on surviving manuscripts
after 1500	a relative open book

However arbitrary all this may be, there are too many coincidences for any revisionist to ignore. So here is another one

Christianity and the Roman Empire started at the same time

Augustus declared himself emperor in 27 BC and the Angel of the Lord impregnated the Queen of Heaven with our Saviour only a smidgin after that. Officially the two were brought together when the Roman Empire adopted Christianity in 323 AD under the Emperor Constantine and there would be nothing of revisionist interest if a causal link were present. This seems not be the case:

- o Christianity has no particular connection with Rome
- o Western Europe has no particular connection with Rome
- o Constantine has no particular connection with Rome

He scarcely set foot in the place. The orthodox account carefully ignores this in the usual fashion

- o "This is what happened, take it or leave it."

According to historians the Roman Empire and Christianity became co-determinate when Christianity was made the state religion in place of the previous 'emperor-worship' (or however one likes to term it). There is a critical difference between the two, qua religions:

- o Emperor-worship is avowedly a Roman state religion. Nobody outside the Empire was expected to adopt it and people inside the Empire could adopt other religions that did not conflict with emperor-worship
- o Christianity is avowedly a 'universalist' religion. It applies to everyone, everywhere and Christians may not adopt other religions, and specifically not emperor-worship.

What Constantine did was unusual because

- o state religions are common
- o universalist religions are common
- o state universalist religions are not common

Universalist religions nearly always divide along political, cultural and ethnic lines, either between religions or between competing versions of the same religion. Christianity is no exception, it has always been compulsively schismatic:

- o Peter/Paul
- o Nicaean/Gnostic
- o Arian/Athanasian
- o Greek Orthodox/Papal
- o Papal/Protestant
- o Lutheran/Calvinist

it never stops. The only times Christianity did achieve some degree of supranational universality were under

- o late period Roman emperors
- o middle period bishops of Rome

Again, this would be of no revisionist interest were the two periods causally connected but making that link is impossible because they are separated by

five hundred years of European Dark Age

This is of no concern to historians. Since it is 'what happened' they can apply careful ignoral to this extended doppelgänger event. Were they called upon to explain it they would have no trouble cobbling something together – we have grown used to how easily historians vault gaps. Anything goes when the gap is known to be there and it is only a matter of how best to fill it. For us, it is not the explaining that is significant, it is the

not bothering to explain

Anybody who might try would be quickly dismissed as 'of the Toynbee School', broad brush merchants with some axe to grind. Not proper historians.

The careful ignoral reaches a zenith when it comes to explaining the existence of the five hundred year gap itself. It never occurs to historians to ponder the sheer oddness of a significant corner of the earth's surface (western Europe) living under the manifold benefits of civilisation

- o for a thousand years (say, c 500 BC to 500 AD)
- o putting it aside for five hundred years (500 to 1000 AD)
- o taking it up again for the next thousand years (1000 to 2000)

Revisionists do not have to ponder it at all. Dark Ages, they know, make ideal devices for laundering history. It goes in one end, comes out the other, and nobody can tell what is genuine history, going in, coming out, or in between. Revisionists would make a start sorting out the genuine history by identifying the presumed launderers. Which means

cui bono?

What came out of the European Dark Age was a western Europe dominated by the Church and, since the people responsible for the history were Church employees, revisionists would make a shrewd guess that they had found the perpetrators. But revisionists try to avoid guesses. We prefer picking holes in official history because if the holes start joining up we shall be left with our favourite brand of history

nothing much is happening

For us, the truth is always boring and nothing is more boring than nothing.

So what are the holes in the standard history of western Europe before, during and after the Dark Age? That history is a bit lively for a Dark Age

Stage 1 Roman Empire in the west collapses. Status of the state religion, Christianity, doubtful.

Stage 2 Barbarian successor-states emerge from the chaos. Some of them adopt forms of Christianity but none of them adopt the form of, or recognise the authority of, the Roman popes

Stage 3 A completely independent, indigenous 'Celtic' form of Christianity has arisen in Brittany. It is systematised into a Church in Wales, spreads to Ireland, Irish missionaries spread the word to Scotland, then England

Stage 4 The most successful of the barbarian successor states (that of the Franks) does eventually adopt Papal Christianity

Stage 5 Papal Christianity arrives in England, via the Franks, shortly after the Celtic missionaries

Stage 6 The two forms of Christianity meet up while converting England

Stage 7 After a conclave (at Whitby) they merge under the Papal badge but continue using the Celtic business model

Stage 8 The now joint-missionaries go on to convert the rest of western Europe to Papal Christianity

Stage 9 The Papacy attains ascendancy over western Europe

Stage 10 Western Europe shucks off this theocratic pretension and attains ascendancy over the world.

It could have happened but the various stages will need testing before deciding whether it did happen.

History is full of declines-and-falls but the most famous of them, the decline and fall of the Roman Empire, is not one of them. Rome had been waxing and waning ever since the Republic was set up (say, 500 BC) so what was so special about a few provinces in the far west being lost in the fifth century AD? The Empire, now headquartered in Constantinople, would barely have noticed but historians treat it as the End of Days. There is the suspicion that

this has something to do with the historians being head-quartered in the lost provinces.

Revisionists have no geographical allegiances. They prefer to ask what could possibly be going on of such a magnitude in the lost provinces that might justify a

a wholesale re-writing of history

Quite a lot, according to the official account. Bereft of imperial protection, western Europe was facing a seemingly unmanageable array of threats from near and far and from every direction

- o Goths, Vandals, Franks, Anglo-Saxons etc
- o Nomadic horsemen from the east
- o Vikings from the north
- o Islam from the south

These threats had mercifully (or conveniently) dissipated by 1000 AD when the whole of western Europe had been incorporated under the Papal banner and everyone was co-existing with that degree of amity that passes for international relations in normal times. Except for Islam.

What made Islam special? Leaving aside Christianity itself for the moment, it was historically something radically new

- o More than a religion, it presented itself as a recipe for statecraft and took root in a way previous state religions had not. (Who worshipped Roman Emperors after the Empire had gone?)
- o It was a nice balance of egalitarianism and submission to the civil power.
- o It did not play favourites, whoever you were, you were in.
- o There were no prolonged initiation rites or ritual. One day a week you were supposed to take it reasonably seriously but everything was perfunctory unless you wanted to get involved.
- o It had its own in-built expansion engine. Membership carried an obligation to bring the message to the rest of the world, if necessary by force (no missionaries).
- o It guaranteed an everlasting afterlife dallying with comely maidens.

I'd be tempted myself were it not for sympathy for the maidens. What did they ever do to be stuck with me for all eternity? None of them seemed that enamoured when I was alive.

How did western Christendom, officially expanding via the voluntarism of missionary work, deal with the threat of Islam? Here's a surprise

We don't know

This gigantic struggle for souls has left few clues. Dubious later accounts feature desultory battles (there are *chansons* celebrating the more romantic of them) but the historical sources are meagre to the point of contra-indications. Did you know for example

There was still a Muslim presence north of Spain, especially in Fraxinet all the way into Switzerland until the tenth century

I didn't. There seems little point relying on a historical record that is largely absent. Never mind that it was written by the victors.

We might look instead to another principle of sound statecraft, the one the modern Chinese have adopted

If you can't beat them, copy them

One thing that gets carefully ignored by both Christians and Muslims is that, despite officially being entirely independent of one another, Islam and Christianity are pretty much mirror-images

Christianity:
- o more than a religion, a recipe for statecraft
- o historic but divinely guided founding figure
- o severely monotheistic in form
- o moderated by written scriptures
- o minimal demands six days of the week
- o passive ceremonies one day of the week
- o afterlife of everlasting bliss

if harps are your thing. What's not to like?

But that is true of all religions, the challenge is persuading people to believe them in the first place. Just how does one go about persuading people that Creators of Universes make a habit of imparting elemental wisdom to Arab merchants or impregnating Jewish women? It is easy if

people already believe it

because human beings will believe anything and it only requires they believe it long enough to beget people who will grow up already believing it. But how is the process to get started? An ex-

pansion engine is essential. Islam already had one, it expanded by the sword, but Christianity was supposedly doing it by the voluntarism of missionary work. *That* is going to require very careful handling.

Christendom has a general principle 'cuius regio, eius religio' ('what the top man says, goes') which is an excellent policy once the expansion has already taken place but to get it started there is the unfortunate need to put the *regio* cart before the *religio* horse. Why would any self-respecting *regio* adopt a *religio* that places a religious apparat above the state's own apparat? Strange as it may seem, there were a whole bunch of regios around at the time who might be quite glad to.

None of the successor-states of the Roman empire spoke literary languages so they were all finding it hard coming up with bureaucracies. So? What self-respecting dark age warrior elite gives a fig about bureaucracies?

All of them

Non-literate states find it impossible to expand further than one man can march/ride with verbal instructions and are therefore doomed to remain small. Being small is terminal for states that find themselves in the maelstrom of warrior elites expanding by the sword. It was bureaucratise-or-die.

If you saddle up with the Pope you get the whole shebang. Scriptoria, seminaries, libraries, archives, law courts, scribes for every purpose, state or church. State *and* Church. The whole super-intended by abbots and bishops that you could, should you wish, appoint yourself. Very handy for stashing deposed kings, siblings, ex-wives and all those dynastic dangers that seem to be the major bane of warrior elite barbarian states. But mostly no need, the pope has your back. Once your papal bureaucracy has been installed, it is cuius regio eius religio ad infinitum. What's not to like?

Plenty, for anybody who was not a direct beneficiary of the scribal state and hardly anyone was since these warrior elites were universally foreign warrior elites. Few natives are likely to sub-scribe to this new religion of theirs. Who looks to the courts of kings for the solace of religion? Especially strange middle eastern religions that insist on telling people what they can and can't do to the nth degree. Getting stoned for adultery? There'd be nobody left. "We'll carry on with the religion we've got, if it's all the same to you, thanks very much."

Unless you already believed it

You may live in a state under some newly-arrived barbarian warrior elite *now* but you used to live in the Roman Empire

- o which was better, the Romans or this new lot?
- o the Romans, even if they were the lesser of two evils
- o the Romans were Christian
- o so you must have been Christian too

A less likely candidate than the Roman Empire to espouse turn-the-cheek values would be hard to imagine but since *we*, with all our fancy historical and archaeological investigatory tools, believe the Roman Empire was Christian, there is every reason to suppose *they* could be persuaded it was.

Still, that would only be revisionist guesswork and we don't go in for that, so let us return to what everyone believes, official history. When the Christian Roman Empire departed western Europe at the end of the fifth century, Christianity had, it seems, survived after a fashion. There were reportedly

- o forays by Byzantine Christians
- o heretical Christian barbarian states
- o even a crypto-Judaic one in Septimania
- o the Popes in Rome

That last was encumbered with some real doozies (floozies in the case of Pope Joan) but they were all irrelevant anyway. The key to the survival, then the expansion, of western Christendom turned out to be... who would have guessed...

Celtic Christianity

This aberrant sect had established itself in the far western fringes of the old Empire, beyond the reach of popes, barbarian heresy and eastern orthodoxy. Though not beyond the reach of historians who have told us all about it.

Celtic Christianity, they tell us, began life in Brittany but spread rapidly to the nearby 'Brythonic' language areas of Cornwall and Wales. It was in Wales where these burgeoning sectaries got organised. To call it a Church would be premature, more a matter of linked churches, *clasau*, and peripatetic teachers, *saints*, spreading The Word. Spreading rapidly by all accounts because

they had solved one gigantic problem

It is easy enough for a charismatic preacher to carry his congregation along with him, several congregations, but what about the next generation? Christianity, like Islam, is a religion of the book, so preaching Christianity requires someone to be copying out the scriptures and someone teaching the next generation of saints how to read them. A hierarchy can be dispensed with but not scriptoria and seminaries. Ask the Muslims, that is their model and it has worked for fifteen hundred years. It would work for Celtic Christianity too except for that aforementioned gigantic problem.

Among the many things not to be found in out of the way places during dark ages will be

networks of scriptoria and seminaries

That should be a puzzle for historians except their "if that's what happened, it isn't a puzzle" doctrine means it isn't. According to them monasteries were invented in Egypt in the third century so somehow the message must have got through. Or maybe the Celts thought it all up for themselves but, either way, with one bound, the Celtic Christians had solved their gigantic problem.

Armed with their newly-acquired knowledge, the Welsh could set about turning *clasau* into monasteries, with scriptoria attached to some, seminaries attached to others and bishops operating from various of them. Celtic 'hedge' Christianity could now become something we would recognise today as a full-blown Christian Church. That is what historians say. And they say more! With another bound the Celtic Christians did what nobody else had ever managed to do

export Christianity outside the boundaries of the Empire

To Ireland. If Wales is thought an unlikely vehicle for Christian expansionism, it does not hold a candle to Ireland which

o had made a nil contribution to ancient history
o has made a near-nil contribution to modern history
o saved history in between

How did the Irish do it? Did you know that Ireland holds the world record for *annals*, that essential ingredient of in-between history? Thirty-three of them, according to our crack team of researchers. I don't expect you did – she was a bit surprised herself – because it is one of those things historians carefully ignore. The

Irish don't ignore the annals, they are as pleased as punch about them, though they should ignore them, they are all fakes.

What historians of every nation and Christians of every denominations never ignore is the breathless accounts of

o Irish missionaries criss-crossing Europe
o founding a monastery here
o a bishopric there
o leaving historical records everywhere

All historians, not just prideful Irish ones, are firmly of the belief that St Columba and his intrepid countrymen set off from the old sod c 563 AD (somebody had been counting) armed with their monastery/scriptorium/bishop formula, on a European tour that excites admiration if you like that sort of thing. We don't:

Them	Us
Irish missionaries set up on Iona, a tiny islet off Scotland's west coast	No archaeological evidence, you will have to take their word for it
Irish missionaries set up on Lindisfarne, a tiny islet off England's east coast	No archaeological evidence, you will have to take their word for it
The Irish missionaries convert the Anglo-Saxons of Northumbria under Cuthbert to Celtic Christianity	Cuthbert coffin and cope: Durham Cathedral Cuthbert's gospel book: British Library Laws of entropy: n/a
St Augustine arrives in Kent and converts Kentish Anglo-Saxons to Papal Christianity	You wait hundreds of years for Christianity and two come along at once
The two sides merge at Whitby	You can have too many Christianities
Hilda of Whitby: starts up English poetry Aethelberht of Canterbury: starts up demotic jurisprudence Bede of Jarrow: starts up English history	What a race we were.
Irish and Anglo-Saxons led by St Willibrord, Apostle to the Frisians, set out to convert Europe	Willibrord's body: Echternach, Luxembourg his gospel book: Bibliothèque nationale, France Not made in: Lindisfarne, England
Irish return to their annals	Don't call us, we'll call you

32 Wales Takes the Strain

There are two kinds of written languages: artificial scribal ones, like Mandarin, and 'literary demotics', like the one you are reading now. They can get confused, they can even get melded (the Han Chinese increasingly speak Mandarin) but they are two different things. Most people, should they stop to think about it at all, would assume literary demotics were the product of the European Middle Ages after 1000 AD for the simple reason that all written records surviving from before 1000 AD are written in scribal languages. How much more evidence would anyone need?

Academics are not most people, they have come up with a wholly different view of the past, one where people went round talking and, if they were educated, writing in scribal languages like Latin or Classical Greek (or vulgar variants) and later turned these into many of the European languages spoken today. Modern Greek, French, Spanish, even Romanian for pity's sake.

Not satisfied with their curious view of Classical times, academics have completely fallen off their literacy trolleys when it comes to the Dark Ages. During these uncouth centuries, when nobody was writing much of anything, they want us to believe the English, the Welsh and the Irish were discovering how to produce these modern 'literary demotics'. They were not going to all this trouble for any clear purpose, they only used their marvellous new toys to write down things that could just as easily have been written in Latin, which they were already using.

The evidence for this theory derives from a handful of Dark Age documents with Old English, Archaic Welsh and Early Irish writing in them. Academics believe these documents to be genuine, and it would certainly prove their case if they were. Only the Welsh were employing their fabulous innovation to do anything that might conceivably warrant having one's own literary language

> Welsh-language literature (llenyddiaeth Gymraeg) has been produced continuously since the emergence of Welsh from Brythonic as a distinct language in around the 5th century AD. The earliest Welsh literature was poetry, which was extremely intricate in form from its earliest known examples, a tradition sustained today.

Welsh academics (and there are no other kind when it comes to studying the Welsh language for obvious reasons) have not produced any evidence of the existence of 'Brythonic'. Nor when Welsh emerged from it. Nor, if truth be told, Welsh poetry before the fourteenth century. What they do have is a gospel book

> **The Lichfield Gospels (also called the Llandeilo Gospels) is an 8th century Insular Gospel Book housed in Lichfield Cathedral. The manuscript is important because it includes, as marginalia, some of the earliest known examples of written Old Welsh, dating to the early part of the 8th century.**

It is incontrovertible. If the land holdings of a Dark Age monastery in Carmarthenshire can be written in Welsh c. 700 AD, it must mean at some point in the fifth/sixth/seventh centuries, person or persons unknown sat down with the twenty or so letters of the Latin alphabet and worked out how to use them to record Welsh. Not the easiest thing to do today so to be the first people in the world to do it, and to do it in the middle of a dark age, is a proud boast.

If true. We might start with that phrase 'some of the earliest known examples of written Old Welsh' because this is academese for 'the only example of written Old Welsh'. The other one being

> **The oldest surviving text entirely in Old Welsh is understood to be that on a gravestone now in Tywyn – the Cadfan Stone – thought to date from the 7th century**

Entirely in... understood to be... thought to date from. The most committed partisan of early literary Welsh would have to concede anybody can inscribe anything on gravestones and they can do it in any century. In a land where even the stonemasons are Welsh partisans my money would be on the nineteenth, but whichever century it was, one can appreciate why the Lichfield Gospels are so important to partisans of early literary Welsh.

When and where the book itself was written (in Latin, only the marginalia are in Welsh) is not known so the Welsh claim that it was taken to Llandeilo in the eighth century 'for safekeeping', has been accepted faute de mieux. Speaking strictly for myself, sending a treasured but imperilled possession to a foreign country in a dark age would not be my first choice. Apart from anything else, they might not give it back. Nothing against the Welsh but if the

Vikings or whoever were coming, I'd either take it with me or bury it in a hole in the ground.

The Welsh calling the Lichfield Gospels the *Llandeilo Gospels* was fair enough, but English historians have been reluctant to give up the Lichfield name, being light on contemporaneous Dark Age documentation themselves. A compromise was reached and it is generally known as the *St Chad's Gospel* (he's Scottish). Now, even that is up for grabs because a twenty-first century American boffin, armed with some hi-tec gubbins, demonstrated reasonably conclusively that the book was written by English scribes (female, as it happens). When, later, an angelic sculpture was dug up from the bowels of Lichfield Cathedral with flecks of pigment identical to ones used in an illustration in the gospel book, there really could no longer be much doubt that the Lichfield gospel book was written in Lichfield, stayed in Lichfield and never left Lichfield. It was not, and nothing against the Welsh, very likely to have spent the eighth century on the other side of Wales.

What then is the current view of the archaic Welsh listing of Llandeilo's land holdings? Welsh scholars are sticking to their guns, as one would expect. English scholars are keeping well clear as, in these delicately devolutionary times, one would expect. Revisionists have waded straight in, as one would expect. They point out medieval land disputes were often a case of one side turning up in court with documents showing the land in question had belonged to their monastic order (or episcopal see or baronial domain) from time immemorial. The other side might turn up with something similar, saying something completely different, but having a judge deciding who had the better forgery was better than the previous conflict resolution model, several hundred armed retainers turning up.

That, at any rate, was the view of Henry II in the twelfth century and as he had just won the English Civil War (Mark I) his will prevailed. He got a bit crotchety when people started turning up with ancient manuscripts saying Edmund the Unfeasible had granted them the privilege of never having to pay royal taxes but we can leave the Plantagenets to sort that out. We dare not leave historians to sort it out. A dearth of genuine historical documents means they have seized on these fake ones and turned them into history lest there be a dearth of historians.

In these delicate devolutionary times their Welsh colleagues are playing for bigger stakes than jobs for the boyos. They have a nation to (re-)create and an ancient literary language would help the cause immeasurably. By the start of the twentieth century they had got one of their ducks in a row

> **The National Library of Wales, holding over 6.5 million books and periodicals, and the largest collections of archives, portraits, maps and photographic images in Wales, is home to the national collection of Welsh manuscripts**

though not the most important one, the one sitting on its shelf in Lichfield Cathedral. But even adding that in, nobody could deny the historical evidence was thin. Welsh archaeologists were going to have to pitch in with their two-pennyworth if the national cause was to prosper.

> **In 1905, the government promised money in its budget to establish a National Library and a National Museum of Wales**

Where were these two institutions to go? Wales might not technically be a country but it is a country of two halves, north Wales and south Wales. One of the reasons Wales has never become a country is that the two halves do not get on. They do not get on one little bit

> **The Privy Council appointed a committee to decide on the location of the two institutions. David Lloyd George, who later became Prime Minister, supported the effort to establish the National Library in Aberystwyth, which was selected as the location of the library after a bitter fight with Cardiff, partly because a collection was already available in the College.**

Lloyd George at the time was not so much a future prime minister as a widely reviled opponent of the Boer War, so it is more likely other considerations tipped the balance

> **Sir John Williams, physician and book collector, had also said he would present his collection to the library if it were established in Aberystwyth. He eventually gave £20,000 to build and establish the library.**

It seems to have worked

On 15 July 1911 King George V and Queen Mary laid the foundation stone of the National Library of Wales in Aberystwyth

Who was this national saviour? Where have they sited his statue? Apart from being one of the many candidates proposed as Jack the Ripper, not much is known

Sir John Williams (1840– 1926), was a Welsh physician, who attended Queen Victoria and was raised to the baronetcy by her in 1894. He is remembered chiefly for his contribution to the collection of the National Library of Wales, in particular the Peniarth Collection of manuscripts.

And for possibly being Jack the Ripper but it is only the literary side of his life that need detain us

Sir John presented a collection of some 1,200 manuscripts in total to the National Library, which divide into three groups: the 500 manuscripts from the Hengwrt–Peniarth collection; the Llanstephan collection of 200 manuscripts, including 154 from the Shirburn Castle library; and 500 Additional Manuscripts that he had collected from various sources.

Ripper murders 1888-91... was he combining activities or was it sequential?

The majority of the manuscripts were acquired between 1894 and 1905 as part of the campaign to establish the National Library in Aberystwyth. In 1905, after it had been confirmed that Aberystwyth would be the Library's location, he almost entirely ceased to collect manuscripts.

He was not nearly so organised with this new pre-occupation

It is regrettable that the arrangement of the remainder of the Sir John Williams manuscripts was made without proper regard for their provenance

If I can tear you away from your morbid fascination with Victorian serial killers for a moment, what you should be asking is why the most important manuscript collection in Wales has not had its provenance thoroughly checked out. If those Jacks-in-office (no pun intended) won't do it, we shall have to. What were they again?

- 500 manuscripts from the Hengwrt–Peniarth collection
- 200 manuscripts from the Llanstephan collection including
- 154 manuscripts from the Shirburn Castle library collection
- 500 manuscripts collected from various sources

Odd lists, as we know, are a clarion call for forgery detectives and this list is odder than most. Unless the Welsh are like those Amerindian tribes one reads about who can count up to a hundred and fifty-four but after that they round everything up to the nearest hundred until five hundred which is as high as their numbering system goes. Alternatively, the National Library of Wales has left everything a bit vague for some other reason.

No arithmetic was needed to identify the stars of the show

> The Peniarth Manuscripts, also known as the Hengwrt–Peniarth Manuscripts, are a collection of medieval Welsh manuscripts now held by the National Library of Wales in Aberystwyth. The collection was originally assembled by Robert Vaughan (c.1592–1667) of Hengwrt, Merioneth-shire, and in the 19th century was housed in Peniarth Mansion, Llanegryn, Merioneth. It contains some of the oldest and most important Welsh manuscripts in existence.

Provenance by hyphen is not sound practice. There is, we are being told, a nineteenth-century collection called the Hengwrt-Peniarth Manuscripts. There is a seventeenth-century 'Hengwrt Collection' because that is the name of Robert Vaughan's house. But there were other Vaughans doing their bit

> The manuscripts were preserved at Hengwrt for gener-ations, and some other volumes were added to them over the years

Those investigative fiends at the National Library of Wales may not know which manuscripts, they may not know which Vaughan, they may not know when they were added, but they are gimlet-eyed when it comes to how the manuscript collection as a whole fell into their laps. After a couple of hundred years there were no more Vaughans

> When Sir Robert Williames Vaughan of Hengwrt died in 1859, without an heir, he left the collection to his friend W W E Wynne, who moved the manuscripts to the Peniarth Library, Meirioneth

A Welshman without heirs is unusual but since the manuscripts were being passed to a fellow aficionado it did not matter whether there were heirs or not. Though it matters a good deal to provenances because there is always a lot of tiresome legal bumph that gets generated when things are passed to heirs but not if they are passed to a fellow aficionado. We must watch out for that.

W W E Wynne had an heir but the heir was not an aficionado and got shot of the lot

> **The whole collection was bought by Sir John Williams in 1904. When W R M Wynne, the eldest son of W W E Wynne died in 1909, the manuscripts were transferred from Peniarth to the new National Library at Aberystwyth.**

I know you are getting restive, you may not be Welsh, but we are dealing with the most important literary artefacts of a great literary nation (and, I promise you, unveiling the true history of the world) so it behoves us all to remain gimlet-eyed. To sum up

1. W W E Wynne is gifted the collection in 1859
2. Son inherits collection
3. Son sells collection to Sir John Williams in 1904
4. Sir John, an avid collector, has acquired the greatest prize any manuscript collector in Wales could ever hope for
5. Sir John hands collection back to son
6. Sir John gives up collecting
7. Son dies in 1909
8. Collection goes to National Library of Wales
9. National Library of Wales opens for business
10. Sir John surely deserves a baronetcy for this act of self-abnegation alone though he was not to know W R M Wynne would die just in time for the opening of the National Library of Wales.

Or did he?

In such unresolved circumstances would anyone object if we ran provenance checks on the manuscripts themselves? The Welsh will, 'interfering English busybodies', but we are going to anyway. Not because we are interfering English busybodies but because we are interfering revisionist busybodies

> **Robert Powell Vaughan (?1592 – 16 May 1667) was an eminent Welsh antiquary and collector of manuscripts. His collection, later known as the Hengwrt-Peniarth Library**

from the houses in which it was successively preserved, formed the nucleus of the National Library of Wales, and is still in its care.

He sounds tickety-boo. Any red flags?

Vaughan also transcribed texts himself

"Dear National Library of Wales, could you let me have a list of the manuscripts Robert Vaughan transcribed as opposed to collected. To transcribe them he would have needed the originals and as an 'eminent antiquary and collector' he will have kept the originals, which presumably will now be in your care. As you know, strict protocols demand that transcribed texts be carefully distinguished from originals."

"Dear Mr Harper, we'll get back to you on that one."

He was able to increase his holdings further after making an arrangement with the calligrapher and manuscript collector John Jones of Gellilyfdy, Flintshire, in which one would combine both collections on the other's death.

Another aficionado-transfer. Another polite enquiry.

"Dear National Library of Wales, could you let me have a list of the manuscripts that the calligrapher, John Jones, transcribed as opposed to collected. To transcribe them he would have needed the originals and as a manuscript collector he will have kept the originals, which presumably will now be in your care. As you know, strict protocols demand that transcribed texts be carefully distinguished from originals."

"Dear Mr Harper, we'll get back to you on that one."

I admit I have yet to write these letters but we have discovered the 'Hengwrt-Peniarth collection' should more properly be called the 'Hengwrt-Gellilyfdy collection' so not even the Welsh can object if we do a background check on this new character

John Jones of Gellilyfdy (c. 1578 - c. 1658) was a Welsh lawyer, antiquary, calligrapher, manuscript collector and scribe. He is particularly significant for his copying of many historic Welsh language manuscripts which would otherwise have been lost. Jones was a friend of the antiquary Robert Vaughan and the latter seems to have come into the possession of Jones' manuscript collection on his death.

285

John Jones of Gellilyfdy sounds tickety-boo. Any red flags?

> **however, by 1611 he was in a debtor's prison in London. Jones was to spend much of his life in prison from this point, although he used his time while incarcerated to carry out much of his transcription work and did relatively little copying while at liberty.**

To the Governor, Marshalsea Prison

What is the official policy about having valuable manuscripts being transcribed in your fine establishment? One likes to see vocational programmes for inmates although, given Mr Jones's record of recidivism, the padre will no doubt want a word with him about his vocation.

I fully concur your duty of care extends to the nation's literary heritage as well as its prisoners, so there would be no grave objection were you and your officers to act as facilitators. However, one point that might be drawn to your attention is that, as Mr Jones is in your care for debt, the fruits of his labour really should go to his creditors as a first charge. Arguably they would be entitled to seize the originals.

But I must let you get on, so with all best wishes etc etc

> **John Jones was educated in law, probably at Shrewsbury School, and by 1609 was engaged in the Court of the Marches at Ludlow as an attorney. By this time he had already begun to make copies of manuscripts that he located in the houses of the Welsh gentry**

Before he was a prison-calligraphist Jones was a lawyer and, according to the National Library of Wales, a kind of literary rag-and-bone man quartering the highways and byways of Wales. 'Any old manuscripts? Bring out your manuscripts.' According to the National Library of Wales, the Welsh gentry did have manuscripts for Jones to copy but this must have resulted in a tricky question of etiquette. It will take weeks for Jack Jones, being on his Jack Jones, to copy out their precious family heirlooms so does one invite him to sit with the family at mealtimes or is he more 'downstairs'? (Note to the lady of the house: do not permit Mr Jones to take anything away under any circumstance.)

Jones's status may be modest, what he copied was not

> including the White Book of Rhydderch. (Welsh: Llyfr
> Gwyn Rhydderch), one of the most notable and celebrated
> surviving manuscripts in Welsh

The National Library of Wales, in its endearingly casual way, is applying the word 'surviving' to a seventeenth century copy, and they go on to admit that what Jones was copying, even assuming he was, goes back no further than the fourteenth century

> Mostly written in southwest Wales in the middle of the
> 14th century (c. 1350) it is the earliest collection of Welsh
> prose texts, though it also contains some examples of
> early Welsh poetry. It is now part of the collection of the
> National Library of Wales.

They have managed to convey the impression

- o there were any number of prose texts in the 14th century
- o there is any amount of early poetry
- o that some thoughtful scribe has anthologised a selection of them in the *White Book of Rhydderch*

which they do not possess but have taken a seventeenth century jailbird's word that he made a fair copy of it.

Now inspect those last two passages again. It has all been said without transgressing any of the norms of fair comment. It is a masterpiece of academese. Who would ever notice the National Library of Wales has

<p align="center">sold the paradigm pass</p>

because if those two passages are translated into plain English, the dimmest academic would recognise the situation is catastrophic

- o the world authority for Welsh manuscripts is the National Library of Wales
- o it has admitted no Welsh vernacular literature earlier than 1350 AD has survived
- o leaving Wales with no evidence of Welsh literature between the fifth and the fourteenth centuries
- o despite Welsh being a literary language for the whole of those nine hundred years

This is not to say there cannot have been reams of the stuff that have not survived but

- o academics are not supposed to believe things for which there is no evidence

- they absolutely, definitely, no two ways about it, should not be using official websites to give the impression there was
- scoundrels the lot of them.

Nothing against the Welsh, that is the power of academese. Everyone professionally concerned wants Welsh literature to stretch back to the birth of Wales, they have all been trained to believe Welsh literature stretches back to the birth of Wales and, so long as academese and Welsh academics are employed, Welsh literature will stretch back to the birth of Wales.

If they ever did translate their own words into plain English (not plain Welsh, I think, on this occasion) would it result in a paradigm crash? For the Welsh, it probably would. For everyone else it is more about cash than crash. Penguin Classics are always on the lookout for colourful tosh they can sell in wagonloads to people who like their colourful tosh to be officially endorsed as antient. The *Mabinogion* for instance

> **The White Book of Rhydderch, contains the Four Branches of the Mabinogi. The Mabinogion are the earliest prose stories of the literature of Britain. The stories were compiled in Middle Welsh in the 12th–13th centuries from earlier oral traditions.**

The Penguin Mabinogion will have a lengthy and learned introduction from an academic which will not be much read but it is part of the deal that it has to be there. What will get a mention? [I have deliberately not looked so this is by way of a hostage to fortune.]

- the text has been copied from C 12th-13th manuscripts
- the manuscripts are based on earlier oral traditions

What will be carefully ignored?

- the manuscripts have disappeared
- second sight is required to know what oral traditions were extant in 12th-13th century Wales

But not to worry

- manuscripts are famous for disappearing
- bards are famous for keeping oral traditions going
- the Welsh are famous for their bards
- Celts in general are famous for their second sight

Reluctantly we shall have to let this one through.

Oh no! We've let the Penguin marketing people through. The *Mabinogion* may be old but it is only medieval-old. What people really want is full-on Dark Age Arthurian swords-and-sorcery. As the Welsh have been famously writing these things down since before Arthur met Merlin, they will have no trouble supplying it

> The collection also includes treasures such as the Book of Taliesin. Taliesin (fl. 6th century AD) was an early Brythonic poet of Sub-Roman Britain whose work has possibly survived in a Middle Welsh manuscript, the Book of Taliesin. Taliesin was a renowned bard who is believed to have sung at the courts of at least three Brythonic kings.

Who needs Cecil Sharp when you've got the National Library of Wales?

33 The Death of Christianity

Wales was wholly within the Roman Empire, the Roman Empire
was wholly Christian, but little has been found for Christianity in
Wales during the Roman period

> Caerwent has been the subject of archaeological excavation
> for over 150 years, which has revealed the layout of most of
> the Roman town, including the basilica, two temples and
> many artefacts and mosaics. Among the discoveries was a
> pewter bowl with a Christian chi-rho symbol scratched on
> its base, which is the earliest evidence for the new Roman
> faith in Wales.

Slender, considering chi-rho is not a Christian symbol

> In pre-Christian times, the Chi-Rho symbol was also to
> mark a particularly valuable or relevant passage in the
> margin of a page, abbreviating chrēston (good). Some
> coins of Ptolemy III Euergetes (r. 246 – 222 BC) were
> marked with a Chi-Rho.

Maybe he just loved his bowl, maybe they were his initials. If it was
Christian symbology his dining companions surely had reserv-
ations about the name of the Lord being banged down on the table
at every mealtime.

 But Our Saviour is famously forgiving (unlike his Da) and Caer-
went was a garrison town, used to rough ways. In fact this whole
chi-rho business was a soldiers' thing from the very earliest days
of Christianity's long history as a state religion. Historians as well
as Church authorities are clear on the point

> According to Lactantius, a Latin historian of North African
> origins saved from poverty by the Emperor Constantine
> the Great (r. 306–337), who made him tutor to his son
> Crispus, Constantine had dreamt of being ordered to put a
> "heavenly divine symbol" on the shields of his soldiers

though not on this occasion the chi-rho symbol

> The description of the actual symbol chosen by Emperor
> Constantine the next morning, as reported by Lactantius,

**is not very clear: it closely resembles a Tau-Rho, a similar
Christian symbol.**

You can't have too many Christian symbols.

The archaeology can be left to Welsh Romano-Christian archae-
ologists, we are solely interested in post-Roman, pre-Norman
Christianity. There are a great many religious sites reported as
active in Wales during these six hundred years but we shall be
confining ourselves to the 'majors', those capable of keeping
Christianity going (exporting it even) because of their episcopal,
scriptorial or teaching facilities. They should not be hard to find,
they are all in the historical record in one form or another –
chronicles, hagiographies, cartularies and the like. Such substantial
establishments will all have left archaeology to a greater or lesser
extent.

As is usual with our exacting procedures, we shall be taking them
in alphabetical order but, needing only a representative sample to
illustrate how the Church in Wales operated during the Dark Age,
as soon as we have identified one or two, three to be on the safe
side, we can move on to less arcane matters. **[#1] Bardsey** heads
the list

> **Bardsey (Ynys Enlli), known as the 'Rome of Britain'.
> According to the most important of the cartularies, the
> Book of Llandaff, this is the burial place of twenty thou-
> sand saints, and was still a 'Celtic church' when the most
> important of the Norman commentators, Gerald of Wales,
> visited it in the twelfth century. The island has been an
> important religious site since the 6th century, when it is
> said that the Welsh kings of Llŷn and Saint Cadfan founded
> a monastery there. In medieval times it was a major centre
> of pilgrimage and, by 1212, belonged to the Augustinian
> Canons Regular. The monastery was dissolved and its
> buildings demolished by Henry VIII in 1537, but the island
> remains an attraction for pilgrims to this day.**

The difficulty here is that neither the Book of Llandaff nor
Gerald of Wales are primary sources. They may be valuable in all
sorts of ways to historians but they cannot be used by historians
to verify the sixth century monastery as the accounts were written
five hundred years later. Still, promising.

If not self-supporting, monasteries relied on either renting out
their land or the pilgrim trade. Bardsey Island, being one of the

more remote corners of Wales, did not command high rents, but it did make for an ideal pilgrimage destination. Standing at the tip of the Llŷn peninsula in the far north-west, Bardsey offers the longest pilgrimage route in Wales.

It always comes as a shock to those of us who think of walking as something humans had to do before the horseless carriage was invented, but walkers relish a challenge. The difference between today's recreational masochists and medieval pilgrims is that the latter required a justification before setting out. Bardsey Island provided twenty thousand saints for them to commune with though archaeologists have not yet found the corporeal remains. However, the general ambience their presence lends has made Bardsey a magnet for pilgrims of all ages

> The spirituality and sacredness of the island, its relative remoteness, and its legendary claim to be the burial site of Merlin have given it a special place in the cultural life of Wales, attracting artists, writers and musicians to its shores. It has inspired award-winning literature, and attracted internationally renowned singers.

Bodies or no bodies, Christian or 'other', the authenticity of an ancient Bardsey is vouched for at the highest levels

> The Bardsey Island Trust bought the island in 1979 after an appeal supported by the Church in Wales and many Welsh academics and public figures. The trust is financed through membership subscriptions, grants and donations. When, in 2000, the trust advertised for a tenant for the 440 acres sheep farm on the island, they had 1,100 applications.

Archaeologists can confirm the sheep farming but not the ancient monastery

> Some of the huts of which traces remain on Mynydd Enlli may have formed part of the early monastic settlement, but no certain attribution can be made on the evidence of their present appearance.

One cannot say definitively there was not a Dark Age monastery on Bardsey Island but the evidence does not meet our exacting standards that there was. We shall have to continue our quest.

[#2] **Beddgelert** holds out particular hope because it is

> traditionally regarded as one of the oldest religious found-
> ations in Wales

Tradition exists on the edge of history proper. Historians use tradition quite freely but only as academic chat because traditions cannot be pinned down with citations. Unless they are citing one another in which case the tradition bit often gets omitted. Gerald of Wales claimed Beddgelert was a Culdee foundation which would make it very old indeed, except every historian knows he is more excitable than citable.

Archaeologists cannot use tradition, they have to produce physical evidence. In the case of Beddgelert they have been given a good steer

> It is thought that the early medieval (Celtic) clas previously
> occupied the site of the later Augustinian monastery

'It is thought' is a variant of 'traditional'. The physical evidence has not been forthcoming so help has been sought from a third branch of academia's hydra-headed approach to the past, the place-name specialists. They use a completely different methodology, making it up as they go along

> The village is probably named after an early Christian
> missionary and leader called Celert or Cilert

Or, failing that, what about a dog?

> The folk tale of the faithful hound "Gelert" is often
> associated with the village. A raised mound in the village
> is called "Gelert's Grave" and is a significant tourist
> attraction. But the grave was built by the late 18th-century
> landlord of the Goat Hotel, David Pritchard, who created it
> in order to encourage tourism. Similar legends can be
> found in other parts of Europe and Asia.

Landlord-assisted archaeology is a tradition in Beddgelert

> On 21 September 1949 a meteorite struck the Prince
> Llewelyn Hotel in the early hours of the morning, causing
> damage to the roof and a bedroom in the hotel. The prop-
> rietor of the hotel, a Mr Tillotson, subsequently sold half
> the meteorite to the British Museum and half to Durham
> University, which had placed an advertisement in the local

papers asking for information and offering a reward for any recovered fragments of the meteorite.

Falling meteorites are a tradition in the Beddgelert area

> **There have only ever been two such verified meteorite falls in Wales: the Beddgelert incident, and an earlier incident fourteen miles away in Pontllyfni in 1931, at the other end of the Nantlle Ridge.**

Falling meteorites may be the 'bread of heaven' referred to in the traditional Welsh national anthem.

Beddgelert does have one site that meets the evidential standards of both archaeologists and place-name specialists

> **The village is also linked with the Rupert Bear stories, as Alfred Bestall wrote and illustrated some of the stories whilst he lived in the village, in a cottage at the foot of Mynydd Sygun. There is even a small area known as 'Rupert Garden' in the village, dedicated to the Bear; a short walk from Alfred Bestall's old home.**

but not historians. The first textual mention of Rupert Bear is in the *Daily Express* which is not considered a reliable source. On paper, Beddgelert must be considered a borderline fail.

There is nothing fictional about our next Dark Age monastery, **[#3] Caerwent**, Wales' most exhaustively examined archaeological site. Few stones will have remained unturned after a hundred and fifty years of effort

> **an early Celtic monastic site was established at Caerwent within the old walls of the former Roman town**

and is fully confirmed by the historical record

> **We also know that a large monastery existed at the site by the tenth century, according to information found in the Llandaff Charters**

But we are the awkward squad, we insist on chapter and verse

> **Excavations at Caerwent have revealed remains and everyday objects from the post-Roman period. Metalwork, including elaborate penannular brooches and fastening pins, have been dated to the 5th–7th centuries**

but no monastery. Archaeology is, of its nature, a hit and miss activity. It is entirely possible to hit fastening pins and miss monasteries. They never miss the graves

> A large number of Christian burials, some stone-lined, dating from between the 4th and 9th centuries have also been discovered, both around the town's East Gate and close to the parish church

They must have been Christian because Caerwent had a monastery at the time. But until that is found we must vote Caerwent a miss.

[#4] **Caldey Island** is the only entry on the list that is still a working monastery, and hence offers a unique insight into the practical difficulties (and opportunities) of Welsh monkish life

> In the 6th century AD the island became known by the Welsh name Ynys Byr or Pyro's Island, after the first known Abbot.

We know so much about Dark Age Wales it is a surprise we do not know what Ynys Byr was called before the sixth century. Something in Brythonic, one would conjecture.

> By about the 10th century the Celtic settlement may have been abandoned, possibly as a result of Viking raids.

Not good for monks but good for archaeologists as it means undisturbed strata containing evidence left by four hundred years of pre-Viking monks. Unless disturbed by later monks

> After a Norman priory was established on Caldey around 1131, the monks rebuilt the Celtic chapel, incorporating stonework from the 6th century building in the nave of the new church. The medieval church also reused the foundations of the Celtic building.

Leaving nothing for the archaeologists, who can only date stone from undisturbed strata. There are claims stonework can be dated on stylistic grounds but that will have to await the finding of stonework from strata of the Dark Age period. Later monks took the view that centuries-old building material had passed its use-by period

> The current abbey was built by Anglican Benedictine monks in the Italian style with assistance from Lord

Halifax and others between 1906 and 1910. The much stricter Trappist Order, who now occupy the abbey, came in 1929 from Scourmont Abbey in Belgium. The monastery was rebuilt in 1940 after a fire.

One thing is for sure, Caldey Island could not support monks from any period by renting out the land. It is barely tolerated by sheep. Monks tolerate it because of their vow of poverty but that is not incompatible with making money

> Profuse growth of wild lavender flowers on Caldey Island prompted the monks of the abbey to create scents with new fragrances. They branded the scents and marketed them with the brand name "Caldey Abbey Perfumes." With booming demand for this brand of scent there was need to import scent oil from outside the island. The scent is now manufactured throughout the year and is partly based on the island's gorse.

The collective noun for Welsh bards is a *gorsedd* so they may sing of the special bouquet of Caldey gorse over other Welsh gorses. I am uncertain on the point, a verdict that will have to be extended to the existence of Caldey's Dark Age monastery.

[#5] **Carmarthen** is another Celtic establishment in a Roman town, or nearly so

> The native Welsh township of Llandeulyddog or 'Old Carmarthen', was based partly on and to the east of the Roman city and may have been the site of an early Christian community during the Dark Ages and into the medieval period.

A site that existed in the Dark Age and into the medieval period is just what we are looking for. The written sources are good, if later

> Lann Toulidauc (Llandeulydogg) is one of the churches listed in a papal letter of Pope Innocent II in the Book of Llandaff.

so not historical evidence for the earlier church. There *are* earlier sources

> The church is also listed in the account of the churches granted to St Teilo in the sixth century. The original

> church was one of the seven bishop-houses of Dyfed
> mentioned in the Welsh laws.

but none of these are, in the jargon, 'extant' so none of them are, in the jargon, 'historical evidence'.

The archaeological prospects hold out more hope

> The priory site is unusual in having nearly all its former
> precinct area surviving as open and largely undisturbed
> ground

The official guide to ancient Welsh monasteries has told archaeologists where to look

> Carmarthen Priory was founded by Bishop Bernard of St
> David's (1115 - 48) and replaced a Benedictine community
> who had occupied the site for only a few years. The site
> however, had a longer history of religious occupation for it
> was originally the ancient 'clas' church of Llandeulyddog,
> which may have had its origins in the sixth century.

Nothing to report so far from archaeologists' favourite milieu, under the ground, but they have had more luck on top of it

> Outside the south-western corner of the church stands a
> shaft of local granite with a vertical sundial engraved on it.
> It is described as being of Irish type dating from 10th to
> 12th century.

Though from someone else's ground

> The stone is not in its original position, as it previously
> stood at Llyn y Gele Farm

Claims for the existence of a Dark Age priory at Carmarthen would seem to be not well grounded.

The Dark Age in Wales is synonymous with 'The Age of Saints' as exemplified by **[#6] Clynnog Fawr**

> The Church of St Beuno dates mostly to the late 15th or
> early 16th centuries, but stands on the foundations of a
> much earlier site. St Beuno is said to have founded a clas, a
> Celtic monastery and centre of learning, on land donated
> to him by St Cadfan. The traditional date given for the
> foundation of the clas is 630.

Saintly origins came in handy when less saintly folk arrived

The foundations of Clynnog Fawr seem to have survived the Viking period

'Seem' seems to indicate they may not be of much use for dating purposes, and it seems much the same could be said for the rest of the church

> On the southern side of the church, connected by a dark cloister is the ancient Chapel of St. Beuno, also known as 'Chapel of the Grave'. There is also a stone, known as St. Beuno's stone (Maen Beuno) which is said to have the finger marks of St. Beuno. His holy well, Ffynon Feuno, is about 200 yards from the church. In former days, rickety and epileptic children, as well as impotent folk generally, were dipped in it, and then carried to the chapel and put to lie overnight on the saint's tombstone.

Not recommended for rheumatism. Or anything else, according to present day medical practitioners, who claim the 'placebo effect' accounts for any so-called cures. And they turned out to be right. St Beuno may not have had anything to do with Clynnog Fawr

> The very existence of a monastic house is in some doubt: this is certainly the case with the alleged Cistercian abbey of Clynnog Fawr. The church there is well-known as an ancient clas, subsequently a portionary church, dedicated to the seventh-century saint, Beuno; but in the sixteenth century the antiquary, John Leland (d. 1552), noted that Clynnog Fawr had once been the location of a 'house of white monks' - i.e. a Cistercian monastery. There is no other evidence for the existence of this 'monastery' and it is tempting to speculate on possible confusion between Clynnog Fawr and Rhedynog Felen, which was the original site of Aberconway Abbey and lies some five miles to the south of Clynnog Fawr.

Fiddlesticks. Five miles is no distance for saintly intercessions but there will have to be intercessions from sub-celestial academics before the existence of Clynnog Fawr's Dark Age monastery can be assessed as more than a placebo.

The *Fawr* in Clynnog Fawr stands for 'great' but that does not necessarily equate to size. When we Londoners drive through English places with names like Appleby Magna or Great Missenden,

we often remark, "No wonder we missed Little Missenden."
Motorists would be forgiven if they were equally dismissive when
driving through **[#7] Llanbadarn Fawr**

> Much of the early history of the church must remain
> speculative rather than definitive, due to the absence of
> documentary or archaeological evidence. St Padarn is
> traditionally said to be the first bishop.

Professor Howard M R Williams is determined motorists will stop
for a look-see

> Llanbadarn Fawr is just to the east of Aberystwyth on the
> north bank of the Afon Rheidol. Inside the church, in the
> south transept, is a display of two striking pieces of
> sculpture that reveal that Llanbadarn Fawr was a major
> ecclesiastical centre by the tenth century. Written sources
> tell us that the site was sacked by Viking raiders in AD 988.

"Leave the sculptures, Olaf, no room in the boat."
 There is no mystery about how Llanbadarn got its 'Fawr'. Its
founding saint was a mighty figure in the land

> Notes on Vita sancti Paternus [the Life of St Padarn]: A
> final chapter tells how Padarn, David and Teilo divide
> south Wales into three episcopates, with Padarn as bishop
> of Ceredigion. Then, convinced by a miracle performed by
> Padarn, a local governor called Eithir is persuaded to give
> land between the rivers Rheidol and Paith to Padarn.

Any doubts about the veracity of this account can be banished
thanks to place-name evidence

> The obscure figure of Eithyr is commemorated in the farm
> name of Llaneithr, which stands a mile east of Devil's
> Bridge near the river Mynach

You couldn't make it up. Unless you were making up the *Life of St
Padarn*. Places founded by St Padarn's followers rather than the
man himself will not be entitled to a *Fawr*

> St Padarn's seven known dedications are beside two
> Roman roads that run north and south linking forts on
> either side of the Cambrian mountains. This implies,
> according to Rees, that Padarn's followers worked around
> the ruined Roman garrisons. According to Evans, 'On the

west side of the mountains Llanbadarn Fawr, Llanbadarn Fach [Llanbadarn Trefeglwys], Llanbadarn Odwyn and Pencarreg. On the eastern side of the mountains (another) Llanbadarn [possibly he means St Padarn's Church, Cross Gates, Llandrindod Wells], Llanbadarn Fynydd and Llanbadarn.'

It may be that St Padarn was known in his time as Soapy Sam because *padarn* is Welsh for 'soap' and one thing mid-Wales would need is sheep-processing centres along the main routes, lanolin being a chief by-product, so it was lucky they were already called Llanbadarn, a 'place for soap'. Whether Llanbadarn Fawr was the chief centre for cleansing Dark Age souls is, one regrets to say, eithyr/or.

Place-name theorists insist 'llan' means 'church of' rather than 'place of' (apart from Llaneithr), a supposition that can leave etymological stretch marks. An entire consonant shift in the case of 'Llanfair' which means *St Mary's* according to the place-name people, not somewhere that holds a fair. They do concede that 'llan plus a saint' can run into occasional difficulties, a case in point being **[#8] Llancarfan**

> Llancarfan was once the site of one of Glamorgan's most important pre-Norman monasteries. The name 'Llancarfan' means "church of the stags".

You should have seen the mayhem every time Harvest Festival came round. There *is* a local saint but he had not been granted naming rights

> The principal historic building in the village is St Cadoc's Church, an important early 13th century building. It is one of several churches in Wales dedicated to St Cadoc, but it was at Llancarfan that the saint is believed to have served as abbot of, or possibly founded, a monastery of some importance.

The village may have hesitated about renaming itself 'Llancadoc' after the stags had moved away because nobody could remember who *had* founded the monastery

> The monastery, an early Celtic monastery or a greater clas, is attributed to either St Germanus in the 5th century, Dubricius in the late 6th century, or, more generally

300

accepted, St Cadoc/Cattwg, son of Gwynllyw, a contemp-
orary of Dubricius, about AD 500.

Whoever it was, there was definitely a monastery because later
medieval scribes could remember when, even if not whom

> Certainly the 12th century document, the Book of Llandaff,
> refers to the presence of a monastery at Llancarfan from at
> least c. 650 AD

This Book of Llandaff is proving a godsend. Its authors are due
our respect for being able to lay their hands on records at least half
a millennium old when compiling their book. They had more
recent material as well

> By the 9th century the 'clas' of St. Cadoc was flourishing
> as one of the great centres of Christianity and learning
> within south east Wales.

Everyone knows what happens to flourishing centres of Welsh
Christian learning

> Despite being amongst those places destroyed by the Danes
> in 998 AD

Everyone knows the Welsh are great ones for bouncing back from
adversity

> by the 11th century Llancarfan had become the most
> powerful ecclesiastical community within Glamorgan

Everyone knows nobody bounces back from Norman adversity

> However, this period of supremacy was brought abruptly
> to a close in 1093 when the Normans invaded Glamorgan.
> The monastery at Llancarfan was dissolved and the lands
> and incomes eventually granted by the Norman lord
> Robert Fitzhamon to the Abbey of St. Peter's, Gloucester.

Archaeology stood no chance against the combined forces of
Vikings and Normans

> nothing now remains (the site is a scheduled monument).
> St Cadoc's church is listed Grade 1

which is good to hear but thirteenth century so no help to us. Has
nothing survived from Dark Age times?

> The pillar-cross today preserved within Llancarfan church-yard, perhaps itself an enclosure of monastic origin, can be dated to the late-9th, or possibly 10th century, cut with secondary inscription in 11th or 12th century.

There is no objective way of dating stonework, only expert opinion, so have a go at being an expert yourself. Your options are

A. It is basically late ninth or possibly tenth century
B. The overlay is eleventh or possibly twelfth century
C. Any competent stonemason could have knocked the whole thing up in the nineteenth or possibly twentieth century

To identify the correct century, you should take into account the village's overall enthusiasm for heritage items

> The other listed building is the K6 telephone box dating to 1936.

By a nice piece of alphabetical serendipity, **[#9] Llandaff** is next

> Llandaff is positioned at what was originally the lowest fordable crossing point of the River Taff. Consequently it could be the site of settlement of all periods; however the first recorded settlement was founded by St. Teilo in the 6th century AD. He established a "clas" (monastery) on the site of the later cathedral and the importance of this religious settlement is demonstrated by the construction of the Cathedral by the Normans on this site rather than in their new town at Cardiff.

Such a metro-hub can be expected to leave its mark on the Dark Age ecclesiastical landscape

> The area is extremely well served as regards evidence for the period. In pride of place is the extensive collection of charters known as the Liber Landavensis, the Book of Llandaff. The studies of Professor Wendy Davies have demonstrated that most of the charters can credibly be attributed to the time at which they are alleged to have been drawn up, and can therefore be used as evidence for the pre-Norman period.

There are unmistakeable traces of academese here

Academese	Meaning
demonstrating	A term employed when people have been arguing something else
most of credibly attributed to alleged to have been used as evidence for	Terms employed when the demonstration has proved insufficient to stop other people arguing something else
The studies of Professor Wendy Davies have demonstrated that most of the charters can credibly be attributed to the time at which they are alleged to have been drawn up, and can therefore be used as evidence for the pre-Norman period.	The studies of Professor Wendy Davies have demonstrated that up to a half of all the charters cannot credibly be attributed to the time at which they are alleged to have been drawn up, and cannot therefore be used as evidence for the pre-Norman period.

Historians of the Welsh Dark Age may be divided about which charters are genuine but all agree some of them must be genuine or there could be no genuine historians of the Welsh Dark Age.

It matters nought because the Book of Llandaff is not technically a historical source anyway, being twelfth century, hundreds of years after the events it is describing. But since it *is* used as a historical source for so many Dark Age Welsh monasteries, proving the existence of the Dark Age monastery at Llandaff itself is of the utmost criticality. Sleeves rolled up!

> During 1962 a small excavation by Cardiff Archaeological Society took place on weekday evenings at the Bishop's Palace in Llandaff although little of note was found due to the major part of the site being covered by allotments.

In Wales, leeks are of even more criticality.

> The Museum of Wales reports a chance find of a Bronze Age burial at Llandaff, containing a clay vessel of the 'Beaker' period

It's a start.

> In 1992, renovations at a house in the Llandaff area of
> Cardiff uncovered an unusual stone slab buried by river
> sands and silts.

It's a finish.

The name *Teilo* has cropped up for a second time, another neat
segue as his eponymous monastery, **[#10] Llandeilo Fawr**, is next

> Llandeilo is named after one of the better-known Celtic
> saints of the 6th century, Saint Teilo. The Welsh word llan
> signified a monastery or a church. Saint Teilo, who was a
> contemporary of Saint David, the patron Saint of Wales,
> established a small monastic settlement (clas) on the site
> of the present-day parish church.

Alternatively, *llan* can be translated as 'place of' and as *teilo* is 'dung'
in Welsh there is the possibility *Llandeilo* means 'place of a livestock
market'.

> The early Christian settlement that developed around the
> Church of St Teilo prospered, and by the early 9th century
> it had attained considerable ecclesiastical status as the seat
> of a Bishop-Abbot. The Church of St Teilo soon became a
> 'mother church' to the surrounding district, acquiring an
> extensive estate.

Or it is the local market town with its livestock market. How is this
to be resolved?

> The discovery of fragments of two large Celtic crosses
> from this period provides further testimony to Llandeilo's
> importance and indeed prestige as an early ecclesiastical
> centre.

Does it? Cannot any ecclesiastical centre put up Celtic crosses, and
do so in any century?

We shall have to look to proper, stratified archaeology for the
answer and Llandeilo has a lengthy, if patchy, record

> There is some possible evidence of human activity around
> Llandeilo during the Bronze Age period (2200 BC – 700
> BC) in the form of the mound, the Cae Crug Mawr, which
> is thought to be a Bronze Age round barrow or burial
> mound

then peters out

> The Iron Age (700 BC - AD 70) is, surprisingly perhaps, as
> yet not represented in the archaeology record for Llan-
> deilo, although the view northwards from the town is
> dominated by the impressive Iron Age hillfort of Garn
> Goch, positive proof of the presence of a well-settled Iron
> Age population in the district. There is little recorded
> archaeology within the boundaries of Llandeilo Fawr town
> relating to the prehistoric periods. The little evidence that
> is recorded indicates that human communities have made
> use of the land around the modern town since at least the
> time of the first farmers

All of which leaves the field clear for St Teilo to found Llandeilo
as the official account requires. Clear, that is, until AD 2003

> Recent discoveries have revolutionised our understanding
> of Llandeilo in Roman times. When a geophysical survey
> located the site of a Roman fort and vicus town in Dinefwr
> Park in 2003, the long held suspicion that Llandeilo had a
> Roman past was at last confirmed.

'Llandeilo' is not a Roman name though there will be need of
one if the soldiery and the vicus are to have somewhere they can
call home. Let the academic chat begin

> This may have been the first town to grow at Llandeilo and
> although we do not know its name or, at present, much
> about its character, its presence allows us to speculate that
> Llandeilo town can indeed claim 2000 years of history. If
> nothing else, the establishment of Llandeilo as a centre of
> Roman military and, possibly, a political and civil authority
> may have ultimately led to the appearance of an early
> Christian community.

Let the revisionist backchat begin

o It is not speculation, Llandeilo *is* at least two thousand
 years old, the archaeology says so
o It is not therefore a Teilo foundation
o Llandeilo does not owe its significance to a Christian
 community, but to geography

> Llandeilo's location had already marked out the town as a
> strong candidate for the location of a fort or fortlet. It is

> halfway between the Roman forts at Carmarthen and
> Llandovery and within a day's march of each

Or, as geographers say, the normal distance from one market town to the next because everyone needs access to a market town, there and back within a day's march.

> but also close to the known route of the Roman road along
> the Tywi valley and at a fording and bridging point on the
> river Tywi

East-west routes are dictated by South Walian topography and there is no better route than the Tywi valley and no better bridging point over the Tywi than Llandeilo. That is why the Roman road is now the A40. The topography has not changed since the Bronze and Iron Age so, if the Bronze Age mound and the Iron Age hillfort in the vicinity are anything to go by, Llandeilo has always been there, in one form or another, ever since the coming of agriculture to south Wales made settled communities and trade possible.

But don't get me started on the revisionist interpretation of hillforts (you may be sure it does not involve either hills or forts) let them get started on their man Teilo instead

> This may perhaps have been the foundation for the next
> glorious chapter in the history of the area, when the
> settlement that we now know as Llandeilo Fawr takes
> shape in the centuries following the end of Roman rule.
> Teilo was certainly one of the great figures of the early
> church in Wales and ranks along with saints such as David
> and Padarn and his cult spread across much of south-west
> Wales. This is the reason why so many churches dedicated
> to Teilo can be found even today.

Or why so many livestock markets can be found today.

> Although the traditions are strong and exceptionally
> important in terms of explaining the historical develop-
> ment of the district, there is of course little physical
> evidence of the early church or the saint who is believed to
> have founded it

This is bordering on a deliberate falsehood. There will be vast amounts of physical evidence if an early church, then an important monastery and finally a diocesan centre had existed at Llandeilo over a five hundred year period. So why haven't they said so? Why

have they slipped in an 'of course' to discourage anyone from not saying so?

It is because although archaeology is a major subject in the television schedules, it is a lowly one in the academic pecking order. It is treated by everyone, including archaeologists themselves, as an adjunct to history. Historians say there is an ancient monastery at Llandeilo and

<center>what historians say, goes</center>

It is for the archaeologists to explain why they cannot find it and while there may be very good reasons why they have not been able to, we would be obliged if they did not lie about why they haven't.

One reason for archaeologists' lowly status is their doctrine

<center>the absence of evidence is not evidence of absence</center>

when what they mean (of course) is

<center>it *is* evidence of absence though not *proof* of absence</center>

If archaeology had ever grown an intellectual backbone it would have developed internal rules of evidence long ago to cover this situation. Rules that would allow archaeologists to draw prima facie inferences that if there is an absence of evidence it probably wasn't there in the first place. They would then stand fast, challenging any academic discipline claiming that it did, to justify their position using their own evidence. Unless *that* evidence is copper-bottomed

<center>what archaeologists say, goes</center>

Then again, one of the reasons academia itself is such a useless congeries of futility is its rule that one discipline may not challenge another discipline's assumptions. If academia had any kind of intellectual backbone, it would long ago have developed rules that each discipline *must* challenge other disciplines' assumptions if for no other reason than there isn't anyone else to do it.

And, maybe just as important, it would allow time to see which discipline gets to dominate the petri dish. That can never happen if they are being cultured in separate dishes. Then, just maybe, academia would cease to be a meal ticket for all the "After you, Gaston", "No, after you, Alphonse" slack Alices that presently gum up the joint. Except Gaston, Alphonse and Alice are no fools, academia would not survive long were such a policy instituted.

Better to be slime mould in separate petri dishes than vertebrates bestriding the world in seven-league...

Sorry, I've forgotten where I was. Oh yes, it's all chaff in the wind because we have the *Llandeilo Gospels*. More accurately, Lichfield Cathedral has the Llandeilo Gospels, though that has not stopped the locals reminding the world who put the Fawr into Llandeilo Fawr

> By means of sophisticated digital technology, the Llandeilo Gospel Book can be seen again in Llandeilo, where it spent such a significant part of its early history. The Gospels Exhibition was officially opened by the Bishop of St David's, Rt Rev Carl Cooper...The highlight of the occasion was a lecture by Professor Michelle Brown on the art and history of the Gospel book. The Exhibition has been made possible by a grant of £74,528 of European Objective One funding.

We are out of Europe now so in future the burghers of Llandeilo will have to come cap-in-hand to London and, believe me, we're not the soft touch Brussels were. It's our own money we'll be handing out. As a Londoner myself I can help by devising some role-playing exercises to prep them for their next trip. I'm not your average Londoner, I'm all heart.

"So, Llandeilo, what is to be your opening statement?"

> Llandeilo's greatest treasure was a fine gospel book, written probably in the eighth century, and donated to the community c.820 by a man named Gelhi, who had bought it and had given it 'to the altar of St. Teilo'

"Huh! Last we heard it had been brought to you for safe-keeping. Now you're making out Llandeilo was some sort of ninth century Hay-on-Wye. What is your evidence for this *Gelhi*?"

"It is in the book itself, kind sirs, as marginalia on page one hundred and forty-one. And, look you, it is written in archaic Welsh, which was only used in the very earliest of times."

> Tudfwlch son of Llywyd and son-in-law of Tudri arose to claim the land of Telych, which was in the hand of Elgu son of Gelli and the tribe of Idwared...

"Oh yeah, Taff, why is it in any kind of Welsh? The book is in Latin, isn't it? Ninth century legal records were written in Latin,

weren't they? Are you saying Welsh scribes weren't literate in Latin?"

"Indubitably they were but, with the greatest respect, anyone seeking to establish legal title to an estate in Llandeilo, and their claim rests on people with names such as *Tudfwlch, Llywyd, Tudri, Telych, Elgu, Gelli* and *Idwared* could not use Latin to record the fact. Latin cannot be transcribed into Welsh names with the degree of unambiguity essential in what amounts to a title deed."

"Cor lummee, strike a light, that would explain why medieval church authorities were always turning up in court with ancient-looking gospel books containing land entitlements written in apparently archaic Welsh, English or Irish. How else could you demonstrate your claim preceded anyone else's? Though never so archaic you could not tell who was entitled to what. That aspect had not occurred to us. Please, have some lottery money."

"Could you make it cash?"

"Nod's as good as a wink, but you won't be getting your gospel book back."

"No prospects at all?"

"None. It's all down to antidisestablishmentarianism, the Archdeacon of Lichfield was telling us. He was in here the other day, looking for a grant to put up some new shelving."

> The margins of the gospel book were used in the ninth century to record land transactions, and settlements of legal actions. These short passages are of enormous importance, because they form the oldest surviving examples of written Welsh and tell us something about social and ecclesiastical conditions at this early period. They tell us, for instance, that there was a bishop at Llandeilo Fawr in the ninth century.

The bishop of Llandeilo Fawr is no more, if he ever was, but we can piece together some true, if dull, history without him. In historic times, South Wales was, and is, divided between the bishoprics of Llandaff and St David's. With Llandeilo Fawr on the cusp, a strategic river crossing on the road between Llandaff and St David's, the two bishops had a keen interest on which side of the episcopal divide Llandeilo Fawr fell. St David's held an early lead

> St Teilo is reputed to be a cousin, friend, and disciple of Saint David

but Llandaff held a trump card

> **Teilo was bishop of Llandaff and founder of the first
> church at Llandaff ... He also founded Llandeilo Fawr**

They even had the final word

> **Llandaff Cathedral... where his tomb is**

It is fortunate saints' bodies are incorruptible in view of the five hundred years separating Teilo and Llandaff Cathedral.

But all this still won't be enough when up against one's own metropolitan see. It will have to be for the courts to decide and they demand evidence not legendary tales. So Llandaff commissioned Lichfield to come up with an antique gospel book with lots of Welsh Teilo references written into the margins.

Twentieth century scholars, taking the gospel book as gospel, were a few centuries out

> **Before the end of the eleventh century, the Llandeilo
> gospel book had been taken to Lichfield, where it remains
> today (it is displayed in the cathedral as the Lichfield or
> St. Chad Gospels). No-one knows how the transfer was
> made, but a likely guess is that it was given as tribute to a
> Saxon king by one of the Welsh princes of the period.**

That's just English historians talking. No Welsh historian would subscribe to theories about Welsh princes paying tribute to Anglo-Saxons who had just built Offa's Dyke to keep them out. Though they would be even more centuries adrift believing Offa's Dyke is Anglo-Saxon since it would require more Mercians than there were Mercians to garrison. However many Mercians there were, they were unlikely to build fortifications a hundred and fifty miles long that would not keep anyone out for more than two minutes. Maybe five if it had been raining and things were a bit slippy.

Those dwelling in the House of Righteousness, where the truth is always boring, would conclude Offa's Dyke was a tolling device ensuring animal drovers used approved crossing points between England and Wales. They would point to numerous structures of the same kind that can be found all over Britain bearing names like Devil's Dyke and Grim's Ditch. Any ancient linear feature that people can negotiate with relative ease but their animals cannot. Though the Offa's Dyke Visitors Centre will not be in favour of

the righteous option, what with replica Anglo-Saxon helmets being such a steady seller.

We can leave the English and the Welsh to their age-old spats while we hurry to our next port of call, **[#11] Llangennith**

> **A complex of ruined structures represent 'the hermitage of St Kenydd-atte-Holme', and is mentioned in 1195. St Cenydd's life was recorded by John Capgrave in the Middle Ages 'from a variety of Welsh sources' in his Nova Legenda Angliae. Liturgical calendars and place name evidence suggest the historical existence of Cenydd. His legend, however, is too late and too obviously derivative to be relied upon.**

Very honest of them.

> **This 12th century church is on the site of a 6th century llan, or churchyard, which retains the original circular footprint of Kenneth's priory established here sometime in the 6th century. The circular shape of the churchyard is typical of Celtic llans, or church enclosures.**

Very dishonest of them. The shape of Celtic church enclosures is not known on account of none having been found (yet).

> **Cenydd's church was built of wood**

One thought it might be. Celtic and Anglo-Saxon churches are always made of wood, Norman churches are always made of stone. Such inexplicably divergent absolutism has struck everyone dumb with careful ignoral but we may be able to spark some life with one of our infamous checklists

o Normans, Anglo-Saxons and Welsh had access to the same building technologies
o all three would know that timber suitable for constructing sizeable buildings is more expensive than stone
o all three certainly knew stone lasts longer than wood
o two out of three decided to use wood, but a special kind of wood that did not leave post-holes
o two out of three may have suspected they were not long for this world

All too true in Llangennith's case

> **and was burned in a Danish raid around 986 AD**

If only they had used stone.

In the late 11th or early 12th century Cenydd's church was rebuilt in stone under the new Norman lords of the Gower

Churches are cripplingly expensive to maintain, whatever they are made of, and a steady income stream is essential. Llangennith, at the far end of the Gower peninsula, would generate a steady stream of pilgrims if a reason could be provided to persuade them to come. The name of the parish being Llangennith, could they be persuaded to make a pilgrimage to the shrine of Saint Gennith?

The church is dedicated to St Kenyth variously known as Cynydd, Kynyd, and Kenneth, who was reputedly washed ashore on Burry Holms

There will have to be attractions. Maybe a health angle?

St Cenydd's Holy Well is just opposite the lych gate. A small spring gushes forth, protected by a stone well-head. The spring is one of several in the area connected to legends of St Cenydd. It is said that the water sprang forth when Cenydd struck his staff on the earth, and like many holy wells the water is said to have healing qualities.

A word of warning though. Modern pilgrims are advised to browse the internet with care before setting off, to makes sure things are of genuine Kennethian vintage. There is a great deal of fraud on the internet.

The capstone to the Llangennith well is incised with a cross similar to those on many Early Christian monuments

They should avoid the rank agnosticism of the Royal Commission on the Ancient and Historical Monuments of Wales

though it is not included in RCAHMW 1976c, either as a genuine example or a rejected one

and the Glamorgan-Gwent Archaeological Trust's page is strictly for people fluent in academese

In most cases the dedicatee(s) of the church is Celtic whilst that of the well is non-Celtic, or else they are both Celtic. This appears to run contrary to the normal pattern observed by Morris (1989, 86), in which the well saint was frequently obscure

312

They will however be amply rewarded once inside the church

> On the chancel arch has been placed a 9th century grave-slab with intricate knotwork carvings, believed to have marked the grave of St Cenydd who founded the llan.

Pilgrims can look up at the chancel arch by all means but then it's eyes-down because the miracle is to be found in the intricate knotwork carvings surviving a thousand years of pilgrim footfall

> This is legendarily the former gravestone of St Cenydd and, until the nineteenth century remodelling, was set flat in the chancel floor

They can retain confidence in the Kenneth brand and nineteenth century remodelling because in another traditionally Celtic part of Britain PLC

> An incised stone monument featuring images apparently of the Cenydd legend was discovered during renovation work at St Mungo's Church (Cumbria), in the 1880s and is displayed there as the 'Kenneth Stone'. The Saint's connection with Cumbria is currently unexplained.

There is a preferred checklist for naming Welsh Dark Age churches

o *llan* means 'church of'
o the rest of the name provides the saint
o the saint founded the *clas*
o the Norman church is named after the saint

but the checklist goes out the window if those battling bishops of Llandaff and St David's are around. It was oranges or lemons for
[#12] Llangyfelach

> At the centre of the village is the Parish Church of St David and Cyfelach. The site dates back to the 6th Century: St David, the Patron Saint of Wales, founded an early Celtic monastery there.

said the bishop of St David's.

"I'll chop off his head," said the bishop of Llandaff

> Cyfelach was evidently the true founder but it was later dedicated to St David

313

"That's not how it happened," said the bells of St Daffyd

> and included in the list of his foundations in the Life of
> David by Rhygyfarch (1057–1099)

"Because it is daft," said the bells of Llandaff

> there called Langemelach

"But customary."

> It has been customary to identify Cyfelach with Cyfeiliog,
> (e.g. Rice Rees, Welsh Saints, pp.274, 305)

"Rice Rees, mouthpiece."

> but this is improbable as Cyfelach has no convincing
> hagiographic record

"You are seriously equating a nouveau-riche local nobody with
the blessed St David?"

> and may have been a lay founder

"If you're going to play top trumps, we've got an Archbishop of
Canterbury."

> In Liber Landavensis, it is said that "[Cyfeiliawg] was con-
> secrated bishop by Ethelred, archbishop of Canterbury, at
> his own house, in the year 872" (W. J. Rees, p. 490 note 1,
> of his edition of the Book of Llandaff)

"W J Rees, microfiche."

> No authority is given

"All right, what about a King of England?"

> The Anglo-Saxon Chronicle records under the year 915
> how the Danes plundered Wales, captured Cameleac, the
> bishop of Archenfield [Ergyng], and led him to their ships.
> King Edward later released him for forty pounds.

"Haven't you forgotten something?"

> He is perhaps the same as Camelauc, mentioned in a list of
> abbots of Llanilltud

"Abbot, schmabbot. He was a bishop."

314

> The Book of Llandaf calls him Cimeilliauc and treats him as a bishop of Llandaf

"Would that be your Book of Llandaff, my lord bishop of Llandaff?"

> But there was no see of Llandaf at that time and there is no doubt that Ergyng was the region where he operated. Cyfeiliog would be the modern Welsh form of the name. In the list of bishops of Llandaf in the Book of Llandaf he is placed between Nudd and Llibio, which is chronologically correct

"Haven't *you* forgotten something?"

> even if they did not actually succeed one another

When bishops (and historians) fall out, archaeologists get the casting vote

> The testimony to Llangyfelach's association with St. David is admittedly late and, coming from such committed protagonists of the rights of St. David's as Rhigyfarch and Gerald of Wales, a little suspect. But there is other evidence for the importance of Llangyfelach as an ecclesiastical centre in the early Christian period.

Though we had to await a much later Christian period to find it

> Three early Christian stones have been found on the site and preserved. The first is the socketed base of a pillar cross on each face of which are panels of decoration in knotwork carved in low relief. This can now be seen surmounted by a record of its restoration in 1926 just south of the tower.

> The second is an incised framed ring cross now acting as a lintel above the north doorway into the tower. The face of this is gradually being eroded through exposure to the weather.

> The third is a slab with carved cross and the inscription CRUX.XPI (the cross of Christ) which was found in the floor of the present church in 1913. It has been reset into the north wall of the nave.

Stonemasons go way back but they never come cheap

> These carved stones indicate that there was an important
> monastic or collegiate body at Llangyfelach in the ninth
> century which was rich enough to be able to employ skilled
> sculptors to carve memorials for them.

Some places get a *fawr*, **[#13] Llantwit Major** gets the full English.
Will there be a Saint Twit? Sadly, no.

> Llanilltud Fawr is named for the Llan of Saint Illtud. The
> Llan was home to the Monastery of Illtud and the College
> known as Côr Tewdws. Llantwit would grow into one of
> the most esteemed centres of Christian culture in the
> Celtic world.

That's a major in any language.

> According to the Life of St Samson, an important mon-
> astery (and school) was established in the early 6th
> century by St Illtud. The primary source for his biography
> is the Vita Sancti Samsonis, written sometime between
> 610 and 820 and clearly based on earlier materials.

We do not have the earlier materials to judge how clear a base they
provide for the eighth century Vita Sancti Samsonis, but we do not
have the eighth century Vita Sancti Samsonis either, so it would be
a particularly difficult call to make.

> It gives useful details of contacts between churchmen in
> Britain, Ireland and Brittany

Just what we have been looking for.

> Samson was the son of Amon of Demetia and Anna of
> Gwent, daughter of Meurig ap Tewdrig, King of Glam-
> organ and Gwent. His father's brother married his
> mother's sister so that their son Magloire was Samson's
> cousin twice over. Due to a prophecy concerning his birth
> his parents placed him under the care of Illtud, abbot of
> Llantwit Fawr, where he was raised and educated.

Just what the Benedictines were looking for. Medieval pilgrims
were tourists in all but name and the tourist industry has the same
imperatives whichever century it is operating in. Brand recognition
being the main one, and there was no bigger name in the medieval
pilgrim trade than the Benedictines. After visiting the Benedictine
monastery at Llantwit Major, pilgrims could kill two birds with one

stone by taking in the Benedictine monastery at Caldey as part of the package

> Samson later sought a greater austerity than his school provided, and so moved to Llantwit's daughter house, the island monastery of Caldey off the coast of Dafyd (Pembrokeshire), where he became abbot after the death of Pyr. Samson abstained from alcohol – unlike Pyr, who was killed when he fell down a well while drunk.

Two birds, one stoned. After this double-header, pilgrims looking for a more ambitious challenge might consider the 'Samson on Tour' Tour, as set out in the Benedictine brochure

> As a cenobitic and later an eremitic monk, he travelled from Caldey to Ireland, where he is said to have founded or revived a monastery. Later he travelled to Cornwall (where he founded a community in either South Hill or Golant), then the Scilly Isles (where the island of Samson is named after him), Guernsey where he is the Patron Saint and Brittany, where he founded the monastery of Dol. He was buried with his cousin Magloire in the cathedral of Dol.

Pilgrims who make it as far as the Benedictine monastery at Dol can take advantage of another two-for-one

> Saint-Magloire Abbey in Léhon was founded in the 9th century by the King of Brittany. Burned by the Normans, the abbey was rebuilt in the 12th century

by the Benedictines. On their way home English pilgrims can round off their Samson Grand Tour with an overnight stay at this royally-endorsed Benedictine monastery

> The Anglo-Saxon King Athelstan (r. 924–939) obtained several relics of Samson, including an arm and a crozier, which he deposited at his monastery at Milton Abbas in Dorset.

And all thanks to Samson and Llantwit Major, so what can archaeological pilgrims planning next summer's field trip expect to find at the Mother Church?

> At its peak it attracted over two thousand students, including princes, numerous eminent clergymen and revered saints.

With cohorts of two thousand students, princes and clergymen in residence for upwards of five hundred years, they should pack plenty of buckets and spades

> **Apart from carved and inscribed stones, very few artefacts of Early Medieval date have been discovered in the study area, and fewer still have any association with the early church**

Put away those buckets and spades and get out the glossary

Archaeologese	**Englishese**
Apart from carved and inscribed stones	Apart from non-archaeological artefacts
very few artefacts	very few archaeological artefacts
of Early Medieval date	from the Welsh Dark Age
have been discovered in the study area	wherever we looked
and fewer still	none, or we would have mentioned them
have any association with the early church	nothing at all has been found that would in any way suggest the monastery of St Illtud ever existed

There must be an explanation for this melancholy state of affairs

> **The institutions were destroyed by raiding Vikings in 987**

Viking archaeologists!

It was all change when the Benedictines arrived

> **the monastery was rebuilt by the Normans in 1111 and continued to be a centre of learning until it was disbanded in 1539 during the Dissolution of the Monasteries.**

It was all change when Iolo Morganwg arrived (né Edward Williams, founder of the *Gorsedd*)

Iolo Morganwg was responsible for the rediscovery of the Samson Pillar at St Illtud's Church, Llantwit, in about 1789

It was all change when his collection of ancient *Welsh Triads* was found to be all his own work

his suggestion that it was erected by Samson himself was discredited by later historians with access to more reliable written sources

It was all change when the National Library of Wales arrived

However, in the 20th century, genealogical studies threw further light on the subject, and the pillar is now considered by many to be "one of the oldest inscribed Christian monuments in Britain"

It was all change when the Glamorgan-Gwent Archaeological Trust arrived, armed with a quiverful of ambiguous formulations

GGAT report, Llantwit Major: Fragments of decorated crosses, one of them mid to late 9th century (00431s)

What is 'mid to late ninth century'? If they mean c. 875 AD, perhaps they should come right out and say so.

Three 10th - 12th century (00429, 00430s, 00433)

Literally that is 900 AD to 1200 AD, as much Norman as Welsh, more than a little important in the context. Perhaps they should come right out and say so.

Two other decorated stone fragments, now lost, have not been recorded

The Trust has recorded them. Or perhaps they haven't, it's hard to tell. Perhaps they should come right out and say so.

One cross recorded in situ in 17th century

But was it recorded as Dark Age in the seventeenth century? The Trust presumably have the record if they are citing it. Perhaps they should come right out and say so.

I am beginning to lose trust in the Trust. I am beginning to wonder why there is a Glamorgan-Gwent Archaeological Trust in the first place. Glamorgan is the most populous of the Welsh

counties so what is this *Gwent* when it's at home? Ah, it's down to Welsh politics, most things in Wales are.

Following a redrawing of local authority boundaries in the 1970's, the newly created 'Gwent' emerged as the second-most populous county in Wales. That surely entitles it to an archaeological trust of its own. Not when Welsh politics is involved. Glamorgan is the beating heart of Wales but Gwent is only Welsh by recent adoption, having been carved out of the English county of Monmouthshire. To ensure Gwent was part of the archaeological beating heart of Wales, it was felt best to hyphenate it with Glamorgan.

That is my best guess anyway but wherever the lines are drawn we can anticipate Anglo-Welsh complications when it comes to Gwent's chief city **(#14) Newport**

> **Saint Gwynllw Milwr or Gwynllw Farfog (c. 450 – 500 AD) known in English in a corrupted form as Woolos the Warrior or Woolos the Bearded (Latin: Gundleus, Gundleius or Gwenleue) was a Welsh king and religious figure. He was King of Gwynllwg in South Wales and is the legendary founder and patron saint of the City of Newport. According to medieval tradition he was a feared warlord and raider who knew King Arthur, but later found religion and became a hermit, founding St Woolos Cathedral in Newport. He was the father of one of the most revered Welsh saints, Saint Cadoc the Wise.**

The historical evidence for this stirring account is an Anglo-Welsh complication. The *Vita sancti Gundleii* is in the British Library, the *Vita sancti Cadoci* is in the National Library of Wales, and it says so much about modern scholarship that these dubious testaments to father and son lie amicably apart in the manuscript capitals of two of our great nations.

In both of which the elevation of a town to the status of city is a carefully guarded privilege, the possession of a cathedral being a prerequisite. There are four cities in Wales. St David's is Britain's smallest city because despite being an insignificant market town it is where the patron saint of Wales hails from and if he is not entitled to a cathedral, who is? The mighty Swansea is one of Britain's newest cities, accorded that status only in 1969. I remember it well from my visits to Vetch Field. We all had to get used to shouting, "Come on, City" instead of "Come on, Town" though

320

"Eff-off back to England, ref, and take your white stick and your bag of gold with you" stayed the same.

Newport is nearly as old as St David's, nearly as big as Swansea, and has a cathedral more wondrous than either

> **Legend has it that St Woolos founded the Cathedral in c. 500. The mud and wattle structure subsequently erected became his grave, the foundation for a succession of churches built on the site at the top of Stow Hill.**

Wattle-and-daub is one of the few substances known to science that can disappear without trace and yet be readily identified by academics. After mud mixed with manure, it is a relief to find that something more wholesome has survived

> **It retains some pre-Conquest masonry**

Speaking in a purely personal capacity, I am prepared to accept thousand-year-old masonry meets modern building requirements. What I am not prepared to accept – in a building visited annually by multitudes of Anglo-Welsh people – is *two*-thousand year-old structural members

> **The Norman archway through to the nave incorporates Roman columns from Caerleon**

It is an enduring image – Normans sending off their horses and carts to fetch columns that were, even in their day, getting on for a thousand years old – but surely Norman building regs will mean such time-worn supports will be marked out for regular inspection. One is relieved to hear they were

> **with re-cut Corinthian capitals**

The image may not have to endure much longer

> **The claim that the Romanesque archway is supported on reused Roman columns is disputed. A report in preparation by B. Trett, M. Lewis and J. Allen, suggests the alternative view that the columns are contemporary in date with the rest of the archway.**

All respect to Messrs Trett, Lewis & Allen but it was not Norman recycling practices the cathedral authorities had to worry about, it was those inveterate foes of Welsh Dark Age structures,

the Vikings. Not only Vikings either. Being adjacent to England meant the English were joining in

> In A.D. 846 the church was plundered by Irish pirates, in 875 by Danes and in 1060 by Earl Harold's men

Not only Irish pirates either. Irish navvies

> A mound used to stand in the grounds of St Woolos Hospital. According to Octavius Morgan the mound was traditionally believed to be the burial place of St Woolas, and was covered by spoil from the Great Western Railway tunnel which runs underneath.

It spoiled the archaeology, that's for sure.

Despite its name, Anglesey is as Welsh as it comes. In the southeast corner of the island is **[#15] Penmon**, which bears all the hallmarks of Welsh Dark Age Christianity

> The original priory dates back to the sixth century, but the present structures are from the twelfth century. The church houses a 1,000 year old font, and two crosses, one dating from the tenth century. From the church, a path leads to the fish pond, which was in use by the monks as part of their food supply, and ends at St Seiriol's Well. The foundations of this date back to the sixth century, but the brick shelter is a Victorian addition

and makes a bold claim for itself

> The early origins of the church at Penmon are obscure. Nevertheless, Penmon is one of the very few churches in north-west Wales to have tangible, rather than documentary, evidence for its presence during the early mediaeval centuries.

Not quite so bold when the small print is examined

> The two high crosses are the only tangible evidence for the early medieval monastery. Both are now inside the church. One had been used as a window lintel in the later refectory; the other used to stand in the deer park but was moved to the church to prevent further weathering.

Nothing concrete, one might say. More concrete, others might say

More concrete evidence of the church's early presence is in the survival of two exceptionally important decorated crosses

They did not need to be made *from* concrete because Penmon stone has some remarkable properties. For instance, being left out in Welsh weather for a thousand years has little or no effect on it, yet it is easily worked for artistic purposes

> The St Anthony cross is exceptionally eclectic in incorp-orating Viking Irish and Manx style (Borre ring-chain), Irish monastic (figural panels, in particular, St Anthony) and regional Welsh (interlace patterns). In other words, the Penmon headland was in receipt of, and shared, influences from all areas of the Irish Sea basin in the 10th century.

What we would call today 'the international style'. The other cross is equally durable, equally malleable, but bears a more localised artistic signature

> The cross head on the south transept cross finds parallels eastward along the North Wales coast at Maen Achwyfan and, as grave markers, at St John's Chester

and comes with a historical attestation, or one very like it

> The cross, now in the south transept of the church, or one very like it, recorded by Edward Lhuyd, stood on a slightly elevated spur of land in a field later known as Cae'r Groes, in the tenement of Bryn Mawr

Another unusual property is that the source of the stone can be identified with or without the stone

> The stone for this cross, and for two lost crosses, recorded by Lhwyd, has almost certainly been quarried locally, from the outcrop between the priory and Penmon Point.

I am glad they've mentioned Penmon Point because just across from the Point is Puffin Island. Or Priestholme, or Ynys Lannog or Ynys Glannauc or Ynys Seiriol. So important they named it five times. If we go with Ynys Seiriol it will assist in establishing the Dark Age credentials of the whole complex, onshore and offshore

323

> Saint Seiriol was the son of Owain Ddantgwyn, a fifth
> century ruler of the Kingdom of Gwynedd, and the
> brother of Saint Einion Frenin, a 5th or 6th century king
> in the Llyn Peninsula. Seiriol founded and governed a clas
> (ecclesiastical settlement) at Penmon on Anglesey. In later
> life, he abandoned his responsibilities there to establish a
> hermitage on the nearby island, where his remains are
> thought to rest.

Progress in finding Seiriol's hermitage and burial place has been
held up by Puffin Island being accorded Special Protection Area
status. I don't think they meant special protection from Welsh
archaeologists. Everywhere needs that.

Not many to go now. We are already down among the saints,
and the 'llan' factor has reduced them to three, beginning with
[#16] St Asaph

> Llanelwy is the Welsh name for the place called St Asaph
> and means the sacred religious enclosure on the banks of
> the River Elwy

There already being a River Elwy, there was no room for a *Saint*
Elwy. The place-name experts are going to have to earn their corn
with this one

> St Asaph was a local saint whose name is found in the
> neighbouring Llanasa (Asa's Church), Pantasa (Asa's
> Hollow), Ffynnon Asa (Asa's Well) and Onen Asa (Asa's
> Ash-tree). These place names suggest a strong religious
> settlement.

I have to say, in all candour, the patron saint of ash trees is not
doing a very good job, they're dying by the forest-load from ash
dieback disease, but at least the place-name people have done a
good job. It was up to the historians and archaeologists to do theirs

> It is impossible to give an historically accurate account of
> the beginnings of Christianity in the early settlement at
> Llanelwy. Legend and tradition are confusingly mixed and
> there is no archaeological evidence or written record
> before the twelfth century.

They are going to have to earn their corn with this one

> The legend of the founding of the church and monastery
> between the year c. 560 and c. 573 is to be found in 'The

> life of St Kentigern' written by Jocelyn, a monk of Furness
> Abbey c. 1180. St Kentigern was the bishop of Strathclyde;
> he was driven into exile and founded a monastery at Llan-
> elwy where he remained until his return to Scotland in
> 573. There are no local commemorations to Kentigern. St
> Asaph replaced him as abbot-bishop when he died in 596.

If Kentigern had left for Scotland in 573 but carried on as abbot-bishop until 596 this carpetbagger is quite inexcusably holding up advancement for the locals. Commemorations? He's lucky to be remembered at all. So thank you, historians.

That said, it is scandalous that Kentigern's saintly (and local) successor, Asaph, was given the same shabby treatment for five hundred years until, ironically, some non-local people showed up, determined to right this ancient wrong

> Asaph's name and reputation was much advanced by the
> creation of a new territorial episcopal see at Llanelwy in
> the twelfth century. From about 1073 Rhuddlan was in the
> possession of the Normans and it was expedient that they
> protected their interests and those of the Province of
> Canterbury.

Norman historiography can always be relied on. Llanelwy, they explained to the locals, had always been a Welsh bishopric, nothing to do with them

> A monastery and mother church (clas) and an episcopal
> see are believed to have been founded here in the later
> sixth century AD by the exiled holy man, Cyndeyrn (St
> Kentigern)

Llanelwy, they explained to the locals, had always been an important centre of Welsh religious life, nothing to do with them

> The monastery grew and is said, almost certainly hyper-
> bolically, to have contained no fewer than 965 brethren,
> some devoted to religious instruction, and some to labour
> and secular pursuits.

Welsh historiography is less reliable Their sources are full of saints disembarking from floating millstones, banishing dragons, attaching lopped heads back on and things of that sort. The skill lies in disentangling fact from hyperbole in order to present a true history. Including, if necessary, a certain amount of conditionality

The clas may well have continued, but the bishopric fell into abeyance until it was refounded in the Norman re-organisation of the Welsh Church. It was the last of the four episcopal sees to be established.

Episcopates may be proving evanescent but the historiography was thriving as never before

The first reliable historical reference to St Asaph is in 1143 when the bishopric is recorded as Lanelvensis Ecclesiae, while the 1291 taxation of Pope Nicholas provides the first naming of St Asaph, Ecclesia Cathedralis de Sancto Asaph.

until Llanelwy fell into the hands of bishops of a different stripe

Llan Elwy alias S. Asaphe is given in 1536

Thomas Cromwell's historiographers had arrived and St Asaph was history. Even his ash tree has gone.

Welsh historiography should be more reliable now we have arrived at [#17] St David's, the fountainhead of Welsh Christianity. Where better to answer all those puzzling questions that Welsh Dark Age Christianity keeps throwing up. St David's throws up a few more

o If a country wanted to site its metropolitan see so that everyone can access it, would it choose the furthest tip of the corner of that country, the one furthest from Christendom in general? *Probably not.*

o If that country disliked the English would they call it 'Little England beyond Wales'? *Probably not.*

o Did the Welsh select St David's? *Probably not.*

o Who probably did? *The Normans*

o Why would they choose such an outlandish place?

The Normans were not much interested in Wales. They were interested in a great many places – France, England, Sicily, Apulia, Greece, Palestine – but all they desired of Wales was that it afforded trouble-free access to their latest acquisition, Ireland. The most efficient way of doing this was to introduce Papal Christianity to Wales, organised into four bishoprics

o one for the northern land route (St Asaph)

o one for the northern sea route (Bangor)

- o one for the southern land route (Llandaff)
- o one for the southern sea route (St David's)

The Normans were using a standard imperial technique used by the Romans before them and by the British in India after them. Local administration is left in the hands of 'client kings' while control and re-supply points are strung along the road network. The system not only allows tiny numbers of administrators to control vast numbers of locals, the locals get to pay for it all. In a 'What did the Normans ever do for us?' kind of way.

> **Saint David (Welsh: Dewi Sant; Latin: Davidus) c. 500 – c. 589 was a Welsh bishop of Mynyw (now St Davids) during the 6th century, and a relatively large amount of information is known about his life. Many of the traditional tales about David are found in the Buchedd Dewi ("Life of David"), a hagiography written by Rhygyfarch in the late 11th century.**

Why would the Welsh (or anyone else) believe this?

> **Rhygyfarch claimed it was based on documents found in the cathedral archives. Modern historians are sceptical of some of its claims**

Really? And which of his claims are they not sceptical of? The documents being 'unavailable' it would be nice to know how they arrived at their decisions. From a historiographical point of view. This document passed the selection panel apparently

> **One of Rhygyfarch's aims was to establish some independence for the Welsh church, which had refused the Roman rite until the 8th century and now sought a metropolitan status equal to that of Canterbury.**

Though one has to say this is the very first reference to non-native Christian rites in the Welsh Dark Age. They might have said, now I'll have to go back and check whether it is or not. They ought to know because St David's is a founding college of the University of Wales and has thriving departments of history and archaeology. Just the people you'd want when examining the Dark Age evidence in the cathedral just across the road

> **No Dark Age archaeological finds apart from inscriptions on pillar-stones in half-uncial lettering such as the one**

> discovered in 1891 by Mr. Morgan, the leading mason of
> the works, during operations connected with the restor-
> ation of the two arches of entrance into the Lady Chapel.

Our next task is to identify the people who set up the Norman system. They were, as far as one can judge these things, an order of monks called the 'Tironensians'. The academics of St David's are in prime position to investigate them as well because the Tironensians' Welsh HQ was down the road at **[#18] St Dogmael's**

> St David is said to have had a cousin called Dogmael who
> founded St Dogmael's in the Pembrokeshire village of
> Llandudoch

and 'taken over' by the Tironensian Order five hundred years later. The Tironensians never get a fair shake in the history books so we shall have to give the historians a friendly shake

> Bernard of Abbeville founded his monastery on land in
> Thiron-Gardais granted to him by Bishop Ivo of Chartres.
> The Tironensian Order was the first of the new religious
> orders to spread internationally.

That would appear to constitute a world record. Followed closely, as we have come to expect, by another one

> Within less than five years of its creation, the Order of
> Tiron owned 117 priories and abbeys in France, England,
> Wales, Scotland and Ireland

making them far and away the most rapidly expansionist monastic order on record. [Check that one, would you, Griselda.]

The Tironensians sound like an outfit worth a bit of trouble investigating for their historically-recorded accomplishments alone but it is not hard to see why careful ignoral is the preferred option. 'Tiron' refers to Marcus Tullius Tiro who holds a couple of world records of his own

i. the first (and last) Roman slave to invent a shorthand sys-
 tem, which was handy because though he wasn't to know it

ii. he would be responsible for preserving the largest body of
 work of any single writer to have survived from Classical
 times, that of his master, Marcus Tullius Cicero

Historians would have to work overtime explaining such a very odd concatenation.

328

They could, of course, study the Tironensians and, having done so, dismiss the whole thing as a mare's nest, that is their prerogative. It is our prerogative to damn historians for not even getting started on the task. But maybe they don't know something they're not telling us. The official policy of historians (I use the words 'policy' and 'historians' lightly) will certainly have the support of their Classicist colleagues. Cicero's collected works are a mainstay of theirs but only because of their policy of carefully ignoring that Ciceronian epics were a mainstay of Renaissance writers producing cod-Classics.

With everyone busy carefully ignoring the Tironensians, it falls to us to train our basilisk eyes on the St Dogmael's branch of the franchise

> **Dogmael was the son of Ithel ap Ceredig ap Cunedda according to Progenies Keredic and Bonedd y Saint**

Dogmael was well-connected, but was he well connected with Llandudoch, Pembrokeshire?

> **A medieval life of Tydecho, a Breton saint of the sixth century, states that he and a companion, Dogfael, lived together at Llandudoch**

No impropriety is imputed though it has to be said details of the arrangement were kept under wraps for six hundred years

> **The name Dogmael or Dogfael is not found in connection with the parish or with the abbey before about 1115 where it "is first used for both parish and abbey in the charter of Robert de Turribus, founding the abbey and endowing it with the parish"**

So *they* say, I'd like to hear what the charter has to say

> **In Robert FitzMartin's charter, the donor speaks of '... antiquam ecclesiam sancti Dogmaelis cum possessione terrae eidem ecclesie adjacente, cujus nomen est Land-odog'. ['... the old St Dogmael's in possession of the land adjacent to the church, which is the name of Landodog'] He granted the ancient church of St Dogmael to the Norman abbey of Tiron, to establish a monastery for a prior and twelve monks.**

Too much information. There is a Tydecho and a Dogmael, there is a Robert de Turribus and a Robert FitzMartin, there is mention

of a church, an abbey, a monastery and a priory, and there is the Tironensians. Either get them sorted or add a few more

> **Robert fitz Martin was born sometime in the late 11th century to a knight of William the Conqueror, Martin de Turribus and his wife Geva de Burci, heiress of Serlo de Burci. Martin had participated in the seizure of Rhys ap Tewdwr's lands, following the latter's refusal to acknowledge the suzerainty of William Rufus, despite having acknowledged the suzerainty of William the Conqueror.**

Always nice to see the Tewdwrs turning up in the historical record. "They'll be back, that's for sure, that's for dang sure," as Brother John Wayne said.

Show us the archaeology, as Brother Mick Harper is always saying. The Inventory of Ancient Monuments of Wales and Monmouthshire has obliged by sketching out the parameters

> **It is, however, certain that in pre-Norman times there was an important church at Llandudoch**

Although an official and much respected national body, the keepers of the Inventory do not seem to have entirely mastered the concept of *certainty*. It is agreed there is no contemporary historical record. When it comes to physical evidence, they seem to be having equal difficulty with the concept of *uncertainty*

> **though its exact situation (apart from its identification with St Dogmaels) has not been satisfactorily established**

This is academese for 'not found'. Nor have they quite got to grips with *near certainty*

> **St Dogmaels Abbey was built on, or very near to, the site of the ancient pre-Norman-conquest church of Llandudoch**

No, poppets, that has not been satisfactorily established. I think you would be happier back at the office working out how *invent* fits into *inventory*, leaving on-site matters to

> **According to Emily Pritchard (History of St Dogmaels Abbey) the 'old monastery' was about a mile away from the Tironensian Abbey built in 1118**

Ms Pritchard must have secretly found it because she not only knows where it is, she knows where it went

but incorporated into the new building, though "not the same building but the same establishment, owing to the Saxons destroying it 300 years later, and again 100 years later it was pillaged by the Danes."

Late breaking news, tell her. There could be *two* Dark Age buildings. With two founding saints, it was only a matter of time.

A possible explanation of the association of the two saints is the original joint dedication to the two missionary founders, Tudoc and Dogfael; or it may be that there was a second church, perhaps a capella, bearing the name of one or other of the founders, and that it was the church dedicated to St. Tudoc which suffered destruction in the Danish inroad of A.D. 987. St Tudoc's is said to have been on the north side of the enclosure where the circumvallation has been entirely swept away.

Those pesky Danes and their circumvallation sweeps. If I was in charge of Dogmaelian archaeology, I would be insisting on a strict horses-for-courses policy from now on

Whether the building described by Mr Bury as 'seeming to be of an earlier date than the [abbey] church' was the earlier church of the parish is now impossible to ascertain for '...this interesting and well-preserved little structure was demolished and its materials used in the rebuilding of the vicarage and the construction of the present stable'.

That's your modern archaeologist for you, gives up at the first hurdle. Their Victorian predecessors would not have drawn breath until they had found, minimum, an inscribed stone

The Sagranus stone in Saint Thomas Church of St Dogmaels is considered important by scholars for early inscriptions

and what's more, so deeply inscribed it has survived a millennium and a half of Welsh weather

with its inscription clear even to the present day

and what's more, in lettering only used in Dogmael's time

a noted Ogham stone

and what's more, Wales's very own Rosetta Stone

in both Ogham character and in Latin

and what's more, revealing where the ancient Celtic church stood

In its earliest days it probably stood in the burial ground of the old religious house founded by St.Dogmael at Yr hen Monachlog

and what's more, confirming the presence of Dogmael himself

The inscription on this stone in Latin is: 'Sagrani fili Cunotami' or in Ogham, 'Sagramni Maqi Cunatami', Maqi being the Irish form of the Welsh mab (son)

Cunotami is Cunedda, Dogmael is the son of Ithel ap Ceredig ap Cunedda.

At last! It has taken us until the S's to find but St Dogmael's has finally brought the archaeological record and the historical record together in an unbreakable bond. One tries to avoid hyperbole but this single stone might just be the evidentiary proof of the early Welsh Church, demonstrating its relationship to wider Christendom and establishing Wales' central significance in the world story. There can be no doubt as to its authenticity because the provenance of the Sagranus Stone could not be more detailed

Stones of this kind are prized all over Pembrokeshire as, from their peculiar form and hardness, they are very useful as gate posts. The present stone shows, by two holes drilled into its surface, that it has also been used at some time for a similar purpose. This stone, however, has been used not only as a gate post, but as a bridge by generations now dead and gone, for it was used over a brook, not far from its present resting-place, and had acquired a sort of supernatural reputation when thus used, the people nearby firmly believing that at the witching hour of midnight a white lady constantly crossed over it, and no man or woman touched it willingly after dark, and it was this very tradition, added to its peculiar form, that probably led to its ultimate rescue. The Rev. H. J. Vincent, Vicar of St. Dogmael's over fifty years ago, found the stone covered with a thick coat of whitewash, in a wall adjoining his house. When this wall was taken down, the stone fell and was broken in two; it was, however, mended, and conveyed to the spot where it now rests, against the Abbey wall

And so, no doubt to much relief all round, we have reached the very last Dark Age Welsh monastery, **[#19] Towyn**

> According to the Book of Llandaff, one of Wales's earliest ecclesiastical manuscripts, a Celtic monastery, or clas, was established here by Cadfan, a missionary from Brittany, around 516

The *Book of Llandaff* is indeed one of Wales' earliest ecclesiastical manuscripts but it is still six hundred years after these events so we can forgive that vague 'around 516'. Unless they mean 'season 515/6' because they were maintaining league tables

> It was the third most important church in North Wales, and was the mother-church of the whole of the commote of Ystum Anner

There are regrets about gaps in the totality of the evidence

> Little is known of Cadfan's life and nothing now remains of this early site.

But those gaps are being addressed as we speak

> To the north of the present church are a number of rounded boundaries which may indicate that the church lies on the site of the early Christian monastery

Pending reports from that front we shall have to fall back on what has already been found

> St Cadfan's Stone (PRN 4798) is located within the west end of the church, against the northern wall. It is 2.5m tall and inscribed on all four sides in early Welsh script, one of the oldest known examples of the written language and probably dating to the 7th to 9th centuries (Cadw 2001, 76; Smith & Smith 2001).

Exactly which century – seventh, eighth, ninth – has got the early Welsh language community comparing notes

> The date of its creation has provoked considerable debate; recent research suggests that it dates from the 9th century, but earlier dates have been proposed. The inscriptions have proved difficult to interpret owing to the stone's worn surfaces and the archaic form of Welsh used. One is

thought to read 'The body of Cingen lies beneath', but alternatives have also been suggested. Either way, the stone is hugely significant to the history of the Welsh language.

Hugely significant *if* the provenance can keep pace

The stone appears to have been moved to the churchyard in 1761 from Bodtalog, where it had been used as a gate-post, before being placed in its current position.

A gatepost that can be read on all four sides has got the Welsh ophthalmic community comparing notes. A companion stone has got the Welsh osteopathic community comparing notes about cricked necks

The other 'funerary' stone (PRN 4799), a pillar stone, is now lost, but it is recorded as having a Latin inscription PASCENT[I], reading vertically upwards, and probably also dates to the early medieval period.

All communities are agreed the rest are much of a muchness

A second pillar stone, with an incised cross, is located on the outside of the south side of the tower. Other stones of unknown origin (PRN 4800) are also recorded in the HER as being located within the churchyard

With one exception but that exception is exceptional. Nothing less than Towyn's contribution to our understanding of early Welsh horology

Set next to St Cadfan's Stone at the west end of the church is an incised stone sundial (PRN 1793), which was moved to the church in 2010 having been originally found in 1987 during the clearance of rubble at Ynysymaengwyn.

Before the days of church bells summoning the faithful to prayer, Welsh families could, if it was sunny, send the children out to check with the sundial thus giving them an extra lie-in of a Sunday morning

Although the history and provenance of the two funerary monuments is uncertain, it is a reasonable conjecture that they were associated with either the monastery or the Church. It is more certain that the sundial had such a

relationship, since sundials were designed to stand out-
side churches (parish or monastic) to help indicate when
services would take place. The object is one of only two
"Irish-style" dials in Wales.

When finally Welsh church bells did start ringing out, sundials up
and down the land were obsolete and could be put to other uses

An 18th century inscription on the stone indicates that it
was also used as a milestone

Has the bell tolled for early Welsh Christianity or have we a ways
to go?

34 The Birth of Common Sense

We have arrived. By the standards of revisionism. We start from the status quo and keep removing the nonsense until we arrive at 'nothing much is happening'. Academics start from the status quo and teach it. We would not be allowed to teach our version, but then again there would be little to teach if we were. If we ever did get through the Welsh Dark Age classroom door, this would be our checklist to nowhere

- o There seems no real evidence that Christianity existed in Wales before the Norman period, ergo
 Christianity did not exist in Wales before the Norman period

- o Wales had plentiful links with England, ergo
 Christianity did not exist in England before the Norman period

- o England had plentiful links with the rest of Europe, ergo
 Christianity did not exist in Europe before the Norman period

- o Europe had plentiful links with the rest of the world, ergo
 Christianity did not exist anywhere before the Norman period

There is no better example of 'nothing much happening'. It is tempting to add

- o The Dark Age consists of Christian history, ergo
 the European Dark Age did not exist

but that will have to await bolder spirits.

There may be no real evidence of pre-Norman Christianity in Wales but there is a mountain of *un*real evidence, ergo

somebody wanted it to be thought there was

Who is in the frame? There is no question, if the revisionist case be accepted, that the first Dark Age, the ancient Mediterranean one, was the product of historians, so the Applied Epistemological principle of "One input, one output" points to it being historians again. If so, take your pick: Welsh, English, Normans, Christians, A N Other.

But the parallel is limited. The first Dark Age arose entirely from incompetence, no evidence of tampering was found, there was no Greek Book of Llandaff. With the second one, modern historians may have had the wool pulled over their eyes by

medieval historians but they are fully equipped to get to the truth – modern historians are better than medieval ones. One hopes.

They spend their lives among archival documents, some of which they know to be 'plants', all of which they know to be unreliable to some degree or other. That is the nature of historical evidence and all academic historians are trained to use their judgement as to which parts they use and how they use them.

What they are not trained in is the recognition of circumstances that make it unsafe for historians to use their judgement. Would you trust historians when one of the options is 'it did not happen' and hence

there is no requirement for historians

any more than you would trust Christians to arrive at a conclusion that Christianity never happened and hence

there is no requirement for Christians

Historians and Christians are quite safe. Not from us – we do not register on anybody's radar, even one another's half the time – but because of the principle of specialisation.

Academia's compulsive determination never to interfere across specialisms keeps everyone safe. English historians are fully entitled to question how the received religion of England arrived in England, but they will be faced with a series of demarcation issues if they ever did. Wales scarcely comes into it, a mere conduit, but would English historians feel equipped to challenge the antecedents of Irish missionary-saints setting up in Northumbria?

"It is an internal British matter, we could give it a bash."
"It could mean the English bashing the Irish."
"Maybe later."

How would they cope with St Augustine setting up in Canterbury? Delving into the Frankish court, Italian church politics, the palaeography of continental gospel books... all kinds of foreign matters going back at least as far, and as far away, as

Desert Fathers, early Christian hermits whose practice of asceticism in the Egyptian desert, beginning in the 3rd century, formed the basis of Christian monasticism

That can, in theory, be handed over to another properly briefed team of specialists but were they to conclude, yes

o Christian monasticism *was* invented in third century Egypt
o St Benedict *did* set up Monte Cassino
o Augustine *was* trained by Benedictines
o He *was* sent off to convert the English by Pope Gregory

what then? These specialists *will* be faced with Wales. Not a conduit this time but a bunch of people who have seemingly got the same Egyptian monastery idea as St Benedict but ran with it a lot further than he ever did. If it is true that

o the Welsh introduced monasteries to Ireland
o the Irish introduced monasteries to England
o the pair of them introduced monasteries (back) to Europe
o western Europe thereby got delivered up to the Pope

where does that leave Benedict the Great and Gregory the Great?

Maybe not so great. Maybe not responsible for that mountain of documentation bearing their names. Who would be prepared to go through that little lot with the fine comb of truth?

"We would, if we thought it necessary. Joint working groups, secondments, international conferences. It might be quite fun. And we Early Medievalists could do with a bit of fun, it is a pretty thankless task."

Except they would find themselves up against much bigger forces if they ever did. It would not be historians from different specialisms in friendly rivalry, it would be history itself duking it out with other academic disciplines, some with *science* in their name.

English historians could, for example, throw out Anglo-Saxons to their hearts' content but this will mean throwing out the antecedents of the English language, which would not be to linguists' content. That is not a problem in itself, linguistics is a joke subject, but it would mean historians concluding that English villages have English names for the somewhat unavoidable reason that English was the language of the people who founded them, long before the Romans and their villae.

That is not a problem for historians – they do not deal with prehistoric matters – but a very great problem for archaeologists who do. Villages are coterminous with agriculture and that means English villages going back to the Neolithic Revolution c 5000 BC. Archaeologists, in their turn, do not mind the English or their language going back to c 5000 BC, they very much mind English *villages* going back to 5000 BC. The whole of English archaeology

338

(and archaeology is itself a largely English-inspired enterprise) rests on a pre-historic England *without* villages.

This weird situation came about from academic specialisation

o pre-history is archaeologists' fiefdom
o the only thing they took from other disciplines was that the English arrived after the Romans
o English villages have English names therefore the villages are post-Roman
o no villages have been found in England other than those villages
o therefore pre-historic Britons didn't live in villages
o they must have lived in 'isolated settlements' or some mildly extended version thereof

There is no alternative, to quote the only scientifically-trained English prime minister.

You might think that archaeologists would have some difficulty explaining why millions of Bronze and Iron Age Britons declined to live in villages. It is not exactly natural to want to live in isolated settlements and once there is agriculture there is no reason to do so. Every agricultural society on earth (that we know of) lives in villages so you might think British archaeologists would be aghast their own forebears uniquely did not. Except that is what careful ignoral is for.

But let us suppose archaeologists decide 'the hell with this' and drive in any direction until they see a sign

<div style="border:1px solid black; padding:10px;">

Welcome to Little Snoring Please drive carefully

</div>

"Oh, an English village. So that's where the buggers were living." But before they tie themselves to that mast, they should read the rest of the sign

<div style="border:1px solid black; padding:10px;">

Welcome to Little Snoring Please drive carefully
Twinned with Petit Ronflementville

</div>

which did not exist in French pre-history because the French only acquired French after the Romans arrived. So how did good old Vercingetorix manage to persuade "estimates range from 80,000

to 250,000 Gauls" to leave their isolated settlements to confront Caesar at Alesia? At least Gaul was not a land of trackless wastes so he did not have the logistic nightmare facing Arminius at the Teutoburg Forest (the names they come up with) when ensuring Germans could defeat Romans and carry on speaking German. And to cap it all, how come the French and the Germans were not living in villages if the English were? They're not going to like that.

The long march of revisionism has no end, that is why it is so unpopular in the sleepy halls of academe. If there is a Britain (and a France and a Germany) of villages that have existed since the Neolithic Agricultural Revolution, there will have to be further, even more seismic, changes to European pre-history. Have you been to a village lately? They have always got stacks of *this*, they are always chronically short of *that*. Only people in isolated settlements live isolated lives, people in villages trade with one another like mad. And we are not talking trips to the local market town – just getting enough salt from where it is available to where it is needed demands long-distance trade.

But people need all sorts, from near and far, and even if they do not need it, by God they want it, and by God they are going to get it by constructing a trading network as best they are able. They have brains the size of yours, if not mine, and with several thousand years to put those brains to work, even archaeologist-sized brains would surely come up with something.

Careful ignoral has not prevented archaeologists from knowing pre-historic Britain *did* have long-distance trade for several thousand years, the evidence is too blatant to ignore. But it is very peculiar long-distance trade, not used by any agricultural society known to man. Archaeologists are happy to show you flint mines in Norfolk, they are happy to show you the same flints turning up in Cumbria, they are less happy telling you how the flints got from Norfolk to Cumbria

> "Oh, you know, exchange ceremonies, traditional pedlar routes. Non-literate cultures always have good collective memories and an affinity with the landscape. It is too complicated to go into now. I would be happy to show you how they knapped flint."

If really pushed, the emerging orthodoxy is

> "There is evidence the ancients had a grasp of astronomical alignments so navigation by sun and stars was available."

340

No, it wasn't.

It is a simple exercise in 'Is it true of you?' You try getting from Norfolk to Cumbria with any astronomical aid available to *you*. You can have the latest star tables in your pocket, you can have the James Webb space telescope strapped to your back, you still won't be able to get from Norfolk to Cumbria. Without maps and signposts you won't be able to get from Norfolk to Suffolk since you won't know where Norfolk stops and Suffolk starts.

Ask archaeologists to get to their next dig without maps and signposts. Give them any astronomical aid they want, tell them they can use any road they want, tell them they can have any affinity with any landscape they want, they still won't be able to get to the dig site without maps and signposts. Even if they made the trip last year and they've got memories like steel traps.

And do not, whatever you do, mention the Bronze Age. That requires

- o transporting copper from north Wales
- o transporting tin from Cornwall
- o bringing them together to wherever bronzesmiths are
- o sending the finished bronze goods to end-users living in every part of Bronze Age Britain

Those pedlars are really going to have their work cut out working out how to get *from* everywhere *to* everywhere

"No, sorry, I don't know that one. Albert, have you ever done the Edgbaston to Redcar run? No, he doesn't know either."

So how *exactly* does one conduct long-distance trade without maps, without written guides, without signposts? One doesn't mind archaeologists not knowing, one does mind they haven't got round to discovering they don't know.

Archaeologists do not subscribe to 'Is it true of you' principles. They regard the past as a foreign country, a country lived in by people obsessed with ritual practices to judge by how many ritual centres archaeologists excavate. Especially British archaeologists because their fair land positively pullulates with impressive megalithic structures that seem to have no purpose other than ritual ones. But in this case, archaeologists *do* know they don't know. In fact they've gone quite the other way and obsess non-stop about what the megaliths were for, coming up with ever more extravagant reasons with every passing generation.

Revisionists are not like archaeologists, they seldom obsess about anything for more than five minutes unless something jumps out at them. There isn't exactly a shortage of things demanding their attention. Fortunately it takes less than five minutes to mesh the archaeologists' twin problems of how long distance trade was conducted and what the megaliths were for, in order to come up with the reasonably obvious

the megaliths were for conducting long distance trade

Once a few basic facts about landscapes are known and how easy it is to morph bits of it so everyone can find their way about using local megaliths, you can figure it out for yourself. It is all quite straightforward if you've got this far. But not if you've gone too far by studying archaeology.

In departmentally-obsessed academia, archaeologists adopting any such approach would quickly find themselves ranged against the Earth Sciences, who currently speak for the landscape and guard it jealously. Geologists do not like 'their' landforms being morphed by the hand-of-man and they're big bastards with hammers. Such opposition can be faced down (I'll be right behind you) because the 99.99% of landforms that *are* natural provide geologists with all the hammer-bashing opportunities they will ever need.

They relinquished Silbury Hill, now officially recognised as the biggest earthwork in Europe, but only until Glastonbury Tor, Maiden Castle, causewayed tidal islands, and all the other terra-formed marvels out there cease to be objects of careful ignoral. Actually not particularly marvellous if there are millions of people with thousands of years to construct last-forever structures so they can live the good life in those villages of theirs. (Though our advice would be to start with smaller, more obvious works of artifice like the Cheesewring or Durdle Dor to get your eye in.)

If geologists put their hammers down for a minute, they might make themselves useful by developing a methodology for distinguishing man-made from natural. But they in turn must be careful about academic demarcations. If they use baselines provided by archaeologists they will come up with answers desired by archaeologists. The Life Sciences are presently giving an object lesson in the perils of relying on others to provide baselines. When geneticists decided to measure the genes of the British Isles with a

view to showing who came from where and when, they might have been able to do just that, to the great advancement of human knowledge, but they foolishly asked the social sciences to provide them with baselines

> "Alphonse, could you tell us which parts of Britain were Celtic, which parts Germanic, and roughly how long ago the cauldron got stirred?"
> "I'm glad you asked, Gaston, it's like this..."
> "I say, Alice, isn't it marvellous that what we always thought has been confirmed by genetics?"
> "One must always be guided by the science, Alphonse."

What happened next can be summed up in a phrase coined by people from another part of the campus

Garbage in, garbage out

In theory, given the will, given the time, given a miracle, all these things could be addressed. Then the *whole* campus will find itself imperilled. There are bigger guns than academia out there. Can you imagine, say, an England without the Church of England? Well, yes, we've already got that but there would certainly be world ructions if Christianity was reduced to the status of something akin to Arthurian legend. Though that's a constituency the Church fathers might have a think about. And don't forget Islam includes Jesus in its pantheon so there could be words from that quarter. More than words possibly.

No, my advice to academics is to forget about revisionism. Put your feet up, carry on teaching the youngsters what you learned when you were a youngster, and reflect on there being worse things than intellectual tedium. Even if I can't immediately think what they might be.

343

Part Seven

LANGUAGES AS THEY ARE WROTE

35 Academese, A Common Language

No paper will be accepted by a peer-reviewed journal unless it is written in academese, but why? The readers of that journal would be more comfortable reading it in plain English, the way they read all other words on all other pages. Such remarkable acts of collective self-sacrifice can mean only one thing. A quiz.

Is academese:
A. The modern equivalent of writing in Latin, ensuring writer and reader are fully trained in the basics of scholarship
B. A prose style that promotes dispassionate discussion
C. A tradition that has become part of the fixtures and fittings of academic life
D. A chief reason why universities are inimical to intellectual advance and a complete waste of space?

Correct. Certainly academese signals to the reader that the writer is a fully paid-up member of the guild of academics, but that is not its main function. Academese's more immediately useful attribute is being able to say little of substance without anyone noticing. Truisms, circularities, assertions presented as fact, saying the same thing in different ways, saying things other people have said in different ways – all these are hard to disguise in plain English. Ask any sub-editor on any newspaper. But nor is this the main function of academese.

To teach the fundamentals of any subject, teachers must know what they are. They must be taught them. How is that possible when the teacher of that subject will be taught in one place, at one time, by one set of teachers, but will end up teaching at other places at a later time? There must be a higher authority ensuring that what is taught is the same everywhere and that does not seem practical when academic institutions pride themselves on being

<p style="text-align:center">their own highest authority</p>

Academic freedom is a moral and legal concept expressing the conviction that the freedom of inquiry by faculty members is essential to the mission of the academy as well as the principles of academia

How then does every university manage to teach the same basics? They do not teach morphic resonance, there must be some other mechanism at work.

It does not have a name, these things are not much studied by academics, but 'peer review' would probably be the shorthand term most academics would reach for. However, peer review is not involved. Editors of journals cannot know what the individuals they send papers to for evaluation believe about any given subject. What they do know is those individuals have already been screened for orthodoxy. In other words *every* academic in that field is guaranteed to agree on the basics. It therefore requires going back at least one step to discover how that unanimity was achieved.

Is it to the appointment of the peer reviewers? It is true they will all have been appointed by other academics but this does not solve the problem. No interviewing panel checks candidates for soundness on fundamentals, it will be assumed that all candidates arriving for interview hold the same fundamental beliefs as the interviewers. We shall have to go back another level to discover how that was achieved which only takes us back to where we started because everyone in that room will have been taught somewhere else, by somebody else, at some other time. How can *their* teachers be guaranteed to hold the same fundamental beliefs?

It is tempting to draw parallels with religions except

o religions *do* have mechanisms for enforcing uniformity
o they prize the unvarying nature of their beliefs

universities are supposed to be the opposite

o instruments of progress
o throwing out the old, promulgating the new

Market places for ideas not football clubs playing by the same set of rules in front of partisan supporters.

The obvious solution would be to insist on conformity about fundamentals while allowing free rein for disputation about non-fundamentals. In theory such a system will work so long as there are frequent 'paradigm shifts' as one set of fundamentals are overthrown in favour of a newer, better set. Unfortunately

this cannot happen

at least not with the frequency compatible with being in the market for new ideas. Consider a true marketplace where innovations are introduced constantly and market mechanisms ensure they will

spread rapidly to become the new normal within a short time. How could such a model possibly operate in the case of an academic subject where the timescale is generational because teachers are taught once and they teach for a lifetime, and when there is

- o nobody to say the process should start
- o nobody to superintend the change
- o nobody to say the process has been completed
- o nobody to say whether the replacement is any better.

Even when the Time of Troubles is at an end and it is once again safe to assume conformity at all levels, there will surely be a climate of nervousness because someone, somewhere will be cooking up the next paradigm shift.

That is certainly a characteristic of markets where everyone is actively looking for an edge but not a characteristic of academic life since

- o market traders are not appointed by other market traders
- o they are not promoted on the basis of publishing articles in Market Trading Monthly
- o they are not required to teach the next generation of market traders the fundamentals of market trading

It might, even so, be theoretically possible for academic subjects to do all this were there a paramount body cracking the whip, ensuring the process is rapid enough for practical application. If so, peer review, interviewing boards and mandatory in-service re-training could do the job.

But there is no paramount body, every university

is its own highest authority

so practitioners have little choice other than to teach same old, same old. It turns out the very quality most prized by academics, their institutional independence, prevents them having any.

Academics know quite enough about paradigm shifts

> "Well, yes, of course back in my young day I read Kuhn's 'Structure of Scientific Revolutions', we all did. Paradigms were quite the thing, I seem to remember. You don't hear a lot about them nowadays."

They are even quietly proud when a paradigm shift does take place

> "Do you remember when carbon-dating came in and we had to adjust our thinking on so many things."
> "Do I half? Though not that many things, as I recall."

"No, we seem to have got it mostly right first time."

"Goes to show."

In academia the term 'paradigm' is reserved for the eternal verities: Newtonian laws of physics, Darwinian evolution, plate tectonics, chronologies. Academics can be supremely confident these kinds of fundamentals will be securely in place during their professional lifetimes. And for the generation before them and the one after them. If not, well, let the hurricanoes blow, it won't be their problem, the whole world of ideas will be in a furore.

Except that is not what paradigms are

Not in a practical sense. A paradigm is *any* assumption necessary to make sense of raw data. While everyone is skating along on top of the Big Ones, the ones all academic subjects agree on, revisionists are beavering away with the Small Ones, the paradigm theories lurking round every corner *within* each subject. The ones that have been mustering in basements, untended for generations. You have been exposed to plenty of them in this book

- o Egyptian king lists
- o Geometric pottery
- o Stone, Bronze, Iron Ages
- o Dark Ages
- o The popinjay theory of government
- o The Enlightenment
- o Grangerised portraits
- o Longevity of classical sculptures
- o Longevity of classical literature
- o 'The absence of evidence...'
- o Latin a natural language
- o English derived from Anglo-Saxon
- o Indo-European language family

to name a few (and one or two still to come). They are not, for the most part, even considered to be theories. Maybe not absolute self-evident truths but as good as. Academics habitually justify these kinds of corporate assumptions with, "The evidence, I'm afraid, is overwhelming." To which revisionists always retort, "It certainly overwhelmed you." Under their breath, but the point is

they are not up for discussion

What if they were? What if fundamentals at this routine level of teaching were *not* agreed? It would not be a caravanserai changing

350

direction from time to time, it would be students learning one thing in the morning and having it contradicted in the afternoon. It would be exciting but no place for students. You would need to guess who was marking the exam papers to know what to write. And we still have not got to the real function of academese.

Forget paradigms, forget fundamentals big or small, forget organising principles. Just concentrate on the market-of-ideas bit. What is on offer at *this* market, *this* day. Universities are not schools, there is no laid-down curriculum with Ofsted (and politicians) making sure it is taught properly. The Academy has to give at least the impression things are on the move, intellects are engaged, the SCR is alive with the sound of argument, that learned disputations are going on in the journals (or anyway the letters page of The Times).

But it just isn't so

The most cursory inspection of academic discourse in learned journals or on the internet or television programmes will inform anyone who cares to know that academics are determinedly non-disputational. They line up to bestow praise on one another at every opportunity. Stepping out of line about the most minor of matters prompts calumny, not promotion. Academic disputes are so rare they might get on the front page of The Times.

Now take a look at *non*-academic publications, *non*-academics discoursing on social platforms, non-academics appearing on the telly. You will find them all arguing the toss, going at it hammer and tongs, on every subject under the sun. Human beings cannot help but be disputational. The only arena of public discourse that does not promote dispute is conducted in academese.

That is what makes academese essential

Not because academese is a cool and sober medium for expressing ideas or any of the other uses it can be put to, but because it is a scribal language that can only be learned at university and universities are designed to instil uniformity. Academic subjects are not called 'disciplines' for nothing. After the early heroic days of discovery, they always end up as religions, complete with dogma and hierophants. They always end up with authority figures enunciating orthodoxy from pulpits for the benefit of rude folk anxious to learn.

It has to be like that for academia to fulfil its role as the repository of orthodoxy. Current orthodoxy has to last for generations to allow academics to carry out their duties. If plain English was allowed there would be no orthodoxy at all and intellectual life would be a free-for-all. Good gracious, we can't have that. (And maybe we can't.)

36 There's Always Been an England

Everyone knows the English language was brought to these shores by the Anglo-Saxons, but everyone is wrong about that. English is no more Anglo-Saxon than, say, Français is Frankish. People like to know where their language comes from and since, in our present state of knowledge, nobody knows where their language comes from (unless you speak a pidgin) people settle for any old blarney.

Philologists and linguists then start arranging the blarneys into Darwinian-style evolutionary trees. These are useful devices in academic areas like the Earth and Life Sciences, where there are rock strata and fossils to preserve the past, but less so for the study of languages because, unless there is a written record, there is no evidence of what people were speaking in the past. When there *is* a written record, linguists seize upon it and get to work theorising.

Original written language	Evolved into
Anglo-Saxon	English
Latin	French
Old Norse	Swedish
Sanskrit	Hindi

If there is no written language, unwritten ones can be conjectured

Original unwritten language	Evolved into
Brythonic	Welsh
Germanic	German

Once the linguists had acquired two generations of languages, the search for 'common ancestors' could begin and a full blown evolutionary tree of languages was in prospect. Before you know it, linguistics will be a proper science.

The linguists soon ran out of dead languages, real or invented, and turned to living ones. As there are thousands of these there was every prospect of some properly scientific cladistics

Modern Language	similar to	Language group
English	German	Germanic
French	Italian	Latinate
Welsh	Irish	Celtic
Russian	Polish	Slavic

All of them are sufficiently alike to give, say

Language Group	Family	Phylum
Germanic Latinate Celtic Slavic	European	?

...that was presenting a difficulty. Leaving aside outliers like Basque or Hungarian (but leaving in equally outlying 'Celtic' for political reasons) the languages of Europe were clearly a family but a very parochial one.

Covering so small a part of the earth's surface was hardly suitable by the end of the eighteenth century when Europeans were spreading out over such large areas of the earth's surface. The nearest language groups they could link up with – Semitic and Turkic – were unsuitable for political reasons. Oriental languages were too strange by half and the ones being discovered in Africa, the Americas and the Pacific were just plain outlandish.

Leaving India. British India. The early study of languages was dominated by English- and German-speakers so when English-speakers found, quelle surprise, there were links between English and Sanskrit that was very good news. The German-speakers were happy to agree, they had English in their pocket. Presto! European languages belonged to the mighty superfamily of

Indo-European

The amount of science might be nugatory but by the time everything had been tidied up into Linguistics and the iron rule of acad-

354

emic life – First is Best – had worked its magic, the patrons of the Dog & Duck not only knew where their language came from, they could be proud of the superfamily it belonged to

"English is a Germanic language."
"Why can't German be an Englishic language?"
"Because English is evolved from Anglo-Saxon and that's a Germanic language."
"Yes, I'd heard that."
"There's a Germanic group, a Latinate group, a Celtic group and a Slavic group which together form the Western Indo-European branch."
"Why do you call it that?"
"*Aryan* has unfortunate connotations."
"No, I mean why *Western*, *Indo* and *branch*?"
"In simple terms, it was recognised that English and Sanskrit had certain modalities in common which, what with one thing and another, led to the identification of the Indo-European language family."
"I thought there was no evidence of how languages evolved."
"Direct evidence, perhaps, but we can make textual examinations of existing languages plus various extinct languages, our fossils, if you will."
"Fascinating. How's it done? Briefly."
"If a word from Language A sounds like a word from Language B, and they are not loanwords, they must both be derived from a common root-word."
"Why not from one another?"
"They just aren't. Are you evolved from your mother or from your sister? Once we have identified enough root-words, we can recreate whole languages. In this case 'proto-Indic' from which all the Indo-European languages evolved."
"Impressive. When was all this happening?"
"That I couldn't say. We're talking aeons."
"Not so impressive. Do you know *where* it was happening?"
"Central Asia."
"You mean between India and Europe?"
"Quite."
"But according to this President Erdogan everyone in central Asia speaks Turkic."
"There may have been a vacuum after the migrations to India and Europe."
"Makes a lot of sense. Can I get you another?"
"Please. I'll have it in a straight glass, if you wouldn't mind. It makes drinking a bit awkward."

As one discipline does not question the assumptions of another discipline, difficulties arise when the assumptions are wrong. If

English is derived from Anglo-Saxon, historians had to explain how English-speakers could be the product of a few boatloads of Anglo-Saxons replacing the several million Celtic-speaking people already living in Britain. This could certainly be done, it was being done in the Americas and Australasia, but could such a model be applied when it was the aborigines that were the advanced culture? The British Celts had, after all, spent several hundred years in the Roman Empire, the Anglo-Saxons were from the trackless wastes of Germania. Though not so distant that the main standby, infectious diseases, could do the job.

It was equally baffling why the Anglo-Saxons would want to get rid of the workforce anyway, not something other invaders like the Belgae, Romans, Danes and Normans thought a sensible policy. And so quickly too! The historical record appeared to show the Anglo-Saxons arriving c. 450 AD and it was pretty much all over bar the shouting by c. 600. Unless somebody could come up with a decent explanation it looked for all the world like mindless ethnic cleansing and nobody wants to be evolved from genocidal maniacs. That came later.

More agreeable models were proposed from time to time, notably bringing up Anglo-Celtic children to speak Anglo-Saxon. Plenty of that happens in slave societies. On the other hand, sex has never been our strong suit, though we do have form when it comes to forcing parents to speak English. But none of the gradualist models could really be made to work because of the limited time frame. People are remarkably fond of their mother-tongue, so replacing an entire population speaking one language with another one speaking a completely different language could only be achieved by the application of industrial-strength careful ignoral. If you ask, you will be met with, "Oh, that old chestnut," and sent on your way.

The default assumption now is that the Anglo-Saxons sort of *ushered* the Celts into Wales and Cornwall, requiring further careful ignoral to account for how the broad acres of England could be de-Celticised in no time flat but it took until the eighteenth century to do it in Cornwall and the job has still not been completed in Wales. We're probably kind to a fault.

The underlying reason why any of this can be believed is that it is all happening in a Dark Age, those wondrous devices for hiding paradigm errors. But irresistible landing strips for circling revis-

ionists. We are good liberals (a lot of the time) so we prefer dispatching paradigms to people. You may be sure though that our explanation for the language situation in the British Isles will be dull to a fault

- o we agree with orthodoxy that the English-speakers arrived from the east
- o by observing where Celtic-speakers live, we make the not very startling assumption that the Celtic-speakers arrived from the west
- o we are agnostic about when and in which order they arrived

All we require for our model is they arrived! Hence there will be a language cline somewhere in the British Isles running north/south with English being the majority language to the east of it and Celtic the majority language to the west.

Such demarcation lines are always being established, they are always on the move as one group or the other expands and as mixed couplings bring their children up in the language deemed more useful. It may be dull but at least the process can be observed in every corner of the globe which is more than can be said of the orthodox model: Anglo-Saxons, world's greatest TEFL teachers.

We cannot know what the situation was in pre-history but we do know the cline has consistently favoured the English-speakers in historical times. With the cline shifting inexorably from east to west, and with Britain being an island, the cline is going to hit the buffers sooner or later. It reached Penzance in the eighteenth century rendering

Cornish extinct

but has only got as far as mid-Wales in the twenty-first century so

Welsh is extant

That is not going to sell many history books.

Historians certainly aren't sold on it, they haven't even heard of it. The don't listen to us, they listen to other academics

- o the linguists have told the historians the English language is the product of Anglo-Saxons
- o the historians have told the linguists the Anglo-Saxons arrived after the Romans had left
- o both sides agree that somehow the whole of England (less Cornwall) emerged from the Dark Age speaking Anglo-Saxon

giving them their next joint herculean task

turning Anglo-Saxon into English

Only now there is not a Dark Age to hide what is going on but a historical record to illuminate it. England will have to be put into special measures because according to that historical record

- o Anglo-Saxon is still around in the twelfth century
- o English is up and running by the fourteenth century
- o They have got scarcely a word in common

Anglo-Saxon and English are undoubtedly two different languages in terms of vocabulary, syntax and grammar, irrespective of their overall relatedness as 'Germanic' languages, so how are linguists and historians to account for the English

- o changing virtually every word of their language in the two hundred years from the twelfth to the fourteenth century
- o changing very few of them in the four hundred years between Shakespeare and Shakespeare's Sister?

By creative labelling of course. Have you learned nothing?

Step one: rename the Dark Age 'the Early Medieval Age'

thereby creating a Dark/Medieval SuperAge lasting a thousand years from 500 to 1500 AD. We know how useful dark ages are, we are now to witness they are even more useful when merged with a non-dark age because academics can switch from one to the other, as required, to solve any anomaly thrown up by the original paradigm error. Hold on to your hats.

The first requirement was to explain how one written language (Anglo-Saxon) can morph invisibly into another written language (English) when the process ought to be visible every step of the way via the written record. Not when creative labelling stalks the land

Step two: rename Anglo-Saxon 'Old English'

If English is assumed to be an evolved form of Anglo-Saxon, nobody can dispute that Anglo-Saxon is both old and English.

Step three: rename English 'Modern English'

Nobody can dispute what we speak today is thoroughly modern.

It is extremely sly all the same. Every language in the world is exactly the same age as every other language (assuming language was invented once) and it is wholly arbitrary where one language

is chopped off from its preceding form and given a different name. But you will never get linguists to understand this, any more than you will get people counting mitochondrial mutations in their quest to prove 'Out of Africa' to understand that every single human being who ever lived is exactly the same mitochondrial age as everybody else living at the same time. (Assuming we only evolved into humans once and assuming Neo-Darwinism is a valid theory.)

Nothing so ambitious was being sought by conjuring Old English and Modern English into existence. That was done in order *not* to have to conjure Middle English into existence. It is not necessary because if there is an Old English and a Modern English, there must be a Middle English as one is becoming the other. The only difficult bit was getting (real) Anglo-Saxon to (imaginary) Middle English. It was done thisaway:

Step four: the Normans get rid of the Anglo-Saxons

but not, as it were, the English.

Step five: the English give up writing in (Old) English

Nobody knows why. Nobody even wonders why. But for the theory to work, the English have to give up writing in their own (alleged) language before taking it up again. Since this has never happened anywhere else, to anyone else, there is a paucity of theories as to why it happened to the poor old English. Maybe the Normans forbade them using it. Maybe Anglo-Saxon school-teachers had been got rid of. Maybe the English were too dispirited to go to school. Who knows, but since the Normans were hardly likely to be writing in Anglo-Saxon and Norman-French was not a written language, the entire written record was in Latin. What a shame, we'll never be able to observe

Step six: Old English has become Middle English

Middle English not existing has proved no hindrance to writing books about it, even teaching entire courses on it. All kinds of wonders can be wrought from late Anglo-Saxon texts, English texts before standardised spelling, and fake texts in both. But Middle English does have the priceless attribute of taking English linguistic history all the way from Anglo-Saxons to the end of the Dark/Medieval SuperAge and lo and behold

Step seven: Middle English has become Modern English.

It is great stuff but nevertheless we prefer our 'truth is always boring' version:

Step 1: The English arrive in England at some undetermined time after the end of the Ice Age. They are speaking English, which is an unwritten language.

Step 2: The Romans invade. The English are still there, still speaking English, still an unwritten language.

Step 3: The Anglo-Saxons invade. The English are still there, still speaking English, still an unwritten language.

Step 4: The Danes invade. The English are still there, still speaking English, still an unwritten language.

Step 5: The Normans invade. The English are still there, still speaking English, still an unwritten language.

Step 6: The English start writing down English. The Italians, the Germans, the Danes and the Norman-French start writing down Italian, German, Danish and Norman-French.

But what has happened to the Anglo-Saxons? Apparently (step one) the Anglo-Saxons arrive speaking an unwritten language. Quite soon thereafter (step two) they can write down their language. But only in England, there are no records of written Anglo-Saxon from anywhere else. Though, perhaps as recompense, they have England to themselves, having rid themselves (step 2A) of the inhabitants. Cornwall always excepted.

They can bask in not one, not two, but three world records

1. the only invaders of England whose homeland has not been identified
2. the first people in the world to develop a literary demotic
3. the only people in recorded history that are literate abroad but not literate at home

We'll all have to work on that one.

England and *English* is not alone, everyone is subject to invasive academics. French was the world language before English and the French are just as anxious to know where their language comes from and just as beholden to academics for the answer. The French have been fed the standard pap, though they have insisted it must be le pap français

o They too were Celtic-speakers in the olden days and linguists have given this language the name *Gaulish* to distinguish it from the Brythonic Celts on the other side of the Channel and the Bretons in Brittany on their side

360

- The French will have to be given an explanation why they gave up their beloved mother-tongue which they had been speaking since time immemorial
- France not being an island, boatloads of language berserkers turning up was off the table
- Roman landbound language berserkers have turned up so it was they who persuaded the Gauls to ditch Gaulish and take up Latin
- A tough ask for a housewife in Troyes or a shepherd in the Auvergne who likely never clapped eyes on a Roman in their entire lives but they managed somehow
- The French were now facing their equivalent of the British language mountain, turning their newly acquired Latin into French and doing it quickly and invisibly
- The French linguistic historical record begins in the ninth century with the *Strasbourg Oaths* (don't ask, there's only so many times I can roll around the floor in helpless laughter at my age) so they too had only a few hundred years to morph Latin into French
- Or Occitan if they didn't fancy French
- Or continue with Basque or Breton if they didn't fancy entering the early rounds of the linguistic triple-jump

That's always been the trouble with the French, very undisciplined. World language? They'll be lucky to hang on to Quebec.

With the French accepting their fate, the die was cast for all languages sufficiently like French that they must have come about via the same process. This is a puzzle to revisionist tourists who can readily observe

- Portuguese is most like Spanish
- Spanish is most like Catalan
- Catalan is most like Occitan
- Occitan is most like French

and draw the not very startling conclusion that everyone arrived speaking the same language which evolved over time into local variants in the standard way of all languages everywhere. Being academics, linguists like more pizazz and have applied their

- everyone must change language
- everyone must do it quickly
- everyone must do it invisibly

theory to the whole of western Europe:

361

- o everyone is speaking Celtic variants
- o everyone is conquered by the Romans
- o everyone gives up speaking Celtic for Latin
- o everyone changes Latin into something more modern
- o everyone keeps a close eye on how everyone else is doing it across half a continent so that
- o everyone can end up where they started, speaking languages from the same family tree, only not Celtic ones now but 'Romance languages'.

Definitely time for a quiz. The academese phrase *Romance language*

- ? is a nod to troubadours and Eleanor of Aquitaine
- ? a fancy way of referring to Romans
- ? a terrific wheeze because if two different 'Romance' countries colonise a new continent which is also being colonised by evolved Anglo-Saxons, they can call their half 'Latin America'.

You can mark your own paper.

Present day actual Celtic-speakers must be bemused. (Setting aside whether 'Celtic' is an appropriate label, it being a term they dislike intensely but used here because it is what is most widely understood.) According to the linguists' theory, the Celtic branch of the language family tree was once

the biggest in Europe but is now the smallest

That has got to be depressing. So depressing, not all of them have survived

Extant	Extinct
Welsh	Cornish
Irish Gaelic	Manx
Scots Gaelic	Cumbric
Breton	Celtiberian

You may be able to spot a pattern.

They are all situated along the western coasts of Europe

You may be able to guess the academic explanation:

- o language majors like English, French and Spanish always wipe Celtic languages off the map except
- o they always have trouble with that last sliver of far western holdouts but
- o this theory is much to be preferred to the blindingly obvious

Why do Celtic-speakers give this amazing theory the time of day? Maybe if you are the smallest, it is a comfort knowing you were once the biggest. I don't know, you'd have to ask them.

How can anyone give *any* of these amazing theories the time of day? We certainly can. Throughout the English-speaking world there are first-year English Literature students being forced to read Beowulf in the original Anglo-Saxon even though Beowulf was originally written in English by John Milton. They can count themselves lucky. Along the corridor is Anglo-Saxon Studies, a whole department doing nothing but studying forged Anglo-Saxon manuscripts. *They* can count themselves lucky because there would be no departments of Anglo-Saxon Studies were it not for historians and archaeologists coming up with hundreds of years of bogus Anglo-Saxon British history.

Yes, British history. The Scots have been roped in whether they liked it or not. They have the pre-ordained language situation:

o major language in the east
 Lallan Scots (English as Rabbie Burns wrote it)

o Celtic minority language in the west
 Scots Gaelic (all but identical to Irish Gaelic)

o Lallan Scots is derived from Anglo-Saxon
 Scots are as in thrall to linguists as everyone else

As there were no Anglo-Saxons to speak of in Scotland, it might be thought this would result in a few Glasgow kisses being handed round, but the Scots are reasonably well-educated and have come up with a plan of their own devising

Step 1: Scots are speaking Celtic *It's a given*

Step 2: Some Anglo-Saxons from Northumbria push into the Lothians for a bit *No boats required*

Step 3: Scots take fright, ditch Celtic, take up Anglo-Saxon *We've always held the Indian sign over them*

Step 4: Scots turn Anglo-Saxon quite independently into a completely different language they call Lallan Scots *Which turns out to be uncannily similar to English*

Step 5: After the Anschluss with England, the Scots ditch Lallan Scots for Standard English like everyone else *Except during Burns Night*

Step 6: Scots take over the English dictionary industry
Not a word of thanks either

We at Sensible Inc have been obliged to tell you all this because British museums (and the British Library) are so awash with Anglo -Saxon fakes we have had no alternative. Just you, mind, everyone else is more than happy with the way things are. All those linguistic mills grinding all that lovely political corn. Look at Ireland: same language cline as everywhere else – English-speakers in the east, Celtic-speakers in the west – yet they have managed to split north and south. You think they are going to give that up in a hurry?

One does sympathise. Nobody wants to live in Dullsville, UK, where everyone is speaking the language they came with, plus neologisms, minus archaicisms, plus or minus clines. Who is going to give up the exciting history they know and love for the 'nothing happened is what happened' version we offer?

37 Demotics, Literally

It was hard enough training up people to read and write in the middle of a Dark Age without having to teach them Latin as well. It would be so much easier if people wrote the way they spoke, as we do today, but such 'literary demotics' are hard to come by. A natural spoken language consists of a near-infinite number of sounds so making a permanent record of it requires, at first blush, a near-infinite number of symbols. The solution adopted in the west was the 'phonetic literary language' i.e. what people spoke but so drastically simplified it could be rendered phonetically in twenty or so discrete sounds and hence could be written down in an 'alphabet' of twenty or so symbols.

The problem with such systems is not that people have to learn what amounts to a new language – everyone has to learn at least one language in their life – it was coming up with the new language in the first place. Ask Esperantists. Ask the proto-Latinists:

> "What about *amo*, *amas*, *amat* for all the single person present indicatives? No pronouns, see? Saves an awful lot of space when you're writing it down."
> "Good idea. Let's have noun declensions and get rid of prepositions while we're about it."
> "In that case, better include a vocative case, for letter-writing. Dear Blah Blah, it'll be mostly letter-writing, I expect."
> "But how do you address Blah-Blah? People's names are not phonetic, are they? Who's going to know who you're writing to?"
> "Make it a signature feature of the system. You sign up for Latin, you get a Latin tag. That way anyone you write to is guaranteed to be able to read what you have written."
> "Women as well?"
> "*Us* for men, *a* for women."
> "B for mutton."
> "Won't work for places. They've got non-phonetic names and you can't go round changing them willy-nilly. Nobody will know where they're at."
> "Maybe build our own. What is it everybody says? The quickest route to having your own empire is having your own literary language."

Ask the post-1948 Israelis. Except they already had Hebrew and didn't have to invent a new one.

Inventing a phonetic literary language (*and* achieving a decent take-up, ask the Esperantists) is so formidable a task it was only done three times by westerners in the three thousand years after the Sumerians first cracked literacy

- o by the Phoenicians (the clue is in the name)
- o by the Greeks (various)
- o by the Romans (with Latin)

Historians can count the number of times it was done (we all ignore the Etruscans) but are not up to the task of comprehending the difference between

- o a natural language and an artificial language
- o a spoken language and a scribal language
- o a written demotic language and a written phonetic language

It is perfectly possible to converse in Latin or Classical Greek (or Esperanto, if you're a real nerd) and no doubt some of the Ancients did, but supposing ordinary people would ordinarily speak a language restricted to twenty-plus sounds is something only an indoctrinated academic could possibly believe.

Mr and Mrs Cicero's pillow talk might have been in Latin but the rest of their household were conversing the way the entire world does, in their natural mother tongue. Or, given Rome's multicultural society, in someone else's mother tongue. Or in Latin if it was absolutely necessary. Not though in Dog Latin, Soldier's Latin, Vulgar Latin or any of the other imaginary Latin derivatives academics have dreamt up over the years. Latin is simplicity itself so if anyone finds themselves with people who do not speak their language – garrisoning Hadrian's Wall, say, or living in a veteran's colony – are they going to learn Latin or are they going to search out a Latin derivative and hope everyone else speaks it too? Academics are great ones for adding layers of complexity to situations they do not understand.

What languages were the native inhabitants of Roman Italy speaking to one another? We cannot say for sure but we can reconstruct the situation from what is found most everywhere else in the world

- o Italy being something of a geographical unit, the Italians presumably arrived speaking the same (natural) language
- o Italy being a fractured geographical unit, that language will evolve over time into sub-languages

- to the point of all being incomprehensible to people in distant parts of Italy
- as it is this way in *modern* Italy, where a Sard-speaking or a Sicilian-speaking Italian cannot be understood in Rome, it is a fair bet (or a staggering coincidence) that it was the situation in *Roman* Italy.

Unless, like Mr and Mrs Cicero, they had been brought up speaking Latin as a mother tongue in which case they would be able to gabble away like senators. Artificial scribal languages are fine if you are brought up speaking them (they manage in Israel) but apart from an elite, everyone in Roman Italy was gabbling away only to people who spoke their own local variety of... one would have to call it Italic.

Unless they were *writing* to one another. The people of Roman Italy could write to one another in Latin, a simplified phonetic version of the equivalent of Sard or Sicilian spoken in the Lazio region of central Italy. (The clue is in the name and still recalled in the football team). The ordinary people of Roman Italy could, if they so wished, *speak* to one another in Latin but nobody is going to learn a scribal language in order to converse with people they can converse with in a language they were all brought up speaking.

All this is disputed by linguists who are firmly of the view that everyone in Italy

- stopped speaking whatever it was they were speaking, probably something Celtic
- started speaking Latin
- changed Latin into one or other of the Latin derivatives
- changed the Latin derivative into Sard, Sicilian, Umbrian, Tuscan etc
- making sure they did it in a remarkably similar way to the Portuguese, Spanish and French who were busy doing the same thing with their Latin derivative.

Clearly linguists are not going to be much help so we shall have to go in for a quick burst of 'Is it true of you?' What language do you use to speak to other people? For most of you it will be

English

So much drivel gets attached to the term 'English' there is a need for a revisionist primer on the subject. *English* does not mean Queen's English or Educated English or Received English or any other kind of English. These are dialects of English. It means

English, a language anyone can use to converse with any other English-speaker. I can make this confident claim because, after a long and fulfilling life, I have never once failed to achieve mutual comprehensibility with another English-speaker. I have been able to do this because 'English' is just an assemblage of agreed word meanings, pronunciations, grammar and syntax which barely change from one English-speaker to the next. They vary *a bit* because of age, education, accent, region and numberless other individual and group idiosyncrasies, but it is always English. The cat always sits on the mat. However, this *English* is not a natural language. We shall be finding out soon enough what it is.

What language do you use to write to other people? For most of you it will be

English

Actually you write 'Literary English' which is not quite the same as spoken English but close enough. Neither of them are natural languages. 'Natural English' has not existed for centuries and it has never been written down. *It cannot be written down.* The nearest thing there is to it today would be some particularly unreconstructed dialect full of broad vowels and consonantal glissandos that can be represented on the page but only if the reader knows the dialect that is being referred to.

As 'eck as like.

You can read that back, you can hear it in your head, you can say it out loud, you know what it means, but not many of those sounds conform to the English alphabet. Try spelling the vowel sound in 'like' and see where that gets you. And *that* is the key to understanding what a 'literary demotic' is. If you already speak the language and if you have learned various scribal conventions, you can guess what is being written down even if the letters only loosely represent the sounds. As you have just done.

How and when people acquire a 'literary demotic' is critical to the understanding of history.

So we had best learn how they did it. If people wish to write down their own language (as the English, French and Italians do) rather than write things down in an artificial phonetic language (as the Romans, the Greeks and the Phoenicians did) there are a number of things that have to be achieved. Identifying the words for a start. Strange as it may seem to people used to seeing words

368

on the page, it is not immediately clear to people who have not seen their language on the page, what the words are. People do not speak in words. A*sekaslike* is what they say, not *as eck as like*.

They may not know it at this stage but three of those words are comparative conjunctions and the other word, *eck*, has a hidden aspirate and is being used in place of a different word entirely. It is not easy if you do not yet know what you are doing. But, all right, you have identified 'like' is a word and you have discovered that your very rich Wilfred Pickles 'laek' is hard to write down.

If you change it to the more plosive **like**, things should be easier. But still not easy. You have only got the Latin alphabet to write it down in, and while the Romans were kind enough to leave you with an **L** and a **K** they have not provided you with a long **I**. They found this a nuisance themselves and resorted to an *ae* diphthong when dealing with a name too important to change like *Caesar*. You can do the same.

They are called 'digraphs' by linguists and written English uses them all the time in words like **thrush** or **coat**. With the long **i** in **like**, the proto-literary Englishers did something else entirely: they stuck an **e** on the end of **lik**. There is no accounting for this because they could just as easily have used any number of other scribal conventions to signify a long **i** such as **light** or **final** or **guy** or **by** or **eye**. Or **I**. Somebody made these choices at some time, so now you can write "as 'eck as like".

But you will not be *saying* it for long. If you can write it, you must be literate, and primed for the next stage in the development of a literary demotic. Literate English-speakers might come from anywhere in England, and it probably won't be a part of England where they understand your local variant of natural spoken English. They may not speak the same way you do, but they 'eck as like *write* the same way you do, so if you simply

<div align="center">

say everything the way you write it

</div>

the two of you will soon be gabbling away like fishwives.

The literary bandwagon is unstoppable. All over England there are people speaking English the way they are writing it and finding it a great boon for conversational purposes even if they speak 'local English' at home. There must come a point when, unless you speak this spoken Literary English, you will not be able to speak to many

people outside your home. But eventually you *will* be speaking it because it is an iron rule of all languages:

your mother teaches you the most useful language around

which sooner or later will be Literary English. This has nothing to do with class or education or even whether your mother is literate. Lots of non-literate people speak literary English. You for instance from age two to age seven. It's just a language. Nothing special.

In all countries possessing a literary demotic, that language will eventually be everyone's language and, unless there are substantial language minorities, it will be the only language spoken in that country. For convenience, we can call the one spoken in England 'Standard English' though it does not have a name, any more than any of the old regional natural English languages had names. 'Standard English' is the spoken form of Literary English, the cleaned-up version of whichever regional natural English language was originally used as the basis for writing down English.

But to head off the English Language Angry Brigade, this is not to say that anybody's Standard English will be *standard*. It is different everywhere you listen. You should hear my Estuarine English. When I am not making an effort and shifting to Educated Home Counties English. Or going the other way and speaking faux Cockney English. They are all Standard English. They all have the same vocabulary, the same grammar, the same syntax, and no amount of glottal stopping or regional markers can prevent them being comprehensible to all other English-speakers. This is true whether English-speakers live in Kingston-on-Hull or Kingston, Jamaica. If they wish to speak Tyke or Jamaican patois they can do that too but all of them can speak English no matter how tortured standard English may be in Yorkshire or the West Indies. (To my ears anyway. It is amusing but instructive to know that when the talkies arrived in Britain in the 1930's, it had to be explained to audiences that the actors weren't being weird, they were speaking in American accents. Nobody in the audience had, up to that time, heard a non-British accent. But they understood every word.)

Once all this is clear we can address the Big Question for historical revisionism

Why did the Ancients not do any of this?

Why, instead, did they go to the seemingly crazy lengths of

o inventing an artificial version of their language, one that nobody spoke
o that had to be learned in order to communicate with people who already spoke their language
o or worse, they learned somebody else's artificial language in order to write to people who already spoke their language

To understand why they did, two mildly contradictory things have to be borne simultaneously in mind:

Literacy is of staggering significance.

It gave rise to civilisation.

Literacy is not very significant to civilisations.

It was necessary to have it but in the ancient world literacy was a *function*. A tool of bureaucrats for making a permanent record. It did not lead anywhere in itself other than to a bureaucracy, something needed by all civilisations. In the ancient world, you could have a good or a bad bureaucracy but having a good or a bad army was a higher priority.

Once the limited nature of workaday literacy is appreciated it is possible to see why in practice nobody chose their own language in which to be literate. We know most about Roman civilisation (and they were ace bureaucrats) so we can observe, or reasonably conjecture, their thought processes from start to finish

o Rome is an obscure city-state in the Tiber valley where they speak *Latzian*, the Tiber Valley variant of Italic. It is an unwritten language.

o The Roman state has a few dozen literate people – government functionaries, business book-keepers, neighbourhood letter-writers – the pattern could be observed in any part of the undeveloped world until quite recently.

o These literate people are obliged to write in either Greek or Etruscan, the two local written languages.

o They will be writing for the benefit of Latzian-speakers who are not literate so it makes no difference to them what the local scribal language is.

o This will remain the situation unless and until the Roman state decides otherwise.

It did remain the situation for the vast majority of states in the ancient world unless they happened to be very successful states.

As soon as Rome had expanded beyond the Tiber Valley, beyond the confines of Latzian-speakers, the language of the people in the Roman state will not only be Latzian, they will be speaking all sorts. The Roman scribal class – now numbered in the hundreds – can continue in either Etruscan or Greek, except now it will have to be Etruscan *and* Greek. But if the Etruscans and Greeks could do it, why can't the Romans? Why can't they have their own scribal language? If nothing else, it is better to learn one scribal language than two, so why not written Latzian?

One reason *might* be the sheer difficulty of rendering such a complex language on the page using a modified Greek alphabet, which is what the Romans eventually adopted, but somewhat more important is the sheer pointlessness of doing so since

nobody outside the Tiber Valley speaks Latzian

and would not know what the hell you were writing to them about. Leaving the Romans with three choices

1. Resigning themselves to being literate in Greek and Etruscan indefinitely
2. Teaching everyone to speak Latzian, a natural language of great complexity which, as any anthropologist will tell you, takes a lifetime to learn and even then you won't be much good at it.
3. Do what the Greeks and the Etruscans did. Come up with such a brutally simplified version of Latzian that anyone can learn it in school.

As Rome expands, learning Latin at school will be compulsory so they won't have the choice. In the course of time Rome itself will be irrelevant because it is a QWERTY situation. With everyone using Latin why would anyone think of using anything else when nobody can read anything that is not in Latin? This held true throughout western Europe for a thousand years after the Romans had left. Backwoods academics, Roman Catholic priests and public schoolboys are still doing it. Poor mutts.

Once the limited nature of Latin is understood, revisionist historians can ask the Bigger Question

How is it that western Europe shucked off the civilised habits of four thousand years and started producing literary demotics?

We start, as always, with an 'Is it true of you' exercise. It is 1450 AD and you can either spend several years learning to read and

write English or you can decide not to bother. As neither your job nor your social standing requires it, deciding to become literate means you can

- spend a few hundred pounds on the *Book of Margery Kempe*
- spend a few hundred pounds more on *Piers Ploughman*
- spend more hundreds of pounds on similar tedious tosh
- but not the Bible unless you are a Lollard
- and that's about it.

I know what you will do because you are just like me: you won't bother. Who is going to spend years learning to read if there is nothing to read at the end of it? Or learn to write if any local scrivener can do it for you?

It is not the language your country happens to be literate in that matters, it is manuscripts being prohibitively expensive that matters.

When hardly anyone can afford to buy books, hardly anyone can afford to write books. Do you suppose this book would have been written if it depended on somebody copying it out in longhand in the hope somebody else will spend several hundred pounds to read it? Until that overarching difficulty is addressed

- there will never be a mass of reading matter for a mass reading public *but*
- there will never be a mass reading pubic until there is a mass of reading matter

The resolution is not directly related to either literary demotics or printing. Literary demotics were developed before printing and, according to Thomas More, half of Londoners were literate. In English. It would actually have been better if Londoners had been literate in Latin, there being more Latin books than English ones in Thomas More's day. Cheaper too. As a scribal language, Latin is highly compressed, ideal for reproduction whether by hand or by printing press.

However, there is one critical difference between Latin and English, between scribal phonetic languages and literary demotic languages

It is enjoyable reading books written in one but not the other

Take no notice of that Classics don on the telly waxing lyrical about how you have to read Ovid in the original to get the full flavour, she curls up with John Grisham at home. She probably curls up with a Penguin Thucydides at home. The point is, once

everybody can curl up with Literary English *and* there is printing, there will soon be more books than they will know what to do with. Everyone their own Lollard.

Now all that is understood, revisionist historians can tackle the Biggest Question

Why western Europe?

Why did western Europeans stop doing what everyone else had been doing for thousands of years, and develop literary demotics? It was certainly not because of any innate qualities of western Europeans, a desperately backward neck of the woods by the standards of the civilised world. The one thing western Europe did have in abundance was

nation states

This very peculiar form of governmental arrangement has one key characteristic. They are

based on discrete language groups

not something governmental arrangements took much notice of either in antiquity or in the civilised world of 1000 to 1500 AD. Once there is a permanent state based on a single language – and nation states have thus far proved to be immortal – there are all the ingredients conducive to the development of native demotic literary languages

o when it is the whole of country X, not city state X
o when it is only country X, not multilingual empire X
o when there always will be a country X
o there is time and space and people to do it.

Having your own literary language is, we know, a definite plus. Having your own literary language that everyone already speaks is a double-plus. But that brings us to the Biggest Question of All

Why is this so important to the history of the world?

It was because in the demotic-writing western Europe of c.1500 AD there is no longer a scribal class writing stuff, there are entire swathes of the population *reading* stuff. Literacy is no longer an administrative tool (or the plaything of the courtly classes), it is a way of life for everyman

The entire nature and purpose of literacy has changed.

Western Europe is suffused with entire countries composed of all sorts of people reading all sorts of things and it is the first time this has happened in human history. Guess what happened next?

Civilisation took off.

Not many people know this. When everyone is entranced by tales of the rise and fall of this or that civilisation, by sundry religions spreading far and wide, by mankind getting up to every adventure known to man, good or bad, who will ever spot that

nothing is actually happening

The good old 'nothing happening is what is happening' revisionists of course. They have had no difficulty in spotting that

history is a story of complete non-progress

Everyone else finds this proposition absurd but that is because they are human beings and human beings have an absurdly high opinion of themselves. We revisionists have just jetted down from Arcturus V so allow us to spell out the stark truth about your so-called earth history.

No, not a blank page, over the page

Stage	Expectation	Actual Outcome
History begins with the invention of writing in Sumer c 3000 BC which, together with a raft of other innovations, goes by the general term 'civilisation'	Such an amazing development will lead to the rapid spread of this 'civilisation'	**No, it didn't** It took civilisation two thousand years to get from Sumer to Rome, three thousand to reach London, five thousand to cover (nearly all) the world
Even so it gets there eventually	It's all steam ahead once it arrives	**No, it wasn't** What did 0 AD Rome or 1500 AD England have that 3000 BC Mesopotamia did not have? The stirrup? The mould plough? Flying buttresses? Flying aqueducts? Mesopotamia had little need of any of them. What do Sumer, Rome and Plantagenet England have in common? Most everything else. Count them sometime.
Everything is gradually, inch-by-inch, being put in place	These things always take time	**No, they don't** Human beings went from horse and cart in 1800 to moon rockets in 2000
Everything is now going to hell in a handcart	These things always take time	**No, they don't** So, please, remember that.

Appendix

If you have come to the conclusion Christianity did not exist in Wales before the Norman period and wish to consider the larger question of whether Christianity existed anywhere before the Norman period, here are Ten Top Tips to help you on your way. Mind how you go.

Tip No 1: Morale

Choose a country you are familiar with. It will not matter which, they all follow the same pattern as Wales. Consult the official list of churches, abbeys, priories, monasteries, cathedrals etc claimed to be of Dark Age origin. There will be a great many of them but do not be put off by this. They have been accumulating for hundreds of years as the evidence is found but none of them can ever be removed as that would cast doubt on the methodology and imperil the others.

You will be faced with voluminous evidence attesting to their ancient existence but, again, do not be discouraged. This is down to Kennedy Assassination Syndrome:

Evidence accrues proportional to demand

or in the case of conspiracy theories 'proportional to the number of people looking for it'. A profusion of evidence is a *good* thing, it means you can start from the presumption that large proportions of it will be bogus because Dark Ages did not get their name by producing profusions of evidence.

The number of experts vouching for the evidence will be proportionally extensive but since this is an academic premise, not a conspiracy theory, you will be up against people obliged for contractual reasons to be singing from the same traditional hymn sheet, not eagle-eyed nut jobs combing the world for clues. You by contrast can bob and weave, jab, jab, uppercut, knocking out the various sites one by one. It is not like shooting fish in a barrel where you have to allow for refraction.

Academics are institutionally torpid. Maybe they weren't when they started out, maybe they aren't in real life, but they soon learn to be during working hours teaching teenagers the same thing year after year. With students a captive audience and colleagues pre-disposed to go along, any natural polemical skills academics possess soon atrophy. You will be met with dogged resistance but no flair for creativity or improvisation. Or curiosity. Definitely not curiosity. In thirty years presenting new ideas I have never had so much as a nibble from an academic. They can't all have been out to lunch. The ideas, I mean.

Tip No 2: Evidence (Historical)

If the evidence is drawn from a charter, a cartulary, an annal, a chronicle, an early history, things of that sort, check how old the document is. It will normally be claimed as contemporary, i.e. written in the Dark Age, but it takes about five minutes to establish the document is only available as a copy made

- o in medieval times if it relates to a pilgrimage site
- o in early modern times if it is of wider application
- o in late modern times if it is for sale

Never be impressed by the fame of the source

the more famous it is the more reason to fake it

The English are leaders here. They have forged *Gildas*, *Bede* and the *Anglo-Saxon Chronicle* to provide themselves with a historical source for each period of their Dark Age, though the technique is general. There is no need to, say, plough through *The History of the Franks*. Just investigate the bona fides of its author, Gregory of Tours, the biographer of St Martin of Tours. There is no need to visit in person France's premier pilgrimage destination, the tomb of St Martin at Tours.

You should adopt a deskbound approach to all these intensely informative 'survivals' from the Dark Age by looking them up on Wiki (or similar) to find out

- o if the document is contemporary with the institution
 It will be (a few centuries later is permitted)
- o if the document has been scientifically dated
 It won't have been, it is too precious, unless only a later copy
- o if the copy has been scientifically dated
 It won't have been, there's no point, it's only a later copy
- o if it is mentioned in another Dark Age document
 It mostly won't have been but if it is, repeat all steps with that document

The procedure is foolproof because no Dark Age document has been tested for age.

The Swedes claim their Gothic Bible has been carbon-dated and found to be fourth century but they are coy about divulging the results in English. To me anyway, you may have better luck. You

may be Swedish, but I wouldn't recommend it. Back in the seventeenth century, the Swedes decided they were 'Goths' (other Dark Age warrior elites had already been snaffled up by countries quicker off the mark). The Swedes asked the Dutch to build Gothenburg for them and supply the Gothic Bible to go with it. God knows where the Dutch had been keeping it since the fourth century.

Or 'Batavians' as they were calling themselves at the time. The Dutch had still not decided on a final name in 1648, when they told the Swedes (who were besieging Prague at the time) that their Gothic Bible was ready and they could pick it up from Prague's main library. The fines must be astronomical by now. Not that Prague librarians are overly bothered, too busy working out what to call Czechoslovakia without Slovakia. These things take time to get right.

Tip No 3: Evidence (Archaeological)

If evidence is archaeological, accept it only if it comes from a properly stratified layer, which means a properly conducted archaeological excavation and, in these days of crowd-funded digs, dug up by a bona fide archaeologist. You would be surprised who is allowed to wander in and how often they wander off with a memento of their visit. Worth a bit of money too but infuriating for professional archaeologists who can spend whole lifetimes without turning up an artefact of pecuniary value.

Dark Ages should be a boon for professional archaeologists. With writing at a premium, historical evidence will be at a premium, but everybody will be producing archaeology. They cannot help doing that. However, Dark Age archaeology is always at a premium too. Frequently wholly absent. This has obliged archaeologists to conclude the people were frequently absent too. You should examine the stated reasons why the inhabitants have disappeared for hundreds of years over thousands of square miles but do not spend too long on this as the reasons will be neither provable nor disprovable.

Any people who are present will be tremendously poor. Judging by the archaeology, you would be materially better off living in the Bronze Age. As the archaeology consists mostly of stone artefacts, possibly the Neolithic Age. The stone artefacts are typically preserved in churches (sacred objects), as churches (walls), under churches (foundations), outside churches (gravestones) and hence easy to find. This is not necessarily good news for archaeologists who like artefacts to be in chronologically definable strata, but excellent news for art experts who have been able to build up a detailed picture of Dark Age art styles. This in turn is better news for historians lacking historical evidence but able to reconstruct a picture of comings and goings from the art styles. But it is the best news of all for local firms of monumental masons who have a ready-made style catalogue. Ask for a brochure.

If there are Dark Age inscriptions on the stone (Ogham, Pictish, Runic etc) ask why they are not in an alphabet people could read. Inscriptions are made to be read. If you are told these are a very special kind of inscription not intended for public consumption because of their sacredness (or something) tell them it worked

384

- o they all vanished from profane view
- o they all stayed hidden from prying eyes for a thousand years
- o they all re-appeared in new countries keen to show how old they are.

Tip No 4: Evidence (Numismatic)

Old coins are a mass-market product that does not have a mass manufacturing base. The shortfall is offset by finders, dealers and collectors all benefiting from old coins being declared genuine. The revisionist rule of thumb is:

coins from hoards are dull but authentic
single finds are exciting but dubious

Coins are second only to pottery for establishing the age of historical and archaeological finds, but historians and archaeologists are not trained in numismatics as a matter of course. This is more to do with class than classroom. Anything the masses go in for, scholars regard as infra dig. The masses do not go infra Classics so it is lucky that many Dark Age coins are copies of Classical designs. Academics have yet to identify the precise mechanism whereby coins can survive for hundreds of years in order to be copied so it may be that coin-collecting was as popular in the Dark Age as it is today.

Dark Age people may have looked to the past for their coin designs but in other branches of high-value manufacturing they had a keen eye for the future. They could even mimic styles that only came into fashion when their products were found in the eighteenth and nineteenth centuries. They did occasionally spoil the overall aesthetics by crudely etching announcements like 'Alfred had me made' on them. I bet he didn't but there were plenty of swains wanting their sweethearts thinking he did. Don't you believe it, girls, he got his mate to do it. And don't believe the promise of marriage either, he's only after one thing. Whatever decision you come to – and English girls have a worldwide reputation for coming to a decision on the first date – keep the keepsake. You won't know it but Alfred is destined to be our only 'the Great' so it will be very valuable one day. Don't flaunt it in the Danelaw though.

Dark Age 'arms and armour' is always remarkably modernist, in a sci-fi sort of way. Or it may be the other way round and sci-fi people are keen on styles favoured by ancient warrior elites. This is eccentric, science fiction being so futuristic, but they have a point. Any halfway decent Greek hoplite army would have made mincemeat of the English at Agincourt. We were still 'pushing

pike' in the English Civil War two hundred and fifty years after that. But to be fair, we won every battle in that war.

Tip No 5: Evidence (Expert)

In the absence of scientific testing, everything rests on expert opinion. Get ready to be introduced to an array of niche specialists in codicology, diplomatics, epigraphy, ecclesiology, stemmatology. It may stem from Mortimer Wheeler being a panellist on *What's My Line?* Like him, these experts are deferred to, even feared by, their less specialised fellow-experts, notably historians and archaeologists, but they will not impress you because they are subject to the rule:

anything an expert can recognise as genuine, a forger can forge

They all have access to the same works of reference, they all know what features are essential for identificatory purposes.

This has never, to my knowledge, been mentioned by an academic. Too obvious to need saying? One would think so but there is a sound Applied Epistemological reason why academics always carefully ignore it. They rely on experts to provide them with their own raw material so the experts have to be at the top of the tree. They can be first-among-equals (peer review) but the idea that any forger, any*body*, can acquire the necessary expertise in fairly short order would mean the end of any pretence that the Dark Age – and vast tranches of history and archaeology besides – is a secure area for study. Unless the ancients knew something we don't and we can't reproduce anything they could make. But nothing of the sort has ever been found apart from possibly Greek Fire and a decent recipe for absinthe.

In disagreements between revisionists and orthodoxy, an expert verdict is held to be sufficient in itself for establishing authenticity. It makes no difference how powerful our contrary arguments may be, they invariably run into the blanket dismissal

> "I prefer taking the word of people who have spent their professional lives studying these things, rather than you, who appears to have no qualification beyond an ability to look things up on Wiki."

The professionals being referred to are academics, curators and art appraisers, but it applies to forgers.

This is not to say that experts do not disagree among themselves about authenticity but this only happens when decisions about

what is and what is not to be accepted into the canon are being made. Once the peer review stage is passed and historians and archaeologists can use a given artefact for their own purposes, there is no power on earth that can get it removed from the canon.

The efficacy of peer review for authenticating historical artefacts is not quite the winnowing process it seems. In fact it can be rather the reverse, viz

- Pay professional forger F to forge Dark Age Object X
- Show Object X to expert A
- 'It's a forgery,' he says (they are typically male)
- Show Object X to experts B and C
- 'It's a forgery,' they say
- Continue showing Object X to experts until
- Expert ...n accepts it as genuine
- Expert N writes it up in peer-reviewed journal J
- Auction house S sells Object X on the strength of this
- Museum M purchases Object X on the strength of this
- Museum M tells the world about their new acquisition
- Experts A, B, C... recognise it as the fake they were shown
- Experts A, B, C... must decide what to do about it

First weakness of peer review

A, B, C... do not know about one another, only we do and we're not telling. Assessing the authenticity of object x's in general is subjective so each individual expert assumes it is their subjective opinion versus expert N's subjective opinion. Are any of them going to put their reputation on the line against expert N, peer-reviewed journal J, auction house S and museum M? Probably not but let us assume expert A does.

Second weakness of peer review

Expert A writes a paper stating his view that Object X is a fake and submits it to peer-reviewed journal K. How will the editor of journal K react? Is he prepared to go up against expert N, journal J, auction house S and museum M? Probably not but let us assume he sends A's paper to experts on object x's for peer review.

Third weakness of peer review

Editor K gets back unanimous endorsements of A's paper. How can he not? The peer reviewers are not peer-reviewing Object X, they are peer-reviewing A's paper *about* Object X. A has been publishing papers all his working life and they all passed peer review.

Fourth weakness of peer review

With expert A's paper endorsed, editor K has to decide whether to publish or not. Nobody is crying out for it and he is not spoiled for choice, his pigeonholes are full of papers awaiting publication. This particular paper, he muses, will create a rumpus involving warring academics, mutually-contradicting academic journals, an auction house with deep pockets and a museum that is something of a power in the land. And all because two experts differ over their subjective evaluation of an artefact nobody has ever heard of.

> "Deirdre, are you going out for lunch? Could you pick me up a bottle of brandy and a revolver, I've decided to commit professional suicide."

Fifth weakness of peer review

What of the appraiser at auction house S? He *has* seen Object X. He has examined it very carefully, conscious of having employers who will not be best pleased if he passes something that later turns out to be a fake. And we know Object X is a recognisable fake, experts A, B, C... spotted it immediately. But *he* can't. He is not an expert on object x's. Auction houses make a few hundred pounds on the average nick-nack, they cannot be employing specialists on everything. They employ generalist-appraisers who know their stuff, which includes knowing the basics about object x's and knowing where to get technical information about Object X if necessary. This auction house appraiser has a peer-reviewed paper about the very artefact he is holding in his hot little hands and an academic endorsement is Gold Standard by auction house nick-nack standards. But let us assume he decides it is necessary to canvass expert opinion about Object X.

Sixth weakness of peer review

How? He does not know about experts A, B, C... and any other expert in the field is going to say

> "Don't know. I've read N's paper of course, and he's usually a sound man, but if you think he's made a ricket with this one, you can send it to me for a second opinion, my fees are very reasonable."

Will the assessor do so? Of course not. Even if the verdict is favourable that's the auction house's profit gone. It is not employers worried about fakes slipping through the net he has to worry about, it is whether they will employ art-assessors who start having

doubts about Gold Standard work-product. Every working stiff in the Church of England has doubts, it doesn't stop them turning up for work every Sunday.

Seventh weakness of peer review

It is now Last Chance saloon for exposing Object X. Will it survive the flinty-eyed scrutiny of Museum M's curators before being placed reverently in a glass cabinet in the Early Medieval room? Curators of what? Curators of Early Medieval antiquities, of which object x's represent a thousandth part. They are no more expert in object x's than anyone else in the chain with the exception of expert N, whose paper on the subject was what prompted them to recommend acquiring Object X in the first place. As they said to the trustees

> "We don't have any object x's in our early medieval antiquities collection, so Object X will round it off nicely."

Eighth weakness of peer review

The museum staff are not going to be hugely anxious to rush back to the trustees to say that not only is their expertise open to question but the museum is not going to get its money back, the auction house has done nothing wrong. Any professionally-trained curator of early medieval antiquities is going to accept the peer-reviewed judgement of experts about the authenticity of Object X and start looking for the windolene.

Ninth weakness of peer review

Object X will sit in that glass display cabinet indefinitely. It will be cited in papers about object x's, it will generate academic chat about object x's, it will be used to illustrate lectures about object x's to succeeding generations of students, it will feature in standard textbooks about object x's. Object X will be accruing testaments to its authenticity, directly or implicitly, indefinitely.

Tenth weakness of peer review

Should anyone be concerned that Object X is a fake? Not at all. It is a perfectly good example of object x's, our forger made professionally sure of that. It remains a valid teaching tool for universities and an excellent source for the edification of the public, whether it is fake or not. Revisionists should not be overly concerned about Object X. They should be concentrating on the authenticity of object x's.

Tip No 6: Testing

Organic Dark Age artefacts can be carbon-tested for age, at least with the degree of accuracy that would eliminate medieval or modern fakes. You can request such a test be done on any given artefact but you will never get anywhere. Anything new, in the sense of having just been discovered, may be scientifically tested and if it turns out not to be Dark Age you will be hearing nothing further about it (apart from the early publicity which circled the globe).

Anything old, in the sense of having been discovered a long time ago, will not have been carbon-tested and never will be. The age of the artefact was established by expert opinion at the time and has been confirmed, either expressly or tacitly, by experts ever since. Imagine what would go round the world if they have got it wrong.

This applies even when expert opinion is divided as to when in the Dark Ages it was made. A quick carbon test would rule out the more extreme claims but even this does not happen because academics prefer spending years arguing over something rather than minutes finding out. If you offer to find out for them using a few hundred pounds of your own money they will call security.

Any artefact considered fundamentally important – national icons, typology markers, collection centrepieces – will not be subjected to testing on grounds that amount to lèse-majesté. They are too important to be tampered with by the hand of mortal man despite non-destructive tests being available for a trifling investment. In practice

the more important the artefact, the less likely it will be tested

The only time mortal hands get anywhere near national treasures is when they are required for exhibitions in foreign parts. Then they will be loaded on to pallets by brown-coated churls humming *My old man said follow the van.* Which is surprising on the lips of brown-coated Japanese churls unloading it for an exhibition in Tokyo, you archetype prig, you.

Be particularly on the lookout for artefacts that have undergone impressively scientifical analyses of everything

except one for age

This is more and more the case as new tests come on stream, crowding out the old, boring, useful ones. The lapis lazuli used in an illuminated manuscript can now be traced to an individual mine in Afghanistan but one would much prefer the manuscript to have been traced to an individual millennium. Though it is good fun watching when lapis lazuli is first recorded in the west. It wanders from millennium to millennium as this or that manuscript illuminated with lapis lazuli turns up in the west.

Talking of fun, the Bayeux Tapestry is due over here soon, Covid permitting, so why not take the kids along for their first lesson in fake-spotting?

"Aw, dad, why can't you be like other dads?"
"Quiet or I'll stop your pocket money."
"We just used my pocket money to get in."
"Never mind that, have a look at *that*. What's a church with a
 spire doing on an eleventh century tapestry?"
"I don't know, dad, I'm going to ask."
"Well?"
"She said it isn't a tapestry, it's an embroidery. Can we go home
 now?"

Tip No 7: Vikings

You will be hearing this word a lot. If there is nothing to be found at a given site, this is routinely blamed on a visitation from Vikings; if there is something, that may mean a visitation from Danes. You will have to box clever here because, while there is no connection between Vikings (purportedly eighth/ninth century Norwegian pirates) and Danes (the armed forces of the tenth/eleventh century Danish state) the two are *always* conflated. Nobody takes the kids to see the Danish York Experience but if it is the Viking York Experience tailbacks start forming on the A1(M).

As to whether Vikings ever existed, you will be able to judge for yourself after taking part in one of our own Viking Experience re-enactments. Here is your action pack

> 1. Round up a hundred or so comrades
> 2. Kit yourselves out ready to go a-Viking
> 3. Keep the receipts

Full regalia, long boats, two thousand-mile round trip in storm-tossed seas, everything for a six-month expedition to distant and hostile shores.

> 4. Do not set sail

Five minutes being the estimated time of survival for long boats in storm-tossed seas. Instead, using best available sources

> 5. Estimate what's on offer from a Dark Age monastery

Your list should include a gospel book with semi-precious stones on its cover, a reliquary and some candlestick-holders. Include an appropriate number of tonsured slaves if you feel Norway has a use for them. Unless they saw you coming and did a bunk.

> 6. Tot up the notional haul
> 7. Deduct the cost of the expedition
> 8. Divide by a hundred
> 9. Enquire at the office how much we owe you

> 10. If you feel your outlay is about a thousand times more than anything you might get back, return quizzically to the best available sources.

We insist on fidelity so your first Viking re-enactment will be the first Viking raid, on Lindisfarne in 793 AD. To experience what it was like from both sides of the halberd, you will be signed up to an official archaeology excavation looking for the Dark Age monastery on Lindisfarne. There have been eighteen in the last thirty years so one is sure to be available and, you never know, you could be the person who finds that first piece of evidence of the monastery's existence. But don't leave it too long or they might run out of unexcavated parts of Lindisfarne. A thousand acres is not an infinite resource.

Your package will include a tour of Bede's church at nearby Jarrow. You can confirm its authenticity because it has the original dedication stone set securely in the church wall

> **The dedication of the church of St Paul on 23rd April in the fifteenth year of King Ecgfrith and the fourth year of Ceolfrith Abbot and under God's guidance founder of this same church**

Though admittedly not the wall of Bede's time

> **Dating from AD 685, but moved from its position in the eastern part of the north wall of the old nave (demolished 1782), and now built into the north porch.**

A plaque pointing this out would be welcome in case visitors gain the impression everything is in situ. Especially visitors making television series about the Dark Ages of which there have been umpteen in the last thirty years. They all begin with

"The Dark Ages were not nearly as dark as everyone believes"

despite everyone having been told this umpteen times in the last thirty years. We offer re-enactments of these as well so practise walking backwards reading words from an autocue written by an intern on work-experience as per the original.

Tip No 8: Definitions

Never accept definitions at face value, they may be assumptions that have been around long enough to become self-evident facts. Christianity is so deep-dyed, everyone thinks they know how it is represented in Christian cultures but that is because everyone is from deep-dyed Christian cultures, even people that aren't.

You will be deep-dyed too but you can use your loaf to judge the fishes. Jesus did not say

> "Thou shalt use a fish symbol but only early doors when Christian iconography is sure to be a bit patchy. You can drop it later. I may be a fisher of men but I'm not saying we just go round scooping people up in our net whether they want it or not."

St Paul disagreed, he thought that an excellent recruitment policy. He did not however believe Christians should be buried facing east. "We are not a sun cult," as he told the Ephesians in an epistle that didn't get the nod at Nicaea.

A cross may be a Christian symbol or it may be a cross. Simple geometric signs are often found on ancient artefacts and two lines intersecting at a right-angle is one of the simpler kinds. A Saint Andrew's cross is flat out cheating. If there is a circle round the intersecting lines it could be, in ascending order of likelihood

o a Dark Age Celtic cross
o the Irish view of English Protestantism
o the Oxford Movement's view of English Protestantism

> **The enthusiasm for building or restoring churches continued in Victoria's reign, galvanised by the 'High Church' Oxford Movement. Between 1851 and 1875, 2,438 churches were built or rebuilt.**

Large enclosures are large enclosures and should not be identified as enclosing monasteries in the absence of the monastery. Flat surfaces are not necessarily scriptorial desks whether they are on Skara Brae, Iona or next to the Dead Sea. Manuscripts are not old just because someone has scribbled words on it to the effect "This is old". Anglo-Saxon glosses above Latin texts, for example in the Lindisfarne Gospels, were probably not the work of Anglo-Saxons if they were written with the help of lead point and light boxes invented in Renaissance Italy.

If a Dark Age structure is thought to be in a given place but cannot be found, the oft heard

more research is needed

is useful for funding purposes and for giving the impression one more push will find it. However, unlike First World War battles, the troops have paid to be there, so the oft heard

absence of evidence is not evidence of absence

may satisfy the officer class but the PBI will have to be content with the knowledge they all carry a field-marshal's baton in their knapsacks. An Upper Second as we used to call it, though I'm told a First is entry-level in today's more competitive academic environment. In my day a Third was considered pretty good, as I told my parents.

Take no notice of the oft heard

extraordinary claims require extraordinary proof

'Extraordinary' is defined as anything not in textbooks. Claims not in textbooks are unacceptable no matter how much proof is provided. Only revisionists understand that extraordinary claims have the same burden of proof as any other.

Tip No 9: Name Calling

As a revisionist you will be entering a hostile world and must grow a leathery carapace. You will be in frequent contact with people holding very different views from your own. They may be

professionals: academics, curators etc
amateurs: collectors, enthusiasts etc
crazies: conspiracy theorists, political axe-grinders etc

but they all present the revisionist with the same problem

there are a lot of them and only one of you

and they are all united in one belief

the more of them there are, the more likely that they are right

You being on your own is proof enough you are wrong.

Be prepared for the three stages of rejection. Your initial encounter will be marked by a kindly, patient desire to explain. They all want to build their numbers, they all believe the facts are unarguable, they all assume you will sign up once you have been made aware of the facts. At the first hint of querulousness from you, this will be replaced by a brusque, "You need to familiarise yourself with the facts," even though you have just looked them up.

Although the people you will be dealing with consider themselves experts, they will probably not be experts on the precise topic you are discussing, only 'familiar with the facts' about it. Think of it as like talking to your GP about some malady you have suffered from for years. You will undoubtedly know more about the condition than they do but it won't do you any good pointing this out. They will not be changing their minds and they certainly won't be wanting a lecture from you on the subject.

Finally comes a banning of some sort. No matter how affable experts are to begin with they always turn nasty when cornered. They are defending their world, it is no time for niceties. Plus, they hunt in packs. All experts know the first rule of fight club is banning anyone who doesn't obey the rules of fight club. So long as you sit tight, applying their own rules, you will find it is not even a fair fight. You shouldn't be in there if it is.

Although your arguments will prevail easily enough this will have no effect. Experts live among their own kind, people who believe

the same things they do, so they won't ever have lost an argument before and won't recognise they have this time. However, they will be sufficiently puzzled by this novel experience to decline any further contact with you.

Be advised the wider world is not anxious to be disabused either. Folk are fiercely protective about things they have spent time and effort learning and will voice their feelings clearly and succinctly to folk telling them they have got it wrong and will have to learn it all over again. The 'tyranny of knowledge' is a stern taskmaster.

Should you decide nevertheless to air your revisionist thoughts in any public arena you will be accused of any combination of

not being an academic
needing to do some proper research
a conspiracy theorist
a fantasist
clinically insane
indoctrinated
a fascist
a member of a cult
the leader of a cult
an exponent of fake news
a professional contrarian
only out to make money
writing a spoof
an exhibitionist
a troll
a fool
a liar
a crook
an abomination

Though you will come to treasure these accusations because, for the most part, nobody will take any notice of you at all.

Tip No 10: Envoi

You may have noticed how un-academic this book is – no references, no bibliography. I regularly get flak for this despite any source I do use being verifiable by typing a bit into Google and being taken straight there. I know because that is how I got them. The sources themselves are mainly Wiki, otherwise official websites, occasionally more recherché academic papers. Hence the lack of a bibliography, no need to advertise the fact.

Compare that to a book which does have all the academic bells and whistles. What that amounts to is 'citations', those forbidding jumbles at the bottom of the page that everyone ignores but likes being there. Be a devil, examine one sometime. You will find it tough going since scholarly gobbledegook reaches a peak with a barrage of ibid's, op cit's, passim's, q.v.'s and similar discouragements to further investigation.

Once through the thickets you will find the reference will hardly ever be to a primary source, or even a secondary one, there being so few of either. It will be

citing another academic

In academia it is counted a strength to say

> "I am an expert on this subject, I am writing a book about it. But I am relying on someone else for what I am telling you."

To me this is mystifying

> "Either say it off your own bat or don't bother saying it at all, it's already been said."

Their justification seems reasonable

> "I am citing this expert because they have some specific piece of information essential to support a wider argument."

except the practice is now so entrenched, academics do not say anything *unless* it has already been said. Citing another academic is essentially

> "Look ma, clean hands."

and academia practises this form of intellectual hygiene to the point where everyone is intellectually scrubbed clean.

Having adopted a methodology inimical to originality, academics insist everyone adopt the same principle. A typical response to a revisionist argument is

"What is your authority for saying that?"
"I don't have one, it's original to me."
"Oh, I see, you just made it up."

as though this is a criticism. Nobody ever makes things up in academia

with one exception

When you finally arrive at the start of the citation daisy chain and get to the authority everyone is relying on, you discover

"Here is a primary source I have discovered. I have written this paper about it, showing why it should be considered authentic, what it means and why it is significant. I don't have a citation for anything I am saying because as the original authority there was no-one for me to cite."

He made it up! (It is so long ago, it generally is a he.) The way academics see the situation is

"We can cite him even though he does not have a citation. As the leading authority what he is saying is authoritative."

Except it isn't

He is an authority on the source, not what he is saying *about* the source. He may have discovered the source – and he can be cited for that – but his ability to say anything about it is no better and no worse than anyone else's. As soon as the source is set out, we're all in the same boat. We have all, as it were, just discovered it.

But now paths diverge. Every academic has a choice

1. Adopt the original finder's commentary and have a citation
2. Don't adopt the original finder's commentary, think of a better one, and be accused of 'making it up'

Mostly it is the former. (In fairness, one cannot say *always*.) For the revisionist, the choices are

1. Adopt the orthodox commentary if it makes sense
2. If experts have departed from orthodoxy in the past that will be in Wiki, and you can choose between them
3. If none of them make sense, think of a better one
4. If you can't, bash the orthodox one(s) for not making sense
5. Drop the whole thing and move on to something else

This last is hugely important. Revisionists do not have to believe *something*. Something experts often find themselves in a position of having to do. Any way you look at it, revisionists are in pole position because we can adopt or not adopt solely on the basis of what makes better sense. Since our ability is no better and no worse than anyone else's it will be either as good as or better than what is in Wiki. We know everything the daisy chain knows, they do not necessarily know everything we know.

This does us no good because of the standard objection

"How do you know everything we know? You have not been trained in this subject even at undergraduate level."

We looked it up, dummies

That is what has changed in the worlds of both academicism and revisionism. Nobody needs to undergo lengthy courses on the subject, nobody needs to access obscure papers in restrictive academic libraries, nobody needs a ticket to the thicket

It's all on the internet

We are not learning the subject, we are not teaching the subject, we are *mining* the subject.

Suppose it is the authenticity of St Cuthbert's gospel book you are currently interested in. You do not need to be an expert on Early Medieval England though you will have to familiarise yourself with the basics of early medieval gospel books. After that, it is just a matter of knowing everything there is to know about St Cuthbert's gospel book. I promise you this takes an afternoon, tops. Once you have made yourself an expert on St Cuthbert's gospel book, i.e. you know everything a modern expert knows, you can theorise away. You have earned the right.

This will not save you from the asperity of academics but it moves the argument up a notch

"You do not know as much as scholars who have examined the physical gospel book, do you?"

This is true, you will certainly not be allowed anywhere closer than the other side of a glass case. However, you can point out

"Maybe not, but I can examine the replica pages available on the internet, can't I?"

because that is all the scholars will be allowed to do with the real thing. But now comes their crushing

402

"What if they spot something only possible from a close examination of the real thing?"

and you, you good-for-nothing, are reduced to

"Whatever it was, I'll be able to read it on the internet, won't I?"

You will not just be up to speed, you will be travelling faster than they are because of

the tyranny of knowledge

You are not burdened by having spent a fair proportion of your life reading, examining, writing and teaching about St Cuthbert's gospel book. If it is the real thing you will come to that conclusion soon enough, but if it happens to be a fake, which of you is more likely to arrive at that conclusion?

If it is a fake you will be racing ahead when it comes to judging early medieval gospel books in general because you are now in possession of a tool not available to gospel book experts

a fakes typology

They cannot easily argue the point because Cuthbert's book has no evidence of authenticity in its own right – no provenance, no tests. It is accepted as genuine only on the basis of typology, being sufficiently similar to other early medieval gospel books to be considered one itself. Nor can your opponents comfortably rely on textual and aesthetic judgements of Cuthbert's gospel book because forgers know exactly what they are and you're the expert there.

But do not suppose for one moment such sauce-for-the-goose arguments will get you an invite to gander farm

o scholars are not concerned with establishing the truth, they already have it

o scholars are not concerned with establishing the *un*truth of revisionist theories, to do so would lend credence to them

o scholars are not concerned with establishing *new* truths because scholars are concerned with establishing themselves as scholars and scholars do not make things up.

It begins with the step that turns them into scholars. No graduate student would be allowed to choose anything remotely ground-breaking for their master's thesis or PhD. It would be summarily rejected by their supervisor. "Journalism, pure journalism." Having agreed a well-worn theme with their supervisor the bright

young thing may not advance an original argument or they will get the 'where is your authority?' treatment and the thesis rejected. Sticking to well-worn arguments will be rewarded with a PhD. "Has demonstrated a sound knowledge of the sources."

The regulations may insist PhD's contain 'original material' and 'make a contribution to the advancement of knowledge' but only in the sense that sausages must contain original material and be fresh off the production line. This applies throughout academia, top to bottom. Take that most expensive of academic subjects, astronomy. It consists of adding new sausages and astronomers have been guaranteed an infinite supply of them on account of the universe being very big. They not only spend all their days (and nights) finding and cataloguing new sausages, they will tell you it is the most important job in the world, and the world takes them at their word

> "Go on, have a new telescope on us. All we ask is that it's bigger and more expensive than the last one we gave you so we know about more distant sausages."

All academic subjects, aside from vocational ones, are organised on the sausage factory principle. You can never have enough Samian ware either. Every sausage is not only a brand new sausage, it is guaranteed to be of the same traditional high quality of sausage. There will always be an endless supply, there will always be an endless demand. One has yet to hear

> "That's it. We've got what we came for. We're closing this subject down after the current students have finished up."

Not even on a 'care and maintenance' basis pending something turning up in the future. Academic subjects, like sharks, die unless they are constantly moving forward. More of the same counts as moving forward.

There is a fearful price to pay for the sausage mountains. Firstly

❖ the price the country has to pay

Every country in the world believes in spending billions on a vast and ever-expanding industry with the justification that education is self-evidently a good thing. Without bothering to check whether it is or not. Then there is

❖ the price students have to pay

It never seems to occur to the little darlings that getting into a lifetime of debt is not terribly sensible when half the cohort ends up with the same as they do and the other half have a three year start on them. But, hey, if you can get your parents to pay for it (or the state in my case) then go for it. Happiest years of our lives.

❖ *not* the price academics have to pay

Teaching the same old things every year, writing papers on the same old things every year, doing it every year for forty years, may not be what they thought they had signed up for but it is congenial, it pays the mortgage and it carries a cachet in society.

Universities are aware of this, in a careful ignoral sort of way, and have introduced a fabulous swindle

appointment and promotion is not related to ability

What academics are paid to do, teach students, is irrelevant. Being a live wire lecturer does not result in advancement, that is down to having papers accepted by peer-reviewed journals. Not surprisingly, academics write papers that fit snugly into peer-reviewed journals. No editor of such a journal has ever sent out a paper for review and got back

> "I can commend this paper unreservedly. It flies in the face of everything I thought I knew about the subject."

Nobody likes a troublemaker. Unless you are a highly distinguished troublemaker, at the very pinnacle of your profession, and you can afford to be an enfant terrible. Then people will whisper you're losing it and make you an emeritus.

Overall, the strategy has worked. Academics bellyache endlessly about all the usual career stuff but not about being condemned forever to be intelligentsia buffing up the product rather than the intellectuals they thought they were when they started out.

So what is the real price?

It is what economists call the

❖ opportunity cost

The cost of a great swathe of the brightest minds of every generation spending their time doing more of the same rather than anything new.

This book is all-new but not many academics would choose to read it. Any that did would not get far into it before hurling it into

some suitable receptacle. Ask any of them when they *did* last read a book that mounted a sustained challenge to Holy Writ. Ask them to *name* a book that did. Actually they probably would be able to but they will all name the same book, written by an academic for the purpose. They are not fools, they think of everything. Except anything worth thinking about.

You have now read several hundred pages of a book that has challenged their writ. This is not because of any superior intellectual powers I might have (though that helps), certainly not because of any superior knowledge I might possess (though I am a polymath). I did it by the simple ploy of asking 'Is it true of you?' type questions as I go along. Truth to tell, all those rules were something of a rationalisation. Pausing for thought is usually enough, you're not up against a bunch of Einsteins. Not that I'm a big fan of his, a very second division genius as geniuses go. It is largely a matter of treating academics as vaulting horses, not plodding along beside them, feeding them sugar lumps, trusting they know where they are going. Which they do, they are very well schooled.

But I wouldn't want to be one and, since you have got this far, you probably don't want to be one either. Though by a delicious irony, revisionism makes the task of acquiring routine knowledge much easier. Testing stuff as you go along engages the brain and is far more effective than cramming it all in to pass an exam. Or to set one. Nobody becomes a polymath by paying attention in class. You do it later, in your own time. Oh, yes, and along the way you gain those superior intellectual powers I mentioned.

So how about it? Do you want to give up your job, your family, your friends, your opinions, everything you hold dear, to join me in my unregarded and penurious gutter? Rhymes with nutter. Just because it is the grandest life imaginable.

INDEX

archive
 Austrian 142
 British 75 77 83 99 261
 British Museum 226 234
 Brockhaus 149
 crooked archivists 180 189-90
 Dark Age 273 337
 French 75 179 180
 handwritten 135
 National Library of Wales 281
 National Portrait Gallery 250 256
 Scottish 82
 St David's Cathedral 327
 state 121
 Venetian 132
Argenville, Antoine d' 173 174
Arian 268
aristocracy 118 127 173 176 241
Arlington, Henry Bennet, 1st Earl 74
Armageddon (Megiddo) 15 16 40
Arminius 340
armour 239 242-4 246 248 386
arms 91 102 112 242-4 246 248 386
Army Bureau of Current Affairs
 195-6
Arnauld, Louis-Roch-Antoine-
 Charles(?) 174
Arnhem 157
art
 Anglo-Saxon 220
 appraisers 388 390-92
 Besterman 198 -202
 Carthaginian 59
 dealers 239 247-8
 Dulwich Picture Gallery 201
 Egyptian 69-70
 Epstein 200
 galleries 238-9 250
 Gill, Eric 195
 Greek 8 15-17 23
 heritage 254 308
 history 15-16 27-9 173 223 243 384
 Leger Galleries 199
 Levant 16 28-29 43-4
 market 237 255
 National Portrait Gallery (see main)
 restoration 253
 Soane 235
 Somerset House 201-2
 Wallace Collection 235
artefacts
 archaeological 384 396
 Italian 63
 museum 208-9 211 216-7 220 223
 235 239 390
 national icons 226 258 260-1 284
 388-9 392
 testing 392

 typology 216-7
 Welsh 290 318
Artemis 15
artificial languages 366-7 368 371
artistic printing press 192-3
Arts and Crafts movement 192
Arthur, king 289 320 343
Arundel, Richard, 1st Baron 74
Aryan 53 355
'as above so below' 43
Asaph, St 324-6 327
asceticism 337
ash tree 326
Ashburnham 228
Ashcroft, Richard (also Aldworth-
 Neville etc) 91 92
ashlar 22
Assurnasirpal, king 50
Assyria 5 27 28 30 42 43 46 47 48
 49 50 51 53 55 56 69
Assyriology 27 49
asteroid 37 38 153 161
Aston Sir Walter, 2nd Lord 79 80 81
astronomy 341 383 404
Athanasian creed 268
Athelstan, king 318
Athens 16 19 21 40 245 254
Attica 17 18
auction 85 169 199 202 240 241 242
 246 389 390 391
Augustine, St 277 337 338
Augustinian order 291 293
Augustus, emperor 208 227 229 240
 267
Aumont, Arnulph d' 174
Ausonian period 62
Australian diplomacy 41
Austria 107 141 157 186
authentication 191 211 216 261
authenticity 138
 Dark Age evidence 292 332 386
 395 402-3
 historical source 116 120 142 153
 museum artefacts 208 389 391
 paintings 86
 Pepys Diaries 90
authority
 conflicting 29
 discussed 55-6 74 120 401
 establishing 388
 figures 351
 higher 56 347 349
 leading 17 40 54 55 108 287 401
 no authority 270 314 404
 undermined 167
 UNESCO 65
 via peer review 389

413

415

document
 as historical evidence 2 44 49-50 54
 75 83 200 234 238 280 299 322
 327 337 382
 forging of 82-3 93
 incriminating 74 82
 scarcity 278-80
 valuable artefacts 76
dog 231-2 252 253 254
 Gelert 293
 Jennings 254-5
Dog Latin 366
Doge of Venice 110 111 123 124
dogma 351
Dogmael, St 328-333
Dol 317
Don Giovanni 134
Donatello 231
donations 220 292
Donmar, theatre 122
Donne Triptych 235
Dorset 252 318
Dortmund 153 154 156 157
Dotheboys Hall 113
Dow, Sterling 39
dragons 326
Drake, Sir Francis 96
draper 153 154 156 157 263
drawing 89 98 141 199 250
Dresden 122 142 143 156
Drouot, hotel 242 248
drovers 311
Druids 23
Dubricius, St 301
Dugdale, Stephen 81
Dulwich Picture Gallery 201
Dunkirk 125
duplicates 257
Duport, James 101
Durdle Dor 342
Durham, cathedral 225 277
Durham, university 294
Durrells, authors 117
Düsseldorf 153 157
Dutch (see also Holland, Nether-
 lands) 74 75 77 94 126 158 159
 256 383
Dux, castle 107 111 134 143
dynastic 2 27 51 65 68 69 107 174
 212 273

Early Medieval 318 358 391 402
Earth Sciences 37 342
earthquake 12 37 38
earthwork 342
Easter Rising 137
Eastwick, Edward Backhouse 153
Ecbatana 215

Ecclesia Cathedralis de Sancto
 Asaph 326
ecclesiastical 299 301 302 304 309
 315 324 333
ecclesiology 388
Ecgfrith, abbot 395
Echternach 277
Ecole Française, Rome 63
Eden, Anthony 196
Eden, Garden of 51
Edgbaston 341
Edinburgh 81 250
edition
 early 146 170
 first 88 150 169 191 255 257 258
 limited 193
 multiple 252
 pirate 146 147 148
editor (of diaries etc)
 Barthes 175
 Besterman 187 189 191 193
 Bray 86
 Braybrooke 88 91
 Brière 178 179
 Brockhaus 145 153
 Diderot 168 177
 in Dresden 142
 Laforgue 146
 Machen 148
 Plon 150
 Tournachon 146
 Young 194
editor (journals etc) 347 348 389-
 390 405
Edomite 45
educated English (accent) 367 370
Egypt
 chronology 3 26 29 32 41 42 43 45
 46-8 57 60 68 69
 correspond with all 2
 Egyptology 2 3 27 35 65 68 69
 evidence from 2 27 49 67-8
 king lists 2 68 350
 maps 172
 monasteries invented 275 337-8
 Nubia 65-7
 periodic history 35 68
 pharaohs 2 65 68
 scarabs 40
Einion Frenin 324
Einsiedeln, monastery 129
Einstein, Albert 406
Eisenhower, Dwight D 138
Eithir/Eithyr, governor 299
Elam 53-55
Eleanor of Aquitaine 362
Elizabeth I, queen 80 81 103 121
Eltenberg Reliquary 240 248

421

Sanskrit 353 354
Sard 366
Scots Gaelic 362 363
Sicilian 366
Spanish 278 361
Swedish 353
Tuscan 131 367
Welsh 278-9 353 354 357 362
Languedoc 175
Lann Toulidauc 296
lanolin 300
Lanuvium 253
lapis lazuli 393
Late First Temple Period 42
Late Period Egypt 35
Latin
 adopted by Celtic-speakers 362
 alphabet 279 368 369 372
 compressed 373
 construction of 365
 Dark Age scribes 278-9 309 365
 equivalent of academese 347
 glosses 396
 'Latin' America 362
 Latinate group 353-4
 origin of modern languages theory
 278 350 353 361
 phonetic literary language 366
 QWERTY situation 372
 Sagranus Stone 332
 scribal language 278 367
 vulgar variants 366 367
 written record in 359
'Latzian' 371 372
Le Breton, André François 168
Le Conservateur Journal de
 Littérature de Sciences et de
 Beaux-Arts 159
Le Neveu de Rameau 177 179
lead point 396
Leads, the 123
Lear, Edward 199 201
Lefkandi 20 21
left, the (politics) 196
legal documents 49 228 309
Leger Galleries 199
Leghorn (Livorno) 157
Léhon 317
Leibniz Calculus 183
Leipzig 149 156 157 159 160 161
 162
Leith, W Compton 212
Leland, John 298
Lenin 198
Leonidas, king 1 7
Leopold II 186
Les Délices 197
lèse-majesté 392

Lett's 143
Lettre sur les aveugles 176
Levant 15 37 40 41
Lewis, M 322
LHIIIA 60
LHIIIC 14 19 20 60
Lhuyd, Edward 323
Liber Landavensis 302 314
liberal 146 167 196 357
libertine 123 137
library
 Ashurbanipal 229
 Besterman and 189 190-2 197
 Bibliothèque nationale (see main)
 Bodleian 103
 British Library (see main entry)
 Casanova and 107 134 138 142
 Congress 192
 Cotton 228
 crooks in 178-9 180 182
 Egypt 67
 gentry 261
 Hengwrt 263 285
 National Library of Wales (see
 main entry)
 National Portrait Gallery 250
 Old Royal 228
 Peniarth 284
 Pepys (see Pepys)
 Pierpont Morgan 179
 private 95-6
 provided by Pope 273
 Shirburn Castle 282 283
libretto 134
Libri, Giuglielmo 227 228 229
Lichfield Cathedral 279 280 281 308
 309 310
Lichfield Gospels (see also Llandeilo
 Gospels) 279 280
Life of David 314 327
Life of St Padarn 299
Life Sciences 342 353
light box 396
Ligne, Charles-Joseph, Prince de 107
 111 138 139 140 141 142 152 16
likenesses 250 251 256
Lindisfarne 58 277 395 396
Linear B 38
linguist 145 175
linguistics 338 353 355 357 359 360-
 4 367 369
Linnaeus, Carl 174
list
 bogus list 127-8 283
 d'Alembert's output 182-3
 encyclopédistes 170-1
 king 2 27 68-9 350
 'listed' 302

432

435

rolodex 145
Roman
 antiquities 31 253-4
 effect on language 338-40 357
 360-2 366
 Empire 136 267-8 270 273 274 290
 327 340 356
 history 42 60 329
 literacy 365-7 368 369 371-2
 post-Roman 289 291 295 339 357
 religion 267 271 274 290-1
 Romance languages 362
 times 12 31 38 44 60 172
 towns etc 290 294 296 300 305-6
 Wales 290-1 294 296 300 305-6
 321
Roman Catholic 73 270 327
Romanesque 322
Romanian 278
Romantic Movement 152 167
root-words 355
Rosetta Stone 332
Rosicrucian 125
Rossetti, Dante Gabriel 199 201
Rousseau, Jean-Jacques 125 181 185
 186
Rowlandson, Thomas 199 201
royal
 court 128
 Dark Age 222
 dynasty 2 27 65 69 212
 families 110-11
 Geographer 172 173
 licence 91
 Printer 168
 socialise with Casanova 130
 throne name 2
Royal Commission on the Ancient
 and Historical Monuments of
 Wales 312
Royal Theatre, Dresden 122
royalties 148
rubbish 103 222 253 335
Rückert, Friedrich 160
Rufus, William, king 330
runic 220 232 384
Rupert Bear 294
Russell Harty 200
Russia
 Casanova in 130
 Catherine II 182 186
 Diderot manuscript 177-8
 language 354
 Oxus treasure 209-10 213 217
 princes 240-1 (and see Soltykoff)
 publishing industry 177
 Russian-American 1
 Soviet Union 196 213

tanks 150

Saakadze, princes 240
Sade, Marquis de 140
Sadler MSS 79
Saginovy princes 240
Sagranus Stone 332
saint (and see under name)
 patron 180 304 314 317 318 320
 321 324
 saints (generic) 274 275 291-2 297
 299 300 310 313 314 326 337
 Ultramontane 193
Saint Petersburg 130 245
Saint-Geniès (?) 178
Saint-Germain, count de 125
Saint-Jean-le-Rond church 180
Saint-Julien, Brioude church 221
 222
salon 125 128
Saltykov 240 (see Soltykoff)
Samian 404
samizdat 177
Sams, G K 34
Samson, St 316-318
 Samson Pillar 319
San Donato, princes 240
San Samuele, theatre 110 117
Sandby, Paul 199 201
Sangushko, princes 240
sans-culotte 223
Sanskrit 353 354 355
Santa Maria 63
Santorini 38
Sapieha, princes 240
Sarah Campbell Blaffer Foundation
 254
Sardinia 63 64 367
Sarepta 44
Sarkozy, Nicolas 138
Satyginy-Kondiyskie, princes 240
Saudi Arabia 2
Saur de (?) 178
saviour 267 290
Savorgnan, Nanetta and Marton 117
Saxony 143
Sayn-Wittgentien-Berleburg, princes
 240
scarabs 40
Scarlett O'Hara 26
Schaeffer, Claude 56
Schiller, Friedrich 178 179
schismatic 268
Schliemann, Heinrich 12
scholarship (cited) 17 28 40 41 50
 129 169 187 214 220 241 332
school
 at 74 118 188

441

445